RINGS
Five Passions in World Art

ORGANIZED BY THE HIGH MUSEUM OF ART AND PRODUCED BY
THE ATLANTA COMMITTEE FOR THE OLYMPIC GAMES
CULTURAL OLYMPIAD

PRESENTED BY EQUIFAX INC.

THE EXHIBITION CATALOGUE HAS BEEN MADE POSSIBLE BY
JOHN H. AND WILHELMINA D. HARLAND CHARITABLE FOUNDATION, INC.

THE HIGH MUSEUM OF ART IS GRATEFUL FOR THE GENEROUS SUPPORT OF
THE WALTER CLAY HILL AND FAMILY FOUNDATION
THE HALLE FOUNDATION
JOHN S. AND JAMES L. KNIGHT FOUNDATION
NORDSTERN INSURANCE COMPANY OF AMERICA
CANTOR FITZGERALD
UPS TRUCK LEASING

THE EXHIBITION IS SUPPORTED BY AN INDEMNITY FROM
THE FEDERAL COUNCIL ON THE ARTS AND HUMANITIES.

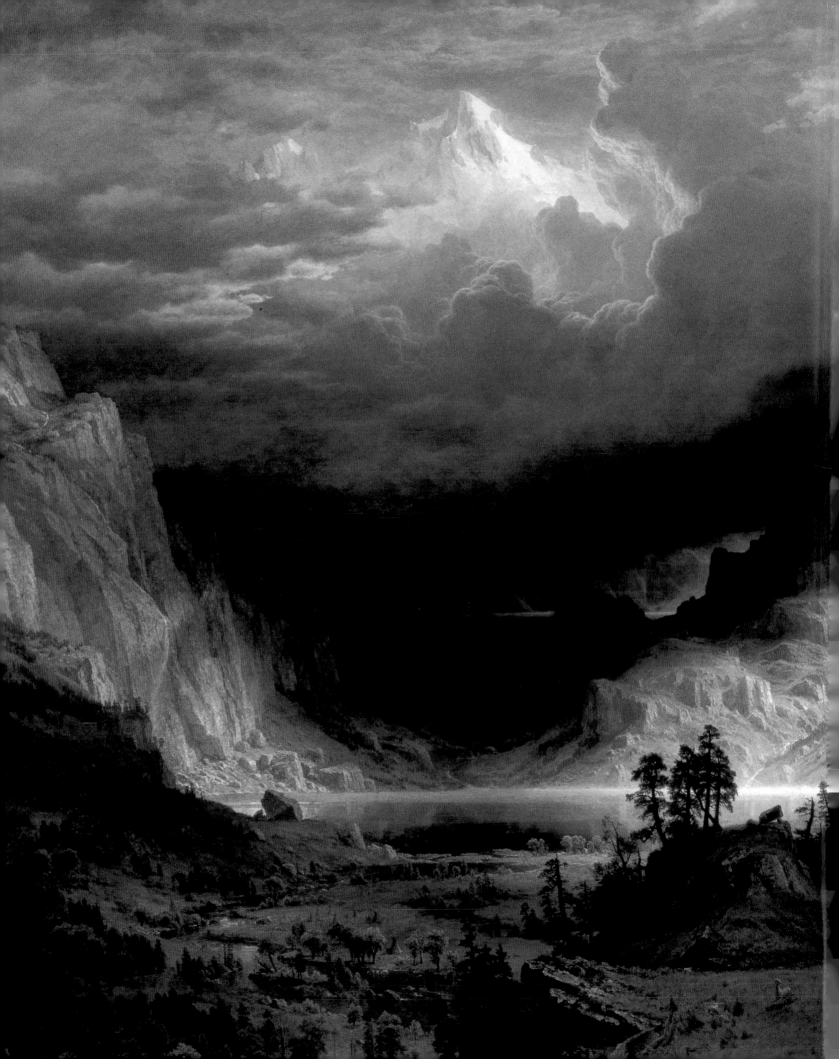

RINGS
Five Passions in World Art

J. CARTER BROWN

ESSAY BY JENNIFER MONTAGU

EDITED BY MICHAEL E. SHAPIRO

HARRY N. ABRAMS, INC., PUBLISHERS,
IN ASSOCIATION WITH THE HIGH MUSEUM OF ART

For Harry N. Abrams, Inc.:

Editor: Harriet Whelchel

Designer: Ana Rogers

For High Museum of Art:

Editors: Kelly Morris, Margaret Wallace

Photo Research: Susan Feagin

Front cover: Auguste Rodin. *The Kiss* (detail), see p. 46

Back cover: Frantešik Kupka. *Disks of Newton* (detail), p. 296

Endpapers: Ivan Avaizovsky. *The Wave,* (detail), p. 150

Title page: Albert Bierstadt. *Storm in the Rocky Mountains,* (detail), p. 158

Page 43: Dieric Bouts. *Virgin and Child* (detail), p. 74

Page 93: Antonia Eiriz. *Between the Lines* (detail), p.116

Page 135: *Goddess of Transcendental Wisdom* (detail), p. 198

Page 207: *Kurukulla* (detail), p. 218

Page 245: William H. Johnson. *Jitterbugs (II)* (detail), p. 304

Library of Congress Cataloguing-in-Publication Data

Rings : five passions in world art / J. Carter Brown ;
essay by Jennifer Montagu ; edited by Michael Shapiro.

p. cm.

Exhibition held in Atlanta, Ga., at the High Museum of Art, in
conjunction with the 1996 Summer Olympic Games.

ISBN 0-8109-4429-4 (HNA cloth).—ISBN 0-939802-81-3
(museum pbk.)

1. Art—Exhibitions. I. Brown, J. Carter (John Carter), 1934–
II. Montagu, Jennifer. III. Shapiro, Michael Edward. IV. High
Museum of Art.

N5020.A87H547 1996

707'.4'758231—dc20 95–43959

PHOTOGRAPH CREDITS

© Addison Gallery of American Art, Phillips Academy, Andover,
Massachusetts: 243; Jörg P. Anders: 227; © 1995, The Art Institute
of Chicago, All Rights Reserved: 261, 297; Dirk Bakker: 201,
© The Detroit Institute of Arts: 67; Basset: 113; Dick Beaulieux: 173;
Carlo Catenazzi: 69; Michael Cavenaugh and Kevin Montague: 179;
Fernando Chaves: 107; Dolores Dahlhaus: 129; © The Detroit
Institute of Arts: 145; Rafael Doniz: 183; Lydia Dull: 97; Tibor Franyo,
© Honolulu Academy of Arts: 119; Lynton Gardiner: 205, 253;
Ben Grishaver: 79; Jerry Jacka: 293; Bruno Jaret (© 1996 Artists
Rights Society [ARS], New York/ADAGP, Paris): 47, 313; Jewish
Museum/Art Resource, N.Y.: 307; Franko Khoury: 231; Ch. Larrieu,
Musée du Louvre, Paris: 291; Jürgen Liepe: 203, 219; Courtesy of the
Los Angeles County Museum of Art: 87; Paul Macapia: 165, 181;
Marburg: 30; © The Metropolitan Museum of Art, New York: 73, 251;
Dan Morse: 279; © Musée de l'Armée, Paris: 237; © Museum of
Contemporary Art, 123; © 1995 The Museum of Modern Art,
New York: 121; © 1995 Board of Trustees, National Gallery of Art,
Washington, D.C.: 89, 271; Courtesy of the National Gallery of Art,
Washington, D.C.: 127, 193; Courtesy of the New Orleans Museum
of Art: 225, 259; Poppi: 33; R. M. N.: 57; Rijksmuseum-Stichting
Amsterdam: 109, 249; Adam Rzepka: 280; Adam Rzepka, Musée
national d'art moderne, Centre Georges Pompidou, Paris,
photo courtesy of the Philadelphia Museum of Art: 53; Mark
Sexton: 175; Dmitris Skliris © Wichita Art Museum Collection: 77;
Lee Stalsworth: 311; Jim Strong: 101; © Tate Gallery: 143; Vatican
Museums: 63, 303; John Webb, © Tate Gallery, 139; Courtesy of
the Board of Trustees of the Wellington Museum: 239; Wettstein
& Kauf: 255; Diane Alexander White: 171.

CONTENTS

LENDERS TO THE EXHIBITION

Adelaide, Australia
ART GALLERY OF SOUTH AUSTRALIA

Amsterdam, The Netherlands
RIJKSMUSEUM

Andover, Massachusetts, USA
ADDISON GALLERY OF AMERICAN
 ART, PHILLIPS ACADEMY

Ankara, Turkey
MUSEUM OF ANATOLIAN
 CIVILIZATIONS

Athens, Greece
BYZANTINE AND CHRISTIAN MUSEUM

Atlanta, Georgia, USA
PRIVATE COLLECTION

Ballarat, Victoria, Australia
BALLARAT FINE ART GALLERY

Beijing, People's Republic of China
PALACE MUSEUM

Berlin, Germany
STAATLICHE MUSEEN ZU BERLIN,
 PREUSSISCHER KULTURBESITZ
 ANTIKENSAMMLUNG
 ÄGYPTISCHES MUSEUM UND
 PAPYRUSSAMMLUNG
 GEMÄLDEGALERIE
 MUSEUM FÜR OSTASIATISCHE
 KUNST

Bloomington, Indiana, USA
INDIANA UNIVERSITY ART MUSEUM

Boston, Massachusetts, USA
MUSEUM OF FINE ARTS

Brooklyn, New York, USA
THE BROOKLYN MUSEUM

Brussels, Belgium
FELIX COLLECTION
PRIVATE COLLECTION

Bucharest, Romania
NATIONAL HISTORY MUSEUM

Cairo, Egypt
GENERAL EGYPTIAN BOOK
 ORGANIZATION

Cambridge, Massachusetts, USA
ARTHUR M. SACKLER MUSEUM,
 HARVARD UNIVERSITY ART
 MUSEUMS

Chartres, France
MUSÉE DES BEAUX-ARTS

Chicago, Illinois, USA
ART INSTITUTE OF CHICAGO
FIELD MUSEUM OF NATURAL HISTORY
MUSEUM OF CONTEMPORARY ART

Cleveland, Ohio, USA
THE CLEVELAND MUSEUM OF ART

Craiova, Romania
MUZEUL DE ARTĂ

Crete, Greece
RETHYMNON ARCHAEOLOGICAL
 MUSEUM

Dallas, Texas, USA
DALLAS MUSEUM OF ART

Denver, Colorado, USA
DENVER ART MUSEUM

Detroit, Michigan, USA
THE DETROIT INSTITUTE OF ARTS

Egham, Surrey, England
ROYAL HOLLOWAY, UNIVERSITY OF
 LONDON

Eindhoven, The Netherlands
STEDELIJK VAN ABBEMUSEUM

Fort Lauderdale, Florida, USA
MUSEUM OF ART

Guayaquil, Ecuador
MUSEO DEL BANCO CENTRAL

Hampton, Virginia, USA
HAMPTON UNIVERSITY MUSEUM

Hartford, Connecticut, USA
WADSWORTH ATHENEUM

Honolulu, Hawaii, USA
HONOLULU ACADEMY OF ARTS

Jakarta, Indonesia
MUSEUM NASIONAL

Jos, Nigeria
JOS MUSEUM

Kamakura, Kanawaga Prefecture, Japan
ENNŌ-JI

Kyoto, Japan
DAIGO-JI

Leiden, The Netherlands
RIJKSMUSEUM VOOR VOLKENKUNDE

Lisbon, Portugal
PRIVATE COLLECTION

London, England
APSLEY HOUSE, THE WELLINGTON
 MUSEUM
THE BRITISH LIBRARY
TATE GALLERY

Los Angeles, California, USA
LOS ANGELES COUNTY MUSEUM
OF ART

Lyons, France
MUSÉE DES BEAUX-ARTS

Madrid, Spain
MUSEO DEL PRADO
MUSEO NACIONAL CENTRO DE ARTE
REINA SOFIA

Malibu, California, USA
THE J. PAUL GETTY MUSEUM

Manchester, New Hampshire, USA
THE CURRIER GALLERY OF ART

Nanjing, People's Republic of China
NANJING MUSEUM

Naples, Italy
MUSEO E GALLERIE NAZIONALI DI
CAPODIMONTE
MUSEO NAZIONALE DI SAN MARTINO

New Haven, Connecticut, USA
YALE UNIVERSITY ART GALLERY

New Orleans, Louisiana, USA
NEW ORLEANS MUSEUM OF ART

New York, New York, USA
THE ASIA SOCIETY
FRENCH & COMPANY, INC.
THE JEWISH MUSEUM
THE METROPOLITAN MUSEUM OF
ART
THE MUSEUM OF MODERN ART
PRIVATE COLLECTION

Oberlin, Ohio, USA
ALLEN MEMORIAL ART MUSEUM,
OBERLIN COLLEGE

Oslo, Norway
MUNCH-MUSEET

Otterlo, The Netherlands
KRÖLLER-MÜLLER MUSEUM

Paris, France
MUSÉE DE L'ARMÉE
MUSÉE DES ARTS DÉCORATIFS

MUSÉE DU LOUVRE
MUSÉE RODIN
COLLECTION CLAUDE AND
BARBARA DUTHUIT

Philadelphia, Pennsylvania, USA
PHILADELPHIA MUSEUM OF ART

Phoenix, Arizona, USA
PRIVATE COLLECTION

Poughkeepsie, New York, USA
FRANCES LEHMAN LOEB ART
CENTER, VASSAR COLLEGE

Prague, The Czech Republic
NATIONAL GALLERY

Rome, Italy
GALLERIA BORGHESE

Rudolstadt, Germany
THÜRINGER LANDESMUSEUM

Safat, Kuwait
PRIVATE COLLECTION

St. Louis, Missouri, USA
ST. LOUIS SCIENCE CENTER

St. Petersburg, Russia
THE STATE HERMITAGE MUSEUM
THE STATE RUSSIAN MUSEUM

Saitama Prefecture, Japan
TOYAMA KINNENKAN

Salem, Massachusetts, USA
PEABODY ESSEX MUSEUM

San Diego, California, USA
MUSEUM OF CONTEMPORARY ART

San Francisco, California, USA
ASIAN ART MUSEUM OF
SAN FRANCISCO
THE FINE ARTS MUSEUMS OF
SAN FRANCISCO

Santa Fe, New Mexico, USA
PRIVATE COLLECTION

São Paulo, Brazil
MUSEU DE ARTE SACRA DE
SÃO PAULO

Seattle, Washington, USA
SEATTLE ART MUSEUM
PRIVATE COLLECTION

Seoul, Korea
NATIONAL MUSEUM OF KOREA

Taipei, Chinese Taipei
PALACE MUSEUM

Tepotzotlán, Mexico
MUSEO NACIONAL DEL
VIRREINATO-INAH

Tokyo, Japan
SEIKADŌ BUNKO MUSEUM
TOKYO NATIONAL MUSEUM

Toronto, Ontario, Canada
ART GALLERY OF ONTARIO

Varanasi, India
BHARAT KALA BHAVAN, BANARAS
HINDU UNIVERSITY

Vatican City
MUSEI VATICANI

Vienna, Austria
KUNSTHISTORISCHES MUSEUM

Washington, D.C., USA
HIRSHHORN MUSEUM AND
SCULPTURE GARDEN
NATIONAL GALLERY OF ART
NATIONAL MUSEUM OF AFRICAN ART
NATIONAL MUSEUM OF AMERICAN
ART

Wichita, Kansas, USA
WICHITA ART MUSEUM

Xalapa, Mexico
MUSEO DE ANTROPOLOGÍA,
UNIVERSIDAD VERACRUZANA

Zurich, Switzerland
MUSEUM RIETBERG

SPONSOR'S STATEMENT
EQUIFAX

MASTERPIECES OF ART ARE TIMELESS IN THEIR APPEAL. THEY TELL THE STORY of every person living and every person who ever lived. They tell of successes and failures, loves and losses, grand achievements, and everyday existence—the common bonds of humanity that span the generations. How art enriches was described by Aldous Huxley:

> The finest works of art are precious; among other reasons, because they
> make it possible for us to know, if only imperfectly and for a little while,
> what it actually feels like to think nobly and feel nobly.

In Atlanta in 1996, each of us will have the opportunity to think and feel nobly, to enjoy an experience that will take but a few hours and yet last a lifetime. The Olympic experience will make our lives richer, a bit more fulfilled.

Rings: Five Passions in World Art brings masterpieces of art spanning eight thousand years to one city, under one roof, at one time. No doubt, it will be a once-in-a-lifetime event.

Equifax is proud to be the signature sponsor for *Rings: Five Passions in World Art,* part of the Olympic Arts Festival. Join our fourteen thousand associates throughout the world in seeing life as it has never been seen before. Join us in learning from the wisdom of artists from all ages and places, through some of the greatest works of art known to humankind.

D. W. MCGLAUGHLIN
President and Chief Operating Officer
EQUIFAX INC.

C. B. ROGERS, JR.
Chairman and Chief Executive Officer
EQUIFAX INC.

PREFACE

The Atlanta Committee for the Olympic Games is pleased to present the largest, most comprehensive arts festival ever held in conjunction with the Modern Olympic Games: The 1996 Olympic Arts Festival. Historically, the Olympic Games have honored in the arts what they honor in sport: the highest achievements of mankind. "In the golden age of Olympia, the harmonious combination of the arts, letters, and sport assured the greatness of the Olympic Games," stated Baron Pierre de Coubertin, founder of the Modern Games. "And so it should be again." And so it is in Atlanta, precisely one hundred years after Coubertin revived the Olympic Games in Athens.

Rings: Five Passions in World Art is a cornerstone of ACOG's 1996 Olympic Arts Festival and a source of great pride to the entire Olympic Movement. Among the largest of the twenty-five special exhibitions prepared in partnership with Atlanta's premier museums and cultural institutions, *Rings* joins the more than two hundred visual arts, music, theater, dance, literary, and humanities programs that the Cultural Olympiad has commissioned to showcase the most exciting contemporary artistic traditions of the world alongside those of our own region.

We hope that our visitors and friends in Atlanta will enjoy this groundbreaking exhibition and take the opportunity to discover some of the world's artistic masterpieces. We thank the High Museum of Art, its Board of Directors and staff, for participating in this unprecedented collaboration with us, and we extend special appreciation and admiration to the exhibition director for the show, the distinguished J. Carter Brown. Our special praise for innovative community leadership must go to the Atlanta-based international corporation Equifax Inc. for its visionary financial support of this most ambitious undertaking. I would also like to commend Linda P. Stephenson, managing director for Olympic programs, and Jeffrey N. Babcock and Annette DiMeo Carlozzi, director and visual arts producer, respectively, of the Cultural Olympiad, for their dedication to the success of *Rings*.

Billy Payne

WILLIAM PORTER PAYNE

President and Chief Executive Officer

THE ATLANTA COMMITTEE FOR THE OLYMPIC GAMES

FOREWORD

NED RIFKIN

RINGS IS A WORD THAT QUICKLY EVOKES MULTIPLE ASSOCIATIONS. ONE THINKS immediately of the cosmological implications—for example, the rings of Saturn. In the realm of entertainment and festivities, the rings of a circus come to mind as well. Certainly the notion of repeated circularity, the ancient image of the serpent devouring its own tail as a symbol of eternal continuity, is a primary interpretation. Circularity also implies a perfection, a striving for the form wherein all points are equidistant from its center. Hence, a ring symbolizes the commitment of one person to another in the matrimonial contract in many cultures. It is also the word used to describe the sounding of a bell, in celebration or in mourning or as alarm, for communication as well as to call people together.

Of course, the Olympic rings have special meaning, not only as a logo for a corporate entity (for which it is known worldwide), but also as a mark that signifies the coming together of individuals from various lands and nations, combining their talents to perform and compete together, as one athlete against another, one nation against another, to demonstrate the oneness of the human race and its striving for excellence and achievement. The genius of the Olympic mark is that, while it distinguishes by colors one circle from the next, these self-contained forms are emphatically overlapping, integrating, and fusing into a singular image of the five rings.

The relationship of fine arts to the Olympic Games from the very beginning of the ancient Games is well documented. The revival of the Olympic Games one hundred years ago sought to keep the ideal of mind and body in balance, but throughout the twentieth century the athletic dimension of the Games has dominated the cultural aspects of this celebration of human achievement. With *Rings: Five Passions in World Art*, the High Museum of Art, together with our partners from the Atlanta Committee for the Olympic Games Cultural Olympiad, presents an exhibition that is unprecedented in the history of this important international event. This thematic gathering of important works of paintings and sculptures from around the world—selected from the great museums and collections from

numerous countries—embodies the human endeavor to express emotions and states of mind that are common to all people, regardless of their nationality, ethnicity, cultural background, social and financial status, or geographical location. These passions, to which the subtitle of the exhibition alludes, are aspects of the human experience that everyone shares and are the very foundation upon which any form of substantial understanding and communication is based. That the arts are the vehicle for these elements of the human psyche is one of the reasons we must value them, appreciating their capabilities for forging bridges between differences.

To realize the High Museum of Art's desire to host world culture, I felt it would be appropriate to seek the counsel of one of the world's leading authorities and most respected individuals within the museum profession. Attending the banquet given in honor of Gudmund Vigtel, my predecessor at the High, was none other than J. Carter Brown, then director of the National Gallery of Art in Washington, D.C. Carter and I had met on numerous occasions over the period of the seven years when I worked in our nation's capital but scarcely had known one another. His visit to Atlanta in the fall of 1991 was both timely and fortuitous. We spent some time together that evening discussing various exhibitions that were on the horizon. However, we did not touch upon what the High's plans might be for presenting something important in conjunction with the centennial of the modern Olympic Games.

Soon after his appearance and remarks that October, Carter surprised the museum world by announcing his retirement from the National Gallery. Immediately the thought occurred to me that, if I could persuade him to assist me in some way, we would have the benefit of his extraordinary experience and vast knowledge of art from the world's great museums. As it turned out, I became Carter's first visitor to his new offices on Pennsylvania Avenue.

I brought to him the wonderful challenge of determining what form the Olympic opportunity would take for an institution that is relatively young, having been established in 1926 and having grown substantially in the post–World War II period. There have been many moments of glory and excitement in this institution's history, not the least of which was the opening of our Richard Meier–designed facility in 1983. But the arrival of these magnificent works of art from around the world, organized in a cogent, compelling, and dramatic manner by an individual with a great love and profound understanding not only of the resonance of these objects, but also of their emotional, intellectual, and spiritual value as well, is perhaps the High's most exhilarating moment. We are delighted to have had the singular brilliance, force, and talent of J. Carter Brown to lead and direct this ambitious undertaking. His presence, his grace, his expansive vision, and his infectious passion for art have inspired us all.

Having these masterworks in our spaces for the period of the exhibition will undoubt-

edly create a lasting impact on this city's cultural life and legacy. For this, the Board of Directors of the High Museum of Art, the staff, the members of the Museum, and the citizens of the metropolitan Atlanta community are all truly grateful to the lenders of these masterpieces.

The High has been most fortunate to have found among its neighbors a remarkable corporate friend who has stepped forward to become a partner in this project. Equifax Inc., headquartered here in midtown Atlanta, has generously provided a major gift that enabled us to realize this exhibition. As the signature sponsor of *Rings*, Equifax not only moved the High Museum of Art into the future, paving the way toward the twenty-first century in a manner that few others could have imagined, but it has also contributed to the health and well-being of the soul of this area by enabling us to bring these wonderful manifestations of human creativity and imagination to our city. Few companies have distinguished themselves in this way with such magnanimous modesty and kindness. I am grateful to Equifax's chairman, C. B. "Jack" Rogers, who served as the volunteer chairman of the Robert W. Woodruff Arts Center during 1993 and 1994, and to D. W. McGlaughlin, president and chief operating officer.

Joining Equifax is a consortium of prominent and generous patrons from Atlanta and beyond, without whom this exhibition would not be possible. These sponsors, who represent the broad spectrum of the global business community, national foundations, and Atlanta's own exceptionally generous business and cultural leaders, have partnered with us in an unprecedented demonstration of support for a special exhibition at the High. Primary among them is the Walter Clay Hill and Family Foundation. Established by the late Mr. Hill, and continued under the leadership of his daughter, Mrs. Laura Boland, a Life Member of the High's Board of Directors, and her brother, Walter C. Hill, Jr., the family and foundation shared our vision and provided us with important and timely support that has helped to make *Rings* a reality. Mrs. Boland, who died recently, brought gratifying enthusiasm to this project, and the coincidental fact that her father was one of the principal founders of the organization only makes this convergence of sponsorship more noteworthy.

We are enormously grateful to Claus and Marianne Halle, who through The Halle Foundation showed great generosity as sponsors of the exhibition. Mr. Halle also provided assistance with several important loans from Germany, particularly the stunning bronze *Praying Boy* from Berlin. Iris and B. Gerald Cantor, through Cantor Fitzgerald, whose sculpture collections and patronage of the arts are known internationally, underwrote the costs of bringing Auguste Rodin's legendary *Kiss* and Camille Claudel's *Waltz* to Atlanta from Paris.

We are honored to have received a major gift from the John S. and James L. Knight Foundation—the first grant to the Museum by this national foundation, which is dedicated to supporting innovative projects in art museums and other cultural institutions.

The John H. and Wilhelmina D. Harland Charitable Foundation, Inc., a longtime supporter of the High, has provided essential support for this exhibition catalogue, enabling us to produce this important publication and ensure its availability to our international audience. Nordstern Insurance Company of America, the U.S. subsidiary of the leading international fine art insurer, Nordstern, has provided very welcome help by insuring some difficult-to-ship objects. UPS Truck Leasing, Inc., gave essential support for domestic ground transportation, through the leadership of Richard Bogen, president and chief operating officer of UPS Worldwide Logistics. The exhibition is also supported by an indemnity from the Federal Council on the Arts and Humanities.

The High's Board of Directors, chaired by John Wieland, deserve special mention. They never wavered from the notion that it would be critical for the Museum to play a role heretofore unknown and untested: organizing a major "blockbuster" exhibition within its own spaces. My thanks go to Board treasurer Matthew Levin for his financial counsel and oversight; John Spiegel, a long-standing member of our Executive Committee, for his insights and recommendations; T. Marshall Hahn, Jr., a key member of the Board during our negotiations with The Atlanta Committee for the Olympic Games (ACOG) and others; and former Board chair Dick Denny, who initiated the Board discussions of *Rings* in 1992.

The High extends its deep gratitude to Billy Payne, president and CEO of ACOG, for his direct assistance in the realization of *Rings*. Billy knew immediately that bringing great art to Atlanta for this centennial event was important and needed his endorsement, and he was quick to offer it. Dr. Jeffrey Babcock, director; Annette DiMeo Carlozzi, visual arts producer; Fern Segerlind, sales and promotion manager; and Susan Elliott, director of communications for the Cultural Olympiad, each played critical roles in this process. I also wish to thank Jan Sugarman, who helped secure important sponsorship, and Margaret Rhodes, for her stewardship of our sponsorship questions.

We are grateful to the High's Members Guild, the largest support group of its kind in the nation, for its remarkable force of volunteers, who assisted with many aspects of visitor services and special events. In particular, our thanks go to Audrey Shilt, president-elect of the Guild, and Lynne Browne.

I must also add that a number of High Museum of Art staff people did exemplary work in preparing for this unprecedented project. To begin with, I want to thank former associate director for museum programs Bill Bodine for the initial work he did during the earliest phases of this exhibition. Dr. Michael Shapiro, the High's director of museum programs and chief curator since November of 1994, has done outstanding work as the managing curator for *Rings*. Michael has never lost his sense of purpose—not to mention his sense of humor—

and his understanding of how important this show could be to the High and its visitors. I am profoundly grateful to him for his indefatigable commitment to *Rings.*

Other key personnel on the High's staff, principally Anne Baker, director of external affairs, and Rhonda Matheison, director of business affairs, have led the complex logistical planning attending an undertaking of this scope. Also Keira Ellis, manager of foundation and government support; Betsy Hamilton, manager of individual support; Susan Brown, manager of corporate support; Roanne Katcher, manager of membership; Ann Wilson, manager of public relations; Marjorie Harvey, manager of exhibitions and design; Frances Francis, registrar; Kelly Morris and Margaret Wallace, editors; Karen Luik and Joy Patty of our department of education; Marcia Mejia, manager of museum-shop operations; Nancy Roberts, chief preparator; Michael Manley, manager of facilities; and Helen James, chief of security, have all contributed significant expertise and energy throughout the planning and implementation process. Denise A. Kramer, Michael Shapiro's assistant, was a key link between Washington and Atlanta offices. Susan Feagin was in charge of gathering illustrations for the catalogue; Alison MacGinnitie, Paige Parvin, and Kate Flores formed an effective research team as we delved into the material. Elisa Buono Glazer, our special consultant for development, and Luisa Kreisberg, our public-relations specialist, and her staff have added extraordinary talent to our already fine group.

Rings: Five Passions in World Art, like the 1996 Centennial Olympic Games in Atlanta, will come and go, leaving a residue of memories etched indelibly in the minds of those fortunate enough to have experienced them. Our hope, at the High Museum of Art, is that this exhibition, its educational programs and other events, will engender and confirm a sense that art can make a difference to individuals because of its essential human and affective component, and that, through this and other publications, will live on beyond the summer of 1996. Art, regardless of where it was made, when it was crafted, or from which materials, is a key aspect of human existence. Seeing a work of art, standing before art's inexorable energy, opening to art's transformative potential, and going on, with heightened curiosity, to learn more about art, gives us hope for future understanding of and appreciation for cultural differences. All of us are very much part of the universal language that visual art embodies. *Rings: Five Passions in World Art* is presented not as a definitive exhibition or final statement, but rather as an offering of what is possible when humankind converges to bring the best of human nature to bear at one time in one place.

INTRODUCTION

J. CARTER BROWN

> After vigorous debates between behaviorists, anthropologists, and sociologists, we have entered a period of exchange of thoughts and a mutual approach, which in many instances has led to cooperative projects of researchers from different disciplines. This work . . . confirms, above all else, the astonishing unity of mankind and paints a basically positive picture of how we are moved by the same passions. . . . I would like to add that the need to understand ourselves has never been so great as it is today.
>
> —Irenäus Eibl-Eibesfeldt, *Human Ethology,* 1989

> To be sure we must never claim the monopoly of truth, let alone look down on other cultures whose values and convictions differ from ours. But the recognition of such differences must not lead us to deny the unity of mankind.
>
> —E. H. Gombrich, *Topics of Our Time: Twentieth-Century Issues in Learning and in Art,* 1991

So much divides us. Each individual is unique; each group has its own affinities. Each nation, driven by pride and survival, fiercely defends its territory, as do the animal kingdoms in the wild. As the affirmation of our individual egos dominates our agenda, as ethnic politics drives us into sharper and sharper differentiations, what kind of a world can we look forward to? In Arthur Schlesinger's brilliant *Disuniting of America* and other discussions in the United States of our eighteenth-century ideal, *E pluribus unum,* we see ourselves degenerating more and more into strident enclaves of affinity. What is there that can lift us out of our most regressive selves? What vision, what idealism, what aspect of our nature can we look to for a world of harmony and interconnectedness?

The idea of the Olympic Games, the centennial of whose rebirth we celebrate in 1996, represents precisely that hope. The catalyst for the revival of the ancient Olympic Games, the Frenchman Baron Pierre de Coubertin, wrote and fought for a rededication to an ideal that he named "Olympism." For almost one thousand years in antiquity, wars were suspended in deference to the evenhanded fairness of the Olympic Games. They represent the ultimate in what we call "the level playing field."

But Coubertin's definition of Olympism went beyond athletics or even the ancient moment of truce. In 1904, he wrote in the Parisian newspaper *Le Figaro,* "In the golden age of Olympia, the harmonious combination of the arts, letters, and sport assured the greatness of the Olympic Games. And so it should be again."

If there is an aspect of humanity that binds us together, it is our emotional selves. Whatever the color of our skin or the shape of our eyes, however conditioned by centuries of widely divergent cultural learnings, there remains in each of us fundamental human passions that we all share.

As James A. Russell concludes in a thoroughgoing review of the literature examining differences in various cultures in describing the emotions (*Psychological Bulletin* 110, no. 3, 426–50), "There is a core of emotional communication that has to do with being human rather than with being a member of a particular culture." The anthropologist Ellen Dissanayake, in her book *What is Art For?*, stresses our common genetic heritage over hundreds of thousands of years, and writes, "It is our specieshood, not our nationhood or race, that unites us."

The means by which we best express these basic feelings and put them into lastingly communicable form is called the arts. The visual arts are our direct access to the hand and mind and heart of the person and the culture that created that specific example of visual creativity. Dance, of course, combines the visual with the dimension of time, as does literature, and in many ways music is the most affecting of all the art forms, although it can require a higher degree of convention. In this exhibition we have attempted to give access to music by electronic means, and we encourage visitors to explore further the full context of the musical excerpts we have quoted. Out of all the varieties of visual art, given constrictions of space and the fragility of certain mediums, we have limited ourselves to painting and sculpture, both defined so as to include ceramics.

Emotions themselves interconnect with each other, and for this reason the exhibition is organized so as to suggest how a given emotion overlaps with the next one addressed. Coubertin was thinking of interconnectedness when, in 1914, he suggested a visual symbol for the modern Olympic Games—the five interconnecting rings that have become one of the most widely recognized symbols in the world. His original concept was, of course, geographic (the rings "represent the five parts of the world which are now part of Olympism and ready to accept the fertile rivalry it entails," he wrote). But with geographical diversity—differences of space—comes ethnic, religious, cultural, and gender diversity, as well as period differences over time.

In conceiving this exhibition, I have taken, in a metaphorical sense, the concept of interconnectedness that those five rings so graphically embody as the guiding principle for an art exhibition of what we believe to be a wholly innovative kind. Its basis is in the emotional, affective (as distinct from purely cognitive) function of works of art, grouped under five rubrics: Love, Anguish, Awe, Triumph, and Joy. These do not pretend to be an exhaustive list of the world's passions, although many emotions can be thought of as being subsumed under one or another of these broad categories. I have summarized the conception of the five sections at the beginning of the Catalogue of the Exhibition, page 41, and subsequently in some detail in the five introductory summaries to be found at the beginning of each "Ring."

Thus, the museum visitor will find right away all of the things that this exhibition is not and has no intention of being. We have come to expect a genre of art exhibition based on the scientific benefits of bringing together objects that are as like each other as possible, so that we may taxonomically study with greater and greater precision the nuances of their remaining differences. This becomes crucial when it is a question of authenticity or attribution. An exhibition devoted, for example, to the late works of Paul Cézanne, with a roomful of his paintings of the same mountain, makes possible great insight and enrichment.

The present exhibition represents the polar opposite of that approach. It brings together paintings and sculpture as diverse as possible, in scale and materials and originally intended function, objects that span more than seven thousand years of creativity, representing virtually all the major geographic areas and principal religious mainstreams of our world. The juxtaposition of such purposely disjunct material is reminiscent, perhaps, of André Malraux's *musée imaginaire* but differs fundamentally in that it deals not in the realm of the imaginary but in original objects, assembled to a specific end.

The one aspect of these objects that justifies their inclusion is their ability to evoke an emotional response. It is this capacity, rather than the more immediately obvious linkages of period, style, medium, scale, color, technique, or artistic philosophy, that counts for whatever coherence and shape the exhibition can be considered to have achieved. Other shows have attempted diversity within thematic categories. That approach depends on iconography, the illustrational side of depiction, and has long borne no appeal for this writer as a justification for the expense and risk of moving original works of art around. "The Dog in Art" can lead to interesting discussions, but virtually the same discussion could be held on the basis of a group of good photographs of the objects adduced.

Nor does this exhibition wish to be merely an anthology of important or famous objects, an agglomeration of "treasures" to amaze the visitor. Some two hundred nations are repre-

sented in the Olympic Games, and, given the space limitations at the High Museum of Art and the attention span of a visitor, it would have been useless to try to represent everybody in some kind of loose assemblage of thises and thats.

When I was approached by the talented director of the High Museum of Art, Ned Rifkin, with the proposal that I conceive and help direct an exhibition at the High in the summer of the Olympic Games, I asked to be allowed to think about it, and wrote him a few days later with a proposal for what is essentially the present exhibition. In accepting Ned's challenge, I suggested, and he agreed, that, like Kenneth Clark's *Civilisation* series and book, conceptually the exhibition should bear the subtitle "A Personal View."

No one is more aware than I how we are limited by our own backgrounds, education, and exposure. Although this undertaking has been largely a team effort, with input and suggestions from scholars and laypeople from around the world, it was agreed from the outset that this kind of show cannot ultimately be selected by committee without degenerating into a series of trade-offs that would blunt whatever acuity and consistency of eye and spirit to which it might aspire. There is not a piece in the show that has not moved me in some way. Many I have known, loved, even coveted over the decades.

In addition to my own limitations of preference and knowledge, the exigencies of borrowing and limitations of space mean that quantities of great material are inevitably missing. This very open-endedness, however, is one of the most exciting aspects of this concept. It is my hope that visitors, particularly students, will try their hand at constructing their own "Rings" exhibitions out of the objects in their local museums or from magazines and books or their own memories.

What this exhibition does attempt to present, and the issue it confronts, is the experience of a work of art as the precipitator of certain emotions in us. The admitted subjectivity of such an approach might go against the grain of some of us who have been trained in the rigors of art-historical methodology, a relatively recent field of study that has striven for legitimacy in the academic world. In this attempt, the academic study of art has tended to downplay subjectivity, hoping to emulate the achievements through objectivity of modern science. Meanwhile, art history has been exploring a variety of avenues. For example, an art historian at Columbia University not long ago asked in the *Art Bulletin* (76, no. 3, 394), in the parlance of the day, "How can [art history] go beyond the hermeneutic and semiotic strategies of poststructuralism?"

Meanwhile in the fields of cognitive psychology and neuroscience, recent developments have begun to give the affective, emotional side of human nature its due. Following on the groundbreaking work of Nobel Prize winner Roger Sperry (left brain/right brain), R. B.

Zajonc (primacy of affect), and Howard Gardner (multiple intelligences), Antonio Damazio states in his *Descartes' Error: Emotion, Reason, and the Human Brain*, published at the end of 1995:

> Neither anguish nor the elation that love or art can bring about are devalued by understanding some of the myriad biological processes that make them what they are. . .
>
> It does not seem sensible to leave emotions and feelings out of any overall concept of mind. Yet respectable scientific accounts of cognition do precisely that. . . . I see feelings as having a truly privileged status. They are represented at many neural levels, including the neocortical. Feelings are winners among equals. . . . Their influence is immense.

In the United States—whose history has reflected the imprint of the early Puritan belief that emotions are dangerous and the arts were the work of the Devil—a society bent on generating material wealth has laid its primary emphasis, in its educational philosophy and system of rewards, on human beings as measured by their capacity to maximize a quantifiable "bottom line." This focus on economic materialism has tended to shunt any consideration of the arts to the periphery, if not all the way to oblivion.

The time has come, then, to reassert the idealism of Pierre de Coubertin. We must strive to integrate cultural values into a concept of the whole person and explore, with openness and sensitivity, the importance—I would say the centrality—of our emotional lives and the riches that await us in receiving, through art, affective transmissions from across great gulfs of space and time.

The cultural legacy of the ancient Olympic Games, to which Coubertin wanted to draw our attention, has a long history. The Olympic Games themselves go back at least to 776 B.C. but probably existed in some form even before that. The Games were originally part of a pilgrimage to the Altis Grove at Olympia, the most sacred place of the supreme god of the Greek religion, Zeus. Over the years it grew as a center for both religion and sport.

Among the events were orations by philosophers and presentations by poets and historians, as well as the singing of specially written victory hymns. We know from the traveler Pausanias that the Altis Grove became a large, open-air art gallery where commissioned statues of Olympic victors were on view. The greatest work of art at Olympia was the gold and ivory statue of Zeus, now lost. It was by their greatest sculptor, Phidias, who was responsible for the design and some of the execution of marbles on the Parthenon in Athens.

The Games were held consistently every four years, with hardly a break, for more than

a millennium. For a month or two around them, there was recognized the Olympic Truce, when all fighting stopped. In 80 B.C., the Roman general Sulla transferred the Games to Rome, but, immediately following his death two years later, the festival was returned to Olympia. In subsequent years, the site came under attack, and, although the Games continued, they probably ended in A.D. 393, when the Christian emperor of Rome, Theodosius I, banned all pagan cults.

Between the fifth and eighth centuries A.D., Olympia was overrun by wave after wave of invaders—Visigoths, Avars, and Vandals (a fate some would see threatening our own culture), and the final devastation was wrought by earthquakes, landslides, and floods, bringing in a layer of silt that covered the site with some twelve feet of alluvial deposit. The very location of the Olympic site passed into oblivion.

Some fourteen hundred years later, a group of French archaeologists investigated the site. Full-scale excavations were not undertaken until 1875, financed by the German government under Kaiser Wilhelm I, with the permission of the Greek authorities. The publication of the findings by Professor Ernst Curtius of the University of Berlin became the inspiration for Coubertin, who vowed to bring back the ideals that had inspired the ancient Games.

Coubertin, whose father was an artist and mother a musician, devoted his life to the cause of education. A French admirer of the British emphasis on sport as relevant to a balanced human being, and fired by a passionate adherence to the ideals of ethics, fairness, and internationalism that he felt the ancient Games embodied, the thirty-year-old Coubertin announced, in the amphitheater of the Sorbonne on November 25, 1892, his intention of reviving the Olympic Games. The audience was coolly polite; the press ignored the event completely. Coubertin later wrote, "When I wanted to revive the Games, everyone thought I was mad." Undaunted, he created an International Olympic Committee on June 23, 1894, and the first Olympiad in modern times was held in Athens from the sixth to the fifteenth of April 1896, with Coubertin as the president of the IOC.

Coubertin pursued his idea of including the arts in the Olympic Games, calling a conference in Paris in 1906 to create a "Pentathlon of the Muses" in the fields of painting, sculpture, architecture, literature, and music, with competitions to be held first in 1912 and limited to "works which have not been published or exhibited before and which were directly inspired by an idea connected with sport." By the time of the Los Angeles Olympic Games in 1932, 31 countries were represented in an exhibition displaying 1,100 works of art, viewed by more than 384,000 visitors.

In the subsequent Games, in Berlin in 1936, politics intervened, and the avant-garde

was excluded. The exhibit in London in 1948 was criticized from a variety of quarters, and the following year, at a meeting in Rome, the Olympic Committee abolished the practice of an art competition.

With the election of Marqués Juan de Samaranch to the head of the IOC in 1980, the concept of an Olympic museum in the IOC headquarters in Lausanne received a new impetus, with a beautiful building for the purpose opening in 1993. Meanwhile, every four years the cultural dimension of the Olympic Games has been celebrated by festivals of the arts with increasing range and depth. The international manifestations in Los Angeles in 1984, including a memorable exhibition of French Impressionism, established high standards in both the performing and visual arts. Munich and Tokyo, to name only two other Olympic hosts, produced very impressive exhibitions, and the most recent summer games in Barcelona offered a rich menu of cultural events. The Cultural Olympiad of the Centennial Olympic Games in Atlanta represents the most ambitious set of offerings to date, focusing on the twin areas of arts of the southeastern United States and internationalism. It is to this latter cause that the present exhibition is dedicated.

To the many people of the Cultural Olympiad and to the wonderful staff of the High Museum of Art, whose valuable contributions are recognized in Ned Rifkin's foreword, I add my own sincerest thanks. In addition, in the design of the exhibition, I am personally grateful to Elroy Quenroe, a former colleague at the National Gallery of Art, now with Quenroe Associates, who has taken on a particularly challenging task with great professionalism, aided by Marge Harvey and her colleagues at the High. It is hard to understate the helpfulness of two pro-bono consultants from the National Gallery's legendary design and installation department, Gaillard Ravenel and Mark Leithauser.

In the conceptual phase of the exhibition, the key contributor, of enormous help, was Jay Levenson, with whom I had worked closely in the *Circa 1492* exhibition at the National Gallery. Other graduates of that team, Cameran Castiel and Elaine Trigiani, have been closely involved with the implementation.

Many scholars and experts from around the world have selflessly offered their assistance. The encouragement of Irving Lavin of the Institute for Advanced Study at Princeton was inspirational. We have been very fortunate in having Professor Jennifer Montagu contribute the essay that follows. Her recent work on the passions, stemming from her study of the seventeenth-century Charles Le Brun treatise on the subject, has equipped her well for this task.

Among the many knowledgeable advisers, I wish to extend special thanks to Vishaka Desai, Barbara Ford, Wai-kam Ho, Helen Jessup, David Joralemon, Thomas Lawton, Yoshi Shimizu, Roy Sieber, James Ulak, and Sylvia Williams. In addition, my warm thanks go to James Ackerman, Svetlana Alpers, Christopher Anderson, Maxwell Anderson, Chryssanthe Baltoyannis, Jaime Barberis, Ezio Bassani, Milo Beach, Marthe Bernus-Taylor, Alf Bøe, Richard Brilliant, Jonathan Brown, Diana Buitron, Shiela Canby, Rand Castile, Bertha Cea Echenique, Pramod Chandra, Edith Cicerchia, Timothy Clarke, Michael D. Coe, Kevin Consey, Andre Aranha Corrêa do Lago, I. Michael Danoff, Hugh Davies, Suzanne Delahanty, James Demetrion, William U. Eiland, Ekpo Eyo, Miguel Angel Fernandez, Virginia Fields, Carmen T. Ruiz de Fischler, John Fleming, Jan Fontein, Mary Garrard, Adelheid M. Gealt, Lucinda H. Gedeon, Mrs. Nicholas P. Goulandris, Anthony Grant, Gilett Griffin, Nikolaus Himmelmann, Hugh Honour, Douglas K. S. Hyland, Ioana Ieronim, Kay Redfield Jamison, William Jones, Albert Kastenevich, David K. Krecke, Sherman E. Lee, Helmut Leppien, Glenn D. Lowry, Marcia Y. Manhart, Paul Matisse, Patrick McCaughey, Christopher McShane, Spyros Mercouris, Charles Millard, Mingde Tu, Meda Mladek, Zachary Morfogen, Frederick Mote, Robert Mowry, Jenny Mullen, Akihiro Nanjo, Ray Orley, Henk van Os, David Penney, Giuseppe Perrone, Paul N. Perrot, Gerald Peters, Dean A. Porter, Richard J. Powell, Lionello Puppi, Antonio Puri Purini, Julian A. J. Raby, Ron Radford, Werner Rappl, Philip Ravenhill, Amy Reed, Günsel Renda, James Romano, Franklin Robinson, Howard Rogers, J. Michael Rogers, Maryann Rogers, Joan Rosenbaum, Robert Rosenblum, Jorge H. Santis, Peter Claes Schuster, Mario Serio, R. C. Sharma, William Siegman, Seymour Slive, Weiwei Sheng, Judy Shindel, Gail Stavitsky, Francisco Stiastny, Jan Stuart, Georgina Stonor, Sema Sungar, Eugene Thaw, Pierre Théberge, Peter Tillou, David J. de la Torre, Richard Townsend, Yannis Tzedakis, August Uribe, Pirú Urquijo, Ashok Vajpeyi, Tatiana Vilinbakhova, Allen Wardwell, Hirotmitsu Washizuka, Akiyoshi Watanabe, James Watt, Stuart Cary Welch, J. Keith Wilson, Wu Shaozu, Wu Tung, Zhang Deqing, and Christiane Ziegler. The members of the Association of Art Museum Directors in the United States have also been most helpful in contributing suggestions and encouragement. Various members of the National Gallery staff, too numerous to list, have also been of great assistance. In addition, I wish to thank all the contributors of entries to the catalogue, whose combined knowledge has been an immeasurable resource.

In view of the important potential of music as an element in the exhibition, we were highly fortunate in being able to benefit from the collaboration of the noted musicologist and con-

ductor Leon Botstein, who somehow manages also to be the president of Bard College. My thanks go as well for the musical assistance of Robert Aubry Davis.

Finally, we are deeply indebted to all those, both museum colleagues and private owners, who have lent and facilitated loans to this exhibition (a list of lenders appears on pages 6 and 7). Needless to say, for them to lend to an exhibition as atypical as this is very much to their credit; their interest in the project and its generating idea has been touching, and we owe them our deepest thanks.

I also want to make a special acknowledgment of the concerned help of Professor Ernst Gombrich of the Warburg Institute in London, the magisterial scholar of art, its history, psychology, and meaning. His dictum published many years ago, "I do not think that there are any wrong reasons for liking a statue or picture," has been a watchword in my own career attempts to bring visitors together with great objects. It was professor Gombrich who reminded me, in the present context, of the passage in Alexander Pope's *Essay on Man*:

> On life's vast ocean diversely we sail,
> Reason the card, but Passion is the gale;
> Nor God alone in the still calm we find,
> He mounts the storm, and walks upon the wind.
> Passions, like Elements, tho' born to fight,
> Yet, mix'd and soften'd, in his work unite: . . .
> Love, Hope, and Joy, fair Pleasure's smiling train,
> Hate, Fear, and Grief, the family of Pain,
> These mix'd with art, and to due bounds confin'd,
> Make and maintain the balance of the mind:
> The lights and shades, whose well accorded strife
> Gives all the strength and colour of our life.

Whatever strength and colors this exhibition may provide, it is our vision that this catalogue, together with the musical suggestions, can afford an opportunity to let the feelings this show may generate live on and resonate long after the experience of visiting the exhibition has passed. The multiple connotations of the word *ring* have been part of the idea since the original proposal. Our hope is that Baron Coubertin would be pleased with the varied resonances and harmonics that we have attempted to give to his stirring idealism. This, the 100th anniversary of the modern movement that he had so great a hand in starting, does seem a fitting time to thank him, and all the athletes and administrators and donors and workers and, yes, artists who have done so much to help create a more interconnected world.

TRADITIONS OF
EXPRESSION IN ART

JENNIFER MONTAGU

Sport arouses strong passions. This is equally true of the players and the spectators, so it is hardly surprising that it should have been from the soccer field that the English derived their current clichés "over the moon" and "sick as a parrot," used to express the highest degree of elation or dejection, the standard reaction to the winning penalty goal or the losing missed save. As for the teams' supporters, their riots are not a modern phenomenon but go back at least to the days of Justinian I in Constantinople.

The focus of this exhibition, as formulated in the foregoing Introduction, is the emotional reaction of the spectator (stopping short, we may hope, of a hooligans' riot), not to an athletic contest but to works of art from a wide variety of different times and cultures.

One way of producing an emotion in the viewer of a work of art is simply to depict an emotional event, made "readable" through the facial expressions and bodily movements of those involved, so that the viewer will share in, or react to, their emotions. However, this is in fact no simple matter, and we shall return to explore the long history of artists' attempts to achieve such communication.

Beyond this recording of the feeling expressed by the actors in a work of art, for most artists it was at least as important to arouse an emotion in the spectator. Indeed, by the mid-seventeenth century there were those who would argue that the first task of the painter was to arouse such an emotional response, which should affect the spectator even before he or she knew what the exact subject of the picture was meant to be.[1]

Many believed that the two aims were identical and that the spectator would inevitably empathize with the figures depicted. This was put in a rather extreme form by the painter and theorist Lomazzo, writing in the later sixteenth century:

> A painting . . . will make one . . . desire a beautiful young girl for a wife when one sees a painting of a naked woman, . . . and also feel hungry seeing those who eat rich and delicate foods, fall asleep with those who sleep sweetly, move the spirit and almost make one furious with those who are shown fighting fiercely in battle expressed with the right and appropriate movements.[2]

But this was a rather naive view (most people find counting sheep more effective than looking at a picture of a sleeping figure), and most theorists, including Lomazzo himself, realized the power of what we should call abstract elements such as color and line to convey, and inspire, emotive effects. In the past, of course, they would write not in terms of abstract art but of the appropriateness of the landscape setting or the weather, though they were well aware of the function of color, light effects, and general composition to establish the mood that the picture as a whole was intended to convey, even before looking at the individual figures and what was actually going on.

So they turned to other arts with longer traditions of such theoretical discussion of "general expression," as it was called by Charles Le Brun (a seventeenth-century painter whose influential discussion of expression will concern us later), and in particular to rhetoric, poetry, and music. Cicero, writing with the politician or the lawyer in mind, had said that the aim of rhetoric was to instruct, to please, and to touch,[3] and Saint Augustine said the same of the rhetoric of the preacher.[4] The means by which the orator could move his audience were extensively examined in treatises on the subject. Poets chose their words to inspire the desired emotion in their listeners, soft and sweet sounds for love, or harsh and disagreeable sounds for storms or battles, and so forth. But no art was believed to have such power over the passions as music, and there were innumerable stories of people being roused to fury, or reduced to calm, by the appropriate musical harmonies. Plato had wished to control the types of music that could be played in his ideal republic, and we have only to think of the fulminations against such modern manifestations as rock 'n' roll and the effect it has had over the young of more recent times to appreciate how readily music works on people's emotions.

It is therefore hardly surprising that the painter should wish to be able to produce similar effects. The nearest visual equivalents to musical rhythms and tones are line and color, and great attention was applied to their correct use within the context of the particular image. This can often be seen even in early periods when such matters did not enter into theoretical discourse, but by the seventeenth century, and even more in the eighteenth, it had become an important part of art theory. It was in the early nineteenth century, however, that books began to be devoted to the investigation of our reaction to line and color, and none was more ambitious or more influential than David Pierre Giottin Humbert de Superville's *Essai sur les signes inconditionnels dans l'art*, published in Leiden in 1827–32. As is apparent from his title, the author believed that the signs that he had identified were unconditioned and must therefore be universal, applying right across the art of the world, and equally to nature itself.

Humbert started from the proposition that "Man is upright, and turned towards the

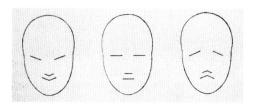

HUMBERT DE SUPERVILLE, *Diagramatic Expressive Faces*, from Humbert de Superville, *Essai sur les signes inconditionnels dan l'art,* 1827, page 6

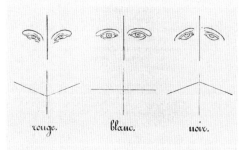

rouge. blanc. noire.

HUMBERT DE SUPERVILLE, *Diagramatic Expressive Eyes and Corresponding Colours,* from Humbert de Superville, *Essai sur les signes inconditionnels dan l'art,* 1827, page 11

heavens" and that any deviation from this vertical would have an expressive potential. Contracting lines pointing obliquely downward from the vertical would both depict and inspire melancholy or spirituality, while expansive lines slanted obliquely upward would signify joy or happiness. He demonstrated this by images of the human face with the eyes and mouth depicted either horizontally, which he saw as expressing calm and wisdom, or sloping upward or downward, which are directions generally recognized as depicting happiness and sorrow, and in which he also saw changeability and lust, or profound thought, solemnity, and spirituality. He found the same principles in the frontal views of the faces of the horse, the cat, and the hound.[5] His principles could even be applied to trees, and he noted that the oak tree is strong and calm and regarded as sacred by many peoples, that the pine tree is expansive, whereas the fir tree, or the Norwegian pine, has mournfully hanging branches and grows principally where vegetation ceases, between existence and nothingness.[6] In architecture he contrasted the horizontally emphasized and massive buildings of the Egyptians and early Greeks with the spirituality of Gothic arches and spires. Humbert disapproved of Chinese buildings, with their upturned eaves, finding them lacking dignity, gravity, or stability. He admitted that he knew almost nothing of Chinese architecture, but his statement is not so much about China as about our reactions to forms that may, or may not, coincide with the nature of the object itself. These reactions are unconditioned—by anything, including knowledge—and it would be absurd to assume that all hounds are melancholy, or that trees have any emotions at all.

Humbert's theories also covered color, as can be seen in a diagram from his book. The association of white, red, and black with his three prototypical images, and the sequence of intermediate colors (straw, yellow, and orange; pearl, azure, and indigo) as intermediate signs, was intuitive rather than based on the upright posture of a man standing between Earth and Heaven. In fact, his theory was based on what he believed to be a natural and universal human reaction to such schemata and was by no means infallible: evidently unaware of the existence of black-maned lions, he regarded a fiery mane as inseparable from the lion's nature and consonant with the form of its head; a lion with a black mane, he said, would look like a poodle.[7] However, color symbolism has intrigued many writers, not necessarily directly connected with art, and, without being able to point to any reasons, most people do indeed react emotively to color. There is also a broad measure of agreement on the subject, even if one can cite such anomalies as the Chinese use of white for mourning.

Couched in a language verging on mysticism, and leading to dogmatic assertions as to what art of the past should, or should not, be imitated, Humbert's *Essay* can all too easily be dismissed as a rather eccentric product of its age. Yet, in a much simplified form, his princi-

ples entered into the theory of art and influenced artists as diverse as Georges Seurat and Wassily Kandinsky. And if one looks at the pictures in this exhibition, including those that were painted long before Humbert wrote, it is interesting to see how often these "unconditional" signs were recognized by the painters themselves. One has only to see El Greco's soaring *Resurrection* (page 204) to respond to the joyful expansive lines of the composition, a triumphant shout of "Hallelujah!"[8]

In looking at the images of nature in the exhibition, however, it is evident that these painters are viewing nature far less rigidly than Humbert de Superville. Yet our emotional reactions to landscape are indubitably quite as natural as anything Humbert's theories would have prescribed, though perhaps not entirely "unconditioned," since they are derived from sometimes bitter experience. We know what weather is agreeable to us, and what sort of surroundings make for a comfortable life: spring mornings and sunny days suggest happiness (see page 274), and ever since classical antiquity poets have delighted in describing the "pleasant place," the fields or woodland clearings with gentle streams, flowers, and sheltering trees, which still give us pleasure today. Such scenes, found already in Roman paintings, were just as pleasing in medieval times.

The concepts of the *picturesque* and the *sublime* came only later. The very word *picturesque* betrays the origin of the concept in preexisting pictures; it depends on the judgment of a leisure class that could look on the landscape in aesthetic terms, without having to worry too much about its suitability for agriculture, or its productivity. The idea of the *sublime,* something that is amazing, awe-inspiring, and with more than a hint of the fearful, and the appreciation of these qualities, depends upon a knowledge that we ourselves are safe from harm. Of course, pictures themselves cannot harm us. We can enjoy the drama of a work by Ivan Aivazovsky (page 150), for example, in rather the way we might enjoy a roller coaster. However, it is doubtful whether in more primitive times, when the forest really threatened and mountains were places of danger rather than splendid scenery to be admired by the tourist or climbed by the mountaineer for pleasure, they would have been seen as such magnificent subjects for the painter. Even a fiery sunrise or sunset in all its glory may have one meaning for the town dweller or the aesthete and quite a different one for the farmer who is primarily concerned with whether or not it presages rain.

What is certain is that images of nature are "expressive" in a very different way from a human face. This is often disguised in language, where we may talk of "smiling fields" or "threatening crags," but such phrases indicate our reaction to them, and no civilized person today would believe that the fields or rocks are expressing their own emotions. Even those for whom the heavens declare the glory of God might hesitate to say that they actually express

the Deity's reactions to man, except in such specific cases as are described in the Bible, like Noah's Flood, or the Day of Judgment. For artists, however, such natural phenomena can provide a clearly recognizable symbol of the relationship between God and his creation, and contain a powerful religious message.

Between the images of human emotions and pure landscape there is a hybrid form of art, depicting man pitted against the forces of nature. It may be just a human figure dwarfed by the majestic landscape, serving both as an indicator of scale and as a reminder of how we, the spectators, should react, in much the same way that painters of the Baroque period would introduce bystanders into their scenes of martyrdom to reflect the emotions that the real spectators of the painting were supposed to feel. Sir Edwin Landseer, however, indicates how ineffective was man's attempt to dominate the frozen northern wastes by showing the remains of a boat and its human occupants picked over by polar bears (page 148).

In such paintings the artists strove to arouse an emotional response but without actually *depicting* an emotion. The "passion" is not in the image but exclusively in the response of the spectator. The essential meaning of Landseer's painting could hardly be mistaken, even without its title—*Man Proposes, God Disposes*—but Landseer had in mind Sir John Franklin's failed expedition to discover the Northwest Passage. He has raised the incident to a symbolic and universal statement, but he might equally well have painted the dying seamen, depicting in their bodily movements and facial expressions the heroic agony of their last moments, in such a way that the spectator would be moved by their plight.

I have said at the outset that this depiction of emotion is no simple matter, but that was not apparent to the first person recorded as having commented on it, the fifth-century Greek philosopher Socrates, and it is appropriate to this exhibition that he should have done so in connection with the sculpting of figures of athletes. Xenophon tells how Socrates visited the painter Parrhasius and discussed the representation of beauty and the related necessity of depicting a man's character in his face and body; he then writes:

> On another occasion he [Socrates] visited Cleiton the sculptor, and while conversing with him said: "Cleiton, that your statues of runners, wrestlers, boxers and fighters are beautiful I see and know. But how do you produce in them that illusion of life which is their most alluring charm to the beholder?"
>
> As Cleiton was puzzled and did not reply at once, "Is it," he added, "by faithfully representing the form of living beings that you make them look as if they lived?"

"Undoubtedly."

"Then is it not by accurately representing the different parts of the body as they are affected by the pose—the flesh wrinkled or tense, the limbs compressed or outstretched, the muscles taut or loose—that you make them look like real members and more convincing?"

"Yes, certainly."

"Does not the exact imitation of the feelings that affect the bodies in action also produce a sense of satisfaction in the spectator?"

"Oh yes, presumably."

"Then must not the threatening look in the eyes of fighters be accurately represented, and the triumphant expression on the face of the conqueror be imitated?"

"Most certainly."

"It follows then that the sculptor must represent in his figures the activities of the soul."**9**

Would that it were as simple as this!

Socrates, who was himself a sculptor, should have been aware that he was twisting his argument, and Cleiton, even though he was no philosopher, should have told him he was talking nonsense. For there is all the difference in the world between reproducing wrinkled flesh or taut muscles and recognizing just what it is that constitutes a "threatening look" or a "triumphant expression." Western artists throughout the ages have striven to identify these transient emotions as they are expressed in the human body and, above all, in the human face.**10**

Visual expression of emotions has concerned Western artists in particular because so much of Western art has been about the telling of stories. These might be the stories of the Bible, which for so many centuries furnished the staple subjects for the decoration of churches or private devotion, or the fables of the Greeks and Romans, with which educated men delighted in surrounding themselves to demonstrate their participation in the culture of humanism and which came to signify a wealth of abstract ideas; the stories might be from history, or touching or amusing scenes from modern life. In order to "read" these narrative pictures—or sculptures—we must be able to interpret who is doing what to whom and how each figure in the scene is reacting. Indeed, as the skill in depicting emotions developed, it was in elaborating on these reactions, or inventing new and more subtle commentaries on the action by means of such expressions, that the old stories remained fresh and vital. And,

of course, it was by the same means that the artist (at this time almost invariably a man) could show off his originality as well as his skill.

The earliest of the writers on art theory, Leon Battista Alberti, emphasized the need for the artist to master the expression of emotion, specifically in the context of his discussion of narrative art.[11] In particular, he was the first to comment on the strange paradox that the polar opposites, laughing and weeping, can look very similar:

> And who would ever believe, if he had not tried it, how difficult it is if he wishes to paint a face which laughs, to do it so that it is not rather weeping than happy? And who, moreover, could ever manage without very great study to create faces in which the mouth, the chin, the eyes, the cheeks, the forehead, the eyebrows, everything fits together to smile or weep?[12]

In fact, laughter presented no particular problems for the artist, and it was with the representation of weeping that the difficulty arose, as can be seen in the tympanum of the Fürstenportal of Bamberg Cathedral. For those on the left, and for those emerging from their coffins secure in the certainty of their own salvation, the sculptor has successfully imbued all the parts of the face with the same smug smile. But what of those at the right? They are, obviously, the damned, as can be seen by looking at their eyebrows; but the sculptor has followed a convention that lasted well into the Renaissance, whereby a weeping mouth usually turned upward. There is no question that this upturned weeping mouth does often occur in nature, and quite frequently one may be left for some moments in a state of uncertainty as to whether someone is laughing or weeping. However, in art it can lead to real difficulties, for, in contrast to nature, in art the laughter or weeping does not develop. Since we have come to associate an upturned mouth with a smile, looking at the Bamberg portal we feel uncomfortable with these figures, finding their expressions ambiguous and self-contradictory.

Such uncertainty and conflict must be avoided if the artist wishes us, the spectators, to read his work correctly. Some half-century after the publication of Alberti's book, Leonardo da Vinci returned to the same paradox and put forward the solution to which artists have adhered ever since: "He who sheds tears raises his eyebrows till they join and draws them together, producing wrinkles in the middle of the forehead, and turns down the corners of his mouth, but he who laughs raises them, and his eyebrows are unfurrowed and apart."[13] Even if this is not invariably true, it provides a useful and wholly acceptable convention. Artists and spectators alike willingly accept a degree of conventionalization that excludes such ambiguous expressions, and a degree of exaggeration—or it might be more correct to say emphasis—just as it was accepted in the similarly speechless medium of the silent film

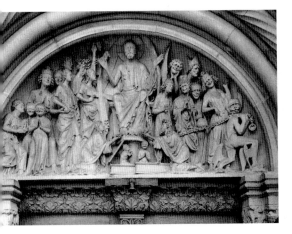

The Last Judgment, c. 1235, stone, Bamberg Cathedral Fürstenportal (tympanum)

and can still be seen today in some traditions of "theatrical" acting. But it is important to keep clear that this was within a tradition that never questioned the need for an accurate, if sometimes a rather idealized, representation of the natural world.

This tradition is reflected in the "notorious handbook"[14] derived from the lecture that Charles Le Brun gave to the Royal Academy of Painting and Sculpture in Paris in 1668, and which was posthumously published in numerous editions and in several languages as his *Lecture on General and Particular Expression*.[15] The *Lecture* was intended to explain the psychophysiological principles of facial expression in order to enable the artists, especially the young students in the Academy, to create whatever expression they wished. Although the illustrations may look exaggerated and, in the worst sense, academic, the complicated theory from which they were derived was based on the most up-to-date understanding of the mechanism of human emotions. Le Brun used René Descartes's *Treatise on the Passions,* which had been published in 1649, in which the philosopher had argued that the soul, while incorporeal, worked most particularly in the pineal gland, which is in the center of the brain; from there it controlled the "spirits" that flow into the muscles and, by causing them to expand or contract, produce our bodily movements. Le Brun reasoned that the eyebrows, being the closest of the facial features to this gland, react first and most strongly. So he devised a system to explain how the "passions of the soul" are reflected in the various movements of the eyebrows and, to a lesser degree, in the other facial features.

Le Brun certainly believed that his theory was in accord with nature and that the drawings by which he illustrated his lecture followed nature (admittedly, in the somewhat idealized form that was deemed acceptable in high art), and it was not entirely his fault that—for more than a century after his lecture was published—artists found it much easier to copy his schemata than to create their own expressions following his very complicated theoretical text. Nor, of course, was it his fault that Descartes was wrong.

I have written of idealization, and it is important to recognize that to idealize is merely to select from nature, not to depart from it. Most high art before the eighteenth century, like the theater of the time, was concerned with humans of the upper classes, or with the divine. When in 1667 the same Charles Le Brun analyzed Raphael's painting of *Saint Michael Overcoming the Devil,* he pointed out that Michael showed little emotion, "scorning the enemy he has overturned too much to take great pains in vanquishing him. This Raphael has shown marvelously well by a certain disdain which appears in his eyes and his mouth." Le Brun demonstrated how the half-closed eyes and the perfectly arched eyebrows express the angel's tranquillity and that his slightly advanced lower lip is a sign of the disdain he feels toward the devil.[16]

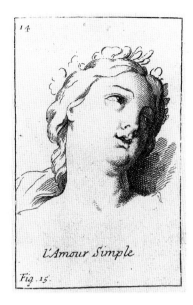

After Charles Le Brun, *Love,* from Charles Le Brun, *Conférence sur l'expression générale et particlière,* London, 1701

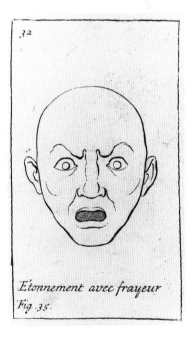

After Charles Le Brun, *Diagramatic Head Expressing Astonishment with Fear,* from Charles Le Brun, *Conférence sur l'expression générale et particlière,* London, 1701

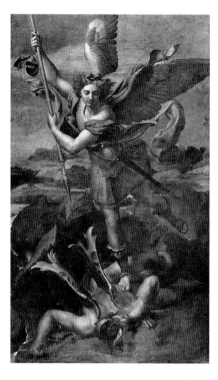

RAPHAEL, *Saint Michael Overcoming the Devil*, 1518, oil on canvas, 105½ x 63 inches (268 x 160 cm), British Museum, London

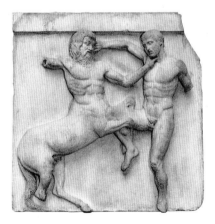

Battling Centaur and Lapith, mid-15th century B.C., marble, 47¼ x 54 x 53 inches (120 x 137.1 x 134.6 cm), British Museum, London

Angels do not need to show the same emotions as mere mortals, but well brought-up mortals also learn to mask their emotions, and we are all to some degree subject to what psychologists call "display rules," which inhibit us from expressing what we really feel or from doing so in too extreme a manner. Nor is this confined to Western cultures. The Japanese in particular may show little, if any, sign of emotion in public. But their reactions will be very similar to those of Europeans or Americans when they believe that they are unobserved, nor do they have any difficulty in identifying emotions on the faces of Americans subjected to similar emotive experiences.[17] Naturally, these display rules are reflected in Japanese art. In particular, one can compare the masks designed for the Noh plays, which, if they show any emotions at all, are relatively restrained, with those of the comic Kyogen interludes, where no such restraint is shown.

This distinction applies across most cultures, where restrictions on the display of emotions, and in particular violent emotions, were not thought to apply to the "lower orders," and still less to subhumans, such as the half-beasts of classical mythology. So the fighting heroes on the metopes of the Parthenon remain almost impassive even while being throttled, whereas the centaurs they are battling can grimace in pain when their ears are twisted. Similarly, Dutch peasants can scream in agony under the surgeon's knife or indulge in drunken brawls for the amusement of the connoisseurs who bought such paintings and who would never have behaved in this way themselves.

Such extreme displays of emotion are always going to be easier to represent, and the paintings of Adriaen Brouwer demonstrate how, by the seventeenth century, a competent artist would have no difficulty in doing so. Nor do we have any difficulty in recognizing them—but, then, we are aided by the context in which they occur. Psychologists have long been interested in the question of how far we are able to recognize the expressive configurations of the face, and for their experiments they have used still photographs, at least up until recent times, when it became feasible to use videos. While this may have little relevance to our normal experience, it has obvious advantages for the art historian who wishes to apply their findings to the still images he or she is studying. While there was considerable disagreement in the past, by now it is generally accepted that we can usually identify a limited range of rather extreme and basic emotions from still photographs of a human face even out of context. It should be emphasized, however, that high scores of correct identifications are achieved for only such basic emotions as sorrow, joy, fear, anger, or pain. And, even then, the scores fall short of 100 percent.[18]

This may seem surprising, because in daily life we do not normally experience any difficulty. But in daily life we are not confronted with still images (let alone out of context), and

facial expression is essentially a movement, a departure from normal impassivity, which develops and fades over time. To restate the obvious: artists present the spectator with a still image, selected from this continuum. It would be useless to study and strive to reproduce exactly the expressions found in nature if the spectator could not recognize them. But far more often than artists or spectators should like to admit, it is the context of a known subject, or even the label on the frame, that enables us to interpret what the still faces of a picture are expressing.

If it is the face that expresses most clearly the emotions we feel, and by means of which we can convey the most subtle nuances of feeling, it is not the only way in which such emotions are communicated. Body language is also a powerful means of such communication, and the forms it takes are, on the whole, easier for the artist to seize and for the spectator to interpret. So the early theorists of art concerned themselves also with bodily actions. Leonardo da Vinci believed strongly in the need for the artist to represent emotions not only by facial expression but also by bodily actions, writing that without such lively movements the painter's figures would be "twice dead,"[19] and even going so far as to advocate studying the gestures of the dumb.[20] It will be remembered that Socrates also referred to the importance of the artist giving the illusion of life to his figures, and the most obvious way of doing so was by reproducing their movements. Leonardo did not only examine the movements of the face, but he was also far ahead of other theorists of his time in emphasizing that "weeping" was a symptom, rather than emotion, and that it could have many different causes:

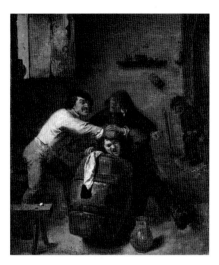

ADRIAEN BROUWER, *Two Peasants Brawling*, mid-1630s (?), oil on panel, 12 x 10 inches (30.8 x 25.8 cm), Alte Pinakothek, Munich

> In weeping the eyebrows and the mouth change according to the several causes of tears. One weeps for anger, another for fear, some for tenderness and joy, some for suspicion, some for pain and torment, and some for pity and pain because of lost relatives or friends. Among those who weep one shows himself to be in despair, another is moderate; some are tearful and some are shouting, some raise their faces to heaven and lower their hands, their fingers twisted together; others seem fearful and raise their shoulders to their ears, and so on, according to the reasons mentioned.[21]

Artists of Leonardo's time, if less involved in such intellectual distinctions, were well aware of the varied bodily movements that can convey differences of character in the way different people react to the same event, thereby also adding variety to their images. This can be seen in Niccolò dell'Arca's moving *Lamentation* in Bologna, in which those mourning over the body of the dead Christ reflect most of the movements described by Leonardo, some with contracting gestures indicating their inward grief, others more flamboyantly flinging out their arms in wild gestures of despair.

NICCOLÒ DELL'ARCA, *Lamentation over the Dead Christ* (detail), 1463 (?), painted terra cotta, approximately life size, Santa Maria della Vita, Bologna

Niccolò makes use of both the face and the body to create his forcefully emotive group. But other artists, particularly in more recent times, have relied on the body alone. This was not because they were incapable of reproducing the more complex motions of the facial muscles, but either because, as in the case of Auguste Rodin, they had a particular fascination with the human body, its slightest movements and their expressive potential, or, as in the case of Jean-Léon Gérôme, because the reliance on the language of the body, without the aid of expressive potential of the face, presented a challenge and thus a means of demonstrating his skill.

In Rodin's sculpture of *The Kiss* (page 46), featured in the first part of this exhibition, Love, it is almost impossible to see the faces of his two lovers, but there is no difficulty in recognizing the yielding eagerness of the woman or the mastery and tenderness combined in the man. In Gérôme's *Pygmalion and Galatea* (page 54), the sculptor and his erstwhile statue are shown from behind, and again it is the yielding curve of her back, together with the tension in his arm and hands, that expresses their emotion. They have, in fact, far more erotic charge than the various frontal versions or the marble sculpture Gérôme produced of the same group (though always with quite significant differences): such is the nature of a kiss that the little one can see of their faces is less effective than what the viewer imagines of their unseen passion.

If generations of poets have attempted to describe love, artists have not found it an easy emotion to represent by the facial features alone. Even Le Brun had to include the position of the head, "inclined towards the object that causes our love."[22] In non-Western art, body language, as it is normally understood, may sometimes be used in India or Japan, but often it was sufficient to show men and women coupling quite impassively. Similarly, in Egyptian representations of married couples or in Roman tomb reliefs (page 62) the position of the hands is a convention—but a convention (particularly in the restraint that characterizes Roman tomb sculpture of the period) that can produce a moving image of harmonious marital accord.

The differences between the depiction of erotic love by these post-Renaissance Western artists and the Indian miniaturists is, obviously, mainly a matter of artistic convention. It is certainly true that all humans feel similar emotions, and, by and large, they express them in the same way. Charles Darwin studied expression with the aim of understanding *why* we express emotions as we do. It is no surprise that the author of *The Origin of Species* should have differed from those who had previously attempted similar enquiries in refusing to accept that man differs from other animals in having muscles specifically provided by the Deity in order to express emotions. Rather, he saw some of our expressive movements as deriving

from earlier stages in human evolution. It was important for him to be sure that such expressions could be found in other cultures, and he sent a questionnaire to missionaries, government inspectors, and others in countries such as Australia, New Zealand, Malaya, and India before declaring that most of the expressive movements he was interested in were universal and not confined to Western civilization.[23] While this is no doubt true of what I have called the basic emotions, and while such expressions can also be recognized when displayed by people of unfamiliar racial types,[24] there are many others where expression is to at least some extent culturally conditioned. And even within these most fundamental emotions there may be some surprising deviations, as among the Balinese who, when experiencing fear, will fall into what they call "afraid-sleep."[25]

J. Carter Brown's Introduction emphasizes the universality of the emotions as binding all humanity together, the "fundamental human passions that we all share." I should certainly not wish to disagree with this, or to deny that, in a natural state, the way in which humans express those passions are essentially similar. But common humanity does not mean bland uniformity. The fascination of meeting other people is to find that, within our basic humanity, we are each of us different individuals. So, on a broader scale, the enjoyment of foreign travel comes from encountering something different from what we might find at home. So, with expression, it can be comforting to recognize the familiar, but it can be more worthwhile to see how, within the range of shared human passions, different peoples over different times have expressed them in different ways, and not only in art, as we see it in this exhibition, but also in life.

This will be most apparent in conventional expressions. Even within the American-European world, where most peoples nod their head in agreement and shake it to show refusal, in Greece a nod signifies "yes," but a backward jerk of the head indicates negation.[26] The Westerner may show his friendly intentions by advancing with hand outstretched, but in other cultures where the handshake is not the normal sign of greeting, this may appear bewildering, or positively aggressive. Even the ingratiating smile can lead to trouble, and there are instances of female anthropologists finding that their smile was interpreted by the people they were studying as a sexual invitation. Conventions and display rules also change within a culture, and even over a short span of time. The Englishman's traditional stiff upper lip has relaxed significantly over a generation, and in my own youth it was inconceivable that rugged soccer players would embrace and actually kiss to celebrate a goal. We can easily recognize the proud gesture of triumph in Thomas Eakins's boxer (page 242), but we should look in vain for such dignified restraint in the ring today.

Those whose experiments have established that expressions can be recognized across

KWAKIUTL CARVER, *Figure*, c. 1900, wood, height 93½ inches (238.8 cm), British Museum, London

cultures have used photographs and, so far as I am aware, no similar investigations have been carried out with paintings or sculptures. With naturalistic images there may well be no problem (at least, no more of a problem than with photographs), but where the imitation of nature, at least as Westerners understand the term, is not sought by the artist, transcultural communication of expression does not necessarily occur. At the time that I was writing this essay, I had occasion to visit the Museum of Mankind (a department of the British Museum) for a separate purpose, but naturally the question of expression was much in my mind. I was struck by a large statue from British Columbia and what I took to be the figure's disagreeable and rather threatening expression, especially evident in his mouth; on reading the label I was astonished to see that the figure was created to welcome those attending a Kwakiutl potlatch feast. Clearly (and one could cite many other examples), while we are naturally disposed to see expression in works of art, the conventions used in such very different cultures may not be easy to interpret in terms of our own cultural expectations.

Nor is this need for some understanding of the cultural context of a work of art confined to nonnaturalistic images; many naturalistic figures may depend upon an understanding of their meaning within a specific culture for a correct response. If one can imagine someone who knew that crucifixion was a method by which the Romans executed malefactors but who knew nothing of the Christian religion, would such a person always recognize a figure nailed to the cross (see page 128) as a representation of the savior of humankind? And how would someone unfamiliar with Christian iconography interpret a woman with seven swords sticking into her (page 106), who expresses no physical pain but only an intense inward suffering? Any competently executed crucifix figure will express suffering (I overheard a very small child looking at a crucifix, and saying "He's not well"), but indicating divinity is very much harder. *Christ on the Cross* is placed in the section on Anguish, but has the artist really fulfilled his task if it could not equally well be placed in the section illustrating Awe?

Transcultural understanding can be extremely difficult, particularly when, because of cultural and linguistic differences, those whom one might question do not have the terminology to explain the meaning of their image in words that correspond to their listener's linguistic categories. The Fang in Africa place reliquary statues over the skulls of their ancestors; these might often be crudely carved, but they still fulfill the function of defending the reliquary. For one scholar these statues express "the essence of maturity. The mature man . . . is he who holds opposites in balance."[27] For another, "Fang figures have a quiet aloofness of expression that is at times combined with an aggressive open mouth; potential energy is represented in the schematic organization of their stylized shapes."[28] A third comments, "This interpretation of the style perhaps is in accord with the function of these pieces in

defending the reliquary against uninitiated women and children, but it is questionable how well it is in accord with still another function, that of expressing the benevolent disposition and overriding orderliness of the unseen world."[29] If experts can be confused, it is not surprising that I should have misinterpreted the Kwakiutl figure—though the carver never imagined that it would be torn from its context and placed in a museum in London to be looked at by people such as me, who know nothing of his culture.

But I do not want to exaggerate the difficulty. Just as a crucifix may convey the suffering of the figure even to those who understand nothing of its fuller significance, the African and Polynesian figures in this exhibition (see pages 164, 170, 174) can inspire awe even in those who do not understand the precise meaning or function they had for those who carved them. Communication of our common human passions may sometimes fail, but it may succeed brilliantly, even where there seems to be no common basis for mutual understanding.

I began by examining works that depend entirely on the spectator's response to phenomena, or abstract images, which do not themselves experience any emotion. I then turned to consider the problems inherent in creating images that attempt to engage our emotions by depicting those of others. I shall end by recalling a third way of conveying emotion, which might be said to combine the two methods, communicating the emotions of figures depicted by relying on the responses of the spectator rather than the accurate transcription of the human face or form: caricature. The caricaturist plays on our enjoyment in recognizing like in the unlike. Caricature may be merely playful, but it can also be aggressive, portraying a public figure as some vile object or animal, or by reducing the subject to just a few lines.[30] When it comes to depicting facial expression, what Gombrich has called "the experiment of caricature"[31] represents an alternative tradition.

The summariness of the image helps the artist to overcome one of the perennial problems in the representation of expression: that the movement which is frozen on the canvas may all too easily change into a grimace as one looks at it. The less detail included, the less this is likely to happen. The caricaturist relies on isolating what the students of animal behavior have called "minimum clues." Just as a male stickleback will try to attack not only any other fish with a red underbelly, but even a crude model painted red below—and even a red van passing the window seen through the glass of its tank—so humans will react to the curve of something recognized as a mouth, or the twist of anything they are prepared to identify as an eyebrow, and read an expression into it.

It is true that this exhibition at the High Museum of Art contains no caricatures or comic strips, not because such pictures usually do not count as high art, but because graphic works on paper are not included in this show. However, *Rings* does include Pablo Picasso's

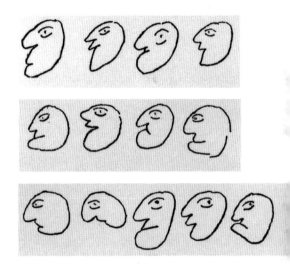

RODOLPHE TÖPFFER, *Doodled Heads*, from Rodolphe Töpffer, *Essai de physiognomonie*, 1848, page 23

Mother with Dead Child (page 100), where one may well assume that the painter judged exactly how he himself, and any other spectator, would react to the picture. The open mouth is not, in itself, a sign of anguish, and if the sharply pointed tongue suggests a piercing grief—or a piercing scream—nothing in the figure was intended to be seen as a rendering of anguish such as one would actually see it in nature. Yet for anyone familiar with the conventions of modern art, and in particular the art of Picasso, the image can tear one's heart with the unbearable loss of the mother holding the lifeless body of her slaughtered infant.

Visitors to the exhibition may compare the Picasso with David Siqueiros's *Echo of a Scream* (page 120), another heartrending image of the grief of war. The Siqueiros, with its relatively naturalistic rendering of the child, has a powerful, immediate impact, but does it continue to move one as strongly at subsequent viewings as Picasso's *Guernica* or the images he created in connection with that major work? If one also considers Edvard Munch's famous and unforgettable *Scream* (page 110), which employs all the emotive potential of color but remains almost equally memorable in a black-and-white reproduction, it is the lack of detail, the schematic treatment of the head and body, and above all the ambiguity of an image that provides us with no explanation for this strongly emotive figure, which works so profoundly on our imagination and our memory.

The task that Socrates set for Cleiton—to convey an emotion through art—is far more daunting than either of them realized, the means of accomplishing it far more complex, and the possible ways of approaching it far more varied. I have tried to show that, if the artist is to succeed, the spectator must also do his or her part. To some extent this may happen without any conscious effort, but often the spectator will be required to adjust to the stylistic language of the artist or to adapt to a wholly foreign culture, and this requirement may apply as much to the art produced at a different time within one's own native culture as to that produced in a foreign land.

The works of art assembled here have been selected for their relationship to five passions, but they can be looked at just as aesthetically satisfying objects. Visitors may, however, prefer to look at them as images intended to convey or arouse a particular emotion, and they may find that some communicate very successfully, while others are hard, or even impossible, to interpret or to respond to emotionally. I hope that, after reading this essay, they may find it interesting to consider how the artist has set about the task of communicating, to test how well they can read a naturalistic image, and to ask themselves whether the message is as powerful as that conveyed by a more stylized, more abstract, or more deliberately anti-naturalistic work. To go on from there and to ask why, at different times or in different places,

artists have chosen one method in preference to another, would go far beyond the scope of such an essay, to cover the history of world art. The selection of world art exhibited here, if it provides no solutions, may perform the more stimulating and more fruitful function of raising this and similar questions.

NOTES

1. See the Notes that Roger de Piles wrote to his French translation of Charles Alphonse Dufresnoy, *L'Art de peinture*, third edition (Paris, 1684), 135.

2. Giovanni Paolo Lomazzo's *Trattato dell'arte della pittura*, in Lomazzo, *Scritti sulle arti*, II, ed. R. P. Ciardi (Florence, 1974), 2:95–96. The *Trattato* was first published in 1584.

3. Marcus Tullius Cicero, *The Orator*, xxi, 69.

4. Saint Augustine of Hippo, *De Doctrina Cristiana*, 4: 12, 27.

5. Humbert de Superville, *Essai sur les signes inconditionnels dans l'art*, 1827, 12–13.

6. He regrets that the weeping willow, with its downward-bending branches, has leaves of light green, a color quite unsuited to this "weeping" form (Humbert de Superville 1827–32, 15).

7. Humbert de Superville 1827–32, 16.

8. It is interesting to see that Humbert de Superville (1827–32, section "Notes," 26, note 18) complains that Raphael had incorrectly used such an ascending schemata for the Christ of his *Transfiguration*.

9. Xenophon, *Memorabilia*, trans. E. C. Marchant (London and New York, 1923), III: x, 6–8.

10. For this problem see J. Montagu, *The Expression of the Passions: The Origin and Influence of Charles Le Brun's "Conférence sur l'Expression Générale et Particulière"* (New Haven and London, 1994).

11. Leon Battista Alberti, *Della pittura*, ed. L. Mallè (Florence, 1950), 87. This was first published in Latin in 1540, though Alberti prepared, but never published, a version in Italian.

12. Alberti 1950, 94.

13. Leonardo da Vinci, *Treatise on Painting*, ed. A. P. McMahon (Princeton, 1956), 1:156. This "treatise" was never actually published; it is a compilation of various notes left by Leonardo on his death in 1519 and probably put together around the middle of the century.

14. This phrase was used by Sir John Pope-Hennessy, *Raphael* (London, 1970), 246.

15. Montagu 1994.

16. André Félibien, *Entretiens sur les vies et sur les ouvrages des plus excellens peintres anciens et modernes . . .* (Trevoux, 1725), 5:336.

17. Paul Ekman, ed., *Emotion in the Human Face* (Cambridge, 1982), 140–41.

18. On this question, see Ekman 1982, with bibliography.

19. Leonardo 1956, 1:149, 150.

20. Leonardo 1956, 1:104, 105.

21. Leonardo, 1956, 1:156.

22. Montagu 1994, 134–35.

23. Charles Darwin, *The Expression of the Emotions in Man and Animals* (New York, 1955), see especially 15–16, 19–22. This was first published 1872.

24. See Ekman 1982, 128–43; Montagu 1994, 2.

25. Gregory Bateson and Margaret Mead, *Balinese Character* (New York, 1942), 39 and Plate 68, with commentary; the illustrations are reproduced in the "Added Illustrations" in Darwin, 1955, Plate 3.

26. See Irenäus Eibl-Eibersfeldt, "Similarities and Differences between Cultures in Expressive Movements," in Robert A. Hinde, ed., *Non-Verbal Communication* (Cambridge, 1972), 303. The author also discusses variations of these movements in other cultures.

27. James Fernandez, "The Exposition and Imposition of Order: Artistic Expression in Fang Culture," in Warren L. d'Azevedo, ed., *The Traditional Artist in African Societies* (Bloomington and Indianapolis, 1973), 205.

28. Paul S. Wingert, *The Sculpture of Negro Africa* (New York, 1950), 48.

29. George Mills, "Art and the Anthropological Lens," in d'Azevedo, 1973, 408.

30. Ernst Kris and Ernst Hans Gombrich, "The Principles of Caricature," *British Journal of Medical Psychology* 17 (1938), 319–42); reprinted in Ernst Kris, *Psychoanalytic Explorations in Art* (London, 1953) 189–203.

31. Ernst Hans Gombrich, *Art and Illusion* (London and New York, 1960), 330–58.

CATALOGUE OF THE EXHIBITION

THIS EXHIBITION REPRESENTS MORE THAN SEVEN THOUSAND YEARS OF ART FROM all of the geographic areas referred to by the original five rings of Baron Pierre de Coubertin. As emotions also frequently overlap with each other, I have attempted to organize the selection tightly into a progression that unfolds in five sections devoted successively to

I. LOVE Objects that communicate most effectively the emotion of love in its many forms—physical, spousal, and parental—constitute the first emotion of the exhibition. As love can have its joyous but also its agonizing side, the section will end with references to parting and separation, leading to

II. ANGUISH The gamut of the darker emotions incorporates not only emotional pain and angst but also the anguish caused by oppression and physical pain, as in martyrdom, ending in death. This leads to a consideration of what theologian Paul Tillich called "ultimate concerns" and to the section we call

III. AWE Beginning with awe of nature, this section moves on to explore the supernatural as well as expressions of inwardness and spiritual transcendence. The result of this emotion is most frequently a sense of

IV. TRIUMPH The emotion of victory will be examined in religious, military, and athletic contexts. Triumph is the one passion that often, paradoxically, involves the discomfiture of someone else. And so the exhibition broadens in its finale to

V. JOY Here joy in creation will be evoked, beginning with the life affirmation of spring, moving to aesthetic, visual delight (which can include abstraction), to joy in music, and ending, finally, in dance.

J. C. B.

I. LOVE

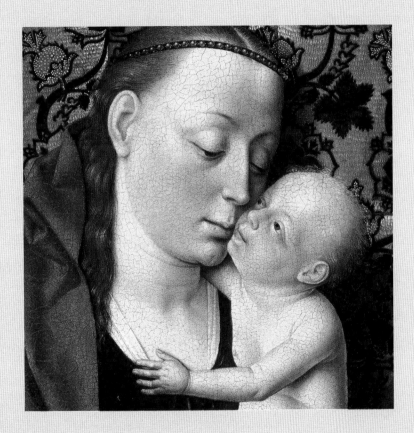

O UR FIRST RING, LOVE, ADDRESSES THE ONE PASSION THAT IS PERHAPS THE MOST UNIVERSALLY felt. This section is broken out into three subsections, each dealing with a different aspect of this fundamental human emotion. As the theme of this exhibition is interconnectedness, even these three subsections will be seen to link with each other, and we have put them in a sequence that has its own structural relationship to nature.

The first grouping goes right to the most passionate dimension of this human experience, expressing the drama and at the same time the tenderness and intensity of a physical relationship between a man and a woman. The initial image is one of the most cherished in Western art, Auguste Rodin's great *Kiss*, here in its original marble version from Paris. Paolo and Francesca were to be condemned to eternal damnation for this moment. The intensity of their passion is dramatized by the abandoned book in Paolo's left hand, as, when reading with his brother's wife, Francesca da Rimini, the Arthurian legend of Lancelot's and Guinevere's forbidden kiss, as Dante puts it in Book II of the *Inferno,* "That day [they] read no farther in it."

There follows a group of three sculptural embraces. A relief from eleventh-century India represents a high-water mark in world art history for depicting the physical, while implying the spiritual, dimension of love. A small ceramic made two millennia ago comes from Mexico. A small stone carving from Romania shows Constantin Brancusi, aware of the Rodin *Kiss* from having apprenticed in his studio, breaking with centuries of Western tradition in his earliest venture into expressing the essence of physicality through near abstraction. Moving from sculpture to painting about sculpture, we experience the passion of Pygmalion for Galatea (the story that inspired George Bernard Shaw and *My Fair Lady*). Jean-Léon Gérôme shows the creator falling so intensely in love with his statue that the very force of his emotion brings her to life, and we watch the cold marble of her legs become living flesh.

In Jean-Honoré Fragonard's *The Bolt*, the painting builds in a great diagonal past the throbbing red of the curtain and the centrality of the bed, impelling us to the far right-hand side of the composition and the fingertip of the man as he slides the bolt shut. One of the favorite masterpieces in the Louvre, the picture hangs as a *pendant,* or companion, to a picture of identical size that depicts a scene of religious love, making a counterfoil to the extreme earthiness and dramatic sweep of this vision, where love and lust are hard to distinguish. A Hindu and an Islamic miniature further reinforce with their romantic landscapes the intensity of physical and emotional interaction. The brilliantly rendered Safavid illumination, a page from one of the most highly prized of all Persian manuscripts, is about love at first sight, as Khosraw happens upon Shirin bathing.

The second subsection turns to spousal love and its consequences. The intertwining tenderness of two people turning outward to the world, side by side, is evoked by the Roman double portrait, considered per-

haps the best of all such images from the high point of ancient Roman art, the Augustan Age, known for its stoical containment of the emotions. A bronze of a mother nursing a baby dates from some four thousand years ago. The nurturing tenderness of mother and child is also explored in sculptures by a Native American of about the thirteenth century A.D., found near what is now St. Louis, Missouri (a larger city in the year 1200 than either Paris or London) and by a contemporary Inuit carving representing the modern Eskimo tradition.

Although we might think of much of Egyptian art over a span of almost three millennia as representing hieratic rigidity, there was one period, just before the brief reign of the young Tutankhamen, in which Queen Nefertiti and her breathtakingly innovative husband, the Pharaoh Akhenaten, allowed artists to depict familiar family scenes. We see this tenderness in the famous Berlin relief of the royal couple playing with their daughters on their knees and in their arms.

India has produced some of the finest and most sensuously finished bronzes in all art, as in the eleventh- or twelfth-century *Yashoda and Krishna*. A Netherlandish artist of the fifteenth century, against a sumptuous background, has evoked to a rare degree for this subject, whatever the religious overtones, an extraordinarily human intensity as mother and child are about to exchange a kiss. Their tenderness, or that of a Zairean mother, is echoed in an evocation of motherhood by a nineteenth-century American woman working in Paris. Herself childless, Mary Cassatt was a particularly gifted observer of the interaction of a child and its mother, as seen in this loosely brushed, complex composition from Wichita.

We are reminded that it is not only maternal love that links children and their elders, as we round out this subsection with two paintings in which the older figure is a man. Both artists came from the Western Hemisphere; one, from South America, was influenced by the Spaniard Bartolomé Esteban Murillo; the other, an African American, came, like Cassatt, from Philadelphia and worked in Paris.

The final subsection of this Ring introduces the first of the interconnecting overlaps among the five passions, with images that prefigure the emotion addressed in the next section, Anguish. Up to now the images of love have represented a coming together. The Anguish side of love is separation. It could be simply the parting of two friends, as in the tenth-century manuscript from the National Palace Museum in Taiwan. It could be one-sided, relating more to power, harassment, and concupiscence, as in the reference to Joseph and the wife of Potiphar, a story shared by Islam, Judaism, and Christianity, from a treasured manuscript in the Cairo National Library. The searing late Titian from America's National Gallery, cleaned and conserved for this exhibition, evokes the pulling apart of a woman and a man. The goddess of love, Venus, implores the handsomest of men, Adonis, to stay with her on their bed, with its rainbow beyond, while he and his mastiffs strain to get on with a wild boar hunt that Cupid's frightened look and the storm clouds at the right prefigure will lead to his death. Edvard Munch terminates this section at a psychological level, translated into physical blood, with *Separation,* one of the definitive statements of love gone awry, leading into the next section, **ANGUISH**.

J. C. B.

AUGUSTE RODIN
FRENCH, 1840–1917
THE KISS
1886
MARBLE
71½ x 46 x 44¼ INCHES
(181.5 x 117 x 112.5 CM)

MUSÉE RODIN, PARIS

THROUGHOUT HIS CAREER, RODIN SOUGHT TO EXPRESS IN THREE DIMENSIONS THE gamut of human emotions. In *The Kiss*, the artist achieved what is undoubtedly one of the most powerful and universal expressions of romantic love.

The basic concept of *The Kiss*—a male and a female figure embracing—derived from Rodin's monumental work *The Gates of Hell*. For that work, the artist had intended a figural group representing Paolo and Francesca, the doomed lovers of Dante's *Inferno*. When this original group, executed in bronze in 1886, was exhibited publicly in 1887, critics dubbed it *Le Baiser*, or *The Kiss*, thereby supplanting its literary title and associations with a more universal designation.

Though Rodin began this enlarged version in 1888, he did not finish carving his masterwork in marble until 1898. In May of that year, Rodin included it in the *Salon de la Societé Nationale des Beaux-Arts*, an exhibition for which he was responsible for the sculpture section. It has been argued persuasively by Daniel Rosenfeld that Rodin finished *The Kiss* in time for that exhibition because he wished to preempt the negative criticism that he expected to receive for the full-scale plaster model of one of his most daring and controversial pieces, the *Monument to Balzac*. While the latter piece was criticized by some for its apparent lack of finish and finesse, the carefully worked carving of *The Kiss* showed the artist to be more than capable of finishing his works. Indeed, contemporary critics hailed *The Kiss* as a masterpiece of the sculptor's craft.

The Kiss eventually made its way into the sculpture garden of the Musée du Luxembourg, where it could be seen among the greatest works of Rodin's contemporaries. After the dispersal of the collections of the Luxembourg, *The Kiss* found its new home in the Musée Rodin, an institution devoted to the works of this great master and has since become one of Rodin's best-known and loved pieces.

DAVID A. BRENNEMAN

The loan of this sculpture was made possible by Cantor Fitzgerald.

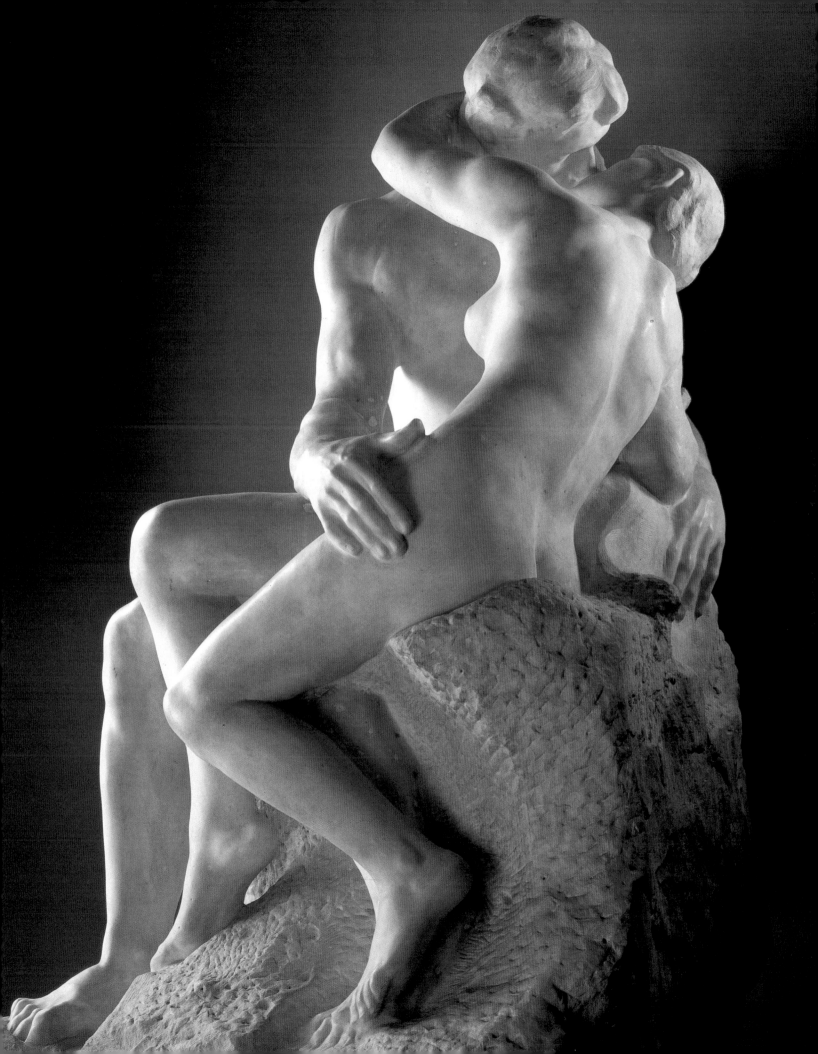

LOVERS (MITHUNA)

11TH CENTURY

KHAJURAHO, MADHYA PRADESH, INDIA

SANDSTONE

29⅛ x 13 INCHES (74 x 33 CM)

THE CLEVELAND MUSEUM OF ART, OHIO,
PURCHASE FROM THE J. H. WADE FUND

BOTH BEJEWELED AND EXQUISITELY DRESSED, EACH BEARING THE IDEALIZED MARKS OF their gender, these figures are from the walls of a Chandella royal temple in Khajuraho, a town in north central India. He is taller, bearded, and represents perfected masculinity. She fits snugly into his space, offering herself up to his attentions. Her full breasts and curvaceous hips represent archetypal femininity and idealized beauty. In her hand she holds the folds of her robe as he peels away the fabric to reveal her. The sculpture presents us with lovers in a moment of rapture.

This statue was originally placed high on the temple walls with numerous other figures. The starkness of this loving couple's activity would have been mitigated by the presence of hundreds of lovers, animals, gods, rulers, dancers, and mendicants, all neatly organized into a hierarchical structure. Even among representations of erotic love, degrees of sexual explicitness mark the status of lovers—divine couples are more clothed, while genre scenes of mortals present a wider exploration of human sexuality. In a museum setting, this statue is placed at eye level, but on a temple exterior it would be subject to the vagaries of changing light and choice of placement on the walls.

Eroticism in a religious setting is hardly anathematic to Hindu art—many ancient, canonical texts refer to the fecundity embodied in sexual love. The presence of a loving couple on the temple has talismanic value, representing notions of wealth, prosperity, and fertility. Equally important in interpreting the presence of such an explicitly erotic sculpture in a religious space are notions of ideal kingship. Along with being a brave soldier and a just ruler, a truly great king is also a patron and connoisseur of all art forms, including the art of love. An inscription from the Nilakanthesvara temple at Kalanjara near Khajuraho praises the Chandella king associated with the temple as being not only mighty and powerful in battle and at court but also in erotic pursuits: "Who like the wind of the Malaya mountain kisses sportively the lips of the maids, red like the pomegranate, seizes them by their beautiful tresses, removes the garments that shine brightly on the high bosom of the maidens, and easily dries the perspiration occasioned by sport from the brows of the fair."

ANNAPURNA GARIMELLA

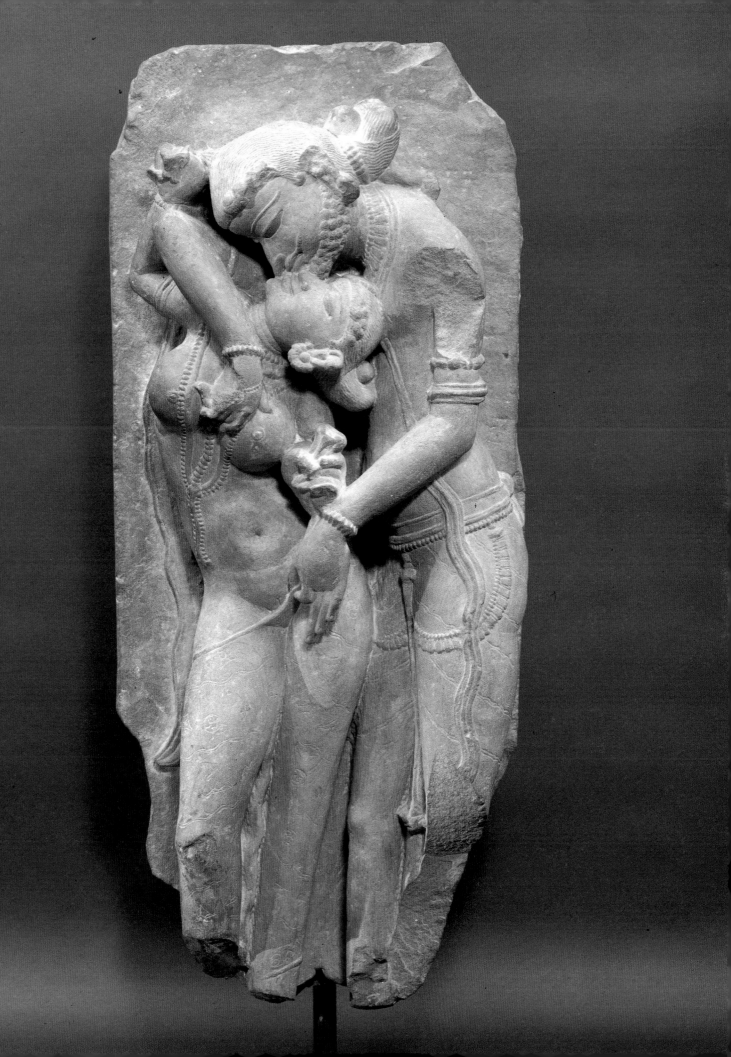

AMOROUS COUPLE
200 B.C.–A.D. 100
COLIMA, MEXICO
CERAMIC
8⅜ x 5 x 3 INCHES (20.9 x 12.7 x 7.6 CM)

COLLECTION VIVIAN AND EDWARD
MERRIN

TWO THOUSAND YEARS AGO ALONG THE WESTERN EDGE OF MEXICO, THE VILLAGE artists of Colima hand-built hundreds upon hundreds of lyrical, expressive ceramic figures, such as this embracing couple. As with all ancient American art, only the sure hand of the artist, smooth stone tools, clay, and a fire pit were used in the creation of these large, intricate images. The possibilities of clay were deeply understood by Colima sculptors, who specialized in sweeping curves and glassy burnished surfaces. The figures' rounded bulbous shapes are emphatically sensual; one longs to stroke them just as they touch one another.

In fact, touching, connecting, and interacting were prime subjects—and subtexts—of ancient West Mexican sculpture, reflecting the importance of the group to these close-knit villagers. Other compositions from the same period depict in charming detail crowded plazas, joyous wedding processions, and lively intertwining dances. In most cases people have their arms around one another. Yet simply to revel in the beguiling appeal of this style is to miss the subtleties of its message and ignore the all-important context for which it was created: the tomb. In West Mexico, the dead were placed in burial chambers dug far below the surface, separated by shafts as long as fifty feet. They were surrounded by clay sculptures of themselves—matching males and females (often joined, as here, or leaning toward each other) are interpreted as married couples—as well as images of their loved ones, even their loyal dogs. The dead apparently were believed to be accompanied on their afterlife journey by stand-ins for those they left behind; the living wanted to ensure that the dead would not want to return aboveground. Therefore, as endearing and colloquial as Colima figures may seem, they had a sacred duty to heal the severed connection between living and dead members of the group. The representation of loving embrace in burial art was not merely illustrative of the importance of love, it served a cosmological purpose as well. Interpenetrating forms embody the strong connections and necessary separations that turn the wheel of life and death.

REBECCA STONE-MILLER

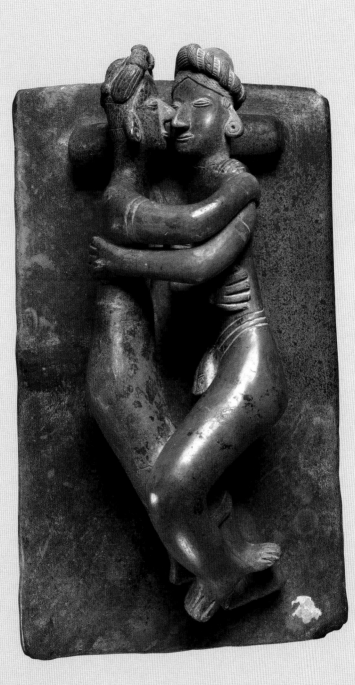

CONSTANTIN BRANCUSI
ROMANIAN, 1876–1957
THE KISS
1907–8
LIMESTONE
11 x 10¼ x 8½ INCHES
(28 x 26 x 21.5 CM)

MUZEUL DE ARTĂ,
CRAIOVA, ROMANIA

BRANCUSI'S **THE KISS** HAS AN UNCANNY SENSE OF MONUMENTALITY, YET IT IS ONLY eleven inches tall, a size more typical of archaic votive objects than modernist sculpture. As the figures contain each other in mutual embrace, their bodies are eternally interlocked. The profiles of their individual eyes and lips together form frontal wholes; the curve of their hairlines meets in an arch whose simple architectural stability underscores the couple's interdependent strength and equality.

This is Brancusi's first version of *The Kiss*, a subject he returned to repeatedly over the course of his life. In all, he made eight adaptations, each reaching greater stylization and columnar blockiness. By the 1930s, Brancusi had reduced the motif to a cryptic geometry of paired monoliths with a wedded eye, as in *Column of the Kiss* (c. 1930) and *Gate of the Kiss* (1938) at Tîrgu Jiu, Romania, an emblem of love and community for his homeland.[1]

This version of *The Kiss* was only the second sculpture Brancusi carved directly. He previously modeled his forms in clay in the academic tradition, learned at the Bucharest School of Fine Arts and the Ecole des Beaux-Arts in Paris. (Such clays were typically translated into marble or stone by artisans using mechanical devices.) Early in 1907, Brancusi was invited by the French sculptor Auguste Rodin to assist in his studio. Although he was long inspired by Rodin's art, Brancusi left after barely two months, declaring "nothing can grow under big trees."[2] With its modesty, emotional restraint, and technique most typical of craft, *The Kiss* is commonly thought to be Brancusi's answer to Rodin's earlier interpretation of the same subject (p. 47), a dramatic statement of sensuality and fleshiness. Brancusi's *The Kiss* is his declaration of independence.

Brancusi sought to express not the appearance but the essence of things. He was influenced by Platonic ideals, Eastern (particularly Tibetan) thought, and a deep connection with nature and materials bred of his peasant background, experience with Romanian folk art and lore, and belief in the metaphysical: "I offer you pure joy. Look at my sculptures until you manage to see them. Those who are close to God have seen them."[3]

SUSAN KRANE

1. See Sidney Geist, *Brancusi/The Kiss* (New York, 1978), 42–45. Geist makes autobiographical arguments for *The Kiss*, noting the relative shortness of the male and the resemblance of his hair to Brancusi's thick, caplike coiffure at the time. In an early lost work, *Study for Pride*, which appears in a 1905 photograph of Brancusi's studio, a woman turns her head in rebuff from the man unsuccessfully seeking her lips. *The Kiss* perhaps represents the consummation of this quest for love.
2. Eric Shanes, *Constantin Brancusi* (New York, 1989), 12.
3. From *The Catalogue of Brancusi Exhibition*, Brummer Gallery (New York, 1926). Quoted in Ionel Jianou, *Brancusi* (Paris, 1963), 12.

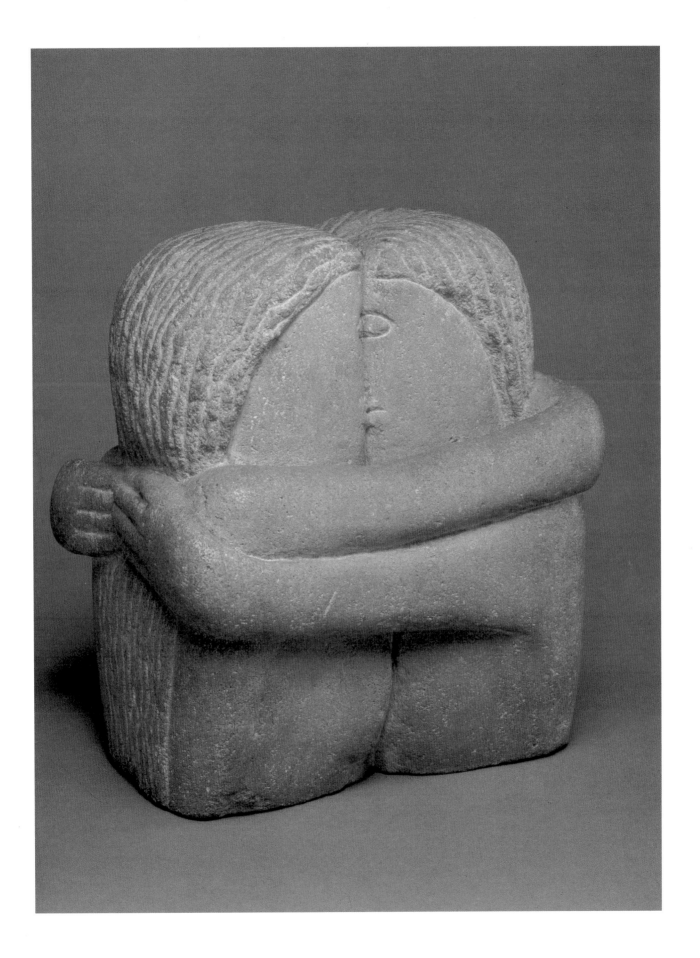

JEAN-LÉON GÉRÔME
FRENCH, 1824–1904
PYGMALION AND GALATEA
C. 1890
OIL ON CANVAS
35 X 27 INCHES (89 X 68.6 CM)

THE METROPOLITAN MUSEUM
OF ART, NEW YORK, GIFT OF
LOUIS C. RAEGNER, 1927

PYGMALION AND GALATEA IS ONE OF THE MOST ENDURING MYTHOLOGICAL SUBJECTS in Western art, not least of all because the story deals with the act of artistic creation. In Ovid's tale, the Cypriot sculptor Pygmalion prays to Venus that he find a wife as beautiful as his statue of Galatea, a wish the goddess rewards by bringing his statue to life. In Gérôme's version of this subject, the lower half of Galatea, whom we view from behind, is made of cold, inanimate marble, but her upper torso has come to life and courses with blood. And as she comes to life, she rewards the sculptor's artistry with an act of love.

Gérôme's treatment reflects his predilection for rendering classical subjects in anecdotal terms. That predilection, so common to late nineteenth-century depictions of antique themes, annoyed art critics but delighted audiences. Nothing expresses Gérôme's storytelling abilities more than the sculptor's mallet lying on the floor in the foreground, surrounded by fragments of marble. Evidently, Pygmalion has been at work, but the sight of Galatea coming to life has led him suddenly to drop his hammer, leap onto the crate lying at the statue's base, and embrace his creation. It is no accident, to cite another telling detail, that Galatea grasps Pygmalion's right hand, in all likelihood the same hand that held the mallet that fashioned her.

Jean-Léon Gérôme was among the most distinguished artists of his day. He was also among the most popular. Crowds gathered around his paintings to marvel at the startling realism of their detail, the suspense of their narratives, and the supreme proficiency of their execution. Professor at the Ecole des Beaux-Arts, the preeminent school of fine art in Europe, Gérôme was an enemy of the Impressionists, and enthusiasm for his paintings declined with the eventual ascendancy of artistic modernism. It is only in recent years that the paintings and sculptures of this so-called academician have returned to the public eye.

MARC GOTLIEB

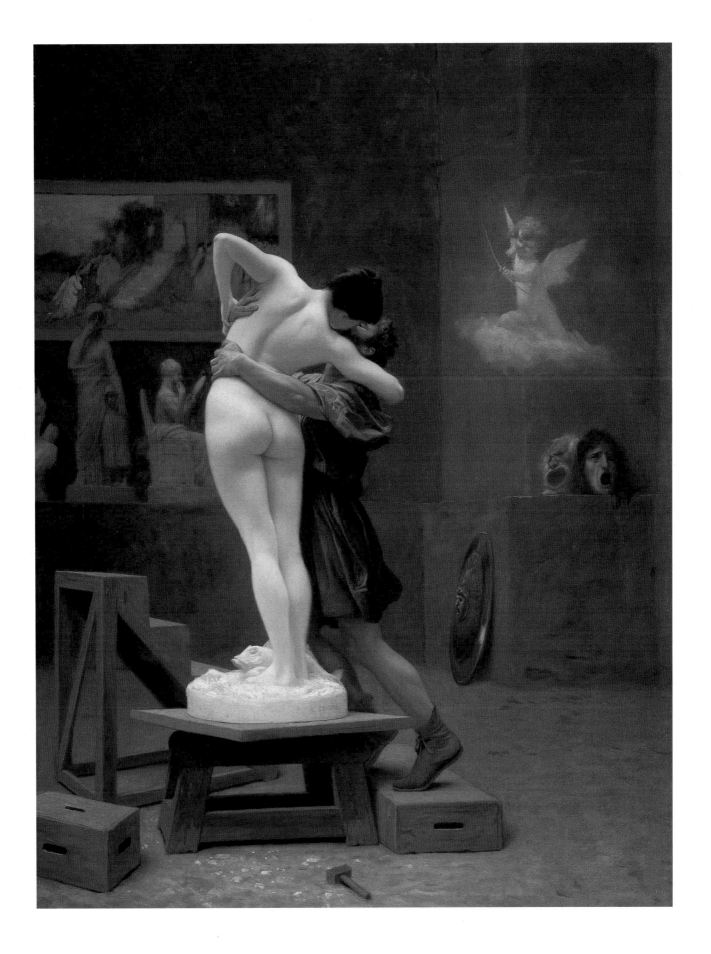

JEAN-HONORÉ FRAGONARD
FRENCH, 1732–1806
THE BOLT
C. 1778
OIL ON CANVAS
28¾ x 36¼ INCHES (73 x 92 CM)

MUSÉE DU LOUVRE, PARIS

THE BOLT IS ONE OF THE MOST PASSIONATE IMAGES OF SEDUCTION PRODUCED IN THE eighteenth century. The man's straining gesture to engage the door lock and prevent the woman from fleeing is the perfect analogy to his yearning sexual desire. The implied violence of the episode is somewhat undercut by the theatrical nature of the scene, exemplified in the balletic posture of the woman and the coyly placed apple on the bedstand, suggesting that temptation has been employed to reach this stage. The apple, with its connotation of original sin, is also significant in that this work was painted for the Marquis de Veri, supposedly as a pendant to another of his ten Fragonards, an *Adoration of the Shepherds* (now in a private collection) of exactly the same size as *The Bolt.* Both works date from the late 1770s and make use of a similar range of colors and a Rembrandtesque burst of light. In the case of *The Bolt*, this dramatic chiaroscuro is particularly effective, leading the viewer's eye along the diagonal from the intensely lit bolt down and across the woman's body to her delicate foot hidden in the shadows but clearly pointed toward the large bed. From this we can conclude that her "fall" is inevitable. The possible juxtaposition of this most secular of subjects with the *Adoration of the Shepherds* has led to the suggestion that the artist and patron intended to contrast sacred and profane love or sin and redemption.

Jean-Honoré Fragonard was born in the south of France but came with his family at a young age to Paris. There, after a brief time in Chardin's studio, he moved to that of François Boucher, the quintessential Rococo painter. Fragonard adopted the master's rich, free style and subject matter of peasants and voluptuous mythologies. He intended to pursue a conventional academic career as a history painter and in 1752 won the coveted Prix de Rome, which allowed him to spend several years in Italy. After his return to Paris, Fragonard, on the verge of reception into the Académie Royale, withdrew from the official art world to concentrate on a variety of inventive personal works, ranging from imaginary portraits, sensual *scènes galantes,* to sentimental and moralizing genre pieces and an occasional rustic religious scene. During the French Revolution, Fragonard benefited from his friendship with the younger, influential painter Jacques-Louis David and was appointed to the commission to form a national art museum. He became its curator in 1793.

ERIC ZAFRAN

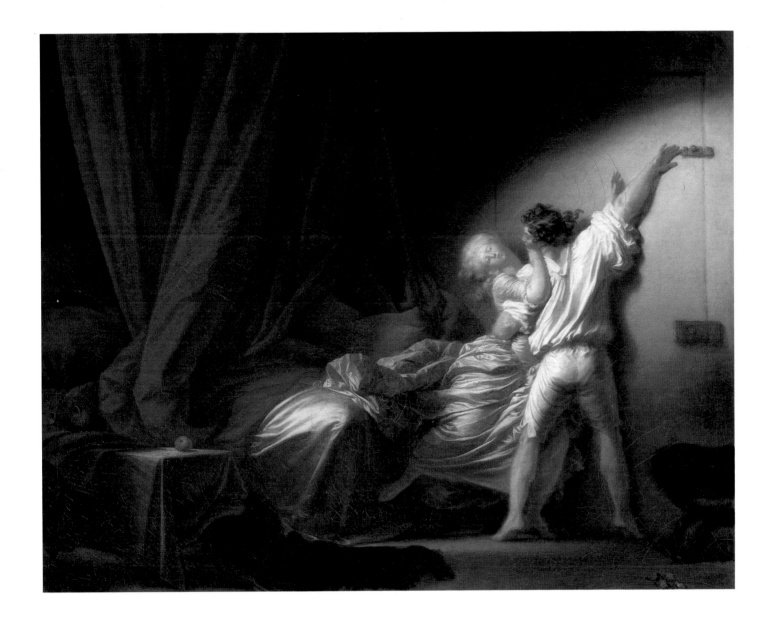

KRISHNA AND RADHA IN A BOWER

C. 1775–80

FROM A **GITA GOVINDA** SERIES

KANGRA (?), PUNJAB HILLS, INDIA

WATERCOLOR AND GOLD ON PAPER

6⅞ X 10¹¹⁄₁₆ INCHES (17.5 X 27.2 CM)

ARTHUR M. SACKLER MUSEUM,
HARVARD UNIVERSITY ART
MUSEUMS, CAMBRIDGE,
MASSACHUSETTS, PRIVATE
COLLECTION

LOVEMAKING HAS RARELY BEEN EXPRESSED WITH SUCH COURTLY DISCREETNESS. Although in this late eighteenth-century painting the amorousness of Krishna, the Hindu god of love, and of his beloved Radha soars above eroticism to achieve a state verging upon *prema*, or unerotic love, the artist—following the mood of the twelfth-century text—has not ignored *sringara*, or earthly lust. He expressed it metaphorically, in the passionate undulation of entwining tree trunks, twisting leaves, and ecstatic flowers that in effect embrace the lovers in a cosmic nest. The style happily weaves together foreign and indigenous elements. Refinements of technique, nuances of gesture, and traces of reportorial naturalism can be ascribed to the Persianate culture as it evolved at the imperial Mughal court. Lyrically poetic otherworldliness emerged from Hindu tradition.

The Rajput rulers of the hills of northwestern India, protected by their isolation from imperial Mughal influences, were able to retain much of their cultural purity into the early years of the eighteenth century. But when in 1739 the Mughal Empire was devastated by the invasion of Nadir Shah of Iran, Pahari princes hired artists who had been trained in the Mughal workshops of the last great imperial patron, Emperor Muhammad Shah (ruled 1719–48). In this work, imperial subtleties blend with the traditional style of the hills in a freshly delightful artistic synthesis.

CARY WELCH

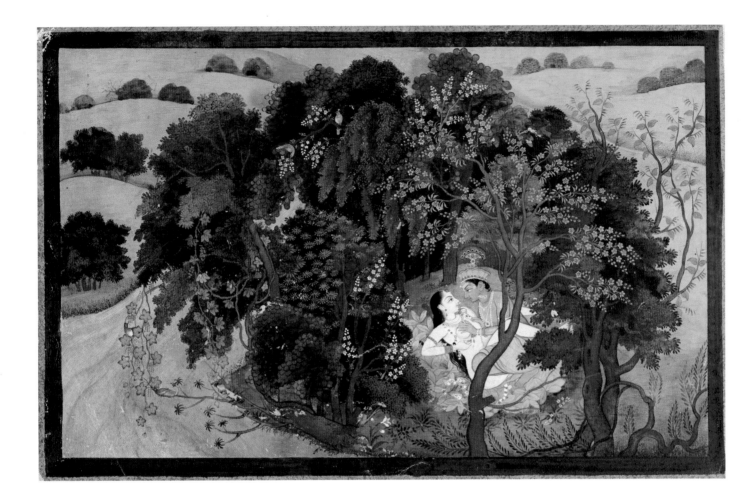

Jayadeva's Sanskrit text written on the verso reads:

When I utter the low sweet sounds of a cuckoo,
he is a master victorious in the practices of love;
my hair then is a bunch of loosened flowers,
my heavy breasts full of his fingernail marks.

—Canto 2, verse 16, translation by Josanna Bazzano

ATTRIBUTED TO

SULTAN-MUHAMMAD

PERSIAN, 16TH CENTURY

KHOSRAW SPIES
SHIRIN BATHING

1539–43

FROM A MANUSCRIPT OF THE

KHAMSA (QUINTET) BY NIZAMI

GOUACHE, INK, GOLD, AND

SILVER ON PAPER

14³⁄₁₆ x 9⅞ INCHES (36 x 25 CM)

THE BRITISH LIBRARY, LONDON

Between the years 1539 and 1543, the Persian ruler Shah Tahmasp who ruled from 1524 to 1576, commissioned an illustrated copy of Nizami's *Khamsa* (Quintet), a collection of five lyrical poems originally written in the latter half of the twelfth century. This lavishly illuminated and illustrated copy of the *Khamsa* is among the greatest masterpieces of Persian art. *Khosraw Spies Shirin Bathing* captures one of the most tender moments in the celebrated romance of *Khosraw and Shirin*.[1] The second of Nizami's five poems, the story is devoted to the legendary adventures of the pre-Islamic Sasanian king Khosraw-Parviz, in particular his amorous relation with the Armenian princess Shirin.[2]

After a long dusty journey to Iran in search of Khosraw, Shirin comes to a sparkling pool[3] and decides to bathe. Khosraw, on his way to Armenia, rides by the same pool. The illustration captures the couple's first encounter: Khosraw, in love with a spoken description of Shirin, and Shirin, enamored with a visual image of him, finally meet without recognizing each other.

The name of the renowned painter Sultan-Muhammad is inscribed on the rock at the bottom of the composition. Closely adhering to the narrative, Sultan-Muhammad has underlined Shirin's beauty and grace. These qualities are evident not only in her appearance but also in Khosraw's expression: overwhelmed, he holds a finger to his lips in the traditional gesture of astonishment.

By choosing the particular moment in which Khosraw and Shirin become aware of each other's presence for the first time, Sultan-Muhammad has enhanced the poignancy of this meeting: An embarrassed Shirin, suddenly realizing that she is not alone, demurely covers herself with her long, dark hair, while nearby her agitated horse Shabdiz bridles in reaction. Even the spirits hiding in the rocks around the pool look startled and bashfully turn away their gaze.

The subtle tension between the hero and heroine reverberates throughout the composition. Respecting the controlled elegance and meticulous execution of sixteenth-century Persian painting, Sultan-Muhammad has nonetheless lent a fresh and keenly sensitive interpretation to this well-known composition.[4]

MASSUMEH FARHAD

1. For another painting from this copy of the *Khamsa*, see *The Ascent of the Prophet Muhammad to Heaven*. (p. 212)
2. For a synopsis of the story, see Peter Chelkowski, *Mirrors of the Invisible World. Tales from the* Khamseh of Nizami (New York, 1975), 21–48.
3. In Persian manuscript painting, water is usually painted with silver pigment, which oxidizes over time, hence the black color of the pool.
4. Since the late fourteenth century, artists have relied on the same, easily recognizable composition to depict this important episode from Persian literature. For the earliest known illustration, see Norah Titley, "A Fourteenth Century *Khamsah* of Nizami," *British Museum Quarterly* 36 (1971), 8–11.

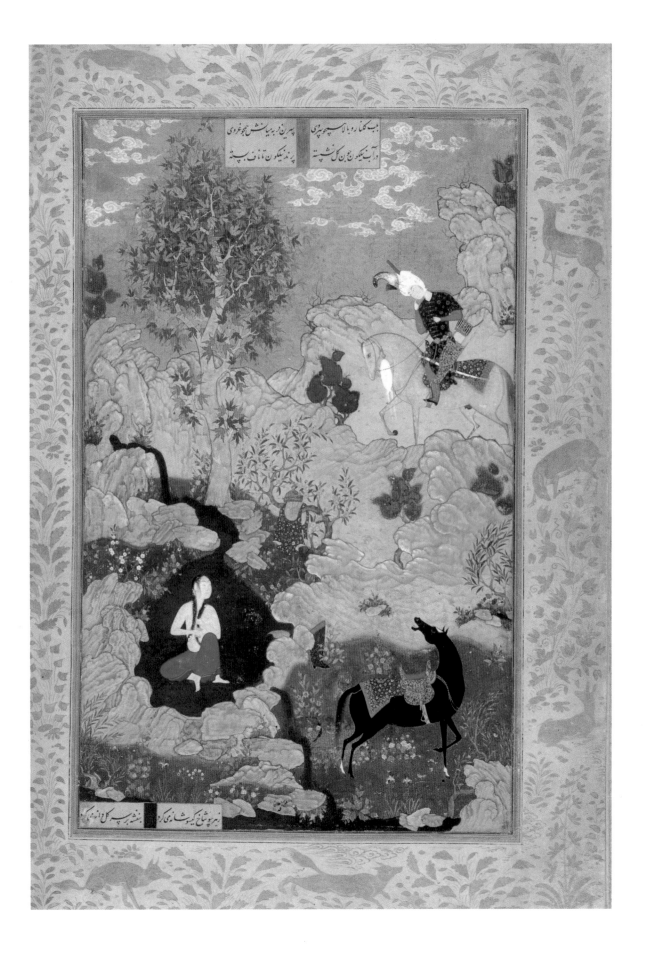

FUNERARY PORTRAIT OF
GRATIDIA M. L. CHRITE AND
MARCUS GRATIDIUS LIBANUS
(CATO AND PORTIA)

13 B.C.–A.D. 5

ROME, ITALY

MARBLE

26¾ x 35⅞₆ x 11 INCHES
(68 x 90 x 28 CM)

MUSEI VATICANI, CITTÀ
DEL VATICANO

T HIS DOUBLE PORTRAIT IS ARGUABLY THE FINEST FUNERARY PORTRAIT PRODUCED FOR the lower and middle classes during the early Roman Empire. These portraits were originally in relief and were transformed by restorers into three-dimensional bust-length portraits in the late sixteenth to early seventeenth century. Popularly known as *Cato and Portia,* the couple depicted are identified by an inscription (recorded in *Corpus Inscriptionum Latinarum,* 6.35397) as Gratidia Chrite and her husband Marcus Gratidius Libanus. Gratidius wears the toga, proclaiming his status as a Roman citizen, while Gratidia wears the cloak and tunic of a proper Roman matron. Significantly, Gratidius and Gratidia have chosen to have themselves portrayed for posterity with their right hands joined. This gesture, *dextrarum iunctio* in Latin, was a major component of the Roman marriage ceremony. Clearly, the husband and wife hoped that the bonds they had forged in life would not be severed after death. Gratidia's left hand, which rests on her husband's shoulder, further emphasizes the physical and spiritual intimacy between the couple.

The inscription that accompanied this portrait in antiquity reveals even more about the pair's relationship. Gratidia is identified as a freed slave of her husband. Since marriages between freeborn men and slaves were not legal in Roman society, Gratidius had to free his bride before their union could be formally recognized. At that time she took the feminine form (Gratidia) of her ex-master and new husband's name (Gratidius). Her second name, Chrite, indicates that she is likely to have been of Greek origin. Her smooth and youthful facial features recall the contemporary portraits of Rome's first empress, Livia, wife of Augustus, while the realistic physiognomy of her elderly husband finds parallels in earlier images of statesmen of the late Republic, like Julius Caesar. This sensitive representation of a loving husband and wife is a signal achievement in the development of Roman portraiture.

ERIC R. VARNER

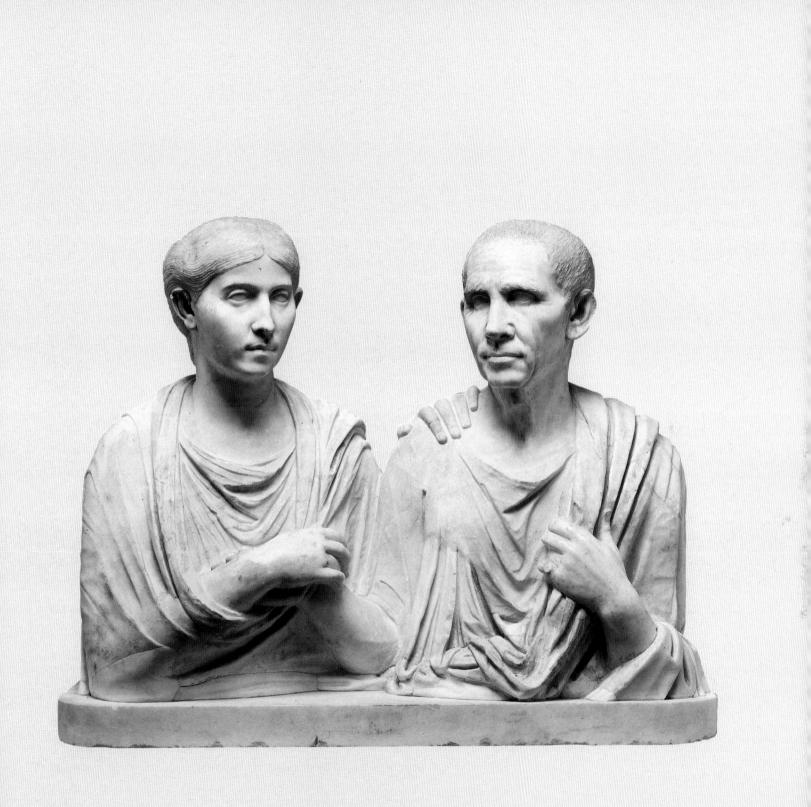

C. 2300 B.C.

HOROZTEPE, TURKEY

BRONZE

HEIGHT 8½ INCHES (21.5 CM)

MUSEUM OF ANATOLIAN

CIVILIZATIONS, ANKARA, TURKEY

THIS STATUETTE FROM NORTH-CENTRAL TURKEY IS AMONG THE EARLIEST KNOWN sculptures in bronze from the ancient Mediterranean region. The figurine of an alert woman nursing her child was deposited in a grave as an offering to the dead. While its function was clearly funerary, its imagery is decidedly life-affirming.

Made of cast bronze, the woman stands stiffly as she clutches a small infant to her breast. One's attention is focused on the woman's slightly upturned face, with her gaze seemingly set fixedly into another realm. The eyes are large and deep-set, the nose rather flat, and the mouth slightly open. A projecting disk to one side of the back of her head appears to represent an off-center ponytail. Her ears are pierced, and she probably once wore separately attached earrings. Her slim figure sets her apart from her more voluptuous and overtly fertile Neolithic predecessors.

Of special significance are the carefully rendered hands of both the infant and the woman, which add immensely to the expressiveness of this work of art. The upper hand of the baby, which grabs the center of the mother's chest with clearly defined fingers, also grabs our attention. The left hand of the woman, cradling and protecting the baby's head, emphasizes her love for the child.

Small-scale sculptures in bronze first appeared in Turkey during the latter part of the third millennium B.C. They were certainly objects of great value, requiring special materials and sophisticated technological knowledge. Human figures are rather rare; animals such as bulls and stags are more common. Most, if not all, of these bronze figurines had strong religious associations and are usually found in the tombs of the elite members of society.

This statuette was found in a grave at the site of Horoztepe, where a cemetery, presumably for royalty, was excavated. The dead were buried in rectangular tombs, some of which had the skeletons of sacrificed bulls on top of them. Other objects from the tombs at Horoztepe include metal vassels, mirrors, and bronze musical instruments.

PAMELA J. RUSSELL

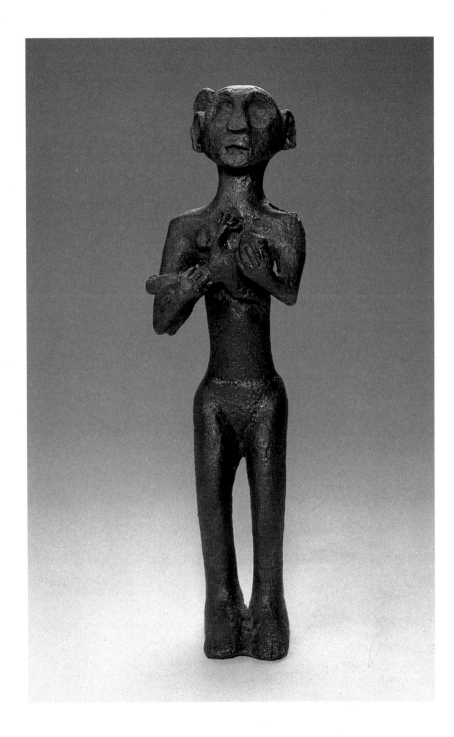

NURSING MOTHER EFFIGY BOTTLE

1250–1350

MIDDLE MISSISSIPPIAN, NORTH AMERICA

EARTHENWARE

5⅞ x 3⅞ INCHES (14.9 x 9.7 CM)

ST. LOUIS SCIENCE CENTER,
MISSOURI, FROM THE H. M.
WHELPLEY COLLECTION

NURSING MOTHER EFFIGY BOTTLE WAS FOUND IN 1876 IN A MOUND IN EAST ST. LOUIS, Illinois.[1] This unusual vessel is a ceramic "hooded" water bottle (the opening is at the back of the head) in human form. Human effigy bottles are usually found at sites in Arkansas, Missouri, and Tennessee, and this bottle may have moved north in trade.

This piece was made by an artist of the Middle Mississippian culture, a Native American culture in southeastern and midwestern North America from about A.D. 1000 to 1500. Middle Mississippian people grew corn, squash, beans, and several seed plants in river floodplain fields and hunted and collected wild foods. Rich food resources, increasing populations along the rivers, and interactions between neighboring groups contributed to the development of large, complex centers. The largest of these was Cahokia, where more than one hundred earthen mounds were built in a five-square-mile area in the Mississippi River valley near East St. Louis, where this bottle was found. With a population estimated in the tens of thousands, Cahokia was the political center of a chiefdom whose elite families lived and ruled from their mound-top residences and temples.

Middle Mississippian ceramic vessels, including animal and human effigies, were often placed in graves, where they may have held food and drink to accompany the deceased into the afterlife. Human effigy bottles often show a kneeling or seated female (or sometimes male) figure; the depiction of a woman and child is unusual. Some bottles show a hunchbacked woman or man with prominent vertebrae on the back. Others portray large-bodied women with hands placed on breasts or abdomen, perhaps representing pregnancy and fertility. Similar themes may be represented in Mississippian stone figurines, such as Cahokia-area figurines with symbols of agricultural fertility, or in figurines from Tennessee chiefly representing ancestors in mortuary temples. While reflecting its particular culture, this piece is striking for its treatment of a universal theme.

MARY BETH TRUBITT

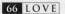
1. Leonard W. Blake and James G. Houser, "The Whelpley Collection of Indian Artifacts," *Transactions of the Academy of Science of St. Louis* 32, no.1 (1978), pl. 7.

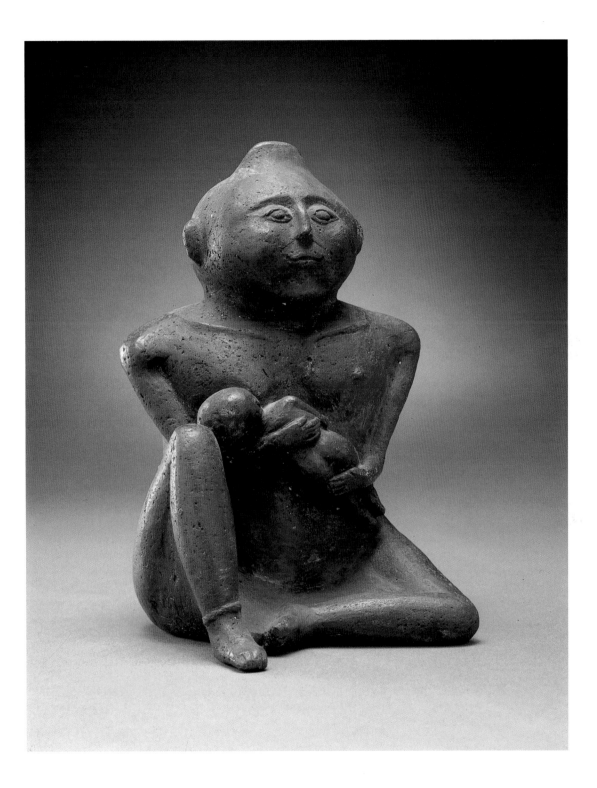

J OHN TIKTAK WAS BORN AT A SMALL CAMP IN THE CANADIAN ARCTIC BETWEEN WHALE Cove and Eskimo Point. As a Padlermiut, he lived a traditional life on the land until 1958, when, on a visit to Rankin Inlet, he was offered employment in the newly opened nickel mine. Though Tiktak carved occasionally after an accident left him unable to work, it was not until the death of his mother in 1962 that he became fully committed to his new vocation. At that time, he went to his friend Professor Bob Williamson and spoke about his grief. Williamson encouraged Tiktak to use carving as a means of dealing with his feelings, leading to an extremely productive period of creativity for the artist.

In *Mother and Child*, Tiktak's arrangement of the two figures, with the child perched on the mother's back, is *inumatiit*, truly Inuit, for the child spends its first years in a large hood (*anaut*) at the back of the mother's parka (*amautik*). By rigorously simplifying the bodies of the mother and child and merging them into a single form, Tiktak has made tangible the bond that unites them. He has imbued them, however, with a seemingly emotional detachment that counters their physical unity. Their carefully carved faces bear solemn and severe expressions. They do not look at each other, nor do they connect with the viewer.

Tiktak formally underscores the illusion of aloofness by carving a deep crescent between the two figures, which becomes an actual space in many of his mother and child carvings.[1] By juxtaposing physical closeness with an apparent physical and psychological distance, Tiktak has visually manifested the dichotomous nature of the mother and child relationship, which involves both a close union and the process of separation. The latter begins with the emergence of the child from the womb and ends with the final separation that death brings—a separation that often came prematurely in the harsh environment of the Arctic. Tiktak's loss of his mother, which caused him to accelerate his carving activity, seems to have made him particularly sensitive to this aspect of the mother-child relationship.

CYNTHIA COOK

1. This space should not be considered a void, defined by *Webster's* as "containing nothing." Like Henry Moore, Tiktak filled his spaces with intrinsic meaning.

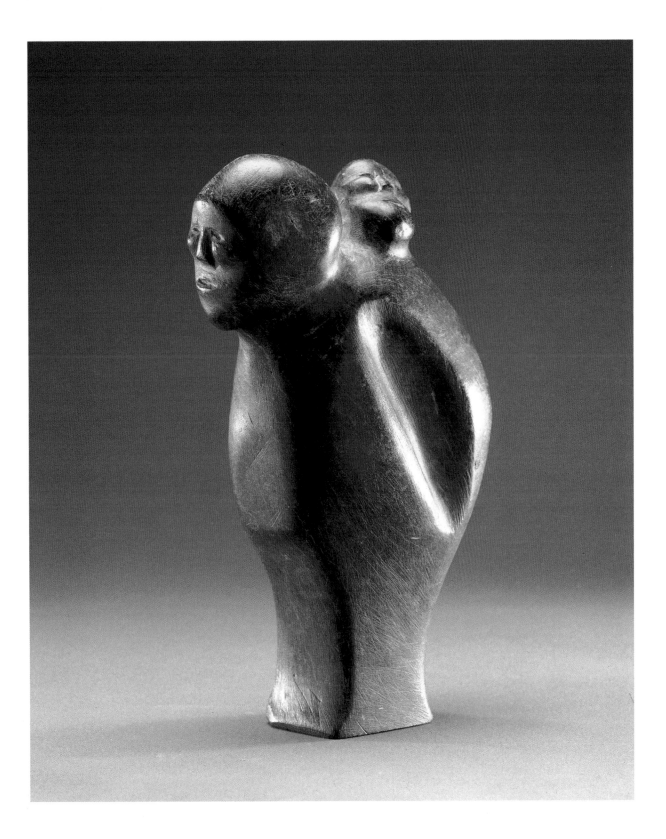

AKHENATEN AND NEFERTITI
PLAYING WITH THEIR DAUGHTERS
C. 1365–49 B.C.
EGYPT
LIMESTONE
12¾ x 15¼ x 1⁹⁄₁₆ INCHES
(32.5 x 38.7 x 3.8 CM)

STAATLICHE MUSEEN ZU BERLIN,
PREUSSISCHER KULTURBESITZ,
ÄGYPTISCHES MUSEUM UND
PAPYRUSSAMMLUNG

FOR SIXTEEN CENTURIES FOLLOWING THE FOUNDING OF THE EGYPTIAN STATE, ARTISTS depicted the pharaoh as a perfect being—a god in human form—with a slender torso, muscular limbs, and a face unmarred by worldly imperfections. Pharaoh's divinity required that his humanity be subsumed into his official role as a "living god." Statues and temple reliefs depict him dispassionately executing his official roles as Egypt's first priest or warrior, never as a loving, passionate husband or father.

When Amenhotep IV became pharaoh in c. 1365 B.C., he initiated basic changes in Egypt's religious and artistic traditions. The new king elevated the Aten, an obscure version of the sun-god manifest in the solar disk, to a position of supremacy among Egypt's ancient deities. In the fifth year of his reign, Amenhotep IV abandoned Thebes and, along with his wife, Nefertiti, transferred the capital two hundred miles north to a site now called Amarna. He also changed his name from Amenhotep ("[the god] Amun Is Content") to Akhenaten ("That Which Is Beneficial to the Aten"). Eventually Akhenaten proscribed the worship of all deities but the Aten, Nefertiti, and himself.

Akhenaten's courtiers worshiped this "trinity" by praying to stelae placed in outdoor shrines at Amarna.[1] These monuments, adorned with images of the Aten and the royal family, testify to the profound changes Akhenaten imposed on traditional Egyptian art. Gods had previously appeared as animal-headed humans or as purely anthropomorphic beings; here the Aten assumes iconic form: a solar disk with radiating beams of light ending in tiny hands. Akhenaten and Nefertiti are shown in an unprecedented highly exaggerated style. Both have extremely long faces, narrow eyes set at severe angles, deep creases running across their cheeks, bony "lantern" jaws, fleshy mouths, and knobby chins. Akhenaten's artists rendered the pharaoh with spindly arms and legs, swollen, almost feminine breasts, and thick buttocks. Equally novel is the casual tenor of these scenes. Royal sculptors invented new motifs and borrowed others from private tomb scenes—such as a daughter playing with her mother's earring—to fashion images of a family captured for eternity in a single moment of playful, loving intimacy.

JAMES F. ROMANO

1. Cyril Aldred, *Akhenaten and Nefertiti* (Brooklyn, 1973), 102.

YASHODA AND KRISHNA
11TH–12TH CENTURY
TAMIL NADU, INDIA
COPPER
HEIGHT 13⅛ INCHES (33.3 CM)

THE METROPOLITAN MUSEUM
OF ART, NEW YORK, PURCHASE,
LITA ANNENBERG HAZEN
CHARITABLE TRUST GIFT,
IN HONOR OF CYNTHIA
AND LEON BERNARD POLSKY

Y

ASHODA AND KRISHNA EPITOMIZES AND VISUALIZES MOTHERLY AND SPIRITUAL LOVE. Krishna, the eighth incarnation of the Hindu god Vishnu, was handed over to his adoptive parents, Yashoda and Nanda, by his birth parents while still a baby. This was done to protect him from the wrath of the ruling king. Yashoda became his mother in every way, even nursing him into childhood. The sculptor of this piece represented the act with great sensitivity: Yashoda's hands very lightly support Krishna; he is not coddled like a baby but held as a young child. Her head is tilted, glancing tenderly at him. But her strong posture signals that, even at this moment of utter absorption, she remains his guardian against external danger.

The plenitude of Yashoda's breasts offers succor to Krishna. But the activity of breast-feeding is not emptied of erotic potential: as Krishna tweaks her nipple, the flow of emotions from child to mother to child creates a circle of meaning implicit in *bhakti,* or the theology of devotion.

Bhakti as a living religious movement grew in various parts of India approximately after A.D. 300. Practitioners of *bhakti* emphasize developing a highly personalized and ecstatic relationship with a favorite god or goddess. In the texts of *bhakti,* largely an oral tradition, this relationship is characterized differently by each writer. One's relationship to god may be that of two lovers, two friends, master and slave, ruler and subject, or, as in this case, parent and child. *Yashoda and Krishna* as an object offers the devotee or viewer both a literal and metaphoric analogy for worship. By actually occupying Yashoda's position, the devotee makes his or her body a site of loving devotion. Yashoda instructs us that even a god needs nurturing to subsist and thrive. Keeping this knowledge in mind, the devotee can then develop more abstract concepts about the mutually dependent relationship between worshiper and divinity. But the offering of self is not unilateral; upon receiving sustenance, Krishna lovingly and mischievously gives the devotee both physical and psychic pleasure. And in the act of performing devotion, Yashoda gains an aura of holiness in her own right. A fundamental tenet of *bhakti* is embodied in this bronze: devotion or love for god can be a manifest bodily sensation, full of ecstasy even in its playfulness.

ANNAPURNA GARIMELLA

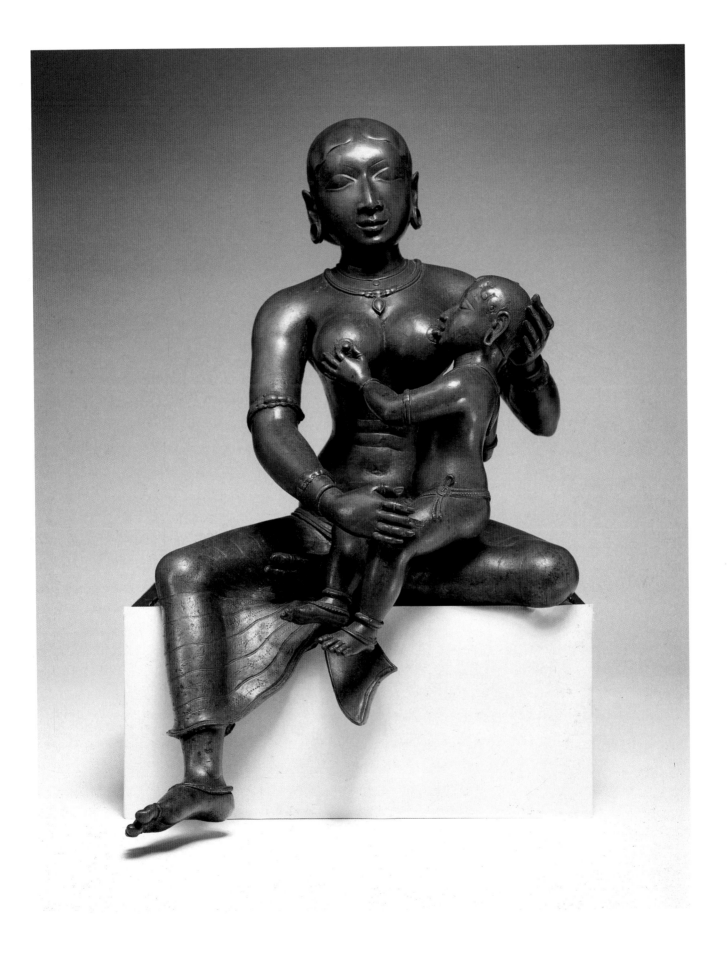

THE HALF-LENGTH IMAGE OF THE VIRGIN MARY HOLDING THE INFANT CHRIST CHILD gained popularity in Flemish painting only in the later fifteenth century, substantially later than in Italy and largely in response to a specific Italo-Byzantine model. Brought north in 1440, the Cambrai *Madonna*, also known as *Notre Dame de Grâce (Our Lady of Grace)*, was installed in Cambrai cathedral in 1452.

This type differed substantially from other Byzantine and Italian models, where the Madonna is more typically lost in her own thoughts, presumably of the Crucifixion to come. The Cambrai *Madonna*, on the other hand, inspired Dieric Bouts's endearing motif of the divine child embracing his mother and nuzzling his cheek against hers. The artist further accentuates the bond between mother and child by having the two figures look at each other instead of out toward the viewer. Popular writings of the time instruct us that the physical intimacy of the Virgin and Child is an allegory of the love of Christ for his earthly church, of which Mary is the symbol, and for the individual soul. As he embraces his mother, so too will Christ welcome the Christian soul into Paradise. The literal forms of the painting help the viewer to comprehend the Christian belief in Christ's, and by extension God's, love for the human race.

Dieric Bouts was part of a remarkable school of artists, including Jan van Eyck and Roger van der Weyden, that flourished in Flanders during the fifteenth century. Bouts had an extensive and highly gifted studio workshop, where, in a pre-Romantic age, the actual identity of who carried out the artist's design is often obscured by history as it was not considered of primary importance. Their art reflects the social, political, and religious changes brought about as the humanistic attitudes of the Italian Renaissance merged with, or took precedence over, northern medieval traditions and institutions.

Still exhibiting the Gothic fascination with naturalistic detail, fifteenth-century Netherlandish artists combined sensitive observation of the natural world with the mastery of the oil medium. As seen in this *Virgin and Child*, the result was a brilliant and unprecedented pictorial realism, remarkable in its ability to describe differing surface textures, such as hair, skin, jewels, and brocaded cloth. But beyond the description of mere things, Bouts and his contemporaries wished to illuminate abstract religious doctrines by giving them convincing form. This tender portrayal of mother and child results from the Renaissance desire to make the most holy Christian personages understandable in terms of ordinary human experience.

LYNN FEDERLE ORR

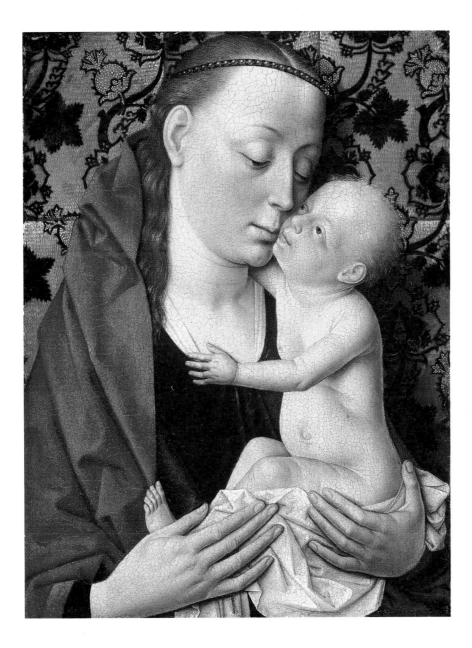

PAINTED AROUND 1890 IN THE PRIME OF MARY CASSATT'S ARTISTIC CAREER, THIS work represents what Cassatt did best—capturing in paint the subtle, psychological intimacy of a quiet moment between a mother and her child. Born near Pittsburgh to an affluent family, Cassatt met with resistance from her parents over her artistic ambitions. Nonetheless, they supported her European artistic training. Cassatt studied with various teachers but claimed to have learned the most by copying old-master paintings in European museums. Having settled in Paris by the mid-1870s, Cassatt endured the humiliation of rejections at the Salon but in 1877 was invited by Edgar Degas to exhibit with the Impressionists. Supported by a circle of artist friends who shared her convictions and desire to exhibit outside of the conservative Salon, Cassatt's professional career went in a dramatic and challenging new direction.

By 1890, Cassatt was a mature artist, and her work demonstrates a willingness to experiment. *Mother and Child* shows evidence of her newly found freedom of color, brushwork, and composition. The short, stubby brushstrokes of her Impressionist years have been replaced with long, flowing, gestural strokes. The feathery, supple brushstrokes on the models' skin enhance the appearance of warm, soft flesh. Cassatt's choice of pinks, rosy reds, and creamy whites is pleasingly sensual, suggesting the gratification in cuddling a sleepy infant. The artist was working on a series of etchings during this period, and her renewed interest in the expressive power of line can be seen in details such as the "S" curve of the mother's head, neck, and shoulders, which is echoed by the silhouette of the water pitcher behind her.

The theme of mother and child emerged in Cassatt's oeuvre around 1880 and continued as a dominant subject throughout her career. Cassatt never married or had children, nor did she leave any records that suggest why she turned so often to the mother and child theme. It was a popular painting subject in the late nineteenth century, yet few artists were able to represent motherhood with such freshness and honesty. Cassatt's models were often country women who were eager to be paid for a few hours of sitting still. *Mother and Child* is typical of Cassatt's compositions in which gestures and expressions are restrained and quiet. The intertwining of the figures through line and color helps focus the viewer's attention on the intimacy between the mother and child, who delight in each other's touch.

JUDY L. LARSON

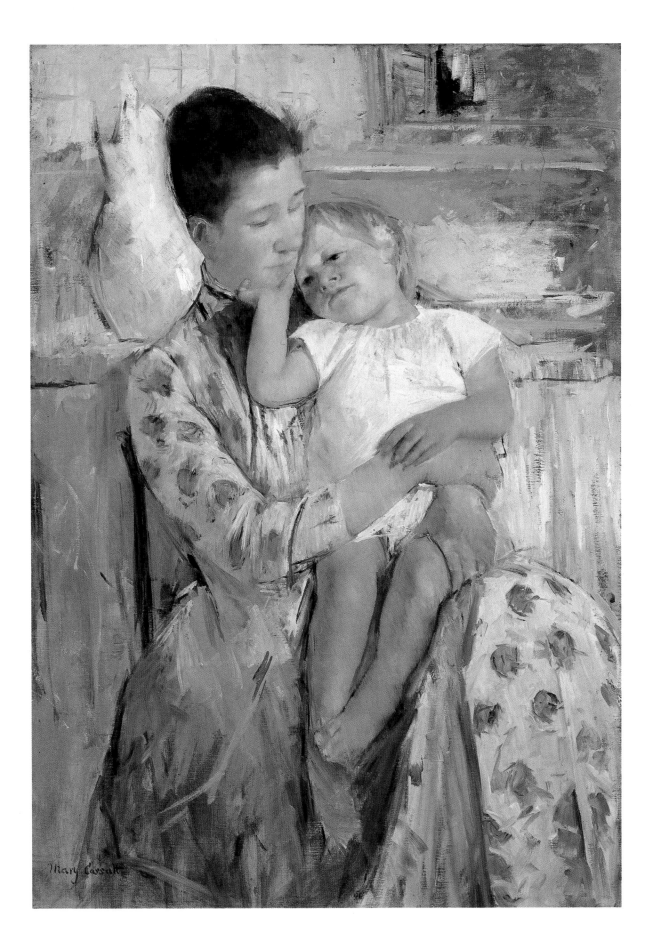

WIFE OF MABYAALA

BEFORE 1885

BAKONGO PEOPLES, CABINDA, ZAIRE

WOOD, GLASS, AND OTHER MATERIALS

HEIGHT 15 INCHES (38.1 CM)

RIJKSMUSEUM VOOR VOLKENKUNDE,
LEIDEN, THE NETHERLANDS

AMONG THE BAKONGO OF CENTRAL AFRICA, **NKISI** ARE OBJECTS THROUGH WHICH spiritual powers of affliction or healing are invoked. *Nkisi,* which come in many forms, are thought of as vessels in which a spirit can reside. They are administered by a ritual expert called a *nganga,* who places in them the appropriate "medicines" to empower them in the service of a client. The *nkisi nkondi,* a sculpture in human form, often appeared in pairs of male and female figures, a bag of medicines, amulets, and various other items of the *nganga*'s equipment. Most *nkisi* objects found in Western collections today were collected in the late nineteenth century or during the first years of the twentieth century.

Several accounts mention Mabyaala ma Ndembe as one of the most important of these figures in the central coastal region of Africa in the late nineteenth century, and sculptures of Mabyaala have been identified. This female *nkondi* was part of a set and served to soften the aggressive powers of her male counterpart (see page 170). This figure of mother and child is remarkable for its naturalistic pose and smooth surface devoid of nails. Female *nkondi* figures were linked to earth and sky, in contrast to males like Mabyaala, who were associated with the violence of thunderstorms and the sky. The pair of figures were intended to function in relation to each other rather than as discrete ritual objects. Even outside of ceremonial context, these sacred figures have a powerful visual effect, evoking, despite the roughness of the materials, the delicacy of a child just touching his mother's breast.

MICHAEL HARRIS

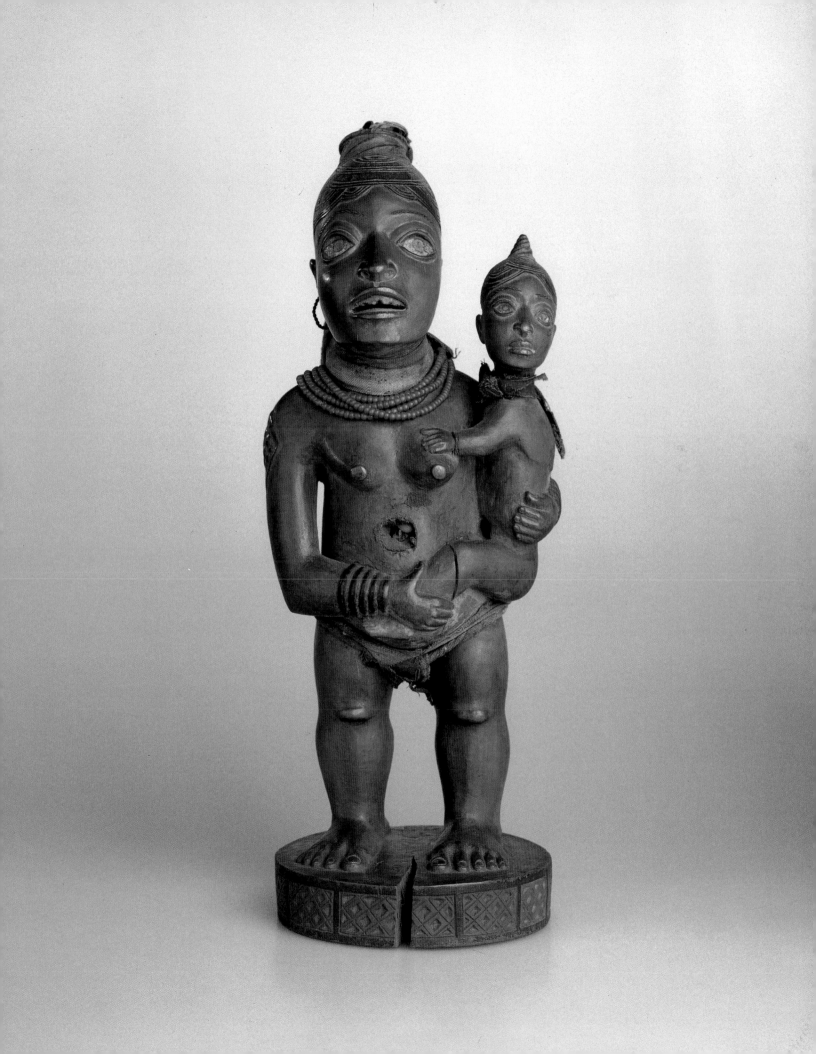

CUZCO SCHOOL
PERUVIAN, 18TH CENTURY
**SAINT JOSEPH AND THE
INFANT JESUS**
18TH CENTURY
OIL ON CANVAS
33 x 29 INCHES (83.8 x 73.6 CM)

DENVER ART MUSEUM, GIFT OF
ENGRACIA FREYER DOUGHERTY
FOR THE FRANK BARROWS FREYER
COLLECTION

SAINT JOSEPH IS DESCRIBED IN THE GOSPELS AS THE "JUST MAN," WHO HUMBLY ACCEPTS his divinely revealed role as husband to the Virgin Mary and earthly guardian of the child Christ. In European art throughout the Middle Ages and Renaissance, he was depicted as an elderly man and confined to a minor role as observer at the birth of Christ. By the eighteenth century, however, the motif of a youthful Joseph tenderly cradling the infant Jesus had become one of the most popular subjects of painting in colonial Spanish America, signifying a growth of devotion to his cult that was particularly marked among the indigenous populations. Not only did it set an example for the average man as lover of the God Child, but it also sanctified the role of the human father.

This new devotion was implanted in America by the utopian friars who established the first Christian communities among Mexican natives and enthusiastically promoted Joseph's cult among their converts; native chapels were commonly called "San Josés," Indian children took his name, and in 1555 Joseph was designated patron saint of New Spain. Another profoundly effective force for the spread of Joseph's cult in America was the great Spanish mystic and reformer, Teresa of Ávila (1515–1582), who founded the order of Discalced (Unshod) Carmelites and whose devotion to Joseph as father and protector knew no bounds. The Carmelite convents that proliferated in America followed her example in prominently displaying images of Joseph in their establishments.[1] But the particular type of image of Joseph promoted by the "Teresitas" was a very different one from that of the medieval Joseph. It presented a young man whose features resembled those of the adult Christ, either holding the youthful Jesus by his hand or, as in the present example, tenderly cradling him in his arms.

Half-length images of Saint Joseph embracing the Child were popularized by Bartolomé Esteban Murillo and in the easily transportable engravings, done for the Jesuits by the Wiericx family and disseminated throughout the colonies. This extravagantly gilded version, its floral framework derived from seventeenth-century Netherlandish imports, is a brilliant example of the indigenous Cuzco School, whose members developed a local style independent of Spanish guild standards. It is, however, only one variant of a type repeated across the entire spectrum of colonial painting, from the most sophisticated to the humblest folk artist in Spanish America today.

JOHANNA HECHT

1. For Carmelite devotion to Joseph and that of the closely allied Jesuit order, see *Patron Saint of the New World: Spanish American Colonial Images of St. Joseph*, ed. Joseph Chorpenning (Saint Joseph's University [Philadelphia], 1992).

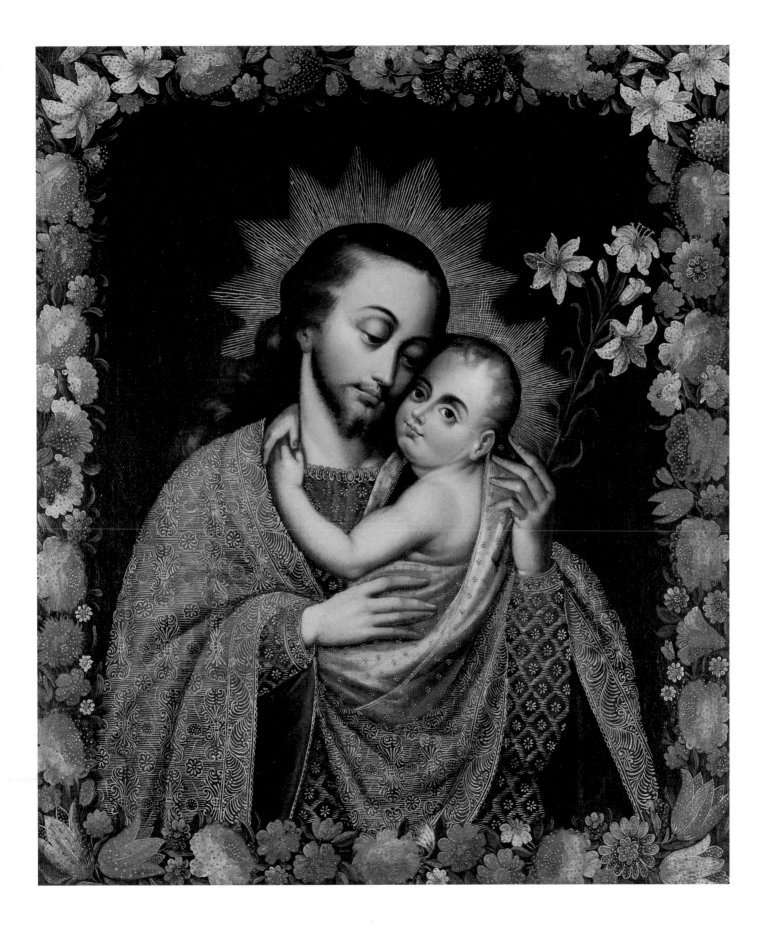

The son of a minister in the African Methodist Episcopal Church, Henry Ossawa Tanner was raised in an affluent, well-educated African-American family. Although reluctant at first, Tanner's parents eventually responded to their son's unflagging desire to pursue an artistic career and encouraged his ambitions. In 1879, Tanner enrolled at the Pennsylvania Academy of Fine Arts, where he joined Thomas Eakins's coterie. Tanner moved to Atlanta in 1889 in an unsuccessful attempt to support himself as an artist and instructor among prosperous middle-class African Americans. Bishop and Mrs. Joseph C. Hartzell arranged for Tanner's first solo exhibition, the proceeds from which enabled the struggling artist to move to Paris in 1891. Illness brought him back to the United States in 1893, and it was at this point in his career that Tanner turned his attention to genre subjects of his own race.

In 1893 most American artists painted African-American subjects either as grotesque caricatures or sentimental figures of rural poverty. Henry Ossawa Tanner, who sought to represent black subjects with dignity, wrote: "Many of the artists who have represented Negro life have seen only the comic, the ludicrous side of it, and have lacked sympathy with and appreciation for the warm big heart that dwells within such a rough exterior."[1] The banjo had become a symbol of derision, and caricatures of insipid, smiling African Americans strumming the instrument were a cliché. In *The Banjo Lesson*, Tanner tackles this stereotype head-on, portraying a man teaching his young protégé to play the instrument—the large body of the older man lovingly envelops the boy as he patiently instructs him. If popular nineteenth-century imagery of the African-American male had divested him of authority and leadership, then Tanner in *The Banjo Lesson* recreated him in the role of father, mentor, and sage. *The Banjo Lesson* is about sharing knowledge and passing on wisdom.

The exposition-sized canvas was accepted into the Paris Salon of 1894. That year it was given by Robert Ogden of Philadelphia to Hampton Institute near Norfolk, Virginia, one of the first and most prestigious black colleges founded shortly after Emancipation. Hampton lent it the next year to Atlanta's Cotton States and International Exposition of 1895, where it hung in the Negro Building. Contemporary critics largely ignored the work. Tanner painted another African-American genre subject in 1894, *The Thankful Poor*, but then abandoned subjects of his own race in favor of biblical themes. When Tanner returned to Paris in 1895, he established a reputation as a salon artist and religious painter but never again painted genre subjects of African Americans.

JUDY L. LARSON

1. Undated, handwritten statement by Tanner in the files of the Pennsylvania School for the Deaf, Philadelphia, as quoted in Dewey F. Mosby, Darrel Sewell, and Rae Alexander-Minter, *Henry Ossawa Tanner* (Philadelphia, 1991), 116.

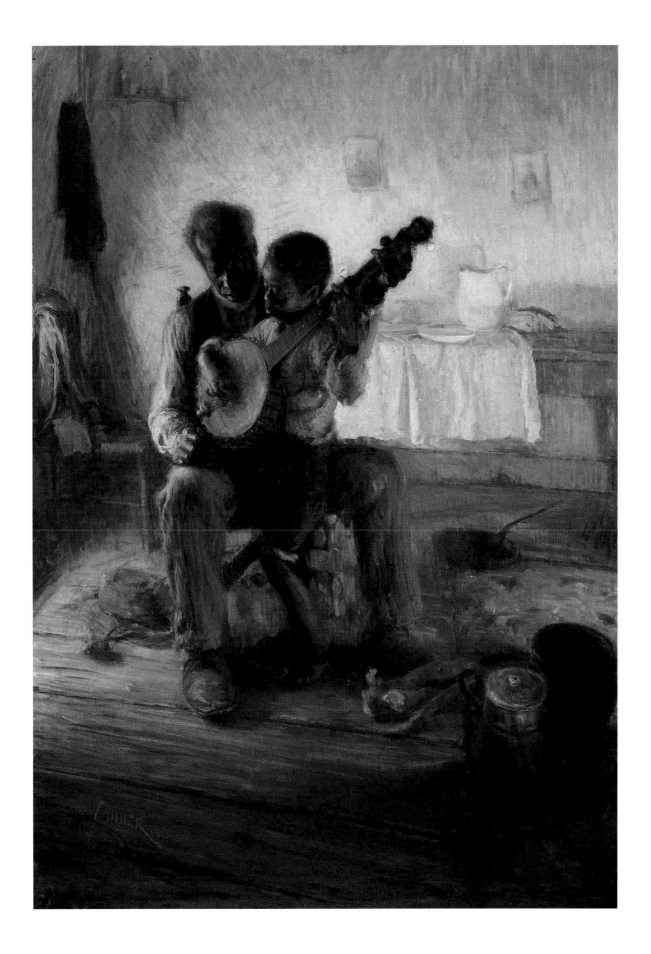

ZHOU WENJU

CHINESE, 10TH CENTURY

**THE PARTING OF SU
WU AND LI LING**

10TH CENTURY

HANDSCROLL; INK AND

COLOR ON SILK

13⅛ x 35⅜ INCHES

(33.4 x 89.9 CM)

PALACE MUSEUM, TAIPEI,

CHINESE TAIPEI

AT THE CENTER OF THIS SCROLL, THE GRIEVING FRIENDS SU WU AND LI LING exchange their last farewell. The scenes on either side represent their respective misfortunes. Su Wu was sent as an envoy to the Xiongnu (Huns) by Emperor Wu Di (ruled 140–87 B.C.) of China's Han dynasty (206 B.C.–A.D. 220). Because he would not renounce his loyalty to the emperor, Su Wu was held captive and forced to tend an all-male flock of sheep on the barren plains of Inner Mongolia. After nineteen years, he made his way back to China. His return was marred not only by the news of his mother's death and his wife's faithlessness, but also by the sad irony of the disaster that had befallen Li Ling.

In the autumn of 99 B.C., Li Ling led five thousand Han troops deep into Xiongnu territory. Returning from this mission, he was surrounded by an overwhelming force of Xiongnu cavalry. Fighting a running battle, Li Ling and his men killed thousands of their pursuers as they withdrew toward Chinese territory. Finally, with no hope of reinforcements and his supplies exhausted, Li Ling surrendered. When word of this reached court, Li was accused of collaborating with the enemy. Furious, the emperor ordered the execution of Li's mother, younger brother, wife, and children. Exiled from his beloved homeland and punished cruelly and unjustly by his emperor, Li Ling's only comfort was a poignant correspondence with his bosom friend Su Wu.

The artist Zhou Wenju was a court painter at a time when China's frontiers were once again threatened by nomadic tribesmen. This painting was meant to recall the past sacrifices of China's soldiers and civil servants—men who endured long separation from family and friends in the nation's defense. Over the centuries the ill-starred friends Su Wu and Li Ling have come to symbolize love that endures even the cruelest twists of fate. They are forever associated with the feelings expressed in this bittersweet lament, attributed to Li Ling:

*The good times will never return,
in a moment our parting is done.*

*At the crossroads we hesitate awkwardly,
in open fields we pause hand in hand.*

*Above us the clouds go passing by,
drifting swiftly together and swiftly apart.*

*Ceaselessly the wind and waves
roll away to the ends of the earth.*

*From now on we'll be separated,
so let us stop here for awhile.*

*If only I could ride the morning wind,
I would go with you to your journey's end.*[1]

ALAN ATKINSON

1. Author's translation

Kamal al-Din Bihzad
Persian, 15th century
**YUSUF PURSUED BY
POTIPHAR'S WIFE ZULAYKHA**
1488
From a manuscript of the
Bustan (Orchard) by Sa di
Watercolor, ink, and
gold on paper
12 x 8½ inches (30.5 x 21.5 cm)

General Egyptian Book
Organization, Cairo

Few Persian painters have inspired as much respect and admiration as Kamal al-Din Bihzad. Although numerous paintings and drawings have been attributed to him by his near contemporaries and later connoisseurs, only the five illustrations in this celebrated fifteenth-century copy of the *Bustan* (Orchard) are unanimously accepted as his genuine work. *Yusuf Pursued by Potiphar's Wife Zulaykha* is perhaps the most dazzling and complex of the group. The story, based on the biblical version of Joseph the Patriarch, also appears in the Koran and plays an important role in Islamic religious and mystical thought.

The focus of Bihzad's painting is an elaborate architectural setting. Its source is not Sa`di's own account of the Yusuf story but a mystical Persian poem entitled *Yusuf and Zulaykha*, written in 1483–84 by the great classical poet Jami, a contemporary of Bihzad. Four lines of this poem have been incorporated discreetly around the open hall (*iwan*) in the center of the painting, providing the viewer with the literary source of the composition.

In Jami's version, Zulaykha, in a desperate attempt to seduce the beautiful Yusuf, raises a palace with seven chambers, each embellished with erotic paintings of herself with Yusuf. Having lured Yusuf to the palace, Zulaykha feverishly pursues him from room to room, locking each door behind her until they reach the innermost chamber. Overcome with desire, she reaches for her beloved.

An underlying theme of Jami's mystical poem is Yusuf's moral dilemma of whether to yield to Zulaykha, given the absence of any human witnesses. Bihzad's setting, with its receding, empty spaces, firmly shut doors, sharply angled walls, and zigzagging stairs, provides a brilliant visual embodiment of Yusuf's conflict. The painting captures the most dramatic moment of the encounter when Yusuf, realizing that God himself will be his witness, chooses to tear himself free from Zulaykha. According to the poem, in the next instant the doors are miraculously flung open in front of Yusuf, allowing his escape. Bihzad's splendid composition, executed within the strict conventions of Persian manuscript painting, transcends the requirements of the narrative, creating a highly personal interpretation of the quandaries of human and mystical love.

MASSUMEH FARHAD

TIZIANO VECELLIO, CALLED TITIAN
ITALIAN, C. 1488–1576
VENUS AND ADONIS
C. 1560
OIL ON CANVAS
48 x 53⅛ INCHES (122 x 135 CM)

NATIONAL GALLERY OF ART,
WASHINGTON, D.C.,
WIDENER COLLECTION

THE STORY OF VENUS AND ADONIS IS ONE OF THE MOST TOUCHING IN ANCIENT mythology, derived in the Renaissance primarily from the Roman poet Ovid. The goddess Venus loved the handsome young mortal Adonis. The painting represents Venus restraining Adonis, who is about to depart with his hounds to hunt the wild boar that will slay him, sending him into the underworld forever. The memory of Adonis will be recalled each spring by the red anemone, whose color represents his bloody wounds. In Titian's painting, Venus is accompanied by her son, Cupid (Eros in Greek), representing the love between Venus and Adonis and suggesting by his gesture a premonition of Adonis's fate.

Titian (the English name for Tiziano Vecellio) lived a long life in the Republic of Venice and became one of the most important artists of the High Renaissance. Venice in the sixteenth century had become one of the great cultural, economic, and political centers of Europe in spite of conflicts with other powers in the Christian and Muslim world. Titian's patrons included Pope Paul III; Emperor Charles V and his son Philip II, King of Spain; and other important figures of the period. These patrons particularly favored paintings with subjects from Greek and Roman mythology, usually of a somewhat erotic nature—a preference illustrated by this version of *Venus and Adonis.* Several versions of this popular subject by Titian exist, but it is in this late version that the sense of foreboding and the agony of separation are perhaps most poignantly expressed.

This version was painted when Titian was around seventy years old. In the 1560s, he developed a loose, free manner of handling oil paint on canvas in which he concentrated on dramatic action, lush color, and vigorous brushwork. (Some contemporaries even suggested that he painted with his bare hands.) The expressive late style of Titian influenced subsequent generations of painters such as Tintoretto, Veronese, Rubens, and Rembrandt.

JOHN HOWETT

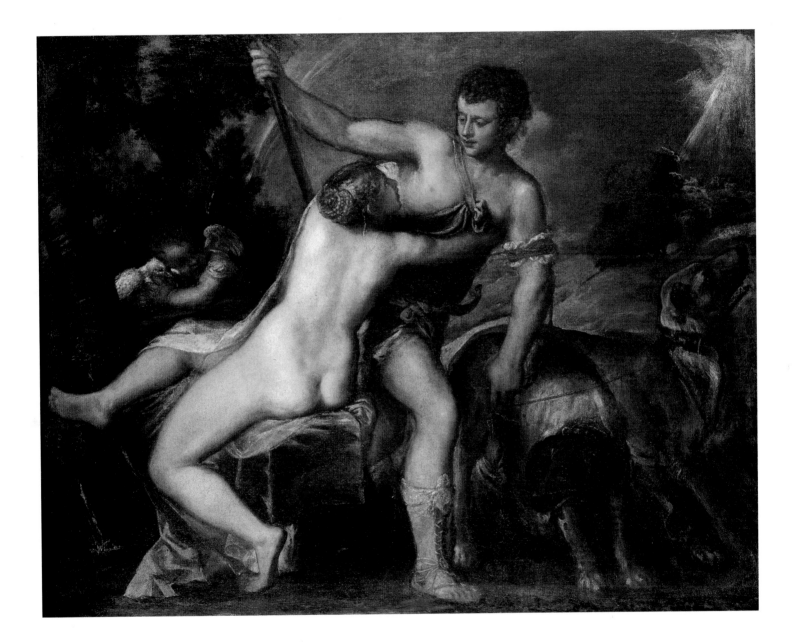

EDVARD MUNCH

NORWEGIAN, 1863–1944

SEPARATION

1896

OIL ON CANVAS

37⁷⁄₁₆ X 50 INCHES (95 X 127 CM)

MUNCH-MUSEET, OSLO, NORWAY

THE DOMINANT THEMES IN EDVARD MUNCH'S WORK DURING THE FIRST HALF OF HIS long career were life, love, and death. Munch took an ambivalent view of women in his depiction of them, sometimes expressing deep sentiment and, alternately, obvious revulsion. His relationships would end with burned-out, jealous spats and with regrets, and in the end he felt that women would stand in the way of his art. The one time a woman pressed him hard toward marriage, Munch turned violent. In the scuffle, a gunshot severed a finger on his left hand, an event that produced a group of grimly illuminating images.

Munch's first sexual experience, with a married woman, left him confused and deeply anxious. His emotional baggage from this entanglement emerged in a number of paintings that became central to the *Frieze of Life,* a series dealing with pain and uncertainty in the course of human experience.

The Norwegian word for the title of this painting, *Separation,* carries a meaning of "tearing apart," of liberation and independence. The young woman in the flowing gown looks expectantly across the waters toward the horizon. Munch depicted this figure repeatedly in various situations as an innocent at the beginning of her life, as yet untouched by loss or regret. He wrote about her in this particular context: "When you went over the sea and left me, it was as if there were still invisible threads uniting us. It was as though something was tearing at an open wound."

The painting could be seen as an expression of grief on the part of the man turning away from the woman's joyful anticipation. It is also possible that the man, Munch himself, draws away from her in profound regret because he is incapable of giving himself in a lasting commitment. The exotic plant before him may be the flower of love, which Munch also saw as the flower of art; thus, art may bring deep pain. In drawing away, the man seems held by strands of the virgin's hair, symbols of her love imbedded in his heart. Women's hair had an irresistible attraction for Munch, who showed it as an ensnaring bond in a variety of Salome themes or, in a more sinister context, as blood coursing over man, paralyzing him.

GUDMUND VIGTEL

II. ANGUISH

OVERLAPPING WITH IMAGES OF LOVE AND NURTURE IN THE FIRST RING, HENDRICK Terbrugghen's *Saint Sebastian* initiates the theme of martyrdom, mixed in this first subsection with the emotional anguish of those confronted by pain and bereavement. The plangent diagonal progression downward from left to right sweeps us into feeling both the pain of Sebastian, having been shot through with arrows for refusing to renounce his faith, and the tender care of Irene, who, finding him left for dead, became his rescuer.

Not so lucky those suffering the carnage of war in Auguste Préault's *Slaughter*, where the agony of the woman's head streaming in from the right prefigures a similar evocation in Pablo Picasso's monumental picture commemorating the bombing of civilians in the Spanish town of Guernica during that country's bloody civil war. Two small studies done within two weeks of that painting depict the anguish of a mother, staring upward at the Fascist German bombers as she holds a dead child, and a woman in a Spanish mantilla weeping into a large handkerchief. The Lulua figure, too, evokes the anxiety of a mother, in the presence of the agony, real or imagined, of a dead child. The pain of a bereaved mother is then represented metaphorically by daggers piercing the *Our Lady of Sorrows* from São Paulo, Brazil.

The consummate explorer in the whole Western tradition of what it means, psychologically, to be human, was, many agree, Rembrandt van Rijn, who probed mental anguish of great complexity in the drama of a composite moment where Saint Peter's guilt is caught in the glaring light of his witnessing accusers. Having predicted this archetypal incidence of human frailty, Christ, in the shadows, looks on.

Munch's *Scream* has become the defining image for the anxiety that has given its name to an age. It is our age, illuminated by Sigmund Freud and Karl Jung and characterized increasingly by humankind's capability for destroying itself. In this, the most intensely colored version, we are drawn into a world verging on hallucination that registers in our consciousness indelibly.

The painter's evocation of the psychological state of a person had been of great interest to Leonardo da

Vinci ("That figure is most praiseworthy which best expresses through its actions the passions of its mind"). He had taken a particular interest in the "mental motions" of the insane. But it was not until the young Théodore Géricault, himself a manic-depressive, studying the inmates in an asylum, that emotional anguish manifesting itself with the intensity of mental illness was explored with such empathic sensitivity, at a moment when a doctor friend of the artist's was just beginning to change society's attitudes toward the mentally ill.

Mental anguish can produce what we call the tortures of the damned. Religions all over the world have pictured the consequences of divine retribution, perhaps none more graphically than in the much-prized twelfth-century manuscript from the Toyko National Museum.

The next subsection, devoted to political anguish, is introduced by the large oil painting of 1993 by the Cuban artist Antonia Eiriz, with its ghostly evocations that resonate with our memory of Munch's *Scream*. The plight of the politically disadvantaged is expressively recorded in the scroll by Zhou Chen, gathering to a climax of agony in the 1930s painting by the Mexican David Alfaro Siqueiros, whose own recall of the Munch is reflected in his title, *Echo of a Scream*. Completing this group is the moving *Cage*, a 1981 sculpture by Magdalena Abakanowicz, a Pole who has known firsthand the abuse of political power.

The final group of images in this Ring brings us to the emotion of physical anguish as it leads to its ultimate conclusion, death. The Spanish Neapolitan Jusepe de Ribera brings in Classical antiquity with his account of Marsyas being cooly skinned alive by the god Apollo as punishment for considering himself as good an artist as the deity. The gifted Artemisia Gentileschi, one of the first women to have attained prominence as a painter, is perhaps venting her own anguish at having been raped in her dramatic portrayal of Judith's slaughter of the tyrant Holofernes, with the blood seeping into the sheet underneath his severed head.

For physical anguish, one of the most depicted scenes in all art is the Crucifixion of Jesus Christ. Here a seventeenth- or eighteenth-century Mexican interpretation maximizes our visceral understanding of the physical hardships of being whipped and crowned with thorns, of having dragged a heavy cross up a rocky path on one's knees, of being nailed to it through the hands and ankles and, finally, pierced in the side by a spear.

The placement of this subject here at the end of Anguish begins the preparation for the next section. With Peter Paul Rubens's evocation of the dead Christ, whose mortality is being underscored by Mary's poignant gesture closing down his eyelid, comes a finality, surrounded by all the attendant grief that echoes the sorrows of the women at the beginning of this section but at the same time raises by implication the question, "At my death, is there anything beyond?"

This, too, is the question posed by the last, transitional work of art in this Ring. Bill Viola's two television tubes of 1992 bear images of his mother on her deathbed and his son just having been born—two events that happened within weeks of each other—images that reflect each onto the other across the space dividing them, as summarized in the title of the work, *Heaven and Earth*. That evocation of the beyond leads us to the emotion we call AWE.

J. C. B.

HENDRICK TERBRUGGHEN
DUTCH, 1588–1629

SAINT SEBASTIAN ATTENDED
BY IRENE AND HER MAID

1625

OIL ON CANVAS

59⅛ x 47¼ INCHES (150.2 x 120 CM)

ALLEN MEMORIAL ART MUSEUM,
OBERLIN COLLEGE, OHIO,
R. T. MILLER, JR. FUND, 1953

ALTHOUGH THERE IS EARLY EVIDENCE THAT SEBASTIAN CAME FROM MILAN TO JOIN the army in Rome around 283 and was martyred under the emperor Diocletian, the pious legend of his having been shot by archers and surviving through the ministrations of Irene, the widow of the martyr Saint Castulus (not Saint Irene as is sometimes supposed), took hold in the late fifth century. A popular subject throughout Europe in the sixteenth and seventeenth centuries, Saint Sebastian became an important saint in the Catholic countries and cities like Utrecht, where he was believed to intercede for the faithful during the ravages of the bubonic plague. The diagonal grouping of the two women and the nude saint with his painful wounds, set against a desolate landscape, creates strong emotions of pity and anguish in the viewer.

Having studied in Italy for ten years between 1604 and 1614, Terbrugghen eventually settled in Utrecht, a Catholic city in the predominately Protestant country of his birth. There, his style, strongly influenced by the Italian painter Michelangelo Merisi da Caravaggio and fused with the tradition of Northern European painting, brought a new dramatic realism to the art of Holland, appealing to pious Christian patrons and influencing a generation of Dutch painters, both Protestant and Catholic, such as Rembrandt and Vermeer. This painting from the artist's late years illustrates the dramatic use of dark and light and immediacy and simplicity in telling a story, qualities that are also found in Caravaggio's work.

JOHN HOWETT

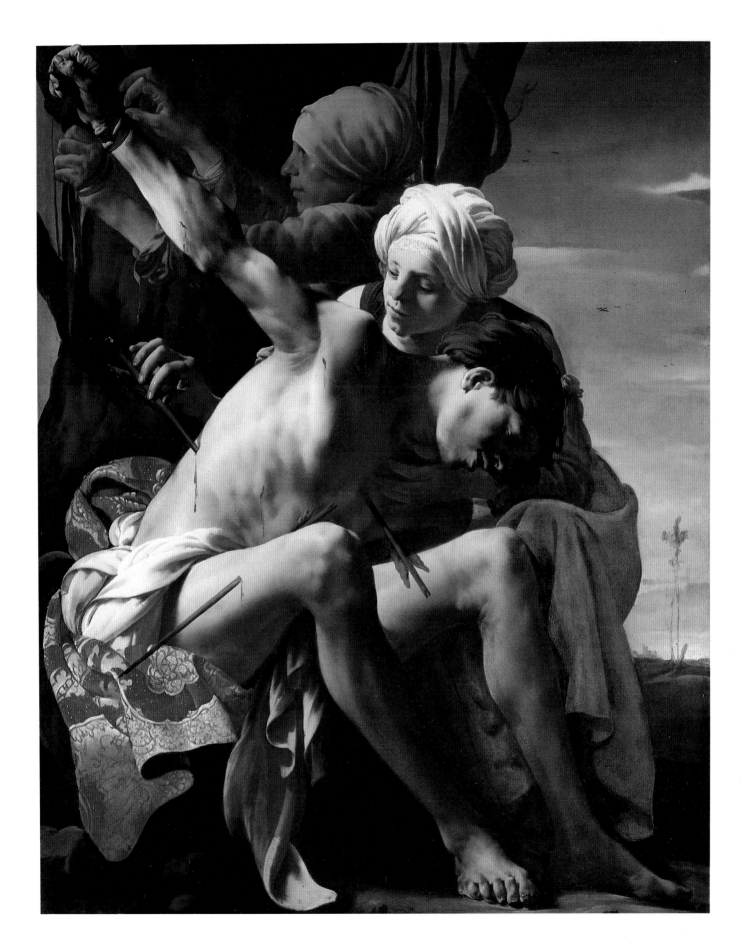

Auguste Préault
French, 1810–1879
SLAUGHTER
c. 1834
Bronze
43 x 55 inches (109.2 x 139.7 cm)

Musée des Beaux-Arts,
Chartres, France

Auguste Préault, who worked in the middle years of the nineteenth century in Paris, was a master of relief sculpture. He studied with David d'Angers, who created a notable series of portrait reliefs of the artists of his time. Préault sent his relief sculpture entitled *Slaughter* to the Salon of 1834, where it was both embraced by supporters of Romantic art and condemned by more conservative critics. The panel was intended to be a fragment of a larger composition, but it stands alone as a self-contained work of art.

The space of the sculpture is congested with emotionally charged figures who seem ready to burst from their two-dimensional confines. Included among the seven figures is a helmeted knight, a distraught and screaming mother holding her child, and the upper torso of a man with two deep gashes in his chest above his heart. Of the seven people, only the child is seen in full figure.

The composition is framed in part by the smooth, long hair of the mother, which blends miraculously with that of the bearded man, whose face is in profile next to her. Compressed together, these swirling, open-mouthed, and panicked faces are responding to some unseen and unexplained apocalyptic event. The inscription of the title of the sculpture at the top center of the relief indicates that a slaughter or a massacre is the subject.

The unconventional composition of the jumble of faces and the high emotional pitch of the work are evidence of Préault's connection to the Romantic movement, including the painters Théodore Géricault and Eugène Delacroix and the sculptor François Rude. The relief was eventually cast in bronze, and the latter version was bought by the French state in 1859, a quarter-century after the sculpture was first created.

MICHAEL E. SHAPIRO

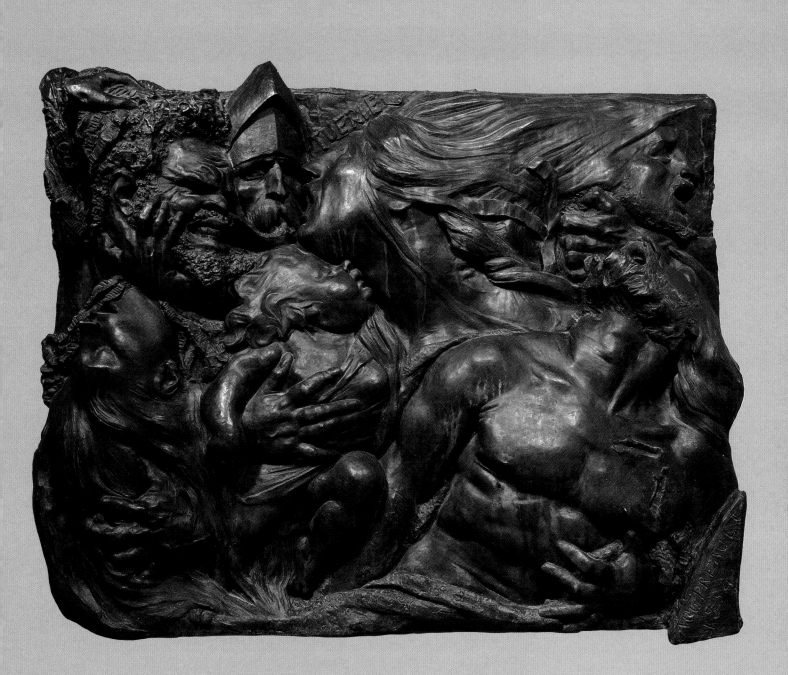

PABLO PICASSO PROFOUNDLY INFLUENCED THE COURSE OF TWENTIETH-CENTURY ART. During his long and prolific career, he developed a highly expressive style of painting that embraced abstraction but always remained tied to figuration. He portrayed intensely personal concerns in archetypal terms: the psychological struggle between human reason and animal instinct, the relationship between men and women, and the artistic process itself.

Although he lived in Paris from 1904 until his death nearly seventy years later, Picasso proudly retained his Spanish citizenship throughout his life. Following the establishment of the Spanish Republic in 1931, he renewed his ties to his native land. He visited regularly, actively exhibited his work there, and hired a childhood friend from Barcelona to be his personal secretary. The outbreak of the Spanish Civil War in 1936 deeply affected Picasso. Although largely apolitical during most of his life, he actively supported the Republican cause.

In January of 1937, Picasso accepted a commission from the besieged Republican government to create a mural for the Spanish Pavilion at the Paris Exposition of 1937. He did not begin working on the commission for several months, however, as he searched for a suitable subject. The bombing of Guernica on April 26, 1937, provided the universal theme Picasso sought. This small northern city, the capital of the Basque region of Spain, was revered as the country's oldest center of democracy. Conducted by Nazi planes at the behest of Franco's forces, the air raid represented the first saturation bombing of a civilian center. The utter brutality and devastating force of the attack evoked horror around the world. Picasso immediately began a series of drawings based on the event and, by May 11, he had begun to transfer these designs to the large canvas for the Spanish Pavilion. As he worked to complete the mural over the next few weeks, he continued to draw and make sketches, working out details for the canvas or exploring a particular protagonist. He finished the canvas less than a month later and titled it simply *Guernica*. Despite its clear relationship to the Spanish Civil War, Picasso adamantly denied that the work was a political statement specifically aimed at the Nationalist forces, maintaining instead that it allegorically depicted the potential for destruction and inhumanity in each of us.

Even after he completed *Guernica*, Picasso continued to create what Alfred Barr has termed "postscripts" based on figures from the canvas. This work, made less than two weeks after he completed the mural, revisits the weeping woman holding a child who appears in the upper left of the painting. Here, Picasso has rearranged the figures, nestling the child beneath his mother's neck. The mother's anguished shriek shatters the tender intimacy of this pose. The peculiar, upside-down position of the child's head and his blank, lifeless eyes concisely convey the source of the mother's grief. With this modern *pietà*, Picasso deftly captured the true evil of war, and presaged the horrors that would soon engulf Europe.

CARRIE PRZYBILLA

Pablo Picasso
Spanish, 1881–1973
**HEAD OF A WEEPING WOMAN
WITH HANDKERCHIEF**
1937
Oil on canvas
21⅜ x 18⅛ inches
(54.3 x 46 cm)

Los Angeles County Museum
of Art, Gift of Mr. and Mrs.
Thomas Mitchell

Picasso painted his mural *Guernica* very quickly, considering its size, although he contemplated making changes to it up until the moment it left his studio, and perhaps even after. He told Josep Lluis Sert, the architect for the Spanish Pavilion, "I don't know when I will finish it. Maybe never. You had better come and take it whenever you need it."[1] The "post-scripts" he produced after the painting was delivered in early June and prior to the inauguration of the Spanish Pavilion on July 12, such as the works included here, may represent the artist's last-minute musing on possible alterations. The emotional resonance of certain figures also may have drawn the artist back to explore them more deeply.

The weeping woman clutching a handkerchief who is depicted in this canvas particularly fascinated Picasso. She appears in dozens of works he completed during the summer and fall of 1937. A similar head appears at bottom of the original draft of Picasso's prose poem *Dream and Lie of Franco*, which is filled with references to cries. The same figure also appears in several of the prints he produced to accompany the poem. Like *Guernica*, *Dream and Lie of Franco* portrays the grim realities of war, but Picasso's indictment of the Nationalists is far more direct and vitriolic.

Many scholars believe that the weeping woman represents Dora Maar, Picasso's mistress at the time. She was known for her elegance, intellect, and emotional sensitivity. We know she was an active presence in the artist's studio during the creation of *Guernica* because she photographed the mural as it developed. As depicted in this canvas, with a scarf on her head, the weeping woman carried deep personal associations for the artist. One of his earliest and most vivid memories was of the violent earthquake that struck his family's home in Málaga in 1884. Picasso was three years old at the time, and his mother was late in her pregnancy with his sister Lola. Years later he recalled, "My mother was wearing a kerchief on her head. I had never seen her like that."[2]

This woman's reddened nose and tear-stained face tell us she has been weeping for a long time. Presented with her head bowed, rather than thrown back as in *Guernica*, she portrays the profound, eternal grief of war. She is the anguished mother, the mourning lover, the bereft survivor of unspeakable horror.

CARRIE PRZYBILLA

1. Judi Freeman, *Picasso and the Weeping Women* (Los Angeles and New York, 1994), 60.
2. Jaime Sabartes, *Picasso: An Intimate Portrait* (New York, 1948), 5.

MOTHER WITH CHILD
(MOTHER WITH DEAD CHILD)
19TH CENTURY
LULUA PEOPLES, ZAIRE
WOOD AND COPPER ALLOY
14 x 3⅜ INCHES (35.6 x 8.6 CM)

THE BROOKLYN MUSEUM, NEW YORK,
MUSEUM COLLECTION FUND

AFRICAN MATERNITY FIGURES REFLECT A DEEP CONCERN WITH THE CONTINUITY OF the family and the group. The primary responsibility of a woman is to ensure the future through childbearing. In turn, children honor their elders, living and dead, and at times are believed to be the reincarnation of an ancestor. In an environment where childbirth is often difficult and infant mortality is high, there is particular concern for the mother and the child. Sculptures such as this Lulua figure may be carried by a mother during a pregnancy or be placed next to her during delivery to secure a successful birth.

A fertility cult, the *Buanga Bua Cibola,* uses figures such as this to ensure that the soul of an infant who had miscarried, was stillborn, or died in infancy will return to be reborn. For a time the mother-to-be is isolated; a figure is carved, rigorous rituals are followed, and the image is kept by her until delivery to ward off the evil that had caused earlier difficulties.

This sculpture depicts a typical Lulua hair arrangement and scarification. Untypical but not unique is the limp pose of the child. It has been suggested that the child is shown dead; however, there is no reference in the literature to figures showing women with dead children. Whether or not the child is alive, the image is one that is believed to aid the mother magically, medicinally, and psychologically during a particularly anxious time.

ROY SIEBER

The advocation of the Virgin called "Our Lady of Sorrows" envisions the anguished Virgin reliving in her imagination the stages of her suffering at the fate of her Son; in the present variation, a subject dating to the late Middle Ages, seven daggers pierce her heart, each meant to symbolize a particular painful event. Although the excruciating realism of this imagery eventually fell out of favor in much of Renaissance Europe, it was enthusiastically retained in Spain and Portugal, where Catholic observance was heavily influenced by the teachings of the Society of Jesus. Following the precepts of its founder, Ignatius Loyola (1491–1556), the order advocated the deepening of Christian spirituality through meditative imagining of the life and suffering of Christ. In the Ibero-American colonies, where devotion to the Virgin herself flourished with particular fervor, the Jesuits also actively promoted the veneration of the Virgin of Sorrows. In her solitude she represents not merely grief over the suffering of her Son but also a more generalized anguish with which any sorrowing devotee could identify.

Although the native communities in America bore the brunt of colonial oppression, in Brazil the indigenous workforce was augmented with imported African slave labor. Blacks were brought in to work not only the agricultural plantations but also the interior mining area, whose chief city was Ouro Prêto, where the famed mulatto creator of the present image was born. Lisboa, called O Aleijadinho ("the little cripple," reflecting his disfigurement by disease), built Rococo churches throughout the region of Minas Geraís, as well as series of massively awesome outdoor stone sculptures. For this human-scaled work, which must once have formed the centerpiece of an altar, Aleijadinho employed the more classic Iberian technique of polychromed wood. However, the gravity of the Virgin's expression and the weighty presence of her figure lend the sculpture a seriousness and power equal to that of the monumental stone figures that earned Lisboa the adulation of his peers and posterity alike.

JOHANNA HECHT

REMBRANDT VAN RIJN
DUTCH, 1606-1669
THE DENIAL OF SAINT PETER
1660
OIL ON CANVAS
60¼ x 66⅓ INCHES (153 x 168.5 CM)

RIJKSMUSEUM, AMSTERDAM

REMBRANDT PAINTED THIS LARGE PAINTING IN THE SO-CALLED "BROAD MANNER" of his late period, when he was applying paint in bold expressive strokes and using dramatic light and dark patterns. Although the incident of Peter's denial of Christ is also found in the Gospels of Matthew (26:69–75), Mark (14:66–72), and John (18:12–27), Rembrandt used the more dramatic account of Luke (22:54–62):

> Now having seized him, they led him away to the high priest's house; but Peter was following at a distance. And when they had kindled a fire in the middle of the courtyard, and were seated together, Peter was in their midst. But a certain maidservant saw him sitting at the blaze, and after gazing upon him she said, "This man too was with him." But he denied him, saying, "Woman, I do not know him." And after a little while someone else saw him and said, "Thou, too, art one of them." But Peter said, "Man, I am not." And about an hour later another insisted, saying, "Surely this man, too, was with him, for he also is a Galilean." But Peter said, "Man, I do not know what thou sayest." And at that moment, while he was yet speaking, a cock crowed. And the Lord turned and looked upon Peter. And Peter remembered the word of the Lord, how he said, "Before a cock crows, thou wilt deny me three times." And Peter went out and wept bitterly.

Luke is the only gospel writer who tells of Christ's looking at Peter at the last denial. Rembrandt has used a technique of collapsing the sequence of events in order to tell the full story, which the text says occurred in the course of an hour, in one image. The maidservant gazing at Peter by the light from her candle illustrates the first denial, the soldier on the extreme left side illustrates the second, and the soldier with the jug, whom Peter seems to address, illustrates the third. That the third denial is the moment depicted is borne out by the fact that the figure of Christ in the background, as in Luke's text, is turning to look at Peter. Also, by making threatening soldiers out of the anonymous men mentioned in the second and third denials, Rembrandt expresses the motivation for Peter's fear of being associated with Christ. The tension created by Rembrandt's condensed narrative of the story of Peter's denial of Christ, and the emotional impact upon the viewer through the dramatic use of light and dark and the loose brushwork, make this one of the artist's most innovative and expressive paintings—an enduring image of intense psychological anguish.

JOHN HOWETT

EDVARD MUNCH HAD NOT TURNED THIRTY YET WHEN HE PAINTED THE RADICAL PICture *The Scream.* By that time he had already produced several of the neurotically charged images that were to have a powerful impact on the Expressionists of the next century. Munch had gained notoriety as an artist who defied conventional values. He wrote in 1890: "I do not paint what I see, but what I saw"—a notion at striking variance with the narrative naturalism current in Europe.

Munch had been deeply scarred in his childhood by the loss of his beloved mother and a favorite sister, emotional blows sharpened by the religious anxieties of a reproachful father. The unstable conditions of Munch's bohemian life-style and hostile reactions to his art did nothing to ease the psychological pressures on him.

The Scream is a synthesis of the artist's emotional turmoil, symbolized by the desperate specter in the foreground and the undulating forms and strident colors pulsating through the landscape. The image was suggested by a spectacular sunset that had unhinged the artist. Munch wrote about this experience: "I walked one evening on a road—on the one side was the town and the fjord below me. I was tired and ill—I stood looking out across the fjord— the sun was setting—the clouds were colored red—like blood—I felt as though a scream went through nature—I thought I heard a scream.—I painted this picture—painted the clouds like real blood. The colors were screaming."

The works that preceded this depiction of his experience are here transmuted into an unrestrained expression of the artist's fears, regrets, and dread of impending insanity—colored by Munch's occasional self-pity. The steeply receding railing gives a sense of vertigo to the scene, with two observers in the distance, one of whom may be Munch himself. Clearly, the androgynous creature is a symbol of the artist's unstable state of mind.

The Scream became a part of Munch's great cycle, *The Frieze of Life*, a group of images dealing with the artist's central themes of life and love, death and loss. This is one of several versions of the subject; one has a statement visible on the upper edge: "Could only have been painted by a madman," apparently written by Munch himself.

GUDMUND VIGTEL

THÉODORE GÉRICAULT
FRENCH, 1791–1824

**PORTRAIT OF A WOMAN SUFFERING
FROM OBSESSIVE ENVY
(MONOMANIE DE L'ENVIE)**

C. 1822

OIL ON CANVAS

28⅜ X 22⅞ INCHES (72 X 58 CM)

MUSÉE DES BEAUX-ARTS,
LYONS, FRANCE

HOW SHOULD PAINTERS, LIMITED TO MANIPULATING PHYSICAL SIGNS, PORTRAY STATES of mind? How may they distinguish between normal and delusionary mental states? And to what extent, in their effort to depict those delusions, must they project themselves into the minds of their insane sitters? These are some of the questions posed by Théodore Géricault's *Portrait of a Woman Suffering from Obsessive Envy,* which—together with four other surviving pictures of individuals afflicted with delusions—number among the most haunting and enigmatic portraits in the history of Western art.

Profiting from an inheritance that, initially at least, freed him from having to satisfy the demands of the marketplace, Géricault was drawn to unusual contemporary subjects, often on a monumental scale. His most notable accomplishment in this respect, the *Raft of the Medusa* of 1819, now in the Louvre, stands as perhaps the supreme expression of French Romanticism. His portraits of the insane, on the other hand, executed near the end of his tragically brief life, mark a more intimate but no less original attempt to expand the mandate of artistic inquiry.

Lamentably, little is known about the portraits or the precise circumstances of their execution. It is generally agreed they were commissioned by, or were in some fashion linked to, the psychiatrist E.-J. Georget, himself a student of another investigator, J.-E.-D. Esquirol, well known for his pioneering research into the social origins of criminality and insanity. It was Esquirol's view that the modern world witnessed the flourishing of a new type of mental illness, *monomania,* in which a single overriding obsession came to dominate an otherwise normal mental constitution. Diagnosis aside, Géricault's depictions of monomania are noteworthy for the subtlety with which they convey the outward signs of his sitters' inner turmoil. Rather than grossly distorting their features and without sacrificing intensity of expression, Géricault treats the "monomaniacs" with unparalleled feeling and humanity. Indeed, in the case of this painting, it is almost as if the most fundamental outward symptom of the patient's delirium is the profound depth of her self-absorption.

MARC GOTLIEB

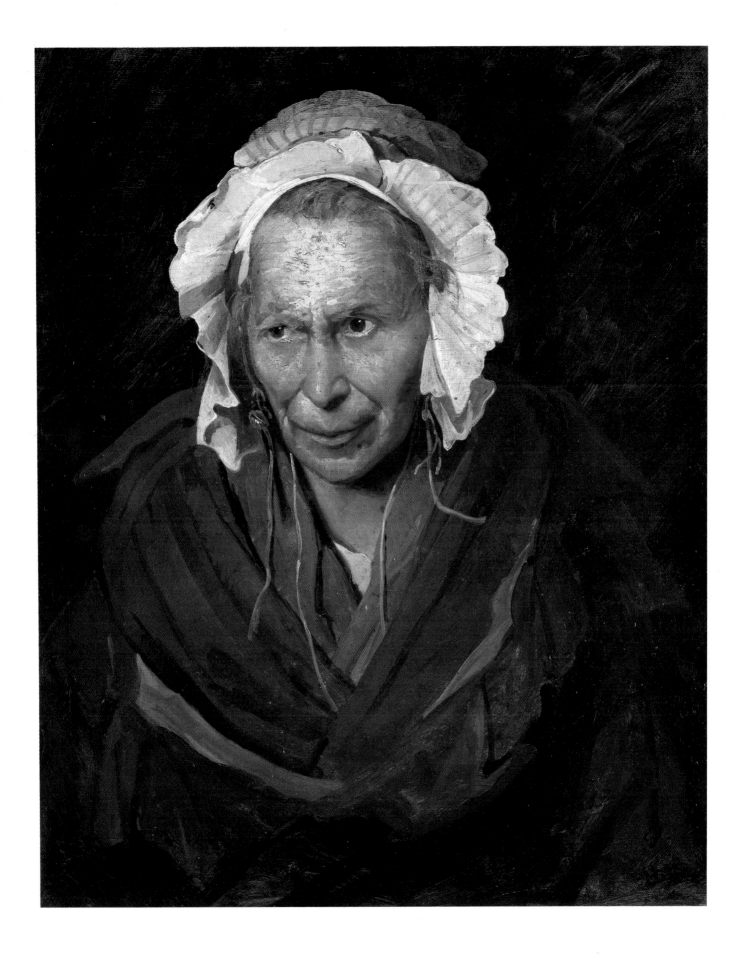

SCROLL OF HELLS (JIGOKU-ZOSHI)

C. 1180

JAPAN

HANDSCROLL; COLOR ON PAPER

10¼ x 95¼ INCHES (26 x 242 CM)

TOKYO NATIONAL MUSEUM, JAPAN

V

ISCERAL HORROR IS THE INTENDED EFFECT OF THE SCENES OF UNBEARABLE ANGUISH in this scroll that depicts four of the sixteen precincts of the "Great Hell of Screaming," one of the Eight Great Hells described in the *Mindfulness of the Right Dharma Sutra*. This Buddhist text, translated into Chinese in the sixth century, expounds the notion of Six Paths of Reincarnation (*rokudō*) into which a soul is reborn according to the judgment passed on the deeds of his past, and exhorts effort toward ultimate release from these realms of suffering in the Pure Land of Bliss. In Japan this doctrine was promulgated by the Tendai monk Genshin (942–1017) whose influential *Ojōyōshū (The Essentials of Salvation)* described in vivid detail the sufferings of Hell and the bliss of the Pure Land, in order to inspire faith in salvation through the practice of *nembutsu*, the invocation of the Buddha's name.

In late twelfth-century Japan, when these paintings were done, the terrors of hell which had until then remained remote in the conscience of the privileged aristocracy became all too real as a weakened court fell prey to rival factions of samurai, to remain ever after at the mercy of their professed guardians. The human world must have seemed little better than that of the lowest realms of animals, fighting demons, or hungry ghosts during the devastating wars that generated unprecedented suffering and valor that remains vivid to this day in Japan's artistic and literary tradition.

Among the earliest surviving Japanese narrative paintings, this scroll was part of a large set devoted to the Six Paths of Reincarnation produced at the behest of Emperor Go-Shirakawa (1127–1192, ruled 1155–58). Surviving sections depict other portions of the Eight Great Hells, with their sixteen subdivisions, the suffering realm of hungry ghosts, and the illnesses and deformities afflicting human life. This scroll was treasured in the Anjū-in, a small Shingon-sect temple in Okayama City, from an indeterminate date until 1950, when it was purchased by the Japanese government and consigned to the Tokyo National Museum. An eighteenth-century connoisseur attributed the calligraphy to the monk Jakuren (1143–1202), but the painter is unknown.

BARBARA FORD

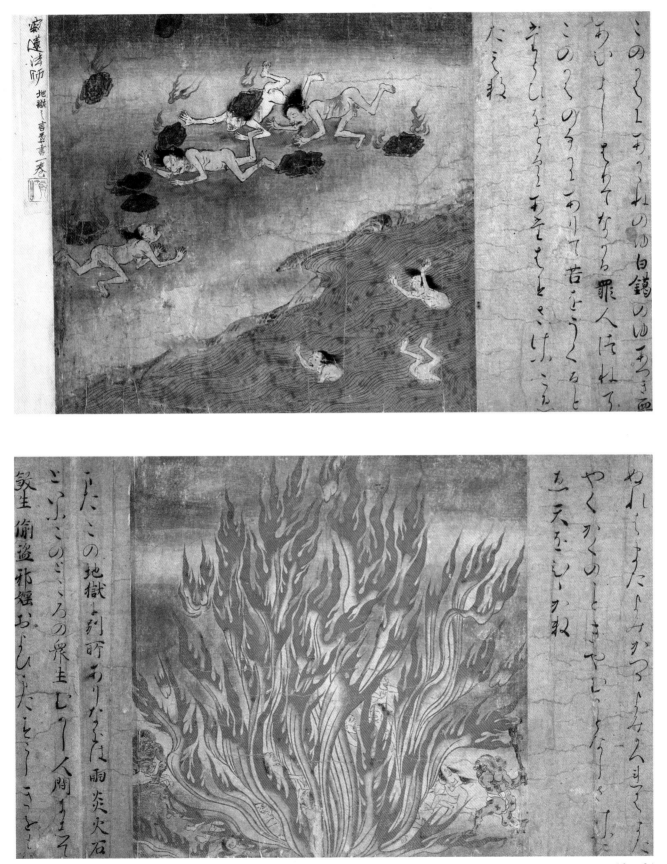

(details)

ANTONIA EIRIZ
CUBAN, 1929–1995
BETWEEN THE LINES (ENTRE LINEAS)
1993
OIL ON CANVAS
65½ x 75 INCHES (166.4 x 190.5 CM)

MUSEUM OF ART, FORT LAUDERDALE,
FLORIDA, GIFT OF SUSANA BARCIELA

ONE OF THE MOST IMPORTANT ARTISTS TO COME OF AGE DURING THE CUBAN REVOLUTION, Antonia Eiriz was a provocative, paradoxical figure. Though she received many awards and honors from the Cuban government, her paintings never conformed to the officially prescribed Social Realist style or subjects. Eiriz associated with members of *Los Onces* (The Eleven)— Cuban artists of the 1950s who, like the Abstract Expressionists, advocated an abstract art that was intuitive and sought to convey existential truths. Although she worked in a figurative mode, Eiriz was sympathetic to the ideas of The Eleven, and through her art and her teaching she influenced two generations of artists.

Eiriz's paintings from the 1960s often dealt with the excesses of demagoguery and (despite her denials) were interpreted as critical of the Cuban government. These works were never officially censored, but the criticism they received caused Eiriz to stop painting and exhibiting for more than twenty years. A 1991 retrospective of her art revived interest in her work and encouraged her to resume painting.

Entre Lineas (Between the Lines) is typical of the works Eiriz painted from the time she arrived in Miami in 1992 until her death early in 1995. With rich, expressive brushwork, the artist depicts a crowd of skulls hovering above a single screaming figure—a direct descendant of Edvard Munch's *The Scream*—isolated in a wide band of muddied chrome yellow. The figure appears between two real lines: the dark bands along the top and bottom edges of the canvas. The title of the painting also implies a hidden meaning written "between the lines." This state of limbo, where the rules are unspoken and constantly shifting, was a condition familiar to Eiriz, and she deftly conveys its terror in this haunting painting.

CARRIE PRZYBILLA

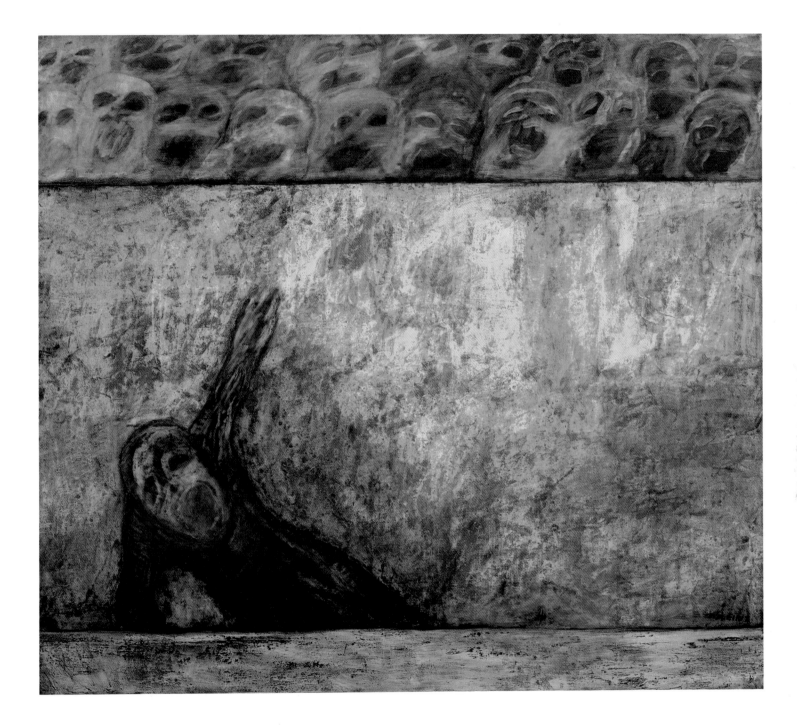

ZHOU CHEN
CHINESE, C. 1450–C. 1535
**BEGGARS AND STREET
CHARACTERS**
1516
ALBUM MOUNTED AS A
HANDSCROLL; INK AND
COLORS ON PAPER
12⅜ x 96½ INCHES
(31.4 x 245.1 CM)

HONOLULU ACADEMY OF ARTS,
GIFT OF MRS. CARTER GALT, 1956

THIS ALBUM REPRESENTS ONE OF THE MOST REMARKABLE SURVIVING FIGURE PAINTINGS of the Ming dynasty. It is now mounted as two separate handscrolls—this one in the Honolulu Academy of Arts and the other in the Cleveland Museum of Art.[1] Executed by the professional master Zhou Chen in 1516, it depicts street people of Suzhou, Zhou's hometown.

The Honolulu and Cleveland sections each depict twelve figures against an empty background. The figures are carefully delineated with assured, spontaneous brushwork. Indeed, the strength of the painting lies in its deft outlines, while the coloring is kept to muted blue, brown, and ocher pigments. That the scroll was originally in the album format is clear from the fold lines to either side of each figure.

In his inscription, Zhou Chen describes the circumstances that led him to paint these figures:

> In the autumn of the *bingzi* year of Zhengde [1516], in the seventh month,
> I was idling under the window, and suddenly there came to my mind all the
> appearances and manners of the beggars and street characters whom I often
> saw in the streets and markets. With brush and ink ready at hand, I put
> them into pictures in an impromptu way. It may not be worthy of serious
> enjoyment, but it certainly can be considered as a warning and admonition
> to the world.[2]

The sixteenth-century authors of the colophon on the Cleveland section saw essentially the same message in these paintings: an admonishment to live honest and virtuous lives, lest one end up like one of these street characters. One of the colophon writers, Zhang Fengyi, speculates that the down-and-out figures in Zhou Chen's painting reflect social conditions that prevailed during the tenure of corrupt high officials in the Zhengde reign (1506–21).

Zhou Chen's figures may be unique in Ming dynasty painting—indeed, in the entire history of Chinese figure painting—for their unidealized depiction of street people and their often anguished and twisted states of mind. The paintings are all the more remarkable for having been created in one of the most affluent cities in Ming China in a period when most figure paintings took as their subject matter literary narratives or highly educated scholars engaged in activities such as composing poetry or playing the *qin* (zither).

STEPHEN LITTLE

1. For the section in Cleveland, see *Eight Dynasties of Chinese Painting: The Collections of the Nelson Gallery—Atkins Museum, Kansas City, and the Cleveland Museum of Art* [exh. cat.] (Cleveland, 1980), no. 160.
2. Translated by Wai-kam Ho in *Eight Dynasties*, 194.

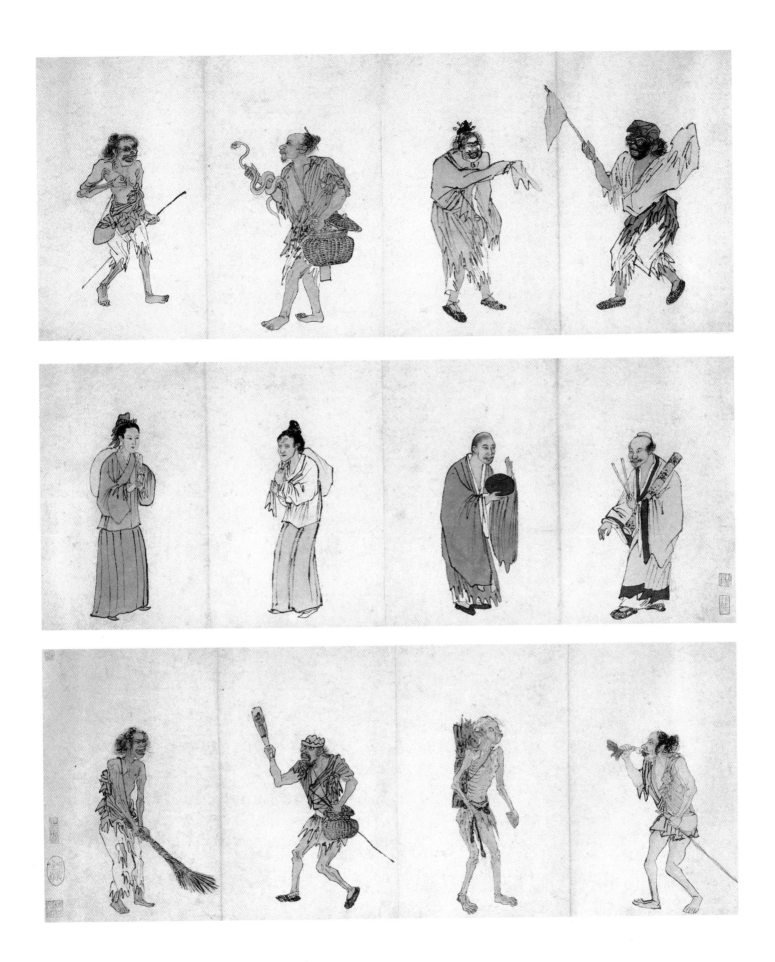

DAVID ALFARO SIQUEIROS
MEXICAN, 1896–1974
ECHO OF A SCREAM
1937
ENAMEL ON WOOD
48 x 36 INCHES (121.9 x 91.4 CM)

THE MUSEUM OF MODERN ART,
NEW YORK, GIFT OF EDWARD
M. M. WARBURG

DAVID ALFARO SIQUEIROS'S POLITICAL ACTIVITIES OFTEN OVERSHADOWED HIS ARTISTIC endeavors, although the two went hand in hand: he organized his first protest in 1911 at the Academia de San Carlos, a traditional art academy where he was a student. An ardent Communist, Siqueiros organized artist and labor unions and helped draft a manifesto that called for the creation of monumental public art rooted in indigenous Mexican artistic traditions and at the service of the Mexican Revolution, which became the basis for the Mexican mural movement. He consistently espoused the cause of revolutionary technique and content that would radicalize the viewer.

Several times in the mid-1930s, Siqueiros traveled to the United States to lecture and work on private commissions. During a trip to New York in 1936, he established the Siqueiros Experimental Workshop, which he hoped would initiate a new period of mural painting that relied on modern technology. Here, he demonstrated his ideas for the use of photomontage and other unorthodox techniques and encouraged the use of new synthetic and industrial materials, such as Duco, a transparent automobile paint. He first used Duco in his murals because it dries rapidly and is extremely durable. He soon began to use it in works on canvas as well because of the range of visual effects he could achieve.

Siqueiros supported the activities of his short-lived workshop through the sale of easel paintings he made there. In these works he felt that he had for the first time successfully coordinated new formal means and political content. *Echo of a Scream* is one of these works. Based on a news photo of a wailing child abandoned in the ruins of a bombed Manchurian railroad station, the painting presents a desolate landscape rendered in somber grays and browns. The face of the child, contorted in a scream of sorrow and rage, is repeated in the center of the picture on a much larger scale. The disembodied head looms over the scene, amplifying the child's heartrending agony. Siqueiros's use of a photograph as his source and the repetition of imagery reflects the influence of his friendship with Soviet film director Sergey Eisenstein, who had introduced Siqueiros to the concept of using multiple perspectives in order to dramatize ideological meanings in his work.

Siqueiros insisted that his easel paintings were subordinate to his murals. He felt easel painting was bourgeois and intellectual, while he aspired to make art that appealed to the ordinary worker. In fact, his paintings contributed significantly to his international reputation. Siqueiros's work differed markedly from the heavy-handed Social Realism prescribed by specific political agendas; his emphasis on innovative process and materials reveals his independent approach to Marxist art.

CARRIE PRZYBILLA

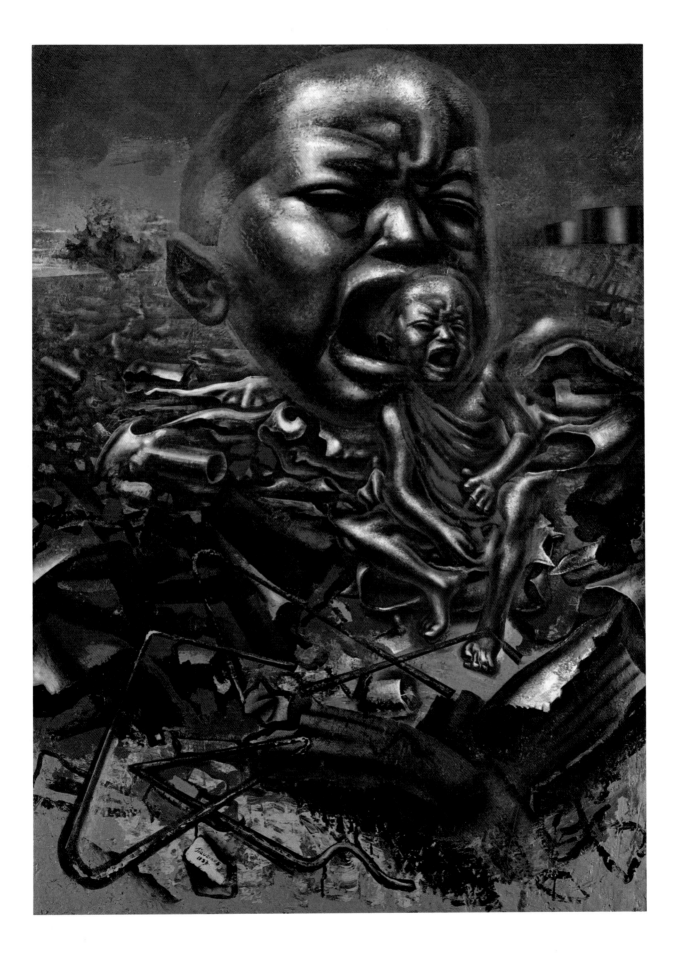

MAGDALENA ABAKANOWICZ
POLISH, BORN 1930
CAGE
1981
BURLAP, GLUE, AND WOOD
66 X 46 X 61 INCHES
(167.6 X 116.8 X 154.9 CM)

MUSEUM OF CONTEMPORARY
ART, CHICAGO, GIFT OF RALPH I.
AND HELYN D. GOLDENBERG

MAGDALENA ABAKANOWICZ'S PERSONAL HISTORY HAS PROFOUNDLY SHAPED HER work. A child of Polish landed gentry dispossessed by World War II and the subsequent socialist government, Abakanowicz vividly recalls the rise of Nazism and witnessed her mother's maiming by a drunken soldier during the war. Her haunting sculptures express the eternal human struggle against repressive forces, whether they be artistic, spiritual, economic, or political. "To protest," Abakanowicz says, "is to give importance to those things, situations, thoughts, against which one takes up a position. Protest is also the only possible active stance in the face of a threat, invasion. . . . My life unfolded in such a way that in order to exist I had to accept this position. It was the constant act of confrontation, self-defense, which, although it could not be realized in the practical aspects of life, expressed itself in work."[1]

In *Cage,* a single, husklike cast of a human back, hunched slightly as if weary and defeated, sits within a rough-hewn log structure. The back is cast of brown burlap, which reflects the artist's early work in textiles. Its coarse texture and earthy color underscore the figure's organic physicality and ordinariness. Similar backs have appeared in many of Abakanowicz's works since the mid-1970s, often in large groupings that evoke the collective human experience. Alone and enclosed in this rudimentary cell, the figure functions as a metaphor for isolation and the constraints of societal authority.

CARRIE PRZYBILLA

1. Magdalena Abakanowicz, quoted in *Magdalena Abakanowicz* (New York, 1982), 148.

ACCORDING TO GREEK MYTH, MARSYAS, A SATYR, PICKED UP THE DOUBLE FLUTE WHEN Athena discarded it out of vanity: she thought that her face became ugly and distorted when she blew on the rustic instrument. Becoming an expert player, Marsyas rashly challenged Apollo, the patron of music, to a performing contest. Apollo agreed but stipulated that the winner could deal with the loser as he wished. The Muses, who served as judges, awarded the victory to Apollo and his lyre, and the god chose to hang the unfortunate Marsyas from a tree and to flay him alive. His suffering and death were lamented by fauns, satyrs, and nymphs, whose flowing tears formed a river that is named after him.

When interest in classical themes revived in the fifteenth century, the tale of Apollo and Marsyas was viewed not only as a cautionary parable of the punishment of audacity and pride, but also as the victory of Apollo's noble music—based on mathematical science and symbolized by his stringed instrument—over the rough and lascivious piping of his earthy opponent. As the god of reason and intellect, associated with the sun, Apollo was even seen as a prototype of Christ. Yet Ribera, the author of numerous gripping canvases of the martyrdom of Saint Bartholomew, who met his death in the same manner as Marsyas, made the agony of the victim the principal theme of his painting. The luminous serenity of Apollo's face as he begins his grim task serves only to emphasize the horror of Marsyas's expression, the features frozen in a scream that compels the viewer to identify with the hapless creature and to sense the unimaginable pain of having his skin removed.

Ribera was born in Spain but spent most of his highly successful career in Naples, then under Spanish rule, where he was known as "lo Spagnoletto" (the little Spaniard). Attracted in his youth to the harsh realism and dramatic lighting of Caravaggio's art, Ribera developed a keen interest during the 1630s in the more painterly Baroque styles of Diego Velázquez and Anthony van Dyck. His heightened feeling for light and color is especially evident during the period in which he painted *The Flaying of Marsyas*.

JAY A. LEVENSON

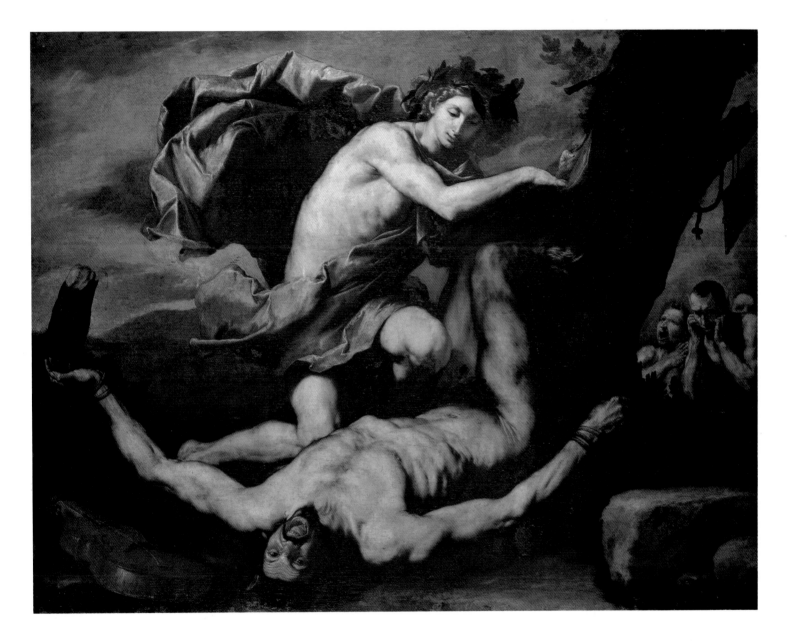

THE BOOK OF JUDITH IS AN APOCRYPHAL TEXT THAT APPEARS IN THE ROMAN CATHOLIC Old Testament but in neither the Hebrew nor Protestant Bibles. During a seige of the otherwise unknown Jewish city of Bethulia, the beautiful widow Judith is determined to save her people by assassinating the Assyrians' general, Holofernes. She pretended to flee the city with her maid, reached his camp, and encouraged him to believe that victory would soon be his. Holofernes invited her into his tent for an evening banquet, intending to seduce her; instead, Judith waited until he fell into a drunken sleep, grabbed his sword, and cut off his head, bringing it in a sack to Bethulia. The Hebrew defenders mounted the head on the town's ramparts and soon routed the leaderless Assyrian troops.

The medieval church regarded Judith as a symbol of fortitude, prefiguring the Virgin Mary, while artists and writers of the Italian Renaissance more often saw her as an exemplar of civic virtue triumphant over tyranny. Artemisia Gentileschi, the only known female follower of the Baroque master Caravaggio, applied the vivid realism and theatrical lighting associated with the latter's early style to this intense and dramatic rendering of the story. Taking her inspiration from a painting by Caravaggio, she concentrated on the single-most violent moment of the narrative to create a horrifying and unforgettable image of the act of taking human life. Judith grips Holofernes's head by the hair to steady it, slicing away from her body through his neck, while her maid pinions his left arm against his chest. The Assyrian general, his eyes bulging out, is portrayed in his final agony, his blood streaming down the edge of the bed.

The picture was at some point cut down on the left side. It is likely that Holofernes's legs were originally visible to the knee, as is the case in another version of the composition in the Uffizi in Florence, once thought to be earlier than the Naples painting but now recognized as a later work by Artemisia of about 1620.

The daughter of the painter Orazio Gentileschi, a colleague of Caravaggio's, Artemisia was born in Rome and was initially trained by her father. In May 1611, shortly before she painted the Naples *Judith*, Artemisia was raped by Agostino Tassi, an artist who had supposedly been engaged by her father to teach her perspective. Orazio filed suit for injury and damage against his former friend in the following year. The full records of the seven-month trial, which seems to have led to a conviction, have been preserved in the Roman archives. Artemisia's choice of themes for the Naples picture, as well as the extreme violence of the depiction, have not unreasonably been connected with the trauma of those events.

JAY A. LEVENSON

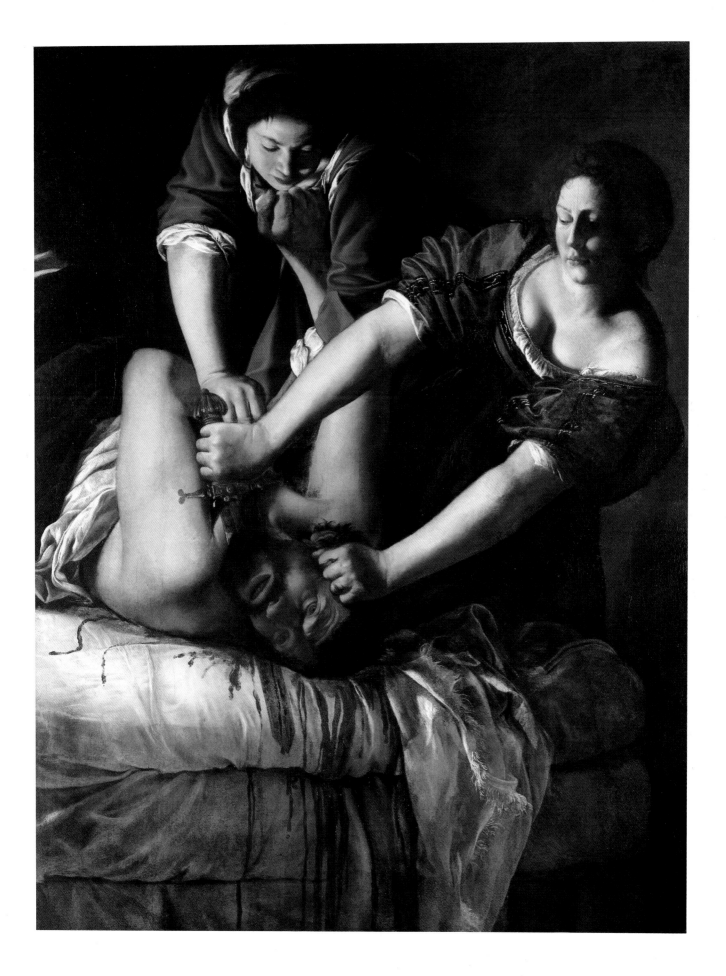

CHRIST ON THE CROSS

SECOND HALF OF 17TH CENTURY

MEXICO

POLYCHROMED WOOD

59 x 43⅜ INCHES (150 x 110 CM.)

MUSEO NACIONAL DEL VIRREINATO-
INAH, TEPOTZOTLÁN, MEXICO

B EGINNING IN THE SIXTEENTH CENTURY, MISSIONARY FRIARS USED THE POWERFUL iconography of Christianity in their evangelization of New Spain. Magnificent mural paintings from this period adorn convent churches and cloisters, and extraordinary Crucifixion sculptures began to appear. The Spaniards especially appreciated figures modeled from cornstalk paste, for their extreme lightness meant that huge processional images could be created.

Artists and sculptors depicted different stages of Christ's agony on the cross. Many show Jesus with his face turned upward toward Heaven, half-opened eyes and lips begging forgiveness for his enemies. Perhaps the most common representation, however, is of Christ in death, his head resting on his shoulder. A wound in his side recalls the evangelist John's account: "They came to Jesus, as they judged him dead . . . one of the soldiers stabbed him in the side with his lance and immediately blood and water issued forth."

The skill of the sculptor is readily apparent in this work, carved in one piece from the trunk of a tree. The tortured body of the dead Jesus, clothing ripped to shreds, face sunken onto his chest, and the vivid colors of the composition give this image its dramatic character. This work is one of the most outstanding examples of New-Hispanic sculpture.

MTRA. MA DEL CONSUELO MAQUIVAR

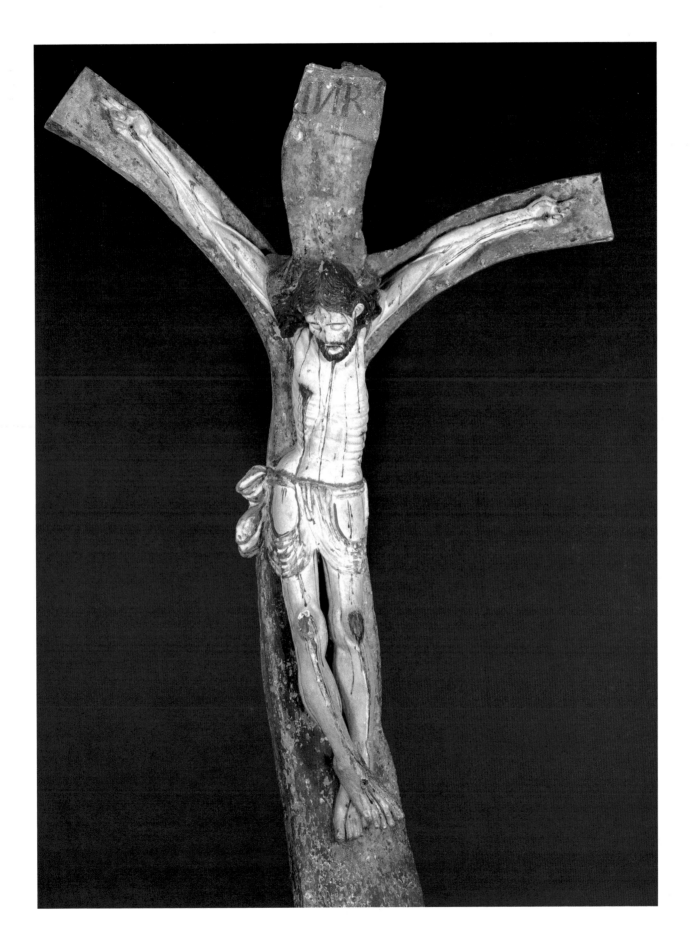

Peter Paul Rubens

Flemish, 1577–1640

**THE LAMENTATION FOR
THE DEAD CHRIST**

1614

Oil on panel

16 x 20⅝ inches (40.5 x 52.5 cm)

Kunsthistorisches Museum,
Vienna, Austria

Peter Paul Rubens was one of the most prolific and important artists of Northern Europe in the Baroque period. After early training in Antwerp, where he had entered the guild of painters in 1597, Rubens went to Italy in 1600 and became court painter to the Duke of Mantua. In trips to Madrid and Rome, he was able to study the works of the Italian masters Titian, Raphael, Michelangelo, and Caravaggio. In 1608 he returned to Antwerp and became court painter to the Spanish rulers of The Netherlands.

In 1614 Rubens finished the altarpiece for the transept of the Antwerp Cathedral commissioned by the Guild of Harquebusiers (a shooting fraternity). The central image of the large triptych (fourteen feet high by ten feet wide) depicts the *Descent of Christ from the Cross.* The image of the dead Christ seems to have occupied Rubens in this period. One of his paintings of this subject is this Vienna *Lamentation,* also done in 1614, and considered by the great Rubens scholar Max Rooses to be "a perfect" example of Rubens's art. There are several other variations on the same theme in drawings and paintings of the same period, but none with the silvery, pearl-like quality and emotional intensity of this small painting.

The Vienna *Lamentation* is composed so that the viewer seems to be participating in the mourning of the dead Christ. The Virgin Mary holds her son in her lap and closes his eyes, while the figures of Saint John the Evangelist, Mary Magdalen, and the other two Marys, described in the Gospels of Matthew (27:56), Mark (15:40), and John (19:25–26), mourn at his side. The limp body of Christ lies on a shroud that covers a sheath of wheat, a traditional symbol of the bread of the Eucharist in which the faithful believe Christ to be incarnate. Thus, the anguish of the mourners lamenting Christ in this beautiful painting is transformed by their hope of redemption and eternal life.

JOHN HOWETT

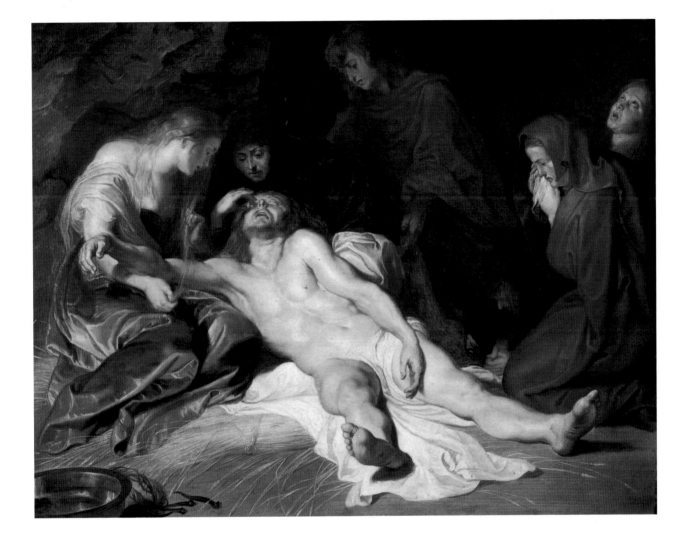

BILL VIOLA
AMERICAN, BORN 1951
HEAVEN AND EARTH
1992
TWO-CHANNEL VIDEO
INSTALLATION
115½ x 23 INCHES
(293.4 x 58.4 CM)

MUSEUM OF CONTEMPORARY
ART, SAN DIEGO, CALIFORNIA.
MUSEUM PURCHASE,
CONTEMPORARY COLLECTORS
FUND

During the 1960s, a diverse group of artists challenged the idea of art as a marketable commodity. Rejecting the belief that art existed only in objects such as paintings and sculptures, they began to explore other means of working, creating conceptual art, performance art, and environments called installations, often presented outside the traditional context of the museum. At the same time, electronics manufacturers introduced the first affordable, portable, consumer-oriented video equipment into the American market. The newly accessible medium attracted the interest not only of filmmakers but also of visual artists, who saw it as an immediate and highly personal form of communication, a poetic tool ideally suited for investigating perception as it documented the real world. They produced videotapes that played on ordinary television screens—single-channel works. Eager to expand the possibilities of the medium beyond the solitary box of the standard television set, video artists synthesized forms, creating what we now call video installation.

Bill Viola, who began working in video in 1972, is a key figure in the first generation of video artists. His large body of work bears witness to his belief that the video artist must "personalize a technology which is economically and politically a corporate institutionalized medium."[1] Viola has been deeply influenced by Buddhism and other Asian religious and philosophical systems. His lyrical and elegantly austere video imagery and installations often explore cycles of existence, issues of perception, and the interdependence of the natural world. Seeking to explode Western habits of mind that divide experience into polarities, Viola's installations allow viewers to "hover between . . . the normative and the extraordinary, waking and sleeping, order and chaos, quietude and violence, life and death."[2]

In *Heaven and Earth*, Viola uses footage of his newborn second son and his elderly mother to reflect upon the eternal cycle of birth and death. Images of an infant and a stroke-stunned woman appear on television monitors, which, stripped of their usual casing, are mounted facing each other in the broken space of a vertical wooden column. The shiny glass surfaces of the monitors mirror the images of the opposite screen, creating a powerful juxtaposition: a baby's face floats silently above the black-and-white mask of a sick, aged woman; the curiously old visage of a newborn grandchild becomes inseparable from the face of his dying grandmother. These simple, unembellished images, which stand in stark contrast to the onslaught of information usually delivered by the video medium, invite us into a meditative space, where joy and pain, renewal and departure are inextricably joined.

LINDA DUBLER

1. Bill Viola, cited in Raymond Bellour, "Interview with Bill Viola," *October* 34 (Fall 1985), 91–119.
2. Marilyn Zeitlin, *Bill Viola: Buried Secrets* [exhibition catalogue, The United States Pavilion, 46th Venice Biennale] (Tempe, Arizona, 1995).

III. AWE

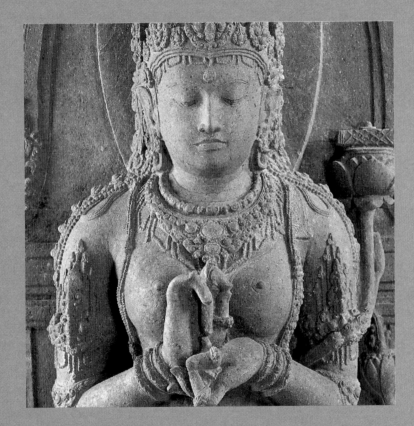

THE THIRD RING, AWE, IS DIVIDED INTO TWO PARTS, THE FIRST ADDRESSING AWE OF THE natural world, and the second, the supernatural. Both halves relate so closely that they, too, interconnect.

We confront first of all an apocalyptic vision by the British Romantic painter John Martin, *The Great Day of His Wrath*, which helps serve as the interlock with the teleological overtones at the end of the last section. A perception of the ineluctable forces of nature is dramatized by an all-consuming bushfire in the Australian outback, and by the innovative vision of J. M. W. Turner, confronting us with the terror of an avalanche in the Alps and daring us to wonder about what forces there might be beyond the perceptible world we inhabit.

The Jewish Cemetery, by the seventeenth-century Dutchman Jacob van Ruisdael, not only embodies a sense of the wildness and astonishment of nature in its overgrowth and in a rainbow, but, by the dominance in the composition of a man-made tomb, forces our attention onto the beyond. Such also is the effect of the work of Frederic Edwin Church, whose intensity of vision, informed by the Emersonian philosophy of transcendence, makes of nature an awe-inspiring, virtually religious experience. The evidence of an Arctic shipwreck and the transcendent forces implied are carried into the very title of Edwin Landseer's *Man Proposes, God Disposes*, and into the vision of the endless power and vastness of the sea in *The Wave*, by the Russian nineteenth-century virtuoso painter Ivan Aivasovsky.

For centuries, Chinese artists have communicated a sense of awe in nature with their paintings of mountainous environments, and never more expressively than in the large-scale works of the Zhe School of Ming painters. The sense of the beyond can be explicit, as with Wang Zhao's magic *Dragon Emerging*, or in the implication of another world, as in Dai Jin's fifteenth-century *Seeking Paradise*.

The same feeling of larger issues implied by mountain peaks and mists is communicated by the great German Romantic of the nineteenth century Caspar David Friedrich, whose work is rare but always charged with its own special sense of awe. Here the artist's intention is proven when one discovers at the very summit a tiny cross. Also during the nineteenth century, the German-born American artist Albert Bierstadt discovered the awesomeness of the overwhelming scale and grandeur of the American landscape. The haunting vision of the German contemporary painter Anselm Kiefer invites us into a spiritual journey beyond the landscape of battle and conquest and over the horizon.

The subsection ends with yet another very large canvas, an Aboriginal "Dreaming" from Australia. Nature as a springboard into the beyond is extrapolated from a microcosmic contemplation of the smallest creatures and the repetitive rhythms of their lives in a landmark dot painting, *Honey Ant Dreaming*, by Clifford Possum Tjapaltjarri.

The second part of our central Ring transports us into the spirit world with the kind of awe best expressed by the German word *Ehrfurcht,* a combination of honor and fear. We can imagine the tall, terrifying Basin-jom figure, with his reflective eyes and a cat skin around his neck, moving through a firelit crowd. The fear-some power of spiritual force is projected by the brilliantly carved, thirteenth-century temple figure from Japan, and by dynamic African masks, and by the great *nkisi* nail figure from Zaire, whose spiritual intensity, emanating from his belly and his staring eyes, is not to be taken lightly. And who is there who cannot feel, viscerally, the angry awesomeness of Ku, perhaps the greatest of all the Polynesian war-god carvings, the sacred Kuka'ilimoku.

Spiritual forces, when interiorized, leave us with unforgettable images of the human face expressing the awe of inner life, the very breath of life. (The Hebrew word *ruah,* the Greek *pneuma,* Latin *spiritus,* and San-skrit *pragna* each mean both "breath" and "spirit.") The gold sun mask from Guayaquil, Ecuador, or the impressively tall and haunting image of an ancestor from the Sepik River in Papua New Guinea, stir in us a perception of spiritual life that is also dramatized by the fourteenth-century Chinese monk (called a *lohan*), with his body twisted and his eyes rolled upward, caught in the moment of enlightenment.

The sense of spirituality is captured, similarly, in the large goddess figure from Jalapa, Mexico; in the sensitive white-painted mask from Angola or Zaire; in a mask from the ancient Japanese Noh drama; or in the face of the tiny figure of a man, in a pose later made famous by Rodin, created in Romania some seven thousand years ago. The spiritual staying power of the martyred *Saint Serapion*, whose viscera had been removed, is captured and made indelible in the resigned face and still, white folds of Francisco de Zurbarán's moving depiction.

As we draw nearer to the next section, Triumph, a series of images embodies that aspect of awe that implies a transcendence into realms that leave the earthly behind. The power of the spiritual over the earth-ly is unforgettably evoked by the image of the fasting Buddha from one of the holiest of cities, Varanasi. A life devoted to spirituality, in Byzantine times, was honored in the persons of the *Three Hierarchs,* or church fathers, clasping their writings. The early seventh-century gilded bronze figure of the seated Buddha is one of Korea's greatest national treasures. It leads us to one of Indonesia's greatest sculptures, the large stone *God-dess of Transcendental Wisdom*.

A sinuous athlete praying, cast in ancient Greece, reminds us that the Olympics were originally a reli-gious ceremony in honor of Olympian Zeus. This and the standing *Maitreya,* or Buddha of the Future, from Thailand, also with arms raised, leads us to El Greco's narrow, soaring painting of the *Resurrection.* Cleaned by Spain's national museum, the Prado, for this occasion, it communicates, in the artist's famous flickering brushwork and elongated forms and format, the spirituality of the subject. But that is not all. The classical nude figure rising at the top, majestically holding his banner unfurled, brings us face to face with the theme of the next section, **TRIUMPH**.

J. C. B.

JOHN MARTIN

ENGLISH, 1789–1854

THE GREAT DAY OF HIS WRATH

1851–53

OIL ON CANVAS

77½ x 119 INCHES (196.5 x 303.2 CM)

TATE GALLERY, LONDON,
PURCHASED 1945

THIS HUGE PAINTING BY THE BRITISH ARTIST JOHN MARTIN IS ONE IN A SERIES OF three paintings depicting the Last Judgment. This particular scene is a graphic view of the terrible destruction of the Apocalypse as described in the Book of Revelation.

Like his early nineteenth-century contemporary J. M. W. Turner, Martin exploited the prevailing taste in England for sublime landscape painting. In fact, Martin's career as a painter was built primarily on his ability to produce spectacularly terrifying visions of apocalyptic events in ancient history. His first great success in that line—*Belshazzar's Feast* of 1820—drew throngs of interested visitors when it was exhibited at the British Institution in London in 1821.

The popularity of Martin's apocalyptic scenes resulted at least in part from anxieties about the Industrial Revolution, which during Martin's lifetime was just beginning to cause social change in England. Martin himself appears to have been acutely aware of and disturbed by the visual transformation of the English landscape caused by industrialization. Martin's son later recalled:

> The glow of the furnaces, the red blaze of light, the liquid fire . . . seemed to his [Martin's] mind truly sublime and awful. He could not imagine anything more terrible, even in the regions of everlasting punishment. All he had done, or attempted in ideal painting, fell far short, very far short, of the fearful sublimity of effect when the furnaces could be seen in full blaze in the depth of night.[1]

The Last Judgment paintings were the last pictures that the artist would produce. After his death, the works toured England and the United States, where they were seen by appreciative and, no doubt, awestruck crowds.

DAVID A. BRENNEMAN

1. Mary L. Pendered, *John Martin, Painter: His Life and Times* (London, 1923), 248.

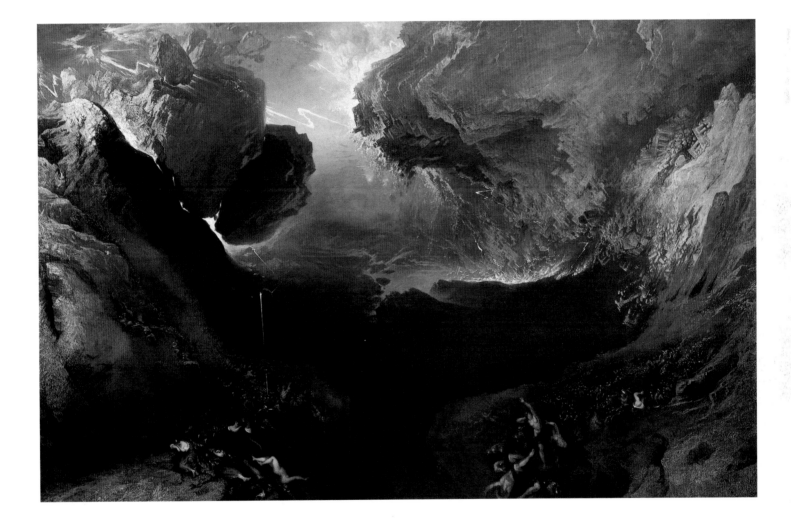

EUGENE VON GUÉRARD

AUSTRALIAN, BORN IN AUSTRIA,

1811–1901

**BUSHFIRE BETWEEN
MOUNT ELEPHANT AND
TIMBOON, MARCH 1857**

1859

OIL ON CANVAS

MOUNTED ON BOARD

14 x 22³⁄₁₆ INCHES

(34.8 x 56.3 CM)

BALLARAT FINE ART GALLERY,
AUSTRALIA, GIFT OF LADY
CURRIE IN MEMORY OF HER
HUSBAND, THE LATE SIR
ALAN CURRIE, 1948

AUSTRALIA IN THE 1850S WAS AN UNEXPLORED LAND. ALTHOUGH IT HAD BEEN circumnavigated and its coastline mapped by the early nineteenth century, the mysterious hinterland had not been traversed. Settlement was confined to the coastal plain. The vastness of Australia—its distances and dangers, together with its promise of riches—offered a subject that cried out for painting and interpretation. Many talented artists and illustrators came to Australia throughout the nineteenth century. Among them was the supremely gifted Eugene von Guérard.

He was born in Vienna in 1811, trained at the Düsseldorf Academy, and was an accomplished landscape painter when he arrived in Australia in 1853. By the time he returned to Europe in 1881, von Guérard had transformed landscape painting in Australia. He brought to the new land the intense scrutiny and the spiritualized vision of late German Romantic painting. In turn, the ancient beauty of Australia, both its abundance and its wildness, challenged and shaped von Guérard's vision. Soon after he arrived, he made extensive sketching expeditions; one of the most extensive tours was to the fertile and temperate Western District of Victoria. An extraordinary landscape, it combined the pastoral with the picturesque, mixing extinct volcanoes and volcanic lakes with extensive sheep and cattle stations already well established by 1857. From the station owners, von Guérard received commissions to depict their homesteads and surrounding gardens and pasturage, which showed the progress of settlement and civilization in the wilderness. At the same time, von Guérard saw the picturesque and sublime landscape offered by the remnants of the volcanic past.

Drawing on both these aspects, *Bushfire between Mount Elephant and Timboon, March 1857* records an event witnessed by the artist and painted two years later. It shows the landscape in extremis, so vividly and tragically part of the Australian experience. The very specificity of von Guérard's title—between Mount Elephant and the township of Timboon (now Camperdown)—suggests that this is no essay in sublimity but a terrifying reality of the Australian topography. The horizon line covers approximately twenty miles, and the fires move at devastating speeds, destroying everything in their path—houses, livestock, crops, animals, whole townships. All this is left implicit in von Guérard's painting, but there is no mistaking the elemental forces at work. The fire lights up the darkness, almost obscuring the moon and stretching limitlessly across the land.

PATRICK MCCAUGHEY

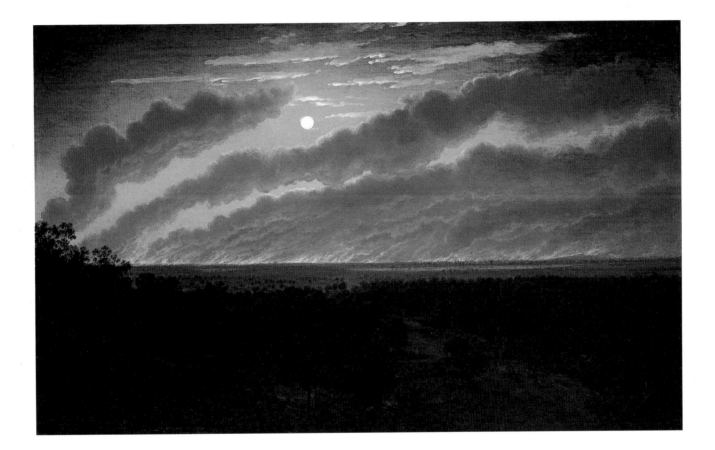

JOSEPH MALLORD WILLIAM
TURNER
ENGLISH, 1775–1851
**THE FALL OF AN AVALANCHE
IN THE GRISONS**
1810
OIL ON CANVAS
35½ x 47¼ INCHES (90 x 120 CM)

TATE GALLERY, LONDON,
BEQUEATHED BY THE ARTIST,
1856

WHEN EXHIBITED IN 1810 AT THE GALLERY OF NINETEENTH-CENTURY BRITISH ARTIST Joseph Mallord William Turner, *The Fall of an Avalanche in the Grisons* appeared with the following lines:

> The downward sun a parting sadness gleams,
>
> Portenteous [*sic*] lurid thro' the gathering storm;
>
> Thick drifting snow on snow,
>
> Till the vast weight bursts thro' the rocky barrier;
>
> Down at once, its pine clad forests,
>
> And towering glaciers fall, the work of ages
>
> Crashing through all! extinction follows,
>
> And the toil, the hope of man—o'erwhelms.[1]

Like the title of Sir Edwin Landseer's *Man Proposes, God Disposes,* the message of these lines is quite clear: human endeavors are subject to God's sometimes destructive omnipotence.

In this work, Turner has depicted an alpine dwelling being obliterated by huge tumbling boulders and falling sheets of ice. The subject of his painting may have been inspired by actual events. Although he does not appear to have visited that section of the Swiss Alps known as the Grisons (*Graubunden* in German), he had probably heard of a massive avalanche that occurred there in 1808 and which killed many people, including twenty-five occupants of a single cottage.[2]

With such pictures as *The Fall of an Avalanche in the Grisons,* Turner demonstrated his mastery of the genre of sublime landscape painting. The term *sublime* refers to a mode of representation in which the image and its subject produce overpowering sensations of fear and awe in the imagination of the beholder. Although this category of representation was first formulated in the eighteenth century by Edmund Burke, Turner was arguably the first to fully express the sublime in visual terms. He was able to do this not only through his careful choice of subject, but also through the monumental format of his pictures, the brilliant rendering of atmospheric effects, and the virtuosity of paint-handling that transformed scenes in nature into highly dramatic stagings of catastrophe or evocations of mystery and power.

DAVID A. BRENNEMAN

1. Cited in Martin Butlin and Evelyn Joll, *The Paintings of J. M. W. Turner,* rev. ed., 2 vols. (New Haven and London, 1984), 1:78.
2. Butlin and Joll 1984, 1:78.

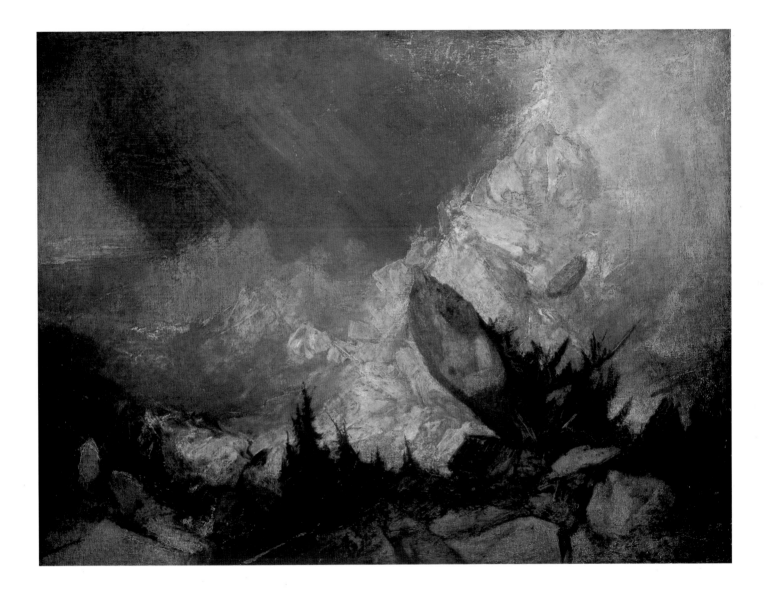

THE NEW GENRE OF LANDSCAPE PAINTING ENJOYED AN EXPLOSIVE POPULARITY IN THE northern Netherlands of the seventeenth century. This burgeoning production may have been due to nascent national pride resulting from Holland's newly won independence from Spain, combined with a growing sense of nature as a reflection of God's power and a general desire to observe and record the surrounding world.

This work is among the most famous paintings in Dutch art. A smaller version of the subject, now in Dresden, was praised by Goethe in an essay published in 1816 as a paradigmatic example of the way a "pure feeling, clear-thinking artist, proving himself a poet, . . . delights, teaches, refreshes, and animates us at the same time." The dating of the two versions is a subject of debate, and there is no agreement among art historians as to which version takes precedence. They both depict the Jewish cemetery at Ouderkerk on the Amstel on the outskirts of Amsterdam, but neither describes the actual setting (which still exists today). The site of the cemetery is flat, rather than on a hillside as in the paintings, and it has no stream running through it. The tombs are accurately depicted and identifiable, however; they mark the final resting place of prominent members of the seventeenth-century Sephardic community. The artist has adopted a low viewpoint to give these monuments a more imposing presence. The primary difference between the two versions, apart from their size, is in the ruins in the background.

These are among the rare landscapes by Ruisdael that were painted with a deliberate allegorical intent. The tombs, ruins, large dead beeches, and broken tree trunks allude to the transience of all things and the ultimate futility of human endeavor. This interpretation finds a parallel in the exhortation of a contemporary chronicler to visit tombs daily in order to contemplate where one's corpse will eventually lie and to think about the vanity and fragility of life; however, the light that breaks through the clouds, the rainbows, and the luxuriant growth in the paintings seem to offer a promise of hope and renewed life.

RONNI BAER

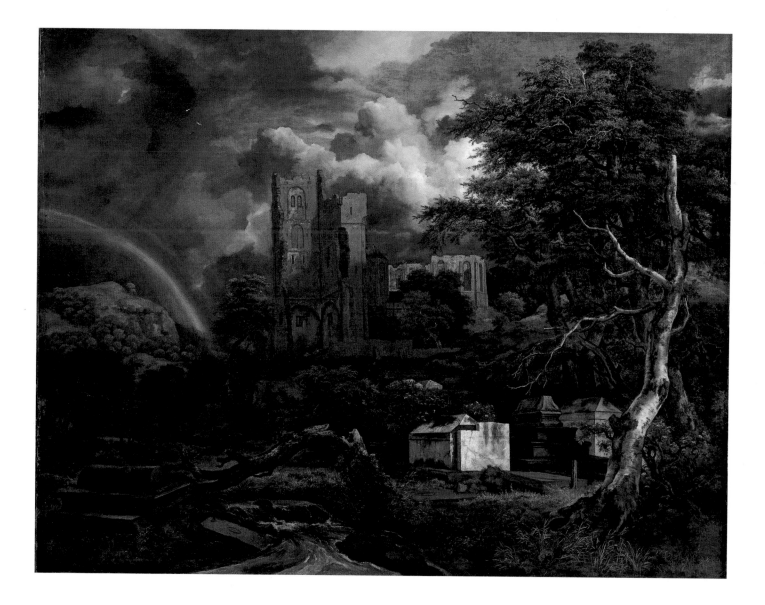

FREDERIC EDWIN CHURCH

AMERICAN, 1826–1900

THE ICEBERGS

1861

OIL ON CANVAS

64¼ x 112½ INCHES (163.2 x 285.7 CM)

DALLAS MUSEUM OF ART COLLECTION,
ANONYMOUS GIFT

FREDERIC EDWIN CHURCH WAS THE ONLY PUPIL OF THOMAS COLE—THE FATHER OF American landscape painting. As teacher to the young Church from 1844 to 1846, Cole must have seen in his protégé someone who shared his convictions about landscape. For them, landscape painting was more than depicting the literal appearance of nature; it was a means of transcending the physical world and entering a metaphysical realm where nature offers a sublime experience of God's power and majesty.

Church traveled widely in the United States in search of dramatic subjects and then broadened his explorations for romantic scenery to include the misty tropical forests of South America and the icy, brooding vastness of the Arctic Ocean. He traveled to Labrador and Newfoundland in 1859 and was awed by the stark beauty of the frozen wilderness, which he called "The City of God." Church made many sketches on this trip that served as the basis for his well-known work *The Icebergs.* An immense canvas, it draws the viewer into this eerie and theatrical frozen wilderness to contemplate Church's minute rendering of the details in this icy wonderland.

The Icebergs went on public view in New York in 1861 and was hailed by critics as the most splendid work of art ever created by an American artist. In 1863 Church exhibited the picture in London, adding the cross-shaped wreckage of a ship's mast in the foreground. Arctic exploration captured the public's imagination in the mid-nineteenth century, and this pictorial reference was most likely intended as a tribute to the British explorer Sir John Franklin. In 1845, Franklin and his crew of 128 men had attempted to discover the Northwest Passage but failed to return. Funds were raised in England and America to send a rescue mission, and, in 1857, Francis Leopold McClintock finally discovered evidence of the Franklin expedition's demise. Church's painted narrative is told without human presence, permitting the awesome landscape to communicate the power of God.

JUDY L. LARSON

SIR EDWIN LANDSEER
ENGLISH, 1802–1873
MAN PROPOSES, GOD DISPOSES
1863–64
OIL ON CANVAS
36 x 96 INCHES (91.4 x 243.7 CM)

ROYAL HOLLOWAY, UNIVERSITY
OF LONDON, EGHAM, SURREY,
ENGLAND

THIS GRAND AND GRUESOME PAINTING DEPICTS THE TRAGIC END OF AN ATTEMPT TO explore the Arctic regions. The title derives from the Latin form of the biblical proverb, *Homo proposit, sed Deus disponit* (Proverbs 16:9), which stresses the insignificance of human undertakings in the face of God's omnipotence. Landseer's picture is supposed to have been inspired by the ill-fated expedition of Sir John Franklin, who disappeared while searching for the Northwest Passage. The discovery of the remains of Franklin's crew in 1857 created a sensation in Victorian England. Although the apparent subjects of this picture are two polar bears who are eagerly devouring the remains of the occupants of a wooden ship, this picture is able to evoke a powerful sense of pathos and awe as one contemplates the fate of the brave explorers who have lost their lives in the desolate and hostile polar sea.

Landseer's painting was both a popular and a critical success when it appeared at the annual exhibition of the Royal Academy in London in 1864. Not only was the subject timely, but—despite the fact that live polar bears could be seen at the London Zoo by 1864—such a dramatic representation of these majestic but potentially dangerous animals would have been something of a sensational novelty to Victorian audiences. Critics were also attracted to the patriotic undertones of the subject. One scholar has pointed to the mythmaking power of "the idea of death in faraway lands in the service of the nation."

DAVID A. BRENNEMAN

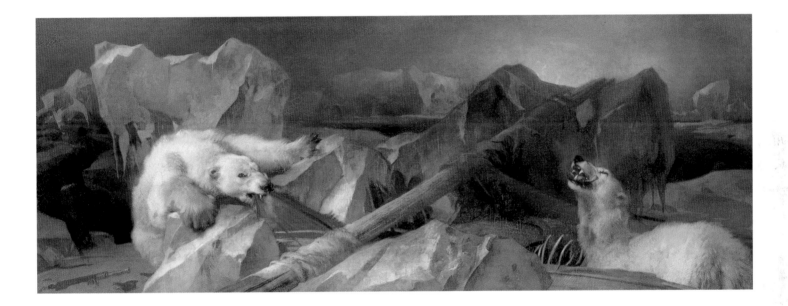

IVAN KONSTANTINOVICH AIVAZOVSKY

RUSSIAN, 1817–1900

THE WAVE

1889

OIL ON CANVAS

119 x 203 INCHES (303 x 505 CM)

THE STATE RUSSIAN MUSEUM,
ST. PETERSBURG

AIVAZOVSKY WAS BORN IN THE CRIMEAN CITY OF THEODOSIA NEAR THE BLACK SEA. In 1833 he went to St. Petersburg to study painting for six years at the Academy of Arts. His early works were rather old-fashioned landscape vistas, but gradually he found his true subject—romantic seascapes, often with dramatic sun and moonlight effects. In 1840 Aivazovsky visited Italy and met the writer Nikolai Gogol. When he returned to St. Petersburg in 1844, he became part of a cultured circle that included the composer Mikhail Glinka and the poet Alexandr Pushkin, whose portrait he painted and whose lyric poems about the sea may have further inspired the artist.

In 1845 Aivazovsky was appointed official artist to the Naval General staff, which allowed him to travel about the eastern Mediterranean, painting exotic subjects like the harbor of Constantinople. That same year he moved back to Theodosia and established his prolific studio, which produced nearly five thousand paintings during the artist's long life. Aivazovsky was widely honored, receiving commissions from the czar and being fêted on his travels throughout Europe and even to America.

One of Aivazovsky's earliest successes was a large painting of 1850 entitled *The Ninth Wave,* which depicted an apocalyptic vision of the final flood, with storm-tossed seas and lightning-split sky, overwhelming the sad remnants of mankind floating on the surface. Throughout his career, the artist returned to the motif of the wave, making larger and larger canvases to convey the sublime beauty and the titanic power of nature. In this example from 1889, Aivazovsky dispenses with almost all distracting detail, to capture the vastness and isolation of what he described in a poem as "the great heaving ocean, striving with agitation and longing for the distant shore."

ERIC ZAFRAN

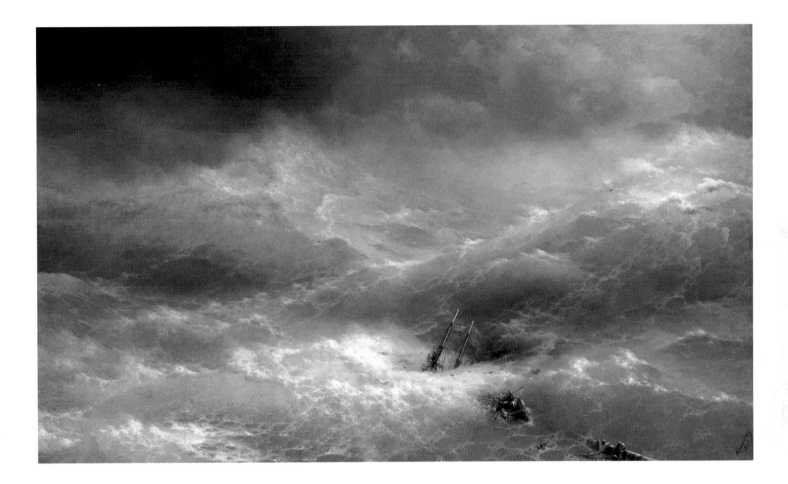

WANG ZHAO

CHINESE, ACTIVE LATE 15TH–
EARLY 16TH CENTURY

**DRAGON EMERGING
(QIJIAO TU)**

EARLY 16TH CENTURY

HANGING SCROLL; INK AND
COLOR ON SILK

66 x 39¾ INCHES (167.5 x 100.9 CM)

PALACE MUSEUM, BEIJING,
PEOPLE'S REPUBLIC OF CHINA

A DRAGON RISES HEAVENWARD, WHILE A SCHOLAR GAZES UP ADMIRINGLY AT THE vitality of this—in Chinese mythology, most beneficent—beast. The painting illustrates the legend of a scholar tossing his bamboo staff into the air and seeing it transform into a dragon. The scholar's silk cap strings are swept skyward and connect along an imaginary line to the dragon's outstretched tail. The vestige of the staff appears as a firm, straight brushstroke in black ink extending from the dragon's tail.

The scholar is probably Fei Zhangfang, a Daoist acolyte who lived in the Eastern Han dynasty (A.D. 25–220) and studied magic arts in a quest to become immortal.[1] Fei mastered the ability to magically alter size, distance, and time.[2] He could shrink to fit within a gourd that contained Heaven and Earth, but it is his triumph over distance that Wang Zhao portrays. Fei Zhangfang once followed a Daoist master deep into the mountains and, after losing track of distance and time, asked leave to visit his family. His teacher handed Fei a talisman that read, "Use this to master the ghosts and spirits that roam the earth," and provided him with a bamboo staff, which turned into a dragon to carry him immeasurable distances in an instant. He was recognized in later history for his powers to subdue demons and cure illness.

While the single powerful brushstroke at the dragon's tail confirms the subject of the painting as the magic staff, its theme has sometimes been identified as the Chinese belief in the dragon that arises from clouds and water to bring nourishing rain (Spring Dragon Emerging from Hibernation). The mysterious light and windswept landscape of the painting capture a moment of raw power and transmutation, which refers to both the legend of Fei Zhangfang and the dragon, lord of the deluging clouds.

Wang Zhao was perhaps the last great master of the Zhe School, whose artists practiced a bold and spontaneous style of painting.[3] Wang was admired for his artistry and eccentric personality, exemplified by his boast that he could drink wine by inhaling it through his nose. Ming dynasty critics rightly accused him of painting many perfunctory landscapes; however, his sure talent is revealed here by his quick, staccato brushwork in wet ink, which imparts an excitable energy suitable to the dragon's metamorphosis.

JAN STUART

1. The subject of the painting could also be the Han dynasty "immortal" named Huang Renlan. Huang practiced alchemy in a remote mountain site but returned home every night from an impossibly far distance. His wife held onto his bamboo walking stick and demanded an explanation, but Huang said the secrets of immortality could not be revealed; he took his staff and patted it, flying away on a blue dragon that emerged.
2. See Rolf A Stein, *The World in Miniature*, trans. Phyllis Brooks (Stanford, 1990), 66–70, for Fei Zhangfang's life within a gourd.
3. Richard Barnhart, *Painters of the Great Ming: The Imperial Court and the Zhe School* (Dallas, 1993), 320.

DAI JIN
CHINESE, 1388-1462
**SEEKING PARADISE
(DONGTIAN WEN DAO)**
EARLY 15TH CENTURY
HANGING SCROLL; INK AND
COLOR ON SILK
82⅞ x 32¹¹⁄₁₆ INCHES
(210.5 x 83 CM)

PALACE MUSEUM, BEIJING,
PEOPLE'S REPUBLIC OF CHINA

THE STRONG VERTICALITY OF THE COMPOSITION IS BISECTED BY A ZIGZAG PATH, WHICH a scholar traverses to approach a mysteriously lit cave. The cave has a door swung open enticingly and a balustrade to protect the traveler from dropping into the void. The luminous cavern is what the Chinese call a "grotto heaven," an image of an earthly paradise, which holds the secret to becoming an immortal.

Seeking Paradise can be more literally translated as "asking the way to the grotto-heavens."[1] Grottos are viewed as openings, rather than as closed vaults, and they are passageways associated with achieving transcendence. "It was not the darkness of the cave that attracted attention, but rather the light of day shimmering far away at its end, and which promised a new world."[2] Dai Jin conveys this by a contrast between sharp, meticulous brushstrokes for the adamantine "real world" landscape that the scholar inhabits and luminous, misty washes for the mystical immortal's cave heaven that he is about to enter to achieve a spiritual apotheosis.

One of the most accomplished painters of the Ming dynasty, Dai Jin is called the father of the Zhe School, which is a lineage of professional artists, some of whom worked for the imperial court and others for private patrons, creating large, impressive scrolls in a bold, spontaneous style. Dai Jin synthesized elements from many painting traditions, but he is admired as "more than merely the sum of those inherited parts" and a force around which his followers coursed "like planets around a sun."[3] Dai created an individual style blending elements of professional painting, including bravado ink wash and abbreviated brushwork, with calligraphically disciplined brushstrokes derived from the painting style of scholar-artists. *Seeking Paradise* is one of his early masterworks. Dai came close to achieving the highest imperial recognition for his talent, but the jealousy of a well-entrenched court artist kept him outside the court.

Seeking Paradise has a rare inscription by the artist dedicating it to Dexuan. As a professional artist from a family of craftsmen, Dai Jin lacked a classical education and seldom wrote long dedications as scholar-artists did. The painting may have been made as a gift but was more likely a commission, perhaps for a birthday. This would be an appropriate subject since entering a cave was considered a route to attaining immortality, a concern of scholars during the Ming dynasty.

JAN STUART

1. *Dongtian wen dao* has also been translated as "Seeking the Dao in the Mountains" and "Searching for a Cave-Heaven." *Dongtian* means "cave-heaven," which refers to a paradise. *Wen dao* means to "to seek the way," but *dao* refers to both an actual pathway and a transcendental "Way." A Chinese reader sees an intentional ambiguity in the title, which means both "Seeking the Way in Paradise" and "Seeking a Pathway to Paradise."
2. Wolfgang Bauer, trans. by Michael Shaw, *China and the Search for Happiness* (New York, 1976), p. 192.
3. Mary Ann Rogers, "Visions of Grandeur: The Life and Art of Dai Jin," in Richard Barnhart, *Painters of the Great Ming: The Imperial Court and the Zhe School* (Dallas, 1993), 127.

THIS PAINTING BY THE GERMAN ROMANTIC ARTIST CASPAR DAVID FRIEDRICH SHOWS a tree-covered mountain, presumably somewhere in the vicinity of Dresden, from which the mist is just beginning to clear. At the top of the mountain, one can barely make out a crucifix, which appears to be surrounded by a halo of clouds.

This painting was probably executed at about the same time that the artist produced his famous work *The Tetschen Altar* (Staatliche Kunstsammlungen, Dresden), which also depicts a mountaintop crucifix. These paintings by Friedrich sparked controversy during the first decades of the nineteenth century, as the artist attempted to formulate a new and expressive visual language employing elements of pure landscape painting. The traditional academic approach to narrative painting held that the actions of the human figure and face alone were capable of expressing and evoking human emotions, but to Friedrich and certain other contemporary artists working in Germany, most notably Philip Otto Runge, this approach had become aesthetically and, perhaps more important, spiritually depleted. Friedrich believed that particular elements of the landscape, such as oak and pine trees, mountains, and the rustic crucifixes that dot the German countryside, were so firmly rooted in the national consciousness that they were capable of evoking by themselves deep emotional—and, ultimately, spiritual—responses from his German audience. Although certain portions of Friedrich's contemporary audience failed either to understand or to accept this innovative approach, his images have since become widely accepted as archetypal symbols of the emotive power of German landscape.

DAVID A. BRENNEMAN

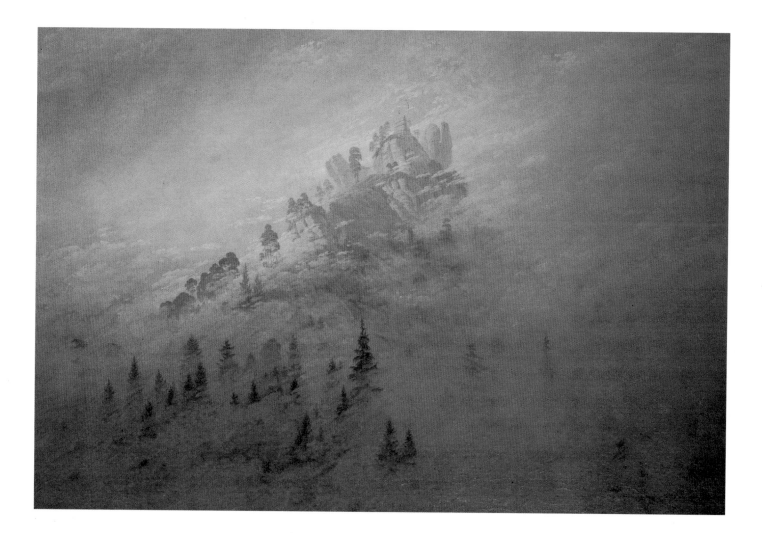

ALBERT BIERSTADT

AMERICAN, BORN IN GERMANY,

1830–1902

STORM IN THE ROCKY

MOUNTAINS, MT. ROSALIE

1866

OIL ON CANVAS

83 x 142¼ INCHES (210.8 x 361.3 CM)

THE BROOKLYN MUSEUM, NEW
YORK. DICK S. RAMSEY FUND, A.
AUGUSTUS HEALY FUND B, FRANK
L. BABBOTT FUND. A. AUGUSTUS
HEALY FUND, ELLA C. WOODWARD
MEMORIAL FUNDS, GIFT OF DANIEL
M. KELLY, GIFT OF CHARLES SIMON,
CHARLES SMITH MEMORIAL FUND,
CAROLINE PRATT FUND, FREDERICK
LOESER FUND, AUGUSTUS GRAHAM
SCHOOL OF DESIGN FUND, BEQUEST
OF MRS. WILLIAM T. BREWSTER, GIFT
OF MRS. W. WOODWARD PHELPS,
GIFT OF SEYMOUR BARNARD, CHARLES
STUART SMITH FUND, BEQUEST OF
LAURA L. BARNES, GIFT OF J. A. H.
BELL, JOHN B. WOODWARD MEMORIAL
FUND, BEQUEST OF MARK FINLEY

ALBERT BIERSTADT'S ARTISTIC CAREER WAS ESTABLISHED IN THE 1860s WITH THE exhibition of his huge canvases depicting the American West, which he presented in a theatrical manner as single exhibition pictures. *Storm in the Rocky Mountains, Mt. Rosalie* is one of the most successful in that series. Bierstadt began the panoramic landscape in February of 1865 and exhibited it first in New York one year later.

Born in Solingen, Germany, in 1830, Bierstadt immigrated with his family to New Bedford, Massachusetts. Little is known of his artistic training, but by the 1850s he was teaching art and exhibiting paintings in Boston. He made two trips to the American West before painting this canvas. The first was in 1859, when he traveled in the Rocky Mountains with the surveying team of Frederick W. Lander. He visited the Colorado Rockies again in 1863 with his friend Fitz Hugh Ludlow en route to California. Field sketches and photographs from this second trip served as the models for *Storm in the Rocky Mountains, Mt. Rosalie*, although Bierstadt depicts no specific site; rather, the painting is a freely interpreted construct based not only on Bierstadt's drawings and photographs but also on artistic imagination. His aim was to render the most breathtaking and idealized image of America's new Eden in the West. The panoramic sweep of the canvas stimulates in the viewer an awesome response—nature is depicted as a sublime force. Bierstadt evokes the wondrous poetry of nature while painstakingly rendering its most minute details, which invite the viewer to step forward for a closer look. The tiny figures of Indians provide the only human presence in the vast landscape. The theatrical effect of dark storm clouds set against the radiant light on the mountainside lends an added sense of the Romantic sublime. Through Bierstadt's inventive imagination, the viewer enters a sanctuary for the contemplation of the wild, unspoiled dream that was America.

JUDY L. LARSON

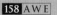

Anselm Kiefer
German, born 1945
MARCH HEATH (MÄRKISCHE HEIDE)
1974
Oil, acrylic, and shellac on burlap
46½ x 100 inches (118 x 254 cm)

Stedelijk Van Abbemuseum,
Eindhoven, The Netherlands

Born during the final years of World War II, Anselm Kiefer belongs to a generation of German artists who seek to reconcile the atrocities of Germany's recent past with its rich cultural legacy. He draws inspiration from such diverse sources as Norse myths, biblical tales, Wagnerian opera, theology, German history, alchemy, literature, and folk culture. In Kiefer's view, today's problems are manifestations of attitudes and behaviors that have existed throughout time. For the artist, events related by history and myth help reveal the nature of existence; he uses them as parables or conundrums that expose recurring and eternal spiritual struggles and moral dilemmas.

March Heath (Märkische Heide) takes its name from an area in the Brandenburg region of Germany, southeast of Berlin, which has been the site of numerous battles since the early seventeenth century. During the nineteenth century, tour books lauded its picturesque scenery and it became a popular place for hiking. In this painting, Kiefer makes passing reference to persistent German Romantic attitudes toward nature by depicting three silvery birch trees at the far right. He pointedly shatters these idyllic illusions with the scorched, barren look of the rest of the landscape, which recalls the grim reality of this land's role in history. Kiefer made this work in 1974—when Germany was still divided and March Heath lay in East Germany— as a reminder of the devastation of World War II and the lingering consequences of territorial disputes. The inscribed words at center reinforce these associations: in addition to naming a place and titling this painting, they call to mind the title of an old patriotic tune, "Märkischer Heide, märkischer Sand," which became a marching song favored by Hitler's army.

CARRIE PRZYBILLA

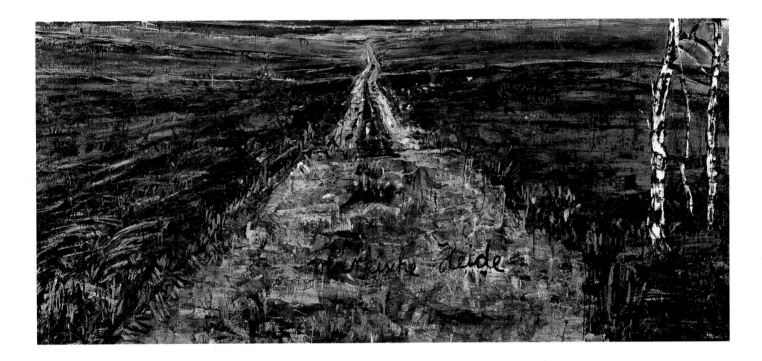

CLIFFORD POSSUM TJAPALTJARRI
AUSTRALIAN, BORN C. 1930
HONEY ANT DREAMING
1980
SYNTHETIC POLYMER PAINT
ON CANVAS
144 x 90 INCHES (366 x 228.5 CM)

ART GALLERY OF SOUTH
AUSTRALIA, ADELAIDE, SOUTH
AUSTRALIAN GOVERNMENT
GRANT, 1990

DREAMINGS, OR THE DREAMTIME, IS THE ABORIGINAL UNDERSTANDING OF THE WORLD, of its creation, and its stories. The history of the Ancestor Beings is the foundation of traditional Aboriginal thought. Images of these Beings—their travels, dwelling places, and experiences—make up the greatest source of imagery in Aboriginal art. *Honey Ant Dreaming* represents a Dreaming site of the artist's grandmother's country at Yuelamu, about 300 kilometers northwest of Alice Springs in the vast Western Desert of Central Australia.

Much Aboriginal Western Desert dot painting can be read as a kind of mythological map of a large site or area. This painting, however, focuses on and enlarges the minutiae of a particular Dreaming site. *Honey Ant Dreaming* is about food-gathering. In the traditional Aboriginal diet, the globular honey-filled abdomens of the honey ants are among the few sources of sugar and are prized as a treat. This "map" shows the underground nests of the ants' ancestors exposed by erosion. The complex subterranean chambers of the ancestral ants are said to have created natural water soakages throughout the sparse dry country. Yuelamu is an important soakage and a special meeting place in the Dreaming of the ancestral honey ants.

The design of *Honey Ant Dreaming* shows the exposed ant colony divided into nine nest centers. The dark ants are sticking to the walls of the nest, which also protects their grublike larvae. These nests are linked by dot lines representing tunnels and the pattern of floodwater. The twelve dark-brown crescent shapes represent the custodians of the site seated around the nests gathering the sweet honey ants. The large curved cream shapes are the sticks used to probe for ants. The rich and sonorous earth colors and large scale give this intimate Dreaming a sense of grandeur.

Clifford Possum Tjapaltjarri was born in a creek bed on tribal lands at a time when Aboriginal births were not registered. He was one of the early artists to revive and transfer ceremonial designs onto boards or canvases. Traditionally, the dot designs were used in body painting and ground designs made of stones, paint, twigs, and feathers on the sand. In 1971, a group of elders painted a mural of the Honey Ant Dreaming on the outside wall of the school at Papuna. The excitement stirred by this transfer of ancient ceremonial designs sparked the Western Desert dot painting movement, extending the life of ancestral Dreamings—rock engravings of which have been dated back forty-five thousand years—and extending the world's oldest continuous artistic tradition.

RON RADFORD

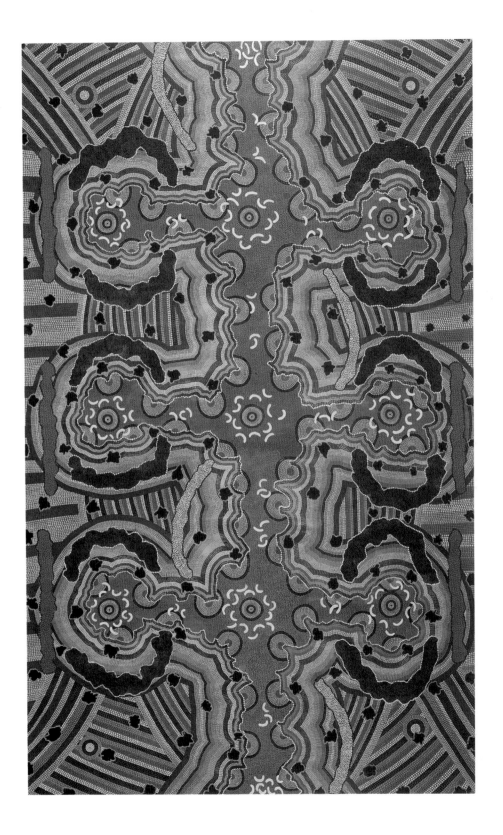

BASINJOM ENGAGES IN COMBAT WITH DECEIT. TO PREPARE FOR CONFLICT, A CARRIER IS given instructions and medicines to enhance his clairvoyance. Accompanied by musicians and a small army, Basinjom emerges from the forest wearing this costume. Loaded with an arsenal of images, the costume enlarges his authority as both a detective and a diviner. It combines a crocodile on the prowl, a cat-skin shield, mirrored eyes of penetrating insight, blue war-bird feathers with porcupine quills as a corona of strength, and a dark gown to ward off dangerous forces. Basinjom grasps a knife in one hand and a wicker rattle in the other, implements that enable him to hear and identify sounds from other worlds.

"*Bwanjoronjo, nkundack!*" (Bird! You should hear!) is called out, urging Basinjom to take flight like an owl, circling overhead to see where dangerous thoughts are gathering force in people's minds and affecting their actions. Sweeping through compounds, Basinjom searches for those who have become carried away by hidden desires. Holding up the front of his gown, Basinjom tilts his head to listen for signs of discontent, then glides rapidly to find it. Jealousy and malice are stalked. Suddenly, he stops and lifts his knife. A crowd gathers behind him while followers adjust his gown. Facing persons who are suspects, Basinjom recites incidents of their selfishness or their nasty words. After such exposure and humiliation, these persons are expected to confess and thereby relieve the community. Finally, Basinjom assigns them a penalty and returns to the forest. His latest combat with destructive personalities is over.

PAMELA McCLUSKY

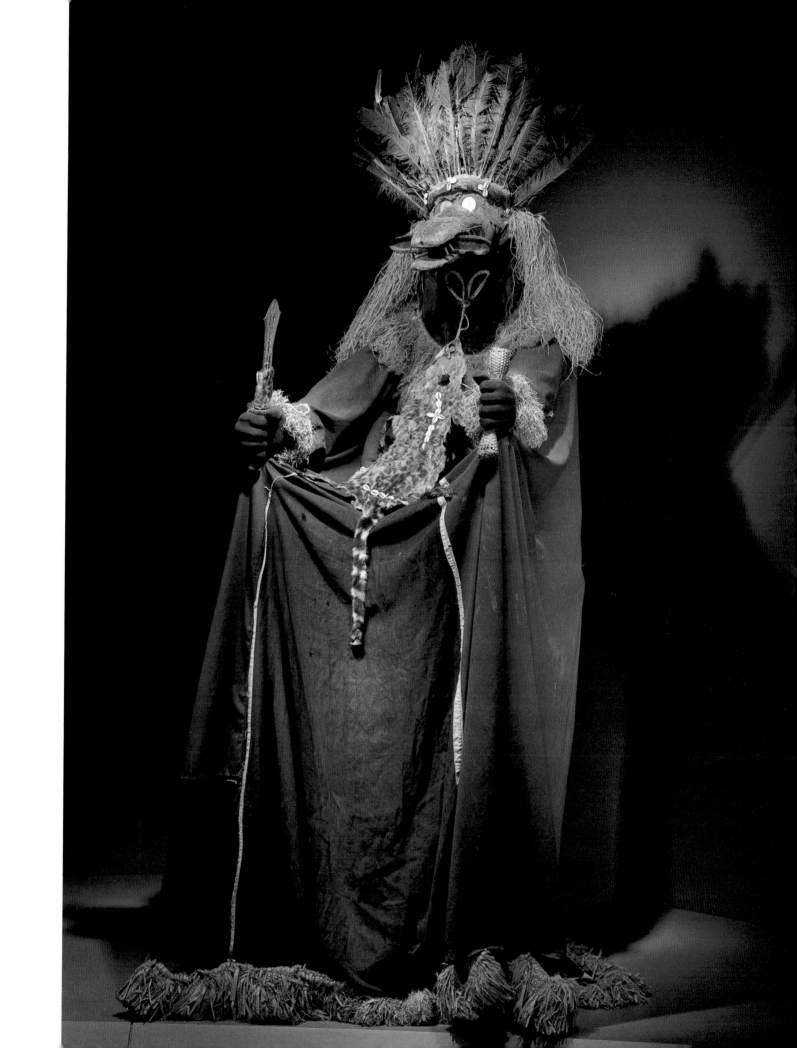

AWE AND TERROR ARE UNFORGETTABLY ELICITED BY THIS LARGER-THAN-LIFE-SIZE statue of Shokō-Ō, one of the Ten Kings of Hell. This frightening tribunal at the gate of the underworld passes judgment on the past deeds of souls in the world of the dead, ruled by Yama, an ancient Indian deity worshiped as the Lord of Death who was transformed in Chinese folk religion into the stern chief justice of the Court of the Underworld. Intended to motivate fidelity to Buddhist law, which alone can ensure a favorable verdict on one's life and determine a welcome state of rebirth, this powerful image, in company with other members of Yama's court enshrined within the funereal darkness of the Emma-do (Hall of Yama) at Ennō-ji, surely inspired both wonder and dread.

Ennō-ji is a branch of the prominent Zen temple Kenchō-ji in Kamakura, where the cult to the Kings of Hell was promulgated by Chinese masters during the thirteenth century. Despite the exaggerated posture and facial features characteristic of this otherworldly figure, the image exhibits the realistic style pioneered by Unkei (1151–1223), who revitalized the Nara tradition of idealized sculpture, invigorating it with a lifelike animation. The intricate carving of the grotesque features and swirling folds of the Chinese costume reflect the influence of Song Chinese sculpture. This dramatic sculpture was made in the *yosegi-zukuri* technique of piecing together hollowed-out sections for the head, torso, and limbs, was lacquered and brightly colored, and, finally, crystal was inlaid to animate the eyes. The sculptor Kōyū, whose signature appears on this statue (along with a date corresponding to 1251), was an otherwise unknown follower of Unkei, active in Kamakura.

BARBARA FORD

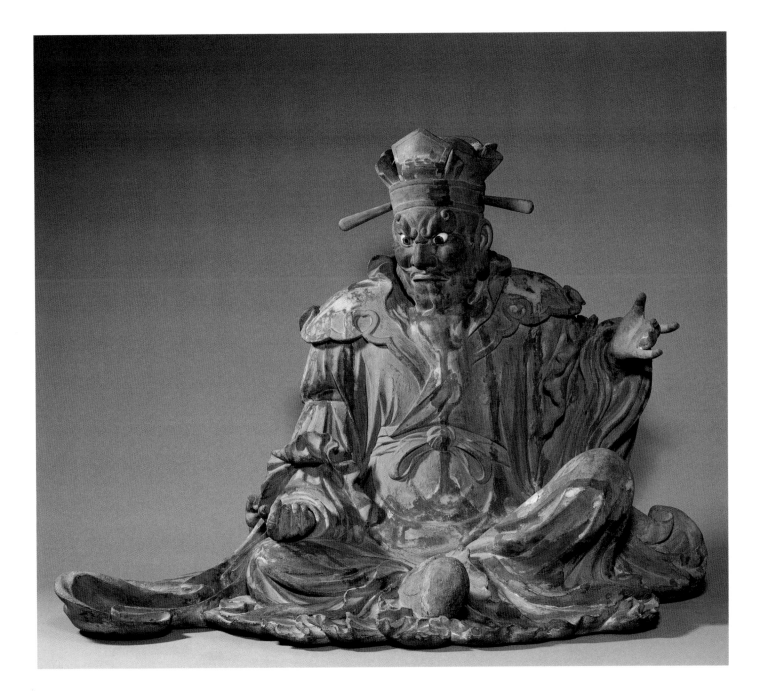

EGBODU
NIGERIAN, BORN C. 1898
EGU ORUMAMU CREST MASK
1941
WOOD
23 x 14½ INCHES (59 x 37 CM)

JOS MUSEUM, NIGERIA

THE IGALA LIVE SOUTHEAST OF THE CONFLUENCE OF THE NIGER AND BENUE RIVERS IN Nigeria. This most important mask of the inland eastern Igala is called *Egu Orumamu*, which may be translated as "chief of the spirits," although the word *egu* may, in context, mean "spirit" or "mask."

It is a most powerful spirit-mask—its power descends from the ancestors—and its influence is broad. The mask makes two annual appearances: it first solicits the success of agriculture, and later it celebrates the harvest. Among peoples whose survival depends on subsistence agriculture, this is vital. In addition, the mask is present at the apprehension and punishment of murderers; it seeks them out and demands their surrender by the family of the murderer. Failing to do so would result in the entire family compound being sealed off, preventing work on the farm or in the markets. Even the collecting of food, water, and firewood would be prevented. In short, the family must give up the criminal or be excommunicated.

The *Egu Orumamu* mask also mediated women's marketplace and marital difficulties, supervised the rationing of water during the dry season, and kept the young adults from becoming too obstreperous. It was the primary symbol of security and social control, lending authority to the dictates and decisions of the elders who accompanied the mask and, indeed, guided the young athlete who danced it by means of signals or whispered instructions.

ROY SIEBER

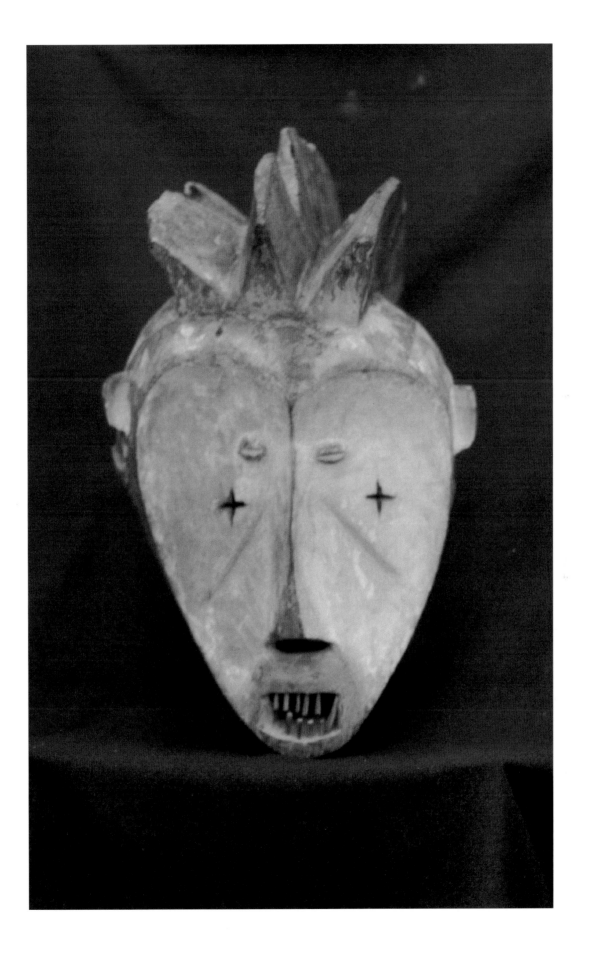

NKISI NKONDI

19TH CENTURY

YOMBE GROUP, KONGO PEOPLES, ZAIRE

WOOD, METAL, RAFFIA CLOTH, PIGMENT,

CLAY, RESIN, AND COWRIE SHELL

HEIGHT 44½ INCHES (113 CM)

FIELD MUSEUM OF NATURAL HISTORY,
CHICAGO

T
HIS FIGURE IS A MALE NKONDI, REPRESENTATIVE OF MORE VIGOROUS OR AGGRESSIVE powers (see also page 78). The name *nkondi* means "hunter," and this kind of *nkisi* was used at night to hunt down unidentified witches, thieves, and wrongdoers. The client paid the ritual master, *nganga*, who then would drive in nails to arouse the *nkondi* to find the criminal and do horrible things to him.

Nkisi nkondi had names and personalities, and some developed reputations for their abilities. The more functions the object performed, the more important and respected it became and the more elaborate and expensive the festivities that surrounded it. Care was given to the outward appearances of these figures so that they would be impressive when introduced into a ceremony or ritual. Though *nkisi nkondi* were created within a complex and explicit belief system, even removed from the context that produced and gave them meaning, these objects retain a striking visual power.

MICHAEL HARRIS

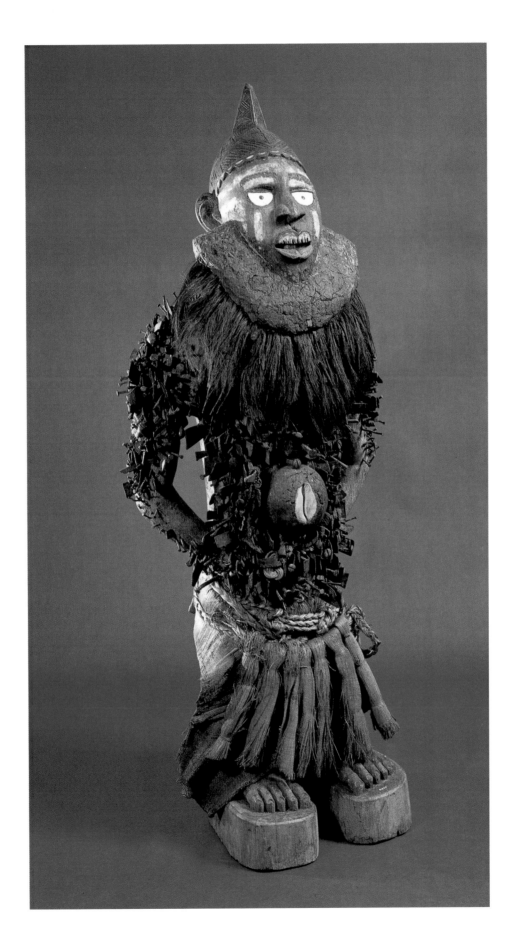

KIFWEBE MASK
SONGYE PEOPLES, SHABA, LOMAMI, ZAIRE
WOOD AND PIGMENT
HEIGHT 24⅜ INCHES (62 CM)

J. W. AND M. MESTACH COLLECTION

THIS IS A FINE EXAMPLE OF A MALE MASK ASSOCIATED WITH THE **BWADI BWA KIFWEBE,** or society of the mask. The striated surface, bulbous eyes, and protruding mouth are hallmark features of *kifwebe* masks. The crest, which extends down the middle of the head, in conjunction with the red color confirms this mask as male. Red represents strength, power, and knowledge and is associated with the sun. Red is the symbolic opposite of white, which signifies purity, beauty, and wisdom and is associated with the moon. Thus, the female mask is recognized by the dominance of white and the absence of the crest. Yellow, used in this mask, is a later addition to the traditional colors of black, white, and red, and its symbolic significance is unclear.

Kifwebe masks are found among the Songye and their Luba neighbors in eastern Zaire. Their origin is linked to the *bwadi* society, which was most likely instituted among the eastern Songye during a period of political unrest, perhaps as early as the eighteenth century. At that time the primary function of the society was the stabilization of local Songye communities. Masks were a later addition, facilitating anonymous control of local communities through fear, extortion, and the magical practices of *buci* (female witchcraft) and *masenda* (male sorcery). These masks are perceived as powerful entities. Their power is articulated through the visual reference to strong and aggressive animals. For example, the mouth and chin of the mask are thought to be the snout of the crocodile, a strong and much-feared aquatic animal; the striation makes reference to the bushbuck antelope, which is aggressive in its behavior.

Today, these masks are generally used in folklore performances and as entertainment. Among the eastern Songye, however, a traditional social structure still exists, and masks play a major role in local governance.

PAMELA FRANCO

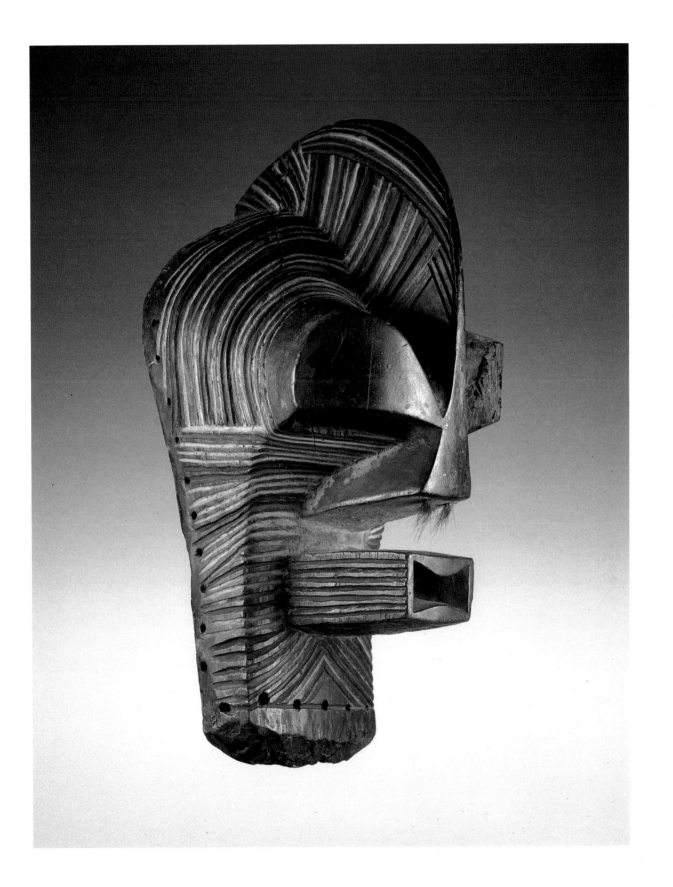

KUKA'ILIMOKU TEMPLE IMAGE
LATE 18TH–EARLY 19TH CENTURY
HAWAII
BREADFRUIT WOOD
HEIGHT 78 INCHES (198 CM)

PEABODY ESSEX MUSEUM OF SALEM,
MASSACHUSETTS

THIS IMAGE OF THE HAWAIIAN GOD KUKA'ILIMOKU WAS CREATED BY AN UNKNOWN master craftsman for a temple (*heiau*) of the great warrior and chief Kamehameha I. Kuka'ilimoku, one of the many forms of the god Ku, became famous as the war god and favorite deity of Kamehameha I, who rose to power on the island of Hawaii during the 1790s. With the help of his allies and Kuka'ilimoku, Kamehameha by 1812 had succeeded in conquering surrounding islands and their independent chiefs, becoming the supreme ruler of all the Hawaiian islands. During this time, Kamehameha I built many temples for religious ceremonies dedicated to Kuka'ilimoku. Ceremonies performed by priests (*kahuna*) included prayers, human sacrifice, offerings, chants, and processions of images. Large images like this one were carved with posts that extended below their feet, allowing them to be placed upright in the ground. Such images were placed side by side along the temple walls.

After Kamehameha I's death in 1819, his son Liholiho (Kamehameha II) succeeded him as paramount chief. He abolished *kapu,* a political and religious system with strict rules governing social behavior, ended the worship of Kuka'ilimoku and other religious figures, and called for the destruction of temples. As a result, many temple images were burned or destroyed. Only two other large carved images of Kuka'ilimoku have survived: one at the British Museum and the other at the Bishop Museum in Hawaii.

John T. Prince of Boston donated this image to the Peabody Essex Museum in 1846. In a letter to the Museum's founding institution, the East India Marine Society, Prince explained that the image was obtained from a Hawaiian chief who had converted to Christianity and intended to destroy the figure. According to Prince, the ship's carpenter sawed the image from its eighteen-foot post.

CHRISTINA HELLMICH SCARANGELLO

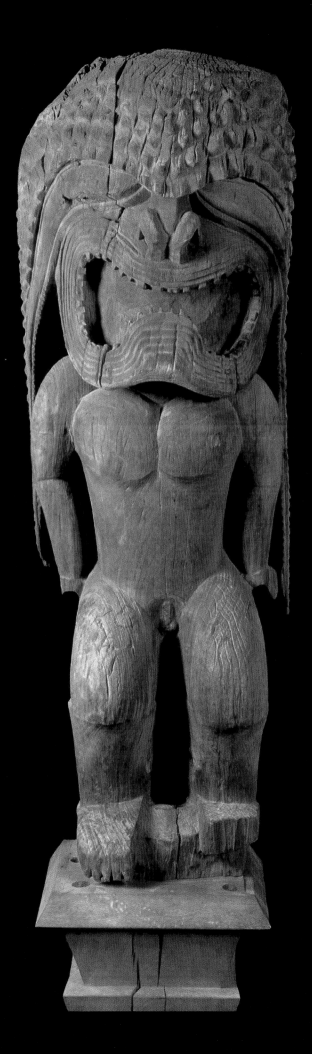

SUN MASK

400 B.C.–A.D. 400

ECUADOR

GOLD

17⁹⁄₁₆ x 19 INCHES (44.6 x 48.2 CM)

MUSEO DEL BANCO CENTRAL,
GUAYAQUIL, ECUADOR

THIS EXTRAORDINARY MASK WAS HAMMERED AND ELABORATELY CUT OUT OF A SINGLE sheet of gold alloy by metalsmiths living along the northern coast of Ecuador more than fifteen hundred years ago. Its sparkling material, dynamic design, and provocative juxtaposition of solar, human, and snake imagery combine to inspire awe today, just as they did in ancient times. As with most ancient American art, we must imagine this mask worn during glorious religious spectacles of song and dance. Works of art were created to be "activated" in rituals—the power of the symbols brought to life for the group to experience. This mask in particular requires the sunlight and the movement of the wearer to set into motion its electrifying rays and, more abstractly, its symbolism of the celestial and the terrestrial, the enduring and the mutable.

Gold was chosen for such a profound expression because, of all the metals, it never loses its brilliance over time. The world over, gold is associated with the sun because the two share warm color and bright reflectivity: the Inkas, later rulers from Ecuador to Chile, called gold "the sweat of the sun." Here, the sun's vivifying rays are depicted as slithering snakes with telltale triangular heads. Known for their abilities to molt and to adapt to water, land, and arboreal environments, snakes symbolically oppose the sun in their mutability and terrestrial nature. Snakes typically embody transformation and rebirth in ancient American art. Finally, at the center of this complex mask is a face, perhaps that of the sun itself or of the human shaman who mediates between the forces of this world and the next. When employed in ritual, the mask transformed the celebrant into a sun-snake-person, a composite that encapsulates the spirit of life, unchangingly changeable and relentlessly dynamic.

REBECCA STONE-MILLER

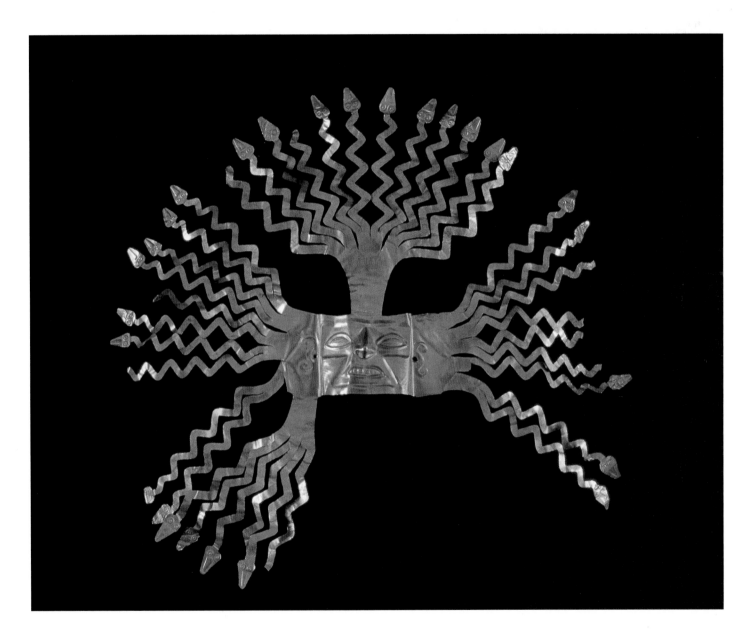

STANDING FIGURE

BEFORE 1913

ANGORAM PEOPLES, SINGGARIN
VILLAGE, PAPUA NEW GUINEA

WOOD, PIGMENT, FIBER, AND GRASS

HEIGHT 80 INCHES (203.2 CM.)

INDIANA UNIVERSITY ART
MUSEUM, BLOOMINGTON,
LENT BY RAYMOND AND
LAURA WIELGUS

THIS REMARKABLY POWERFUL FIGURE WAS MADE TO COMMEMORATE AN ANCESTOR OF the Angoram peoples, a group living on the lower Sepik River. Its large size suggests that it honored a particularly influential person, such as the founder of a lineage or an ancestral mythological hero. It was kept inside the village men's house and displayed at ancestral rites and on other occasions, such as boys' initiations, when the significance of ancestors to Angoram life was emphasized.

Throughout New Guinea, ancestors (both mythological and real) have traditionally played important roles in people's lives. Their importance is based on a two-part belief, shared with many other peoples worldwide, that after death a person's spirit maintains the power and wisdom that the individual had accumulated on earth and, furthermore, that ancestral spirits can have positive or negative effects on individuals and communities. Along the Sepik River, ceremonies and objects enlist the aid of these spirits and assure them that they are still respected and remembered. In this way, it is hoped, the spirits will maintain positive feelings about their living descendants and help them in all aspects of life.

The skull-like form of this figure's head is unusual and emphasizes that the figure represents a deceased person. In addition, it also recalls a practice along some parts of the Sepik River in which actual skulls, sometimes incorporated into wooden figures, were used to commemorate ancestors. The head's three-dimensional form, heightened by its position overhanging the chest, contrasts with the flat body, which is enlivened by relief carving portraying clothing and accessories worn by Angoram men. The carving on the chest, for example, shows a net bag, worn by men over a broad area of northern New Guinea. These bags, usually decorated with shells, as depicted here, were not only ornamental but also often served as amulets containing fragments of ancestral bones or other substances that were believed to protect the wearer.

DIANE PELRINE

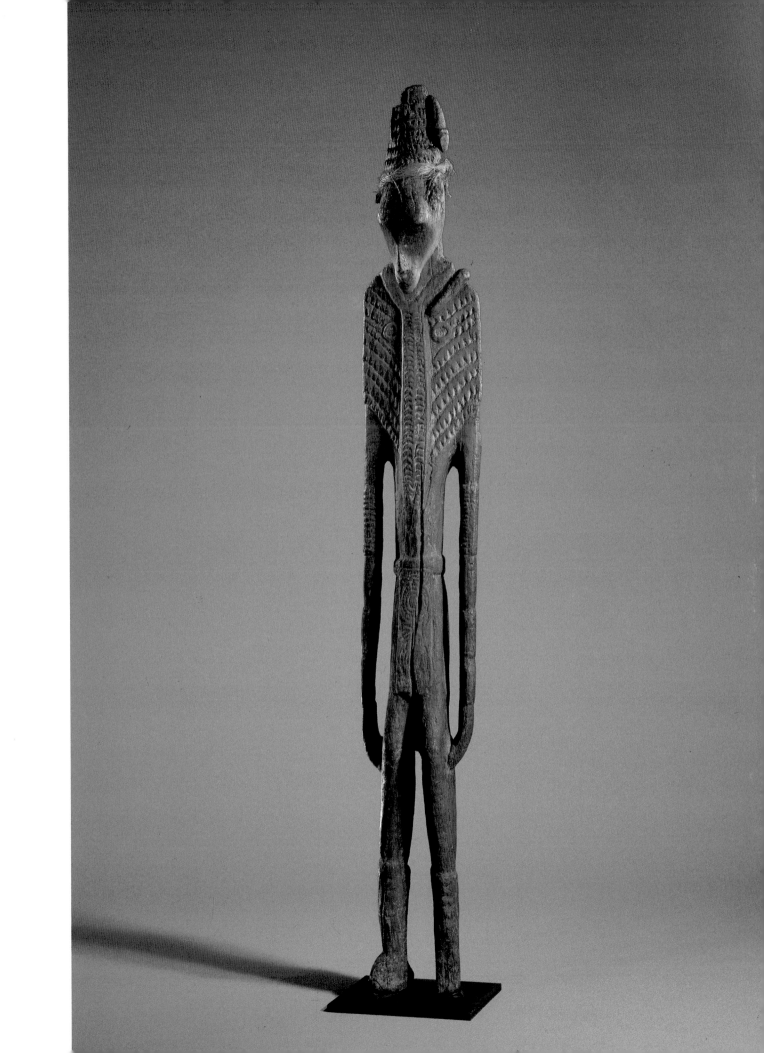

**LOHAN AT THE MOMENT OF
ENLIGHTENMENT**

LATE 13TH–14TH CENTURY

CHINA

POLYCHROMED WOOD

41 x 30 x 22 INCHES

(104.1 x 76.2 x 55.9 CM)

SEATTLE ART MUSEUM,
WASHINGTON, EUGENE FULLER
MEMORIAL COLLECTION

FOR MORE THAN TWO THOUSAND YEARS, THE CHINESE HAVE ADMIRED THE ECCENTRIC philosopher who, through intense contemplation, reached another spiritual level. When Buddhism arrived in China from southern Asia in the second or third century A.D., it brought with it the figure of the enlightened disciple, or *lohan.* By the ninth century, the lohan had come to embody several concepts that had originated more than a millennium before in the teachings of early Daoist philosophers: the denial of the attractions of physical beauty, an appreciation for closeness to nature, and the embracing of startling incongruities. Lohan (*arhat* in Sanskrit) were the first disciples of the historical Buddha Shakyamuni. They attained enlightenment through a regimen of strict study and disciplined contemplation. Images of the lohan usually depicted in groups of sixteen, eighteen, or five hundred became popular in Chinese Buddhist art in the ninth century and have continued to be among China's most enduring spiritual figures.

In certain forms of Buddhism, the moment of enlightenment was thought to come as a sudden flash of awestruck recognition with profound physical and emotional effects—seen here in the lohan's startled facial expression, the dynamic pose of the body, and the swirl of the drapery. The denial of the attraction of physical beauty shows in the figure's large ears, heavy eyebrows, bulging eyes, and bulbous nose, features particularly offensive to the Chinese notions of beauty at that time. Incongruously attached to that face is an elegantly proportioned and draped body. The figure as a whole is firmly placed in a natural setting, here represented by the hole-riddled rock on which the lohan sits.

This sculpture dates to the Yuan dynasty (1279–1368), when China was under the rule of the Mongols and many Chinese escaped into the refuge of nature and religion. During the resulting upsurge in Chan Buddhism, Daoism, and exotic and esoteric forms of Buddhism from Tibet, images of lohans were created in great numbers.

MICHAEL KNIGHT

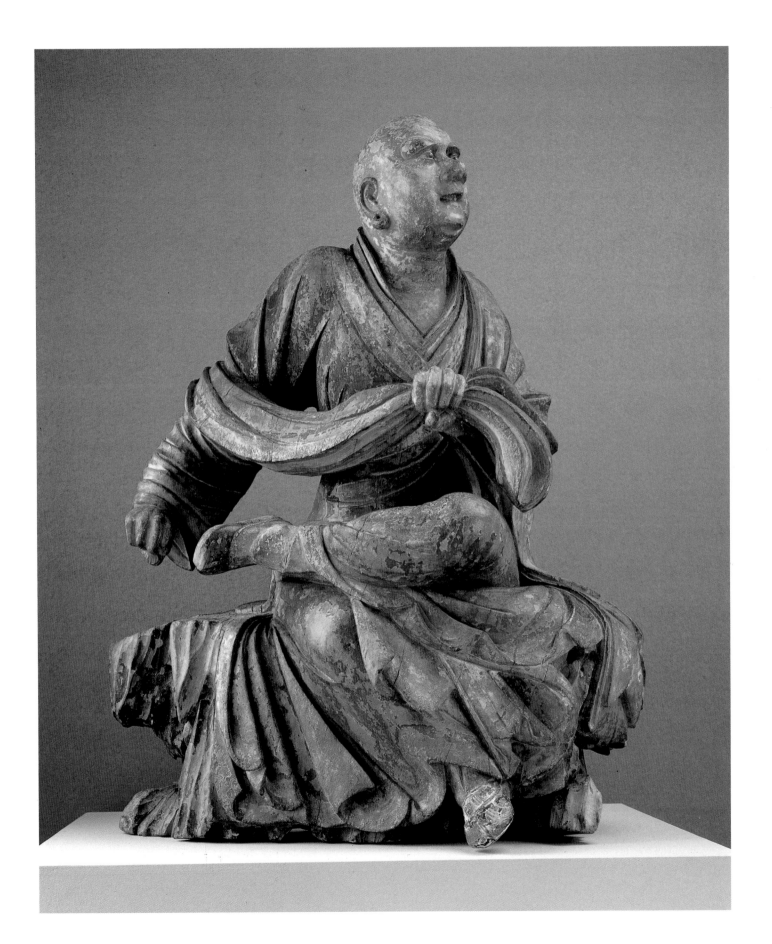

MONUMENTAL FEMALE EFFIGY URN
200–900
VERACRUZ, MEXICO
CERAMIC
HEIGHT 61¹/₁₆ INCHES (155 CM)

MUSEO DE ANTROPOLOGIA, UNIVERSIDAD
VERACRUZANA, XALAPA, MEXICO

STANDING OVER FIVE FEET TALL, THIS MONUMENTAL CLAY SCULPTURE FROM VERACRUZ on the Gulf Coast of Mexico approaches life size. It is extremely difficult to construct ceramic sculptures of this size because, during construction, wet clay tends to buckle under its own weight. As it dries, and as it is being fired, it explodes if any air is trapped in one of its many complex passages. Extraordinary technical and artistic skills were combined with the Stone Age technology characteristic of the ancient Americas to create an arresting deity impersonator on such an appropriately awe-inspiring scale. The extensive remnants of white, blue, black, and green paint attest to the careful delineation of the effigy's headdress, clothing, body paint, and even nails. In ancient American art, it is often the case that the more arduous and painstaking the techniques employed, the more praise bestowed upon the image.

This was certainly an image to be praised and also to inspire awe since it was placed in a shrine, laden with offerings, and involved in elaborate rituals. There were numerous cults in ancient Veracruz at this time, apparently devoted to death, wind, rain, fire, and so on. Natural forces figure prominently in indigenous religions because their superhuman powers affect all life and therefore must be tended. This particular figure wears seashells at her waist and an impressive headdress of symmetrical serpent heads; she seems to relate to an earth and water cult. Her delicately closed eyes, expressive open mouth, and floating arms give the impression that a graceful dance has been arrested momentarily. Together, the concentrated energy in her countenance and stance, her human scale, and her dramatic original setting allow us a glimpse into the magnificent ceremonial life of a long-dead culture.

REBECCA STONE-MILLER

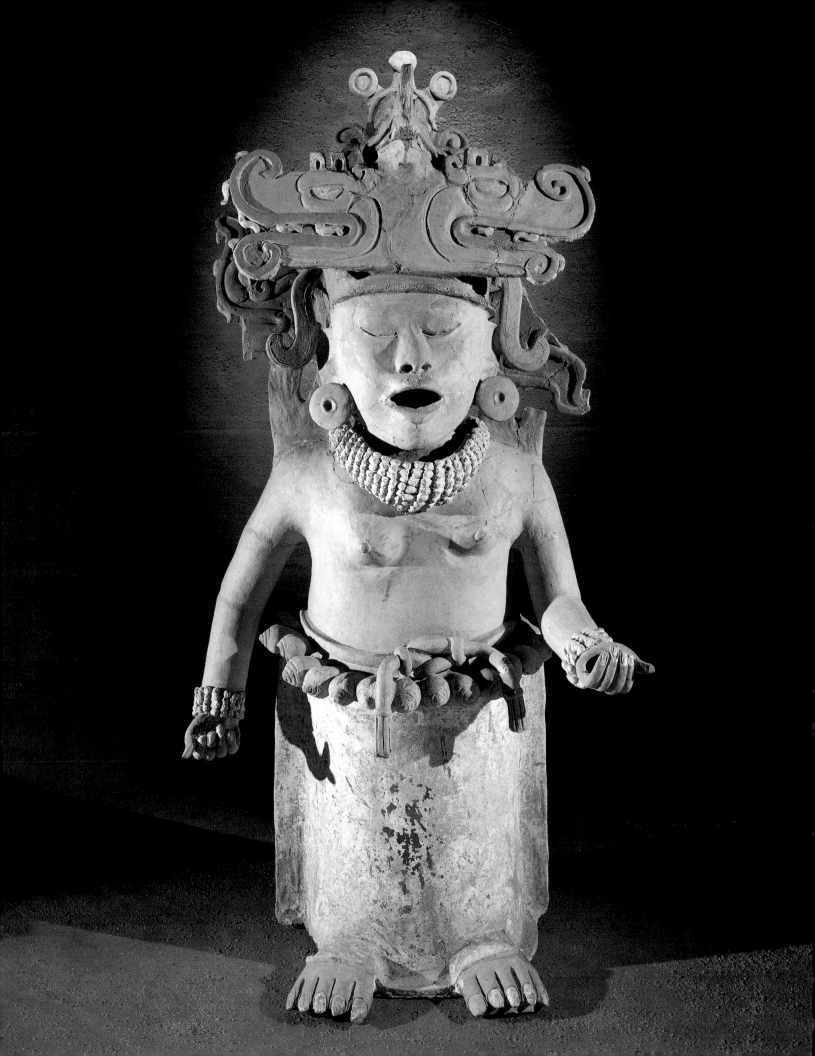

MASK

LATE 19TH–EARLY 20TH CENTURY

KAKONGO OR VILI PEOPLES,

ZAIRE OR ANGOLA (CABINDA)

WOOD, PIGMENT, AND FIBER

13⅜ x 6¹¹⁄₁₆ x 4¾ INCHES

(34 x 17 x 12 CM)

FELIX COLLECTION

UNFORTUNATELY, WE KNOW FAR TOO LITTLE ABOUT THE MEANING OF THE MASKS OF THE Kongo peoples of the neighboring areas of western Zaire and Angola. Because it is painted white, this mask may represent a dead ancestor. At the same time, as Frank Herreman has noted, white may be associated with "justice, order, reason, truth, health, generosity, happiness, matrilineality, intelligence, and clear insight." Many of the latter meanings are associated with the men's voluntary society, called *Ndunga,* found among several of the Kongo groups, where the mask might also be used in initiation rites.

Attributing the mask to a particular group or subgroup is difficult because of shared style characteristics and because sculptures were traded between neighboring peoples. Marc Felix suggests that this mask may come from the Kakongo and could be the female mask of a male-female pair or be ancestral. However, it is clear that—whatever any of its possible functions and meanings—the mask served an important and awe-inspiring role in its parent group.

ROY SIEBER

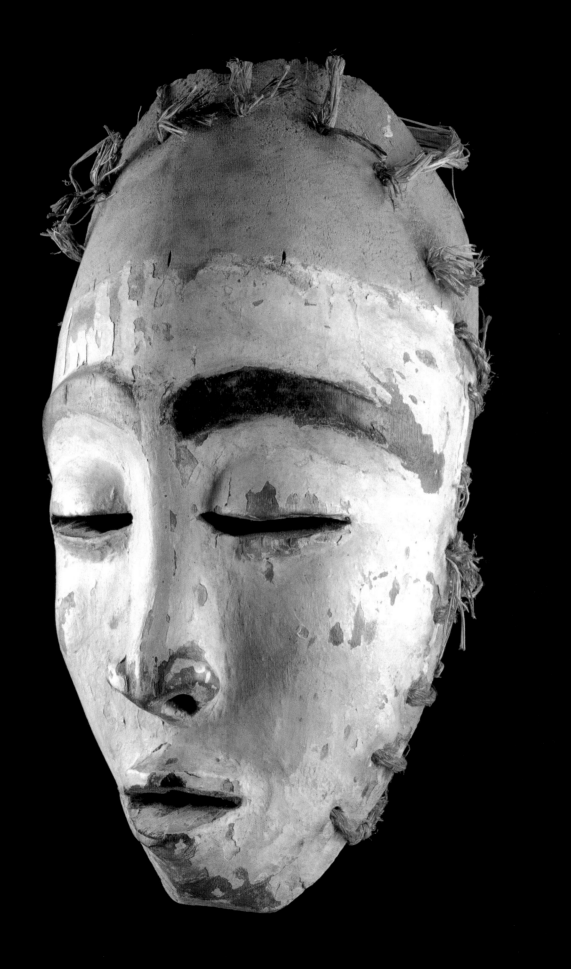

YOROBŌSHI, MASK
FOR THE NOH DRAMA

17TH–19TH CENTURY

JAPAN

POLYCHROMED WOOD

7¹⁵⁄₁₆ x 5⁷⁄₁₆ INCHES (20.1 x 13.9 CM)

TOKYO NATIONAL MUSEUM, JAPAN

THE NOH THEATER OF JAPAN, ROOTED IN ANCIENT SHAMANISTIC RITUAL, DEVELOPED in the fourteenth century into a refined literary form that uses elaborate robes and masks to enhance its desired atmosphere of ethereal beauty and to create a mood of elegant suggestion and spiritual transcendence that is the prized essence of this poetic drama. *Yūgen*, the central aesthetic concept in Noh, connotes a sense of awe and otherworldly mystery that is masterfully conveyed in this mask.

Used for only one play, *Yorobōshi (The Blind Monk)*, written in the fifteenth century by Jūrō Motomasa (1395–1432), the mask's expression captures the complex emotions of intense grief and spiritual deliverance in the deceptively simple tale of a youth who was driven blind in the intensity of his grief at being rejected by his family as a result of a false accusation. His repentant father, having realized his mistake, comes to pray for his son at the great Shittenō-ji temple in Osaka. There, the blind boy daily begs for his bread, enjoying the few pleasures afforded by his refined imagination, confident of the saving mercy of the bodhisattva Kannon. Behind the painful derangement that is the surface expression of the mask are an elegance of feeling and sense of awed faith in the power of the spirit that eventually reunite the blind boy with his father.

Although there is little variation among Yorobōshi masks, this is a superb example of the expression of complex emotions that is possible in this form of sculptural art—fully realized only through the cadence of the actor's practiced movements on an illuminated stage accompanied by the transcendent sounds of a chanting chorus, the shrill notes of a flute, and the percussive rhythms of hand-beaten drums.

BARBARA FORD

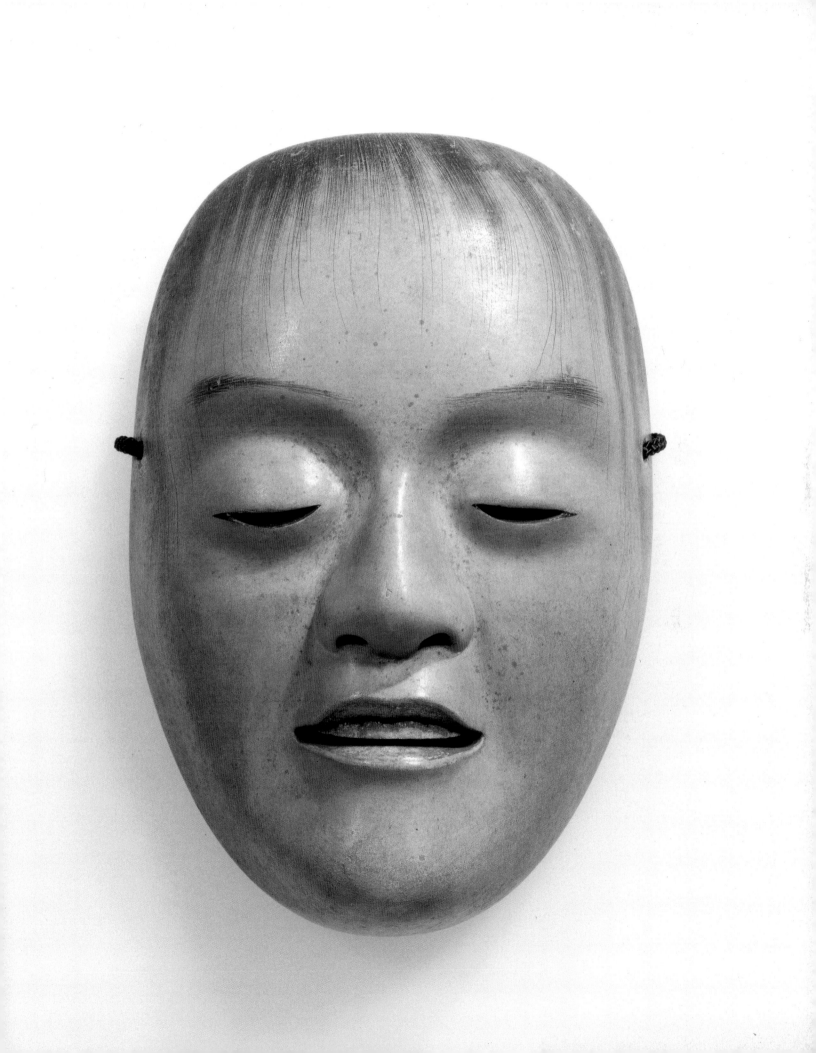

FRANCISCO DE ZURBARÁN
SPANISH, 1599–1664
SAINT SERAPION
1628
OIL ON CANVAS
47½ x 40½ INCHES (120 x 103 CM)

WADSWORTH ATHENEUM,
HARTFORD, CONNECTICUT,
THE ELLA GALLUP SUMNER
AND MARY CATLIN SUMNER
COLLECTION FUND

THE SUBJECT OF THIS PAINTING IS SAINT SERAPION, IDENTIFIED IN THE CARTOUCHE AT the right, illusionistically "pinned" to the painting. He wears the scarlet, white, and gold shield of the Mercedarian Order, founded by Peter Nolasco in 1218 at the height of the struggle to recapture Spain from the Moors. Members of the new order pledged to redeem Christian captives from the enemy by raising money for ransom or by sending Mercedarians to take the place of prisoners. According to an early account, Serapion was captured in Scotland by English pirates in 1240, bound by the hands and feet to two poles, and beaten, dismembered, and disemboweled. Finally, his neck was partly severed, leaving his head to dangle. The position of his head, which falls to one shoulder in Zurbarán's painting, recalls that of Christ on the cross.

The painting hung in the Mercedarian monastery of Seville, which had been founded by Ferdinand III in 1249 and rebuilt in the first years of the seventeenth century. Placed in the funerary chapel, Zurbarán's image exemplified the Christian acceptance of suffering and resignation in the face of death and thus was a fitting subject of meditation for bereaved Mercedarian friars.

Saint Serapion is a masterpiece of Zurbarán's early work in Seville, then the richest city of the Spanish monarchy. The artist's paintings epitomize the religious beliefs and aspirations of his ecclesiastical clientele there. In the seventeenth century, religious art was intended first to instruct and then to inspire devotion. Orthodoxy had become of the utmost importance in the sixteenth century in order to refute the Protestant reformers, who questioned many of the central tenets of the Catholic faith. In this work, Zurbarán has presented an idealized representation of Saint Serapion, choosing not to show the physical horrors of his tortured body. Conservative in subject but modern in style—with its striking tenebrism (sharp contrasts of light and dark) and severe, monumental form—the artist expresses the spirit of the Counter-Reformation, and of contemporary Spanish society, with its faith in both mystical concepts and earthly reality.

RONNI BAER

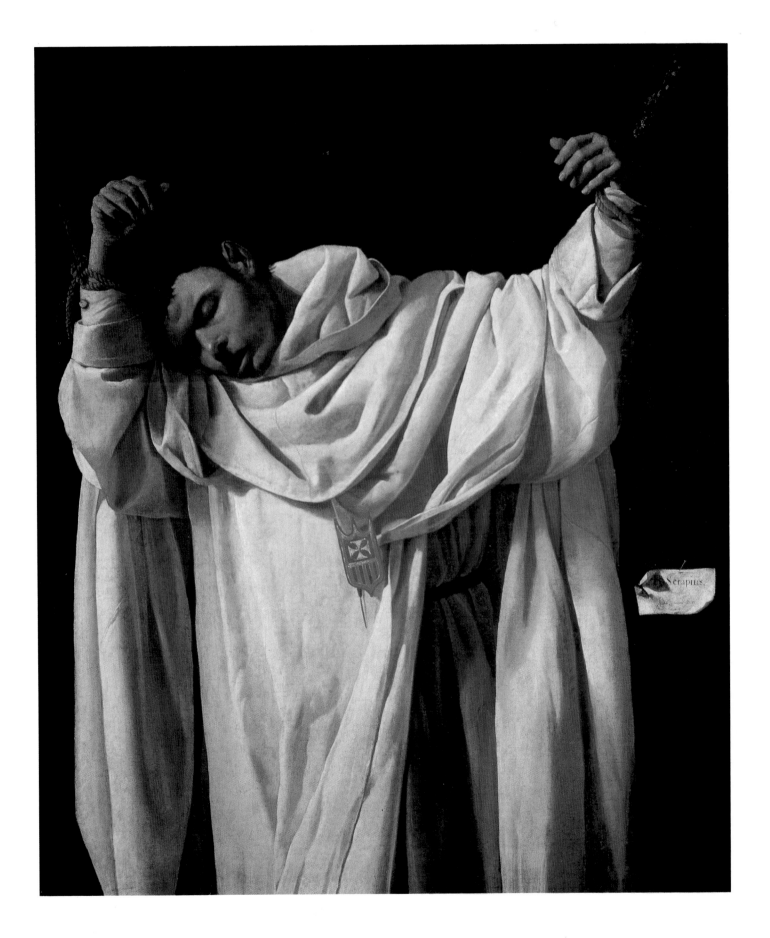

MAN FROM CERNAVODA

5500–4700 B.C.

HAMANGIA CULTURE, ROMANIA

CLAY

HEIGHT 4½ INCHES (11.5 CM)

NATIONAL HISTORY MUSEUM,
BUCHAREST, ROMANIA

THE **MAN FROM CERNAVODA**, OFTEN NICKNAMED "THE THINKER" AFTER RODIN'S famous sculpture, is one of the most important works of art from Neolithic Europe because of its unusual subject and expressive content. The burnished dark clay figurine represents a man sitting on a small stool with his head leaning heavily on his arms, which in turn rest squarely on his bent legs. The posture evokes a mood of quiet introspection. Adding to the pensive melancholy are the remarkable facial features of the figure. The stylized triangular face is pierced by deep-set eyes, themselves recessed triangles. The broad nose leads to a small mouth, delicately delineated as a small circle, as if in the midst of a sigh. One of the most striking aspects of this figurine is the thick, columnar form of the body parts. The full, rounded shapes of the arms, legs, and neck lend a solidity and permanence to this man firmly rooted to the ground.

The statuette was found in a grave near Cernavoda in Romania, a town situated in the Danube River delta, not far from the western coast of the Black Sea. The grave was part of a Neolithic cemetery made up of six hundred burials, four hundred of which were excavated by Romanian archaeologists between 1952 and 1960. The cemetery belonged to people of the Hamangia culture, which flourished around 5000 B.C. The Hamangia culture was a prosperous one, due in part to the role it played in distributing shell and marble from regions around the Black Sea to people farther inland in the Balkans and Europe.

The same grave that yielded the *Man from Cernavoda* also produced a similar-sized statuette of a seated woman. While her position is different (her hands rest on a raised knee), details of her face and the general form of her body suggest the two figurines were deposited in the grave as a pair. Neolithic figurines of full-bodied women are often interpreted as images of the mother goddess, the primeval fertility force worshiped in Neolithic Europe. The presence of this male figure in her company may suggest he, too, is meant to represent a divinity rather than a mortal mourner. Similar male figurines from other Neolithic sites have led to the suggestion that the type represents a sorrowful god, a precursor of the dying god of later mythologies, often associated with the death of vegetation in the cycle of the agricultural year.

PAMELA J. RUSSELL

THIS EMACIATED HEAD OF THE BUDDHA APTLY EXPRESSES THE SPIRITUAL TRANSCENDENCE and physical enervation of Siddhartha Gautama during his six years of self-mortification before he became the Buddha, or Enlightened One. Siddhartha was born around 563 B.C. as the son of a local chieftain in what is now Nepal. He was raised in palatial luxury and, due to a prediction that he would be either a mighty ruler or a numinous religious teacher, was prevented by his father from seeing any of life's harsher realities so that he would not be distracted from the secular path and thus succeed his father as head of the clan. But the gods intervened and caused the young prince to experience the Four Noble Encounters—with an old man, a sick man, a dead man, and a holy man. Freed from the illusion that life is idyllic, Siddhartha resolved to renounce the mundane world and seek spiritual insight. That night he fled the palace and cast off his fine garments and jewelry to begin his search for humility. After wandering from teacher to teacher and practicing asceticism, he realized that the mind could not grow if the body was destroyed. He then broke his fast and began to meditate on the cause of suffering and its emancipation. After meditating under a tree at Gaya for forty-nine days and overcoming great temptation, he gradually achieved enlightenment, becoming the Buddha.

Images of the fasting Buddha are primarily found in the art of ancient Gandhara, a region of present-day Pakistan and Afghanistan that served as the crossroads for travelers and traders on the Silk Route between China and the West. The cosmopolitan nature and possessions of the population enabled Asian artists to come into contact with examples of the Greco-Roman tradition of realism in portraiture. Commissioned by the local rulers and nobles to fashion images of the Buddha, the Gandharan artists emulated the imported Western style to create distinctive portraits of the emaciated Buddha with gaunt features and a skeletal body. This head of the Buddha is particularly expressive, conveying the spiritual serenity that transcends the limitations of his withered flesh.

STEPHEN MARKEL

PORTRAYED ON THE ICON ARE, FROM LEFT TO RIGHT, BASIL THE GREAT, JOHN CHRYSOSTOM, and Gregory of Nazianzos, all fourth-century doctors of the Greek Orthodox Church. Each of the saints holds a gold-covered book and wears a garment that signifies his episcopal rank. After the collapse of the Byzantine Empire in 1453, the Venetian-dominated island of Crete emerged as an artistic center of great importance throughout the Mediterranean: hundreds of artists' names are known from the century after the fall of Constantinople. Although the identity of the painter of this icon remains unknown, the panel can be said to have been executed in one of the island's centers in the early 1500s.

Saints Basil, Chrysostom, and Gregory had been individually recognized for many centuries, when, toward the end of the eleventh, a separate celebration was accorded them as a group: the Three Hierarchs. In creating an icon for the commemoration, the sixteenth-century painter balanced the individuality of each saint with the transcendent spirit that unites them as the embodiment of an essential element of the Orthodox spirit. The three are individualized by distinctive facial features, yet lighting and tonality serve to unify them. Much of the icon's effect of richness is created by the episcopal vestment, called a *polystaurion* because it was covered with crosses. In all important respects the three saints wear the same garment, even though each differs subtly from the others. In addition to their service as bishops, the three were authors, as their books signify. Basil and Chrysostom were credited with prayers used during the mass, and their sermons, like those of Gregory, were read in church and studied as the touchstones of Orthodox belief. Working in a manner that shares much with the art of the Middle Ages, the Cretan painter has created an image that evokes the spiritual intensity of these holy men and stresses the antiquity of the Orthodox faith. The basis of this faith is shown to lie in the authority of the Church, which rests on theological principles voiced centuries before by men such as Basil, Chrysostom, and Gregory. Most important, however, their dress as priests assured the beholder that the mystery of Orthodoxy was accessible to all through the mass.

JEFFREY C. ANDERSON

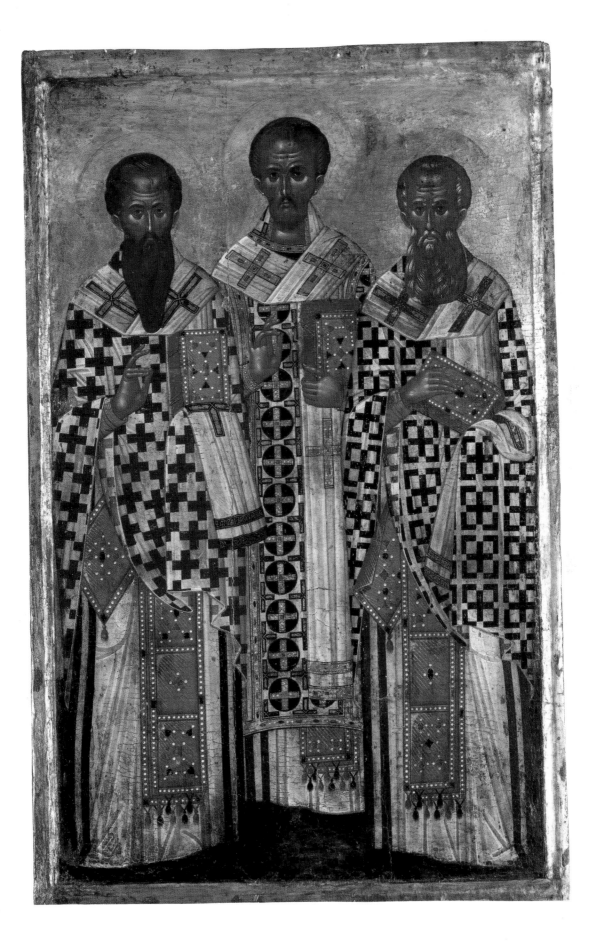

SEATED MAITREYA

Late 6th–early 7th century

Korea

Gilded bronze

Height 36¹³⁄₁₆ inches (93.5 cm)

National Museum of Korea, Seoul

Maitreya, bodhisattva and Buddha of the future, foot resting upon a lotus flower, sits on a throne in elegant contemplation in the Tusita heaven awaiting his time for rebirth on earth. One of the most beautiful and certainly one of the finest sculptures of Maitreya in Asia, this Korean version uses gentle, natural curves echoing throughout the body and crown to convey the youth and inner grace of this spiritual figure. The delicacy and expressiveness of the features speak of the high achievement in casting as well as the unusual religious insight of the Three Kingdoms period. Art has always played an important role in spreading and maintaining faith, as much in the Buddhist tradition as in the Christian. The pure proportions and sheer loveliness of this statue inspire all who might view Maitreya to greater devotion.

Myriad Buddhas and bodhisattvas (literally "enlightenment beings") belong to the Buddhist pantheon and are enlisted to assist others on the path to enlightenment, or nirvana. Bodhisattvas are agents of the Buddhas who use their selfless compassion and powers for those in difficulty. They appear in art as splendid princely beings, often with rich jewels and ornaments that are emblems of their worldly powers and skill. Maitreya is the bodhisattva who is to be the next Buddha or fully enlightened one to return to live and preach in the world. Worshipers of Maitreya, often in times of great political upheaval, prayed that he would soon return to earth to bring peace and unity among men.

DONNA WELTON

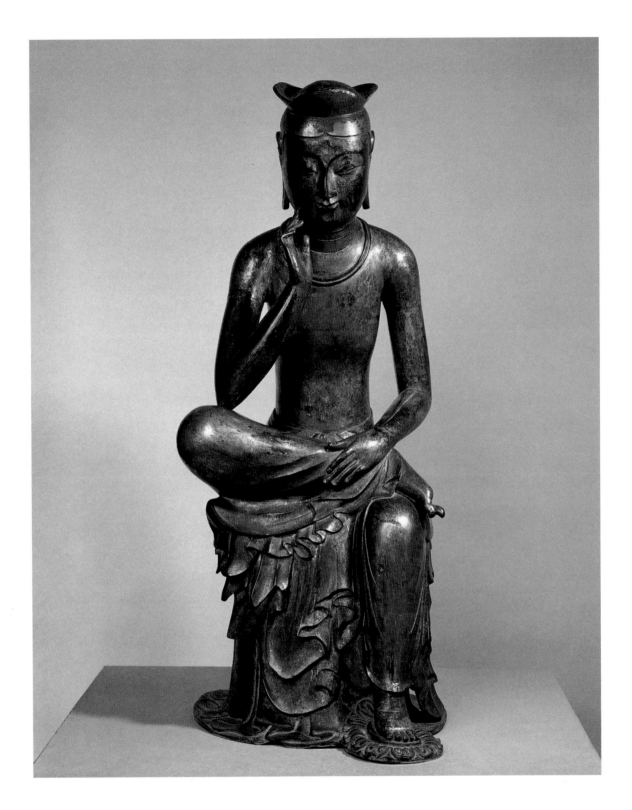

PRAJÑÂPÂRAMITÂ, THE
GODDESS OF
TRANSCENDENTAL WISDOM
c. 1300
East Java, Indonesia
Andesite
Height 49½ inches (125.7 cm)

Museum Nasional, Jakarta,
Indonesia

THE GODDESS OF TRANSCENDENTAL WISDOM IS SEATED IN LOTUS POSITION ON A ROUND lotus cushion that has been placed upon a rectangular base. She raises her hands in front of her chest in the gesture symbolizing the Turning of the Wheel of the Law associated with the highest figures of the Buddhist pantheon. From the lotus cushion rises a stalk that winds itself around the left arm of the goddess and ends in a lotus flower. On top of this lotus flower rests a palm-leaf manuscript of the *Sutra of Transcendental Wisdom*, or *Prajñâpâramitâ-sutrâ*, the traditional attribute of the goddess and the repository of the wisdom, which she personifies. The goddess is represented in royal attire with sumptuous jewelry, a sacred thread consisting of a triple string of beads, and a conical, richly adorned headdress. A patterned skirt covers the lower part of the body; its decorative pattern is reminiscent of classical Javanese batik motifs. The rich adornments of the figure of the goddess contrast with the plain simplicity of the back slab, decorated only with a border of flames.

This masterpiece of ancient Indonesian sculpture was first seen by a Dutch colonial officer who visited the temple complex of Candi Singasari (East Java) in 1818 or 1819. At that time, he noted that the local Javanese villagers referred to the statue as Putri Dĕdĕs—that is, Princess Dĕdĕs. The dramatic history of Putri Dĕdĕs (early thirteenth century), committed to writing more than two hundred years after her death, is given in the chronicle *Pararaton.* She was the daughter of a priest of a Buddhist Mahâyâna sect, who was forcibly abducted by Tunggul Ametung, the governor of Tumapel, who made her his wife. Shortly afterward, he was assassinated by Ken Angrok, who took the pregnant Dĕdĕs as his wife. When in 1222 Ken Angrok succeeded in overthrowing the dynasty of Kadiri, he became the first king, and Dĕdĕs the first queen, of Singasari. The son of Dĕdĕs by her slain first husband later succeeded to his stepfather's throne, and Dĕdĕs thus became the ancestor of all the later kings of the royal houses of Singasari and Majapahit, who reigned over East Java for the next three hundred years.

Even though the oral tradition of the early nineteenth century, mentioned above, is not confirmed in any written source, the fact that the father of Queen Dĕdĕs was a Mahâyâna Buddhist would seem to argue in favor of the identification of this statue as a portrait of this famous queen.

Even the mere possibility that this statue could represent the most famous queen of ancient Indonesia in the guise of the Goddess of Transcendental Wisdom, with whom she is believed to have merged upon death, makes this monumental sculpture a national icon of both the greatest artistic and historical significance.

JAN FONTEIN

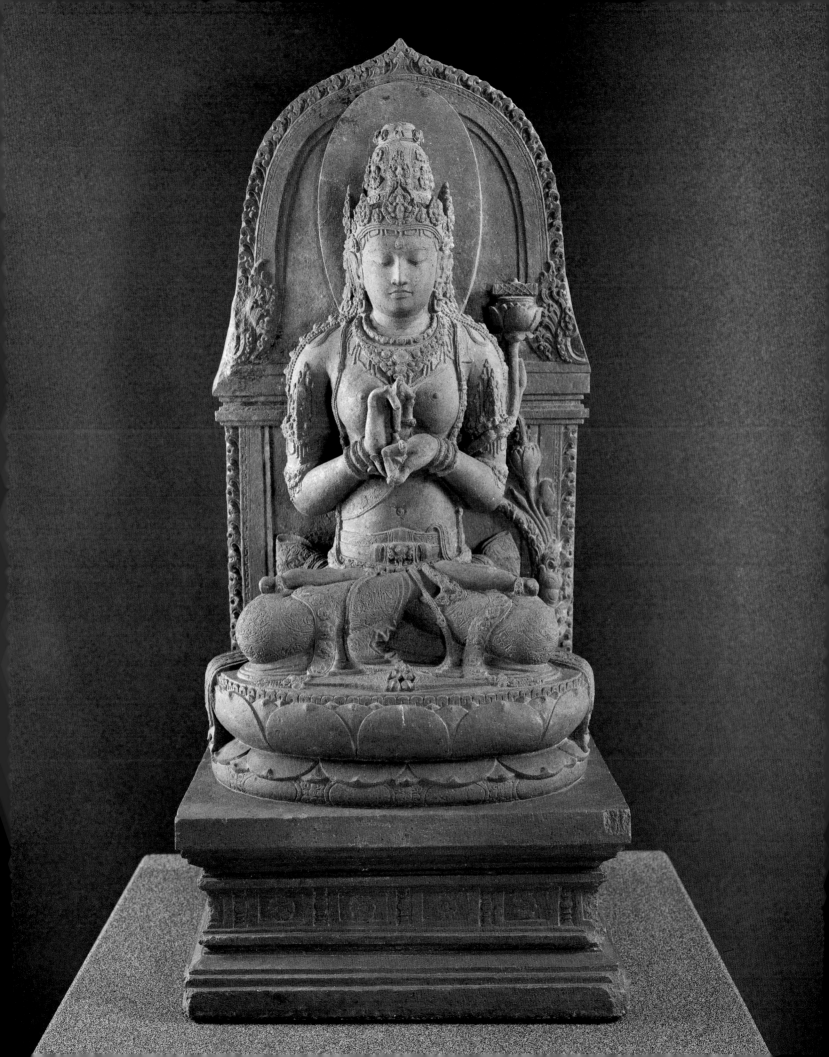

PRAYING BOY

Late 4th century b.c.

Rhodes, Greece

Bronze

Height 50½ inches (128.4 cm)

Staatliche Museen zu Berlin,
Preussischer Kulturbesitz,
Antikensammlung

T HE ANCIENT GREEKS WORSHIPED THEIR GODS THROUGH SACRIFICE, LIBATION, FESTIVAL, and prayer. Scenes of sacrifice and libation abound in Greek art, but the magnificent bronze boy from Berlin represents a rare image of a young athlete raising his eyes and arms upward in the gesture of prayer. Religious festivals featured athletic competition. The boy likely invokes the power of the patron god to bring him success, for prayer in classical antiquity generally expressed wishes rather than thanksgiving.

The life-size statue shows a boy on the threshold of youth, his slender physique developing muscular definition and smooth facial features beginning to sharpen. The restored arms follow in principle the gesture of the original. In *Natural History* (34.66,73), Pliny tells us that Boidas, one of the sons and pupils of the great sculptor Lysippus, made a statue of a praying boy. We cannot know definitively if the bronze boy reflects that master's work, but the gracefully open pose, soft musculature, and small head are characteristic of the finest sculpture from the late fourth century b.c.

BONNA DAIX WESCOAT

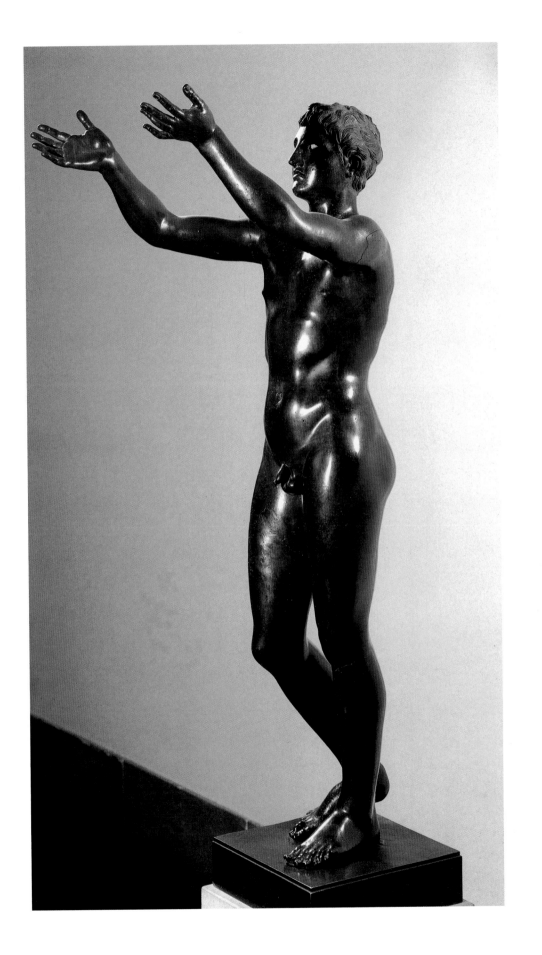

AITREYA, "THE FRIENDLY ONE, THE BENEVOLENT ONE," ALLOWS HIS FOLLOWERS to anticipate the future with serenity. After all, he is the Buddha of the future. This Buddha represents wisdom perfected, an enlightened being. The historical Buddha, Siddhartha Gautama, had already set up an institutional framework through which his followers could work toward *nirvana,* a state where the extinguishing of desire eradicates earthly suffering. Nirvana could be achieved by gaining enlightenment and ending the cycle of birth, death, and rebirth. Soon after his death, his followers—monks, nuns, and laity—worked to spread the message of the Buddha throughout the Indian subcontinent and other parts of Asia. As Buddhism grew in numbers and established a weighty presence in various parts of Asia, changes occurred both in the practice of the religion and the representation of Buddhist icons. Through monks and tradesmen, Buddhism reached Southeast Asia early in the first century A.D. There it was quickly integrated with local pre-Buddhist religions, and specific forms of Buddhist practice emerged out of this historical process. The creation of regional Buddhist art forms both reflects and materially constructs these changes in Southeast Asian religious and artistic culture.

Mahayana Buddhism is one of the major sects of Buddhism and differs from Theravada Buddhism in its belief in multiple Buddhas (besides the historical Buddha) and its worship of bodhisattvas, beings who strive for enlightenment and remain on earth and in heaven to help others by sharing their earned merit. Maitreya is worshiped both as a bodhisattva and as a Buddha. As a bodhisattva, he is shown as a princely figure with longish robes and full jewelry. As a Buddha, he wears a short garment, matted locks of hair piled on his head, and elongated, pierced but empty earlobes. The lack of royal finery presents the viewer with a renunciate par excellence.

This Maitreya, like most other images of him, has a *stupa,* or a relic memorial mound, referring perhaps to his spiritual lineage, and two of his four arms would have held his attributes—a lotus and a water vessel. His stomach full of *prana,* or the breath of life, and his slightly flexed posture allow the worshiper to imagine this awesome being coming to life, stepping off the pedestal ready to bring the future into the viewer's present. Maitreya's serenity and grace are awesome, his calm countenance alleviating any anxieties menacing the devotee.

ANNAPURNA GARIMELLA

Domenicos Theotocopouls,
called El Greco
Spanish, born in Crete, 1541–1614
THE RESURRECTION OF CHRIST
1605–10
Oil on canvas
108 ¼ x 50 inches (275 x 127 cm)

Museo del Prado, Madrid

El Greco lived at a time when the doctrines and devotions of the Roman Catholic Church were undergoing a process of revitalization known as the Counter-Reformation, and no artist better expressed the excitement of the movement. On the surface, he was an unlikely candidate for this honor. He was born on the island of Crete and was trained in the nonrealist style of Byzantine art. At the age of twenty-five (1566), he immigrated to Italy, spending time in Venice and Rome. In these cities, he taught himself the precepts of Italian naturalism.

After his permanent move to Spain in 1577, El Greco combined the elements of his dual heritage—Byzantine formalism and Italian naturalism—into a uniquely expressive manner of painting. This singular fusion of two great artistic traditions was perfect for representing the doctrines and devotions of his clients, many of whom were prelates and theologians living in his adopted city of Toledo. The *Resurrection,* painted for an altarpiece in a church of the Dominican order in Madrid, is a brilliant example of El Greco's late style.

The Resurrection is a climactic moment in the Christian faith, proving Christ's victory over death and demonstrating his saving power. It is narrated with great simplicity in the Gospels, where it is told that the holy women visited Christ's tomb and found it to be empty. Over the centuries, artists used apocryphal texts and their imaginations to create more dramatic and explicit compositions. El Greco adopts a type of composition that became popular in the sixteenth century. Christ floats above the ground while the soldiers who guard his tomb are overcome by the miraculous event.

In El Greco's painting, Christ's resurrection from the dead explodes like a bomb, hurling the soldiers backward as the shock wave hits them. El Greco paints the figures with huge proportions and yet confines them within a narrow, airless space, barren of either natural or man-made objects. Even the tomb is omitted. This tremendous concentration of spiritual energy and movement generates the powerful impact of this painting. The Resurrection is the definitive representation of the definitive triumph of the Christian faith.

JONATHAN BROWN

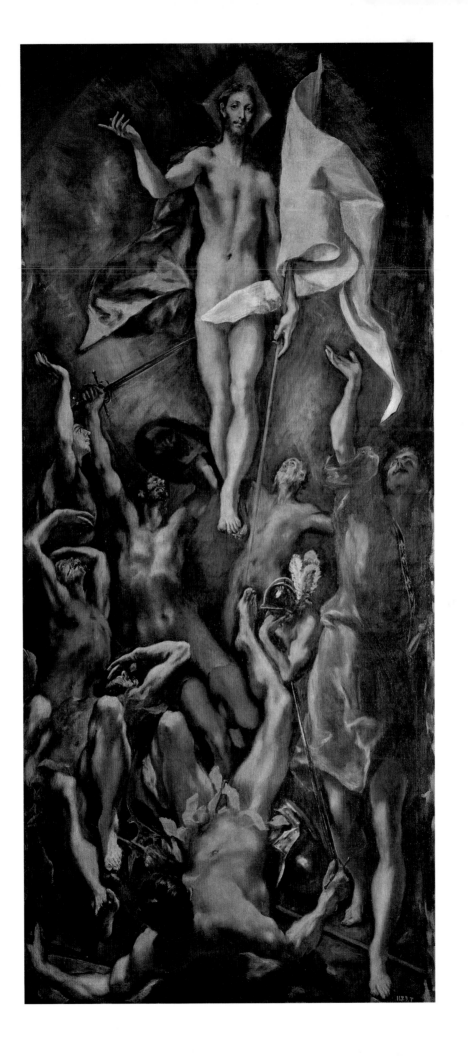

IV. TRIUMPH

VERLAPPING WITH THE END OF THE PRECEDING SECTION, THIS RING BEGINS WITH RELIGIOUS triumph. We confront a Russian icon presenting *Christ in Majesty,* the ruler of all, enthroned in glory, surrounded by angels sketched in calligraphically in white on black. The frontal pose, golden robe, brilliant color, and zigzag of powerful diagonals tie this image to the overlap between Awe and Triumph, as do the upward flicker and swirling angels in the Islamic ascension of the prophet Muhammad. The Archangel Michael, meanwhile, symbolizes, with grace and a delightfully upbeat sense of coloration, the triumph of good over evil, and, by extension, the church over heresy. Meanwhile an Ecuadorean ceramic of circa A.D. 200–400 shows a festival celebrant with a triumphant smile. A Tibetan *thangka*, Kurukulla, the goddess of love, triumphs over the evil of the human ego, while the thirteenth-century image of the Chinese King of Hell loftily metes out punishment to the damned.

In one of the memorable images in Western art, the major innovative painter of the seventeenth century, Caravaggio, continues the theme of triumph over evil, drawing on the Old Testament story of young David's slaying of Goliath. The powerful head of the late Dr. Martin Luther King of Atlanta, carved by a gifted self-taught artist from Georgia, embodies both religious and political triumph, and from Peru of the colonial period, Saint James (Santiago) triumphs over the infidel at the Battle of Clavijo.

To end the subject of religious triumph with a recall of Roman religion and a projection of power literally trumpeted by Triton abroad, we see Nicolas Poussin's great classical expression of the *Triumph of Neptune*, holding his trident and bestriding three sea horses at once, as he observes the arrival of Amphitrite out of his sea, framed by a great cloth whose lifted form recalls a tradition from antiquity, and showered with petals by a posse of weightless cupids.

In Giambattista Tiepolo's oil sketch for a ceiling, another trumpet announces the triumph of another god from Greek and Roman mythology: the original strongman, Hercules. We look in celebration directly upward into the heavens, through which the heavily muscled hero gallops in his chariot, having successfully completed the dozen seemingly impossible labors that his brother had assigned him.

The triumph of power is next celebrated by a series of political and military strongmen. Great pomp also accompanied the attributes of leadership in the Benin culture of Nigeria in the sixteenth and seventeenth centuries, where the Oba towers in scale above his attendants. A second oil sketch, this one by the seventeenth-century diplomat, classical scholar, connoisseur, collector, architect, and magisterial painter Peter Paul Rubens of Flanders, is a visualization of a triumphal arch to be erected for the entry of the Archduke Ferdinand into Antwerp, a picture bought for Russia from the English connoisseur Horace Walpole by another leader of immense power, Catherine the Great.

But no one understood the propagandistic power of art better than Jean-Auguste-Dominique Ingres. His image of *Napoleon on His Throne* at the height of his imperial ambitions contains every possible attribute that would link Napoleon to the glories of the Roman emperors of ancient times or, even, subliminally, as in the enthronement in the Russian icon that began this section, to the Deity himself.

Triumph, however, is a very particular circumstance, generally existing at the expense of someone else's discomfiture, as we have seen over and over again in this section. Not long after the Ingres was painted, it was the British Duke of Wellington and his allies who could revel in the emotion of triumph, as summarized in the Wellington Shield, referring, like the painting, to ancient history, in this case Greek—the fame of the shield of Achilles and the crowning of the great duke by Nike, the winged goddess of Victory.

Triumph is, of course, the essential emotion of the Olympic Games, and we end with evocations of athletic triumph. On the large prize vase or amphora from fourth-century B.C. Greece, remarkable in its scale and state of preservation (complete with its top), winged Nike crowns a victorious boxer, still carrying the thongs that he would have used rather than the padded gloves of modern boxing, flanked to his right by the loser and pointed to in admiration on his left by the referee. The scene marks the annual Panathenaic Games at Athens in honor of the city's patroness, the goddess Athena, who is depicted on the other side. Finally, with a classical reference by means of a title in Latin, the nineteenth-century American Thomas Eakins portrays another victorious boxer saluting the crowd, whose smiles and applause foreshadow our final overlap, **J O Y**.

J. C. B.

CHRIST IN MAJESTY

16TH CENTURY

RUSSIA

TEMPERA ON PANEL

55¼ x 42⁷⁄₁₆ INCHES (140.3 x 107.8 CM)

THE STATE RUSSIAN MUSEUM,
ST. PETERSBURG

A RUSSIAN ARTIST OF THE SIXTEENTH CENTURY HAS DEPICTED CHRIST ENTHRONED in majesty, poised to administer justice at the end of time. Christ looks directly at the beholder with a steady gaze and balances a book inscribed with a quotation promising that he will look into the believer's heart: "Do not judge by appearances, but judge with right judgement" (John 7:24). Christ's body seems charged with supernatural energy: as he twists his torso and raises his knee, filaments of light radiate across the planes of faceted drapery. The area surrounding Christ and his enormous throne has been treated like a green sea alive with divine beings. From visions, the Old Testament prophets described the celestial court and the supernatural creatures attending God's throne—the seraphim and cherubim. The artist has represented these beings as if they were an emanation equivalent with the divine light of God. In the corners of the image, emerging out of the radiance of light, are the tetramorph, the man, bull, eagle, and lion that Ezekiel and Saint John envisioned (Ezekiel 1:10; Revelation 4:6–8). The apocalyptic message is enhanced by the powerful colors, especially the fiery red diamond behind Christ.

The icon was originally part of a group of panels set up as a screen separating the sanctuary—where the clergy celebrated the Eucharist—from the naos, where the laity assembled for the service. The exact church in which the icon was installed remains unknown, but the surrounding subjects can be suggested from similar works. Next to Christ were the Virgin Mary and Saint John the Baptist; archangels and apostles followed in ranks. The core group of Christ, his mother, and the Baptist formed an ensemble recognized in the Orthodox world as early as the tenth century. Known as the *Deësis,* or "supplication," it signified the intercession of the Virgin and Saint John on behalf of humankind, called to account at the Last Judgment. The viewer is offered the hope that the awesome power of the judge will be tempered through the intervention of his mother and the last of the prophets. The painter closely followed the design that is known in Russian icon painting from as early as the fourteenth century, expressing the ultimate, triumphant majesty of the Godhead.

JEFFREY C. ANDERSON

ATTRIBUTED TO **SULTAN-MUHAMMAD**

PERSIAN, 16TH CENTURY

THE ASCENT OF THE PROPHET

MUHAMMAD TO HEAVEN

1539–43

FROM A MANUSCRIPT OF THE

KHAMSA (QUINTET) BY NIZAMI

GOUACHE, INK, AND GOLD

ON PAPER

14 3/16 X 9 7/8 INCHES (36 X 25 CM)

THE BRITISH LIBRARY, LONDON

THE ASCENT OF THE PROPHET MUHAMMAD TO HEAVEN APPEARS IN THE HAFT PAYKAR (Seven Portraits),[1] the fourth poem in Nizami's celebrated *Khamsa*, or Quintet, illustrated for Shah Tahmasp (ruled 1524–76). The illustration, one of the major works of Persian painting, accompanies an account of the Prophet Muhammad's *miraj*, or night journey. The event does not relate directly to the narrative of the Seven Portraits, but it is included here as part of the dedicatory prayers to God and a eulogy to the Prophet.

According to Islamic tradition, on a starry night, the angel Gabriel visited the Prophet Muhammad and, with the human-faced steed *buraq*, led him from Jerusalem to the Seventh Heaven. The Prophet's Ascension became a revered model for mystical meditation and has generated a considerable body of religious literature. *Miraj* stories were also well known in medieval Europe and probably influenced Dante's *Divine Comedy*.[2]

Capturing the unearthly and triumphant splendor of this fabulous event, the composition depicts Gabriel, identifiable by his flaming wings, leading the Prophet and his steed through the skies. Wearing a traditional sixteenth-century turban, the Prophet's face is shown veiled as a sign of respect. Leaving behind the earthly realm and passing through coiling white clouds that partially obscure a shimmering moon, "the night was spurned, the moon reined in."[3] The Prophet, ablaze in a splash of electrifying, holy flames, is greeted by a host of heavenly angels, dressed in elegant courtly attire. They busily perfume the night air and offer trays of food and precious gifts as prescribed by the text. One angel tightly clasps a book, most probably the Koran, the holy Book of Islam.

MASSUMEH FARHAD

1. The "Seven Portraits" explores the pleasures of love. For an excellent translation, see Nizami, *Haft Paykar. A Medieval Persian Romance,* trans. Julie Scott Meissami (Oxford, 1995).

2. For a discussion and further references, see Annemarie Schimmel, *Mystical Dimensions of Islam* (Chapel Hill, 1975), 219; idem, *And Muhammad Is His Messenger. The Veneration of the Prophet in Islamic Piety* (Chapel Hill and London, 1985), 174.

3. Nizami, *Haft Paykar.* 7.

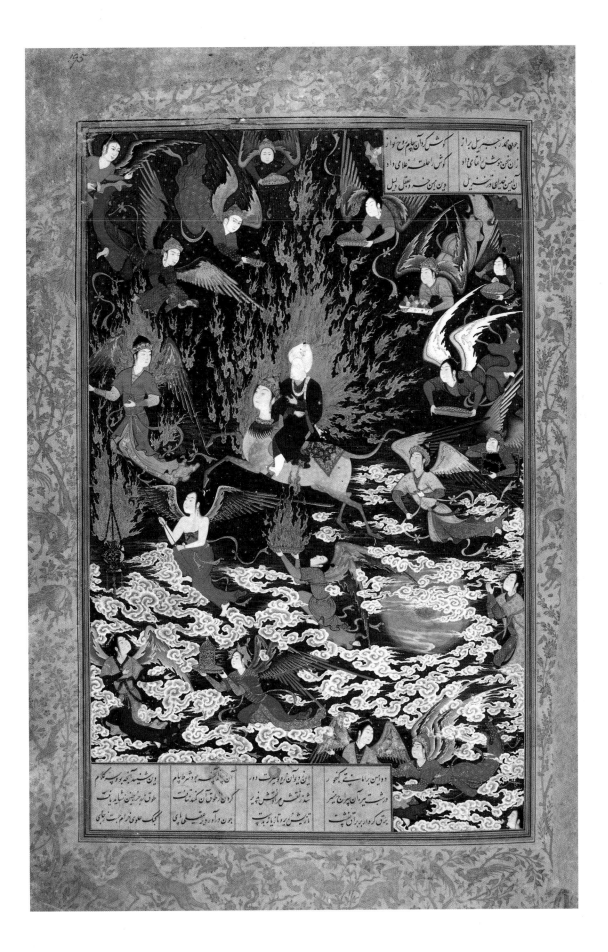

LUCA GIORDANO
ITALIAN, 1634–1705
**SAINT MICHAEL VANQUISHING
THE DEVIL**
C. 1663
OIL ON CANVAS
78 x 57⅞ INCHES (198 x 147 CM)

STAATLICHE MUSEEN ZU BERLIN,
GEMÄLDEGALERIE, PROPERTY
OF THE KAISER-FRIEDRICH-
MUSEUMS-VEREIN

LUCA GIORDANO, THE PROTOTYPE OF THE ITINERANT ARTIST, TRAVELED UP AND DOWN Italy, working in his native Naples, as well as in Rome, Florence, Venice, and Bergamo, before becoming court painter to Charles II in Madrid in 1692. He was perhaps the first virtuoso artist in the eighteenth-century sense: the speed and vigor with which he produced his paintings were legendary.

This painting depicts Saint Michael defeating Satan and the rebel angels as recounted in Revelation 12:7–9. Like nearly all angels, Michael is depicted with wings, a detail that prevents any confusion with the other dragon-slayer, Saint George. The subject was especially popular in the sixteenth and seventeenth centuries, the period of the Counter-Reformation and the wars against the Turks, because it symbolized the guardian of the Christian church triumphing over heresy. Giordano painted the subject several times. Scholars have proposed that this depiction, whose style is marked by firm anatomical modeling on the one hand and beautifully transparent draperies on the other, and exhibits a graceful fluidity of brushwork, dates from around 1663. The size of the painting suggests that it was perhaps made for the altar of a side chapel of a church.

Giordano considered all the art of the past as a source to be used for his own purposes. In the Berlin painting, he artfully combined elements from paintings of the same subject by two famous predecessors. The diagonal thrust of the composition, the pose of the angel's head, and the bright color scheme appear in an altarpiece by Guido Reni in Sta. Maria della Concezione in Rome, painted just before 1636. The motif of the angel holding the lance with both arms stretched out to the left and the balletic pose of the legs derive from Raphael's much earlier painting for Francis I of France (now in the Louvre), which Giordano could have known from engravings. Giordano transformed Raphael's classical and Reni's classicizing designs into a whirling, exuberant, and dramatic composition characteristic of the High Baroque.

RONNI BAER

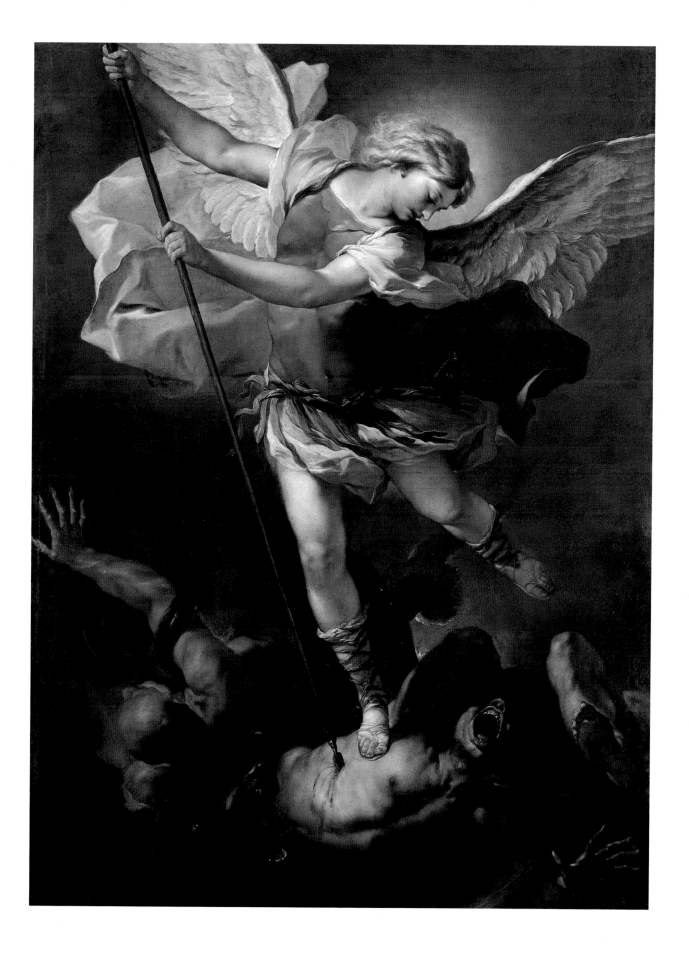

RITUAL CELEBRANT WITH BIRDS
200–400
ECUADOR
CERAMIC
13⅛ x 9¹¹⁄₁₆ x 12⁵⁄₁₆ INCHES
(34 x 24.6 x 31.3 CM)

MUSEO DEL BANCO CENTRAL,
GUAYAQUIL, ECUADOR

THE CERAMIC EFFIGIES SCULPTED IN THE FIRST CENTURIES OF THIS ERA ON THE CENtral coast of Ecuador are among the largest, as well as most complex and arresting, works of art from northern South America. Although quite numerous and built up using mold forms along with handmade elements, each one is nevertheless distinctive. The use of molds to massproduce identical figures takes an interesting turn in this, the Jama-Coaque style. The small birds on this figure's head are obviously all the same, made with clay pressed repeatedly into a form and then appliquéd to the main figure while still damp. Recent research shows that the front half of the figure itself was also molded while its entire back was hand formed and laboriously seamed to the front. This is an atypical and inefficient use of mold technology; a second mold for the back side would have allowed for true mass production. It seems that the mold was used not for labor efficiency, as in other cultures, but rather to produce a ritually correct image as well as to highlight the skill of the sculptor and to add individualizing elements. This work can be seen as the triumph of the Jama-Coaque artistic vision over the limits—and even the advantages—of a chosen technology.

The image also embodies triumph in the spiritual realm. Ancient American religions tend to be shamanistic—that is, based on belief in powerful priests transforming into fearsome animals to battle malevolent forces during nighttime forays into other realms. To communicate the shaman's special nature, it is typical to obscure him with elaborate, significant costuming: bead necklaces and bracelets show his status while the bird earrings, body ornament, and headdress symbolize his particular powers. The ornament, with its diagnostic radiating face feathers, represents a frontal owl, revered for its ability to see at night, hunting accurately and often savagely decapitating its prey. Such a bird constitutes a proper animal spirit of a shaman, who uses its ability to fly, piercing vision, and predatory form to triumph over disease, strife, and disaster.

REBECCA STONE-MILLER

KURUKULLA

17TH–18TH CENTURY

NGOR, TIBET

COLORS ON COTTON

40 1/16 x 28 3/8 INCHES

(101.7 CM X 72 CM)

ASIAN ART MUSEUM OF
SAN FRANCISCO, GIFT
BY TRANSFER OF THE
FINE ARTS MUSEUMS

K URUKULLA IS WIDELY WORSHIPED IN TIBET, NEPAL, AND MONGOLIA AS THE goddess of love. In this painting from Tibet, she dances triumphantly upon her lotus pedestal, with one foot trampling on the corpse representing human ego. As a god, she is depicted with four hands, holding her bow and arrow of sugarcane, an elephant goad of the same material, and a blue lotus. On a higher level, shooting the arrow symbolizes the subjugation of frivolous thoughts in order to transmute passion into wisdom.[1] Above her are three monks floating on clouds. Tiny Tibetan inscriptions in gold identify them as abbots of the Ngor sect (a subsect of the Sakya order) who lived from the fourteenth to sixteenth centuries. During the thirteenth century, Sakya lamas were advisers to the Mongol rulers of China, and, as a result, they reigned supreme in Tibet.

The Ngor monastery Ewam Choden was founded by Kunga sangpo in 1429. At the time of the monastery's construction, Kunga sangpo invited many artists from Nepal to decorate it. Thus, the Ngor monastery was famous not only for its paintings executed in the Nepalese style, but also for playing an important role in the exchange of art styles between Nepal and Tibet. Located in southern Tibet, this monastery soon became a great center of learning among the Sakya order. The founder of Ngor appears in the center, flanked by Konchog phelwa (1445–1514) on the left and Singye rinzin (1453–1525) on the right.[2]

As in many Tibetan Buddhist paintings, there is a table of offerings below the image of the main deity. Below the table are vessels whose shapes are typical of the Yuan dynasty (1260–1368), the period when the Sakya order enjoyed close ties with the government of China. Two gods of wealth holding mongooses flank the table of offerings. Their presence indicates a wish for wealth on the part of the donor who commissioned the painting.

TERESE TSE BARTHOLOMEW

1. Chogyam Trungpa, *Visual Dharma: The Buddhist Art of Tibet* (Berkeley and London, 1975), 108.
2. The author is grateful to bSod-nams rgya-mtsho, the late Thar-rtse Abbot of Ngor, for the identification.

THE KING OF HELL

Late 13th century

China

Hanging scroll; ink and
color on silk

33½ x 19¹³⁄₁₆ inches (85 x 50.3 cm)

Staatliche Museen zu Berlin,
Preussischer Kulturbesitz,
Museum für Ostasiatische
Kunst

Daishan Dawang was originally the supernatural ruler of China's most venerated sacred mountain, Mount Dai in Shantung province. According to ancient Daoist cosmology, Mount Dai was home to the lord of the underworld. Buddhism later adopted the lord of Mount Dai as King of the Seventh Hell. The Ten Kings of Hell, however, were not the exclusive property of any one religion. Their worship penetrated all levels of Chinese society, becoming an important aspect of Chinese folk beliefs.

The traditional Chinese conception of the underworld is of a multilayered bureaucracy staffed by demonic officials and ruled by Ten Kings modeled after the magistrates of China's judicial system. A dead person must appear before each of Hell's infernal kings, who use torture to extract confessions of past misdeeds. Wrong actions are weighed to determine whether the dead are sentenced to be reborn as humans, animals, hungry ghosts, or demons. Fortunately, the outcome of these trials can be influenced by certain religious rites. If ritual offerings are made at proper intervals on behalf of the deceased, the merit thus gained can be applied toward early release from torment and passage into a happier state of existence in the next life. The agonies of purgatory can be mitigated because the Kings of Hell, like the imperial officials they resemble, can be bribed.

This scroll follows a Song dynasty (960–1279) iconographic formula. The Kings of Hell hold court in luxurious garden settings complete with flowers, painted screens, and lacquered furniture. The presiding king sits behind a large desk attended by scribes and demonic bailiffs. The kings wear the costume of Chinese royalty and their chief assistants are dressed as court officials. These opulent settings serve as the backdrop for graphic portrayals of horrifying punishments. This iconography of the Ten Kings of Hell was effective largely because of the average Chinese citizen's ingrained fear of arbitrary justice at the hands of earthly officials, a fear tempered by awareness of the real possibility of influencing the outcome of a legal case through properly placed "offerings."

ALAN ATKINSON

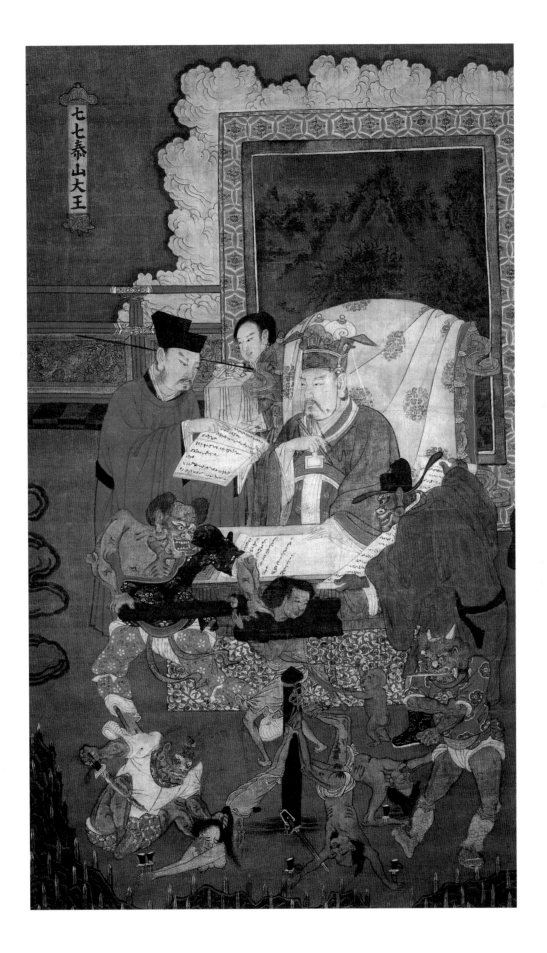

MICHELANGELO MERISI DA CARAVAGGIO

ITALIAN, 1571–1610

**DAVID WITH THE HEAD
OF GOLIATH**

C. 1605–6 OR C. 1609–10

OIL ON CANVAS

49¼ X 39¾ INCHES (125 X 101 CM)

GALLERIA BORGHESE, ROME

THE TRIUMPH OF THE YOUNG SHEPHERD DAVID OVER THE HUGE WARRIOR GOLIATH, which enabled the Israelites to rout the army of the Philistines, has been a popular subject in European art since early Christian times. In the Middle Ages, theologians regarded the story as prefiguring the triumph of Christ over Satan; in Renaissance Florence, artists such as Donatello, Verrocchio, and Michelangelo found the theme a rousing symbol of the defense of civil liberty. The account in I Samuel 18: 49–51 tells the story:

> And David put his hand in his bag, and took thence a stone, and slang it, and smote the Philistine in his forehead, that the stone sunk into his forehead; and he fell upon his face to the earth. . . . But there was no sword in the hand of David. Therefore Daved ran, and stood upon the Philistine, and took his sword, and drew it out of the sheath thereof, and slew him, and cut off his head therewith. And when the Philistines saw their champion was dead, they fled.

Caravaggio, the most famous painter of the Italian Baroque, has been celebrated as much for his ability to reinterpret traditional subject matter as for his mastery of naturalism and dramatic lighting effects. This painting is a work of his late maturity, created either shortly before he fled Rome in 1606, after stabbing to death a certain Ranuccio Tommasoni in a street brawl, or several years later in Naples near the end of his eventful life. Instead of creating a straightforward image of the victory of good over evil, Caravaggio portrays a pensive David regarding the gory head of the man he has just killed. The stone from the slingshot can be seen embedded in Goliath's forehead, while in David's hand is the giant's own sword, which the young hero has used to decapitate him.

Pietro Bellori, in his biography of the artist published in 1672, describes the head of Goliath as a self-portrait of Caravaggio, a claim almost universally accepted among scholars. At present we can only guess at the personal meaning this identification may have held for the artist. Whatever specific allusion he may have intended, Caravaggio reveals by his focus on the defeated Goliath a keen awareness of the always ambiguous nature of triumph.

JAY A. LEVENSON

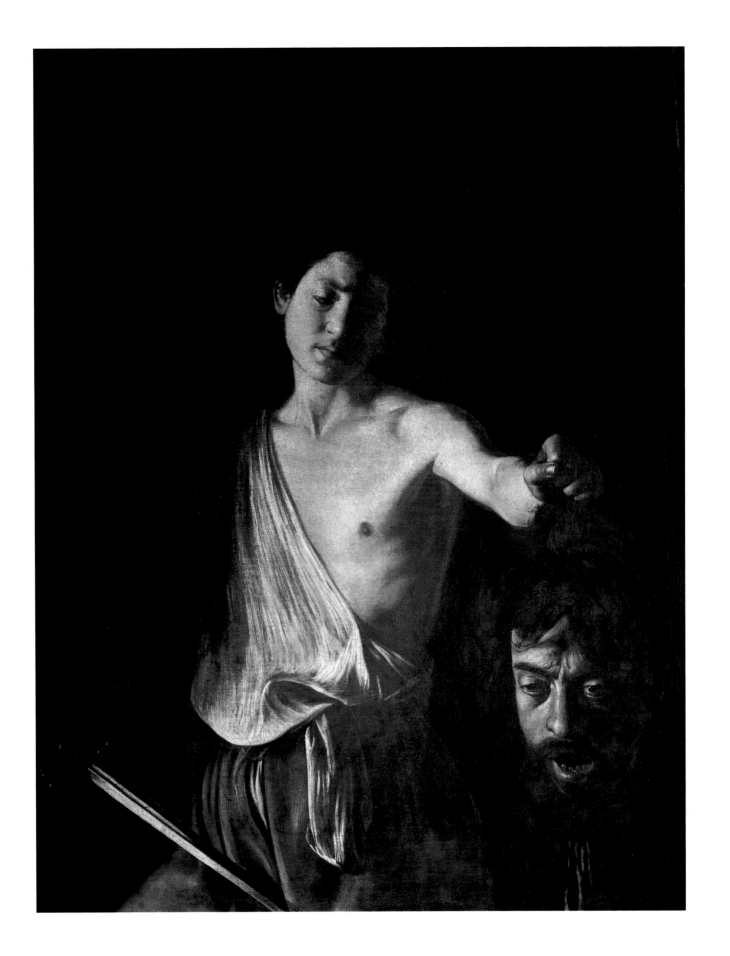

ULYSSES DAVIS
AMERICAN, 1913–1990
HEAD OF MARTIN LUTHER KING, JR.
C. 1968
MAHOGANY
9¼ x 5 x 5 INCHES (23.5 x 12.7 x 12.7 CM)

JANE AND BERT HUNECKE

THIS MASTERFUL PORTRAIT OF DR. MARTIN LUTHER KING, JR., WAS CARVED BY ULYSSES Davis, a self-taught African-American artist from Savannah, Georgia. Believed to have been created in 1968 just after the assassination of Dr. King, the wooden bust is a powerful memorial to the renowned civil-rights activist and spiritual leader.

Davis was a barber by trade, who, working in his spare time, eventually filled the shelves and countertops of his small, two-chair barbershop with more than three hundred wood sculptures. He carved his figures from discarded shipyard lumber and treated the wood pieces with stains and paints. He also achieved a variety of rich surface textures using nail punches that he forged and filed himself. Since the early 1980s, Davis's work has received increasing critical recognition within the United States, both for its skillful carving and its strong expressive vision.

Included among the subjects of Davis's sculptures are many religious images and mythological beasts, but he is also well known for his many carvings of famous historical characters and political figures, from Benjamin Franklin and United States presidents to "the Great Kings and Queens of Africa." This depiction of Martin Luther King is one of the finest examples of the artist's historical portraiture. Composed of strong simplified features, Davis's likeness evokes a sense of Dr. King's humility, courage, and steadfast commitment to social change. The portrait also captures a feeling of serenity, the kind of inner repose achieved through the triumph of the spirit over adversity and struggle.

JOANNE CUBBS

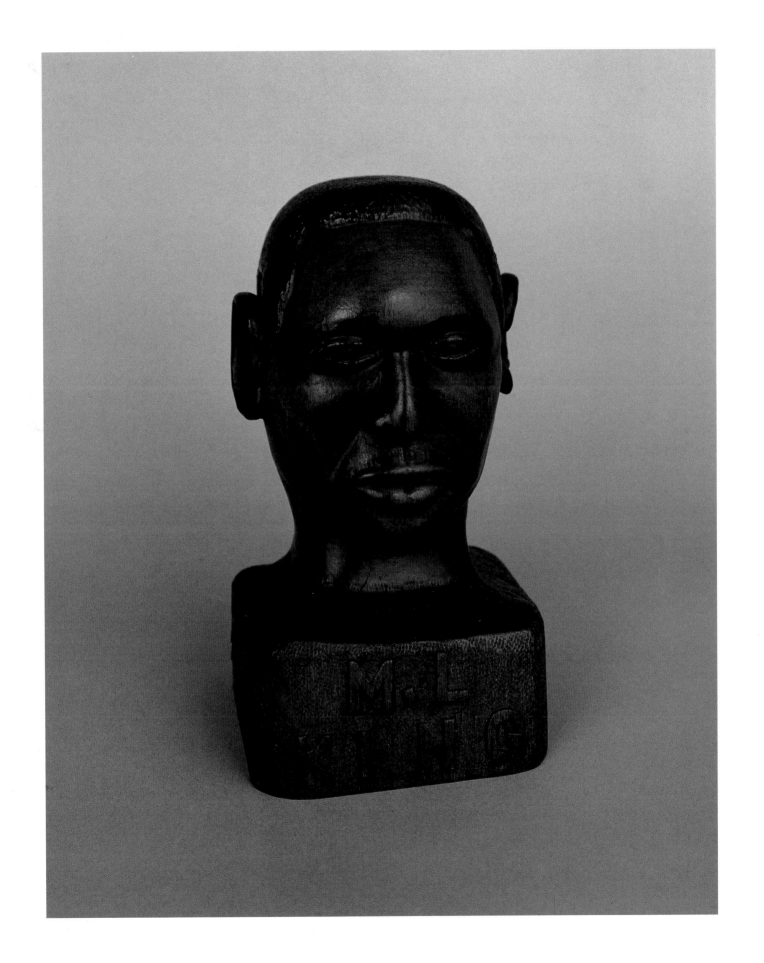

CUZCO SCHOOL
PERUVIAN, 18TH CENTURY
**SAINT JAMES THE MOORSLAYER
(SANTIAGO MATAMOROS)**
18TH CENTURY
OIL ON LINEN
62½ x 45½ INCHES
(159.3 x 115.8 CM)
NEW ORLEANS MUSEUM OF ART,
MUSEUM PURCHASE

THE CHRISTIAN RECONQUEST OF THE IBERIAN PENINSULA FROM MUSLIM DOMINATION was the central fact of Spanish identity. An evangelical crusade that climaxed with the fall of Granada in 1492, its lingering energy helped to fuel the conquest of America. As the *reconquista* was often emblemized by the equestrian image of Saint James the Great trampling the bodies of defeated infidels, this symbol came by extension to represent Spanish triumph in America as well.

The Spanish had long venerated the Apostle James, believing him responsible for the original conversion of their country; legend also held that his body was mystically borne from Palestine to Galicia where the famed pilgrimage church of Santiago da Compostela supposedly marks his final resting place. But the bellicose identity emblazoned in the present composition derives from the legend of James's appearance against the Moors at the critical Battle of Clavijo.[1]

The devotion to "Santiago Matamoros" (Saint James the Moorslayer) took on fresh significance in the Americas. In combat after combat the Spaniards' war cry, "Santiago," accompanied the annihilation of native resistance, along with tales of the saint's miraculous appearance at battles throughout Mexico and Peru. The vanquished Indian peoples soon adopted as their own god this totemic being whose protection was seen to have empowered the Conquest, and indigenous artists began to create their own images of this potent "divinity." In the Andes, this new allegiance was apparently facilitated by his identification with the pre-Conquest deity Illapa, the god of thunder and lightning.[2]

Cuzqueno paintings of this subject abound. In most, the warrior saint is dressed not as a knight but as a sandal-shod pilgrim. Here he rides barefoot, his billowing cloak marked with the Cross of Saint James and his typical pilgrim's wide-brimmed hat bearing Saint James's cockleshell. The overgilding (*brocateado*), which in much popular Cuzqueno painting obscures the form of the drapery, is comparatively restrained.

JOHANNA HECHT

1. Émile Mâle, *L'art religieaux après la concile de Trent* (Paris, 1932), 231, notes that these traditions were only confirmed by Rome in 1728 under great pressure from Aragon.
2. Antonio de la Calancha, *Crónica moralisadora del orden de San Agustín en el Peru* (Barcelona, 1639; reprinted Lima, 1974–82), 1: 370 ("After Pachcamac, the Sun, and Viracocha, the Moon and the stars, there followed in order the one venerated most, particularly in the mountains, the lightning they call Libiac or Illapa; and now because the Spanish cried James when they fired, they call him James.")

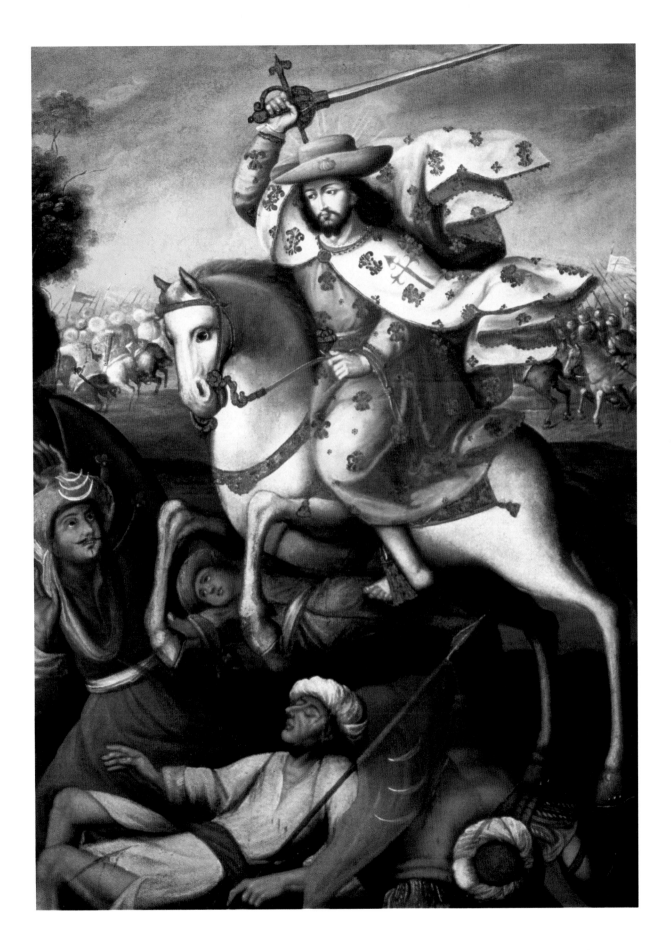

THE MYTHOLOGICAL SUBJECT IN THIS PAINTING IS A COMPLEX NARRATIVE OF THE STORY of Neptune, ancient Roman god of the sea (known as Poseidon by the Greeks) and the brother of Jupiter (Zeus), the lord of the heavens. Neptune's wife was Amphitrite, one of the daughters of the Titan Ocean. One of her sons was Triton, who, with a great seashell, was trumpeter of the sea. Neptune, besides being honored as the lord of the sea, was also believed to have given the first horses to humankind. Poussin, using material from the Roman poet Ovid, has related the entire story of Neptune—his love for Amphitrite and his triumph as the deity of the sea—in one majestic painting. In the center of the canvas all eyes are on Amphitrite, who is accompanied by her sisters, the Nereids, and Triton, blowing his shell trumpet. On her right is Neptune, pulled on the sea by a team of horses; above and below are the winged infants, called *putti,* accompanying Cupid (Eros) with his bow and arrow. In the distance, the youth in a chariot is probably Phaeton, who drove the chariot of his father, the Sun, then fell into the sea and was buried by sea nymphs.

Although born in France, Nicolas Poussin spent most of his career as a painter in Rome, where he was deeply influenced by classical antiquity and the work of the sixteenth-century Italian Renaissance artists. In the 1630s, in particular, Poussin painted subjects from classical mythology in a style based on classical sculpture and on the paintings of Raphael and Titian that were similarly inspired by their enthusiasm for classical art. Because Rome had become a mecca for artists and scholars from all over Europe, Poussin had sophisticated patrons who delighted in his classical style. He was summoned back to France in 1640 to decorate the Louvre, but he disliked the artistic climate there and returned to Rome within two years, remaining there for the rest of his life.

JOHN HOWETT

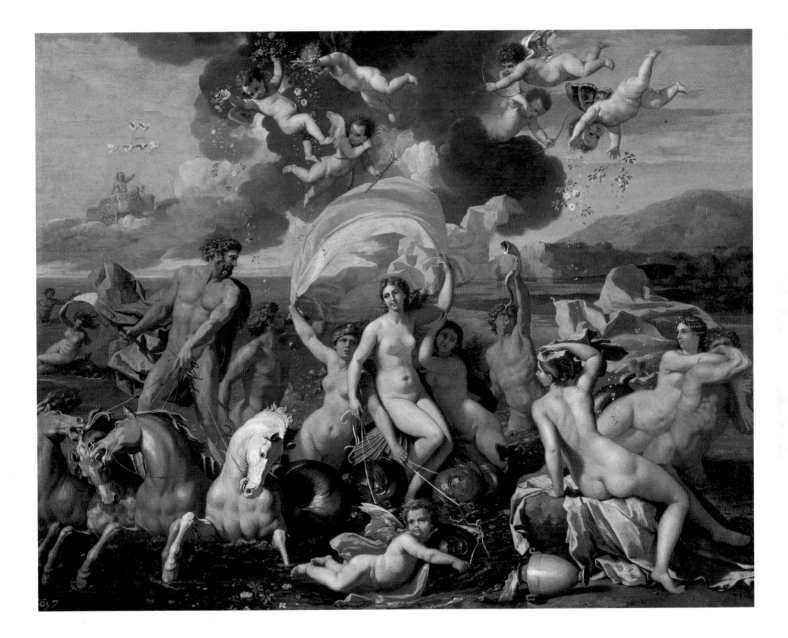

WARRIOR CHIEF AND ATTENDANTS

Mid-16th–17th century

Edo peoples, Benin

Kingdom, Nigeria

Copper alloy

18⅛ x 13¾ x 28⅜ inches

(46 x 34.9 x 72.1 cm)

National Museum of African Art, Washington, D.C., purchased with funds provided by the Smithsonian Collections Acquisition Program

When British soldiers looted Benin City in 1897 after the Punitive Expedition, they discovered a treasure trove of art, including more than nine hundred bronze plaques depicting life in the court of the king. These plaques had been created from the sixteenth through the nineteenth century and may have developed as a creative response to books and engravings brought by the Portuguese, whom the Edo people of Benin first encountered in the fifteenth century. Many of the plaques were nailed onto columns in the king's palace for display.

The Portuguese (depicted on this plaque with long hair, on either side of the chief's head) often appeared in Benin art associated with Olokun, god of the sea from whom wealth flowed. The trade relationship of the Benin with the Portuguese was a very profitable one for the well-organized African kingdom.

The central figure on this plaque is an important warrior chief in the court of the king. He wears a headdress and necklace of coral beads, documenting the regalia of office, and the entire surface of the plaque, made by the lost-wax method of metal casting by a guild in the exclusive service of the king, is adorned with a decorative pattern. His large size compared to the other figures indicates his importance. In Benin art, and in much of African art, size relationships were used to indicate status rather than distance on a picture plane.

MICHAEL HARRIS

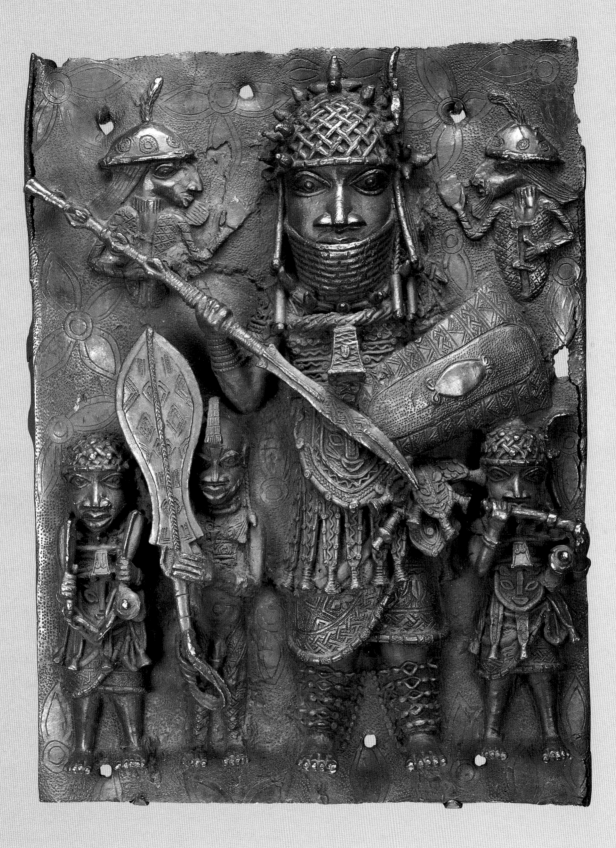

GIAMBATTISTA TIEPOLO
ITALIAN, 1696–1770
THE TRIUMPH OF HERCULES
C. 1761
OIL ON CANVAS
36½ x 27½ INCHES (92.7 x 69.8 CM)

THE CURRIER GALLERY OF ART,
MANCHESTER, NEW HAMPSHIRE,
CURRIER FUNDS

THIS WELL-DOCUMENTED OIL SKETCH WAS MADE IN PREPARATION FOR THE FRESCOED ceiling of the *salone* in the Palazzo Canossa, Verona (destroyed in 1945). In December 1760, Tiepolo was requested by the Marchese Carlo di Canossa to decorate the newly renovated main room. Tiepolo informed his patron that, in order to proceed, he needed the plan of the room, indicating its source of light and its dimensions, as well as the subject the marchese wished to have represented. It is not known how detailed was the program supplied by Carlo di Canossa. It is believed that he had conceived the decoration partly in preparation for his daughter's wedding to Count Giovanni Battista d'Arco on September 13 of that year. The marchese apparently approved the design Tiepolo presented to him by means of this sketch. The extraordinary energy and sensuous richness of this study were lacking in the finished fresco.

In Greek mythology, the hero Hercules was the personification of physical strength and courage. He was the son of the god Zeus and the mortal woman Alcmene. At his death, he was rewarded for his twelve labors and various other feats with deification and was borne aloft in a chariot to take his place as one of the twelve gods of Olympus. After his earthly travails, Hercules had attained eternal peace, a happy marriage to the goddess Hebe, and immortality. The intent of Tiepolo's scene might have been to imply to the newlyweds that such rewards are available to the strong and the courageous.

Hailed by contemporaries as the "new Veronese" (who had painted in Venice two centuries earlier), Tiepolo decorated the palaces of Venice and country villas of the Veneto, dazzling his wealthy patrons with his rich pictorial imagination and the inexhaustible virtuosity of his brushwork. Through subsequent travels, his elegant and light style, epitomizing the Rococo, came to adorn the halls of royal courts, patrician palaces, and religious edifices throughout eighteenth-century Europe. This oil sketch, a design idea made visible through flickering brushwork and lustrous color on a convenient scale, illustrates the vitality and virtuosity that made Tiepolo the most sought-after artist of his day.

RONNI BAER

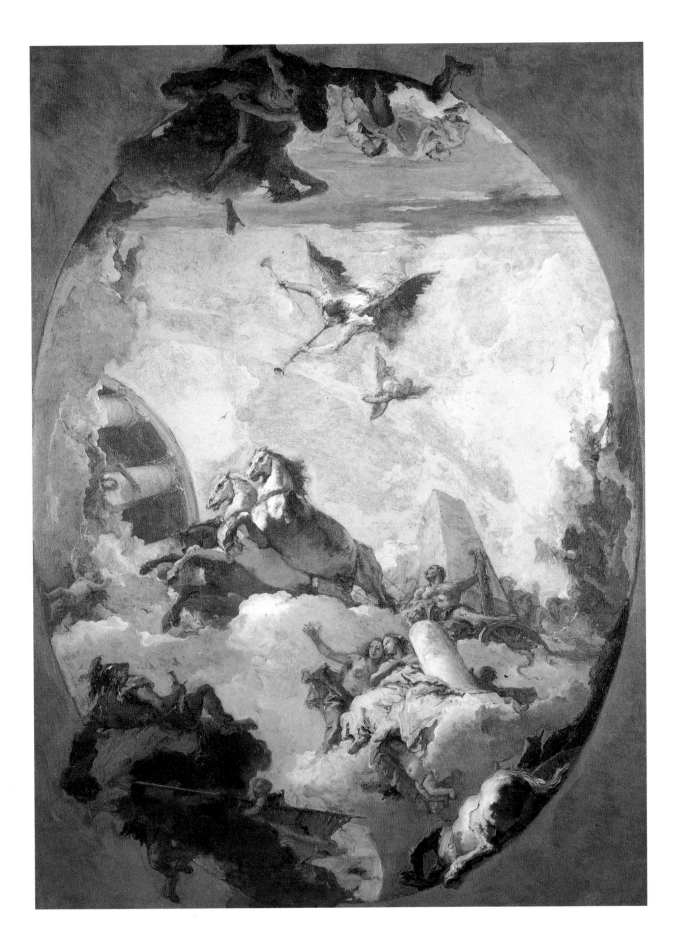

PETER PAUL RUBENS
FLEMISH, 1577–1640
ARCH OF FERDINAND
1634
OIL ON PANEL TRANSFERRED
TO CANVAS
41 x 28⁹⁄₁₆ INCHES
(104 x 72.5 CM)

THE STATE HERMITAGE
MUSEUM, ST. PETERSBURG

A LONG-STANDING FLEMISH TRADITION WAS THE BUILDING OF ELABORATE TEMPORARY festive arches and decorations to welcome visiting rulers. Thus, when the new governor of the Spanish Netherlands, the Cardinal Infante Ferdinand, arrived in Brussels in November of 1634 to take up his position, the magistrates of Antwerp were quick to invite him to make such a splendid princely visit to their city. The design of this complex and costly project, financed in part by a tax on beer, was entrusted to the city's most distinguished artist, Peter Paul Rubens. The artist created a triumphal entry route of four stages and five arches, structures that combined architecture, painting, and sculpture in a detailed allegorical program. It took Ferdinand, met at each location by dignitaries and musicians, more than two hours to make his celebratory procession on April 17, 1935.

In planning this project, Rubens employed a quick and simplified approach for his designs. On prepared wooden panels, he sketched the subject in charcoal and then painted over it in oil to give the artists (who included all the other leading painters of Antwerp) an indication of the necessary colors. These *modellos* are masterpieces of creative genius, investing what might otherwise have been pedantic exercises with vibrant life. The panel from the Hermitage is the *modello* for the rear or western side of the triumphal arch dedicated to the Cardinal Infante himself. The finished arch, based upon the classical prototype of a triumphal arch with three openings, rose to a height of seventy-two feet and was forty feet wide by twenty-six feet deep.

The laudatory images that the prince would see when he turned to regard the rear face of this towering arch are clearly indicated in Rubens's sketch. In the lower tier, the arches at the left and right are capped by profiles of the allegorical figures of Nobility and Youth. The second tier features the triumph of Ferdinand, who is presented as a classically dressed hero in armor and cape, drawn in a chariot, crowned by Victory with a laurel wreath, as Hope rises in the sky above. Mounted on the arch over this scene is the Spanish coat of arms, flanked by two ferocious lions. Allegorical sculpted and painted figures balance this central scene. To the right are Virtue and Providence and, at the left, Honor and Liberality. Topping the structure at the center is the barely visible figure of Lucifer, the morning star, astride a winged horse. This was a symbolic representation of the hope that Ferdinand's military victory (over the Swedes at Nördlingen in September 1634) presaged the dawn of a new era. On either side of the arch at the top are shields and bound prisoners, the spoils of warfare, and at the ends are winged figures of Fame blowing their horns. The exuberance of Rubens's brilliant brushwork captures the excitement of the festive occasion. Rubens wrote about this project with justifiable pride to a friend, "You would not be displeased at the invention and variety of the subjects, the novelty of the designs, and the appropriateness of their application."

ERIC ZAFRAN

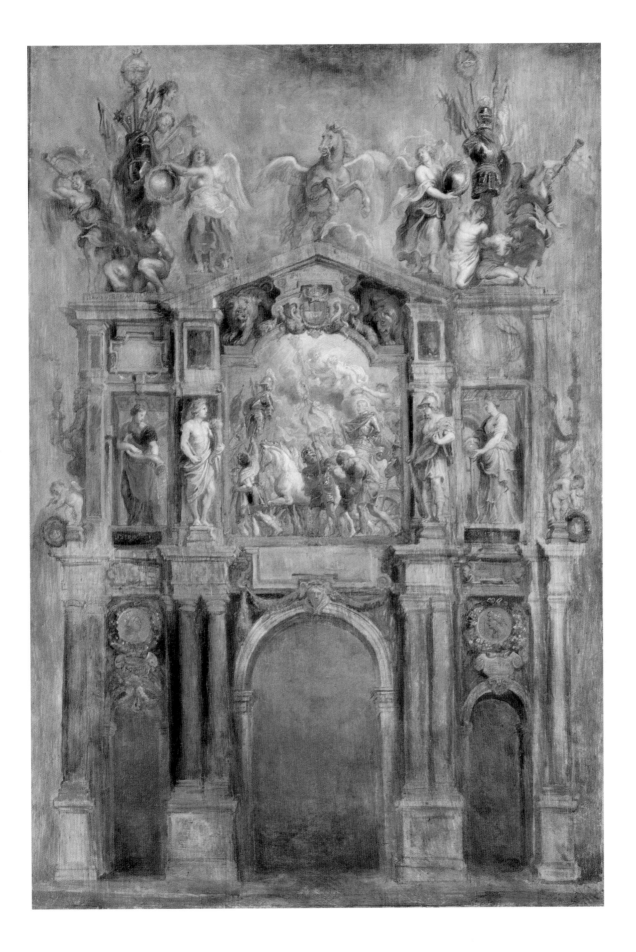

JEAN-AUGUSTE-DOMINIQUE INGRES
FRENCH, 1780–1867
NAPOLEON ENTHRONED
1806
OIL ON CANVAS
102⅜ x 63¾ INCHES (260 x 163 CM)

MUSÉE DE L'ARMÉE, PARIS

NGRES'S **NAPOLEON ENTHRONED** EXUDES POWER. AS ONE EMINENT ART HISTORIAN has splendidly described it, "For unworldly, terrifying grandeur, no image of Napoleon, not even the marble classical giants of Canova and Bartolini, can approach Ingres's vision of the new Emperor on his throne."[1]

Ingres's imposing portrait of Napoleon was the artist's first major public work. The artist, who had not yet finished his studies, was just twenty-six years old when he undertook to paint this monumental canvas. In the fall of 1806, this portrait, along with several other works by Ingres, was exhibited at the annual Salon, where it elicited negative criticism from all factions.[2] His meticulous rendering of the detail of the emperor's costume and accoutrements was deemed "gothic," then a pejorative term indicating that the style did not adhere to the cherished Neoclassical values of the state-run academy, which stressed the generalization rather than the particularization of forms. Critics linked Ingres's style to that of the late-medieval painter Jan van Eyck and noted Napoleon's resemblance to God the Father in the Ghent Altarpiece. Ingres's image of the emperor may also have been influenced by even older representations of Byzantine monarchs, which the artist studied in Paris. By employing this medievalizing style, Ingres evidently hoped to establish connections between images of medieval rulers and that of Napoleon, legitimizing Bonaparte's imperial aspirations. Although Ingres's contemporary critics, steeped in the classical tradition, could not appreciate the originality of the artist's efforts, this portrait of Napoleon has since become one of the signal images of early nineteenth-century European art. It is housed in one of the great buildings of Paris, the Palais des Invalides, which, besides continuing to provide a home for wounded veterans, contains a museum of military history and, under the landmark gilded dome of its chapel, the tomb of Napoleon himself.

DAVID A. BRENNEMAN

1. Robert Rosenblum, *Jean-Auguste-Dominique Ingres* (New York, 1967), 68.
2. Susan L. Siegfried, "The Politics of Criticism at the Salon of 1806: Ingres' *Napoleon Enthroned*," in vol. 2 of *The Consortium on Revolutionary Europe 1750–1850: Proceedings*, eds. Donald Horward, John L. Connolly, Jr., and Harold T. Parker (Athens, Ga., 1980), 69–81.

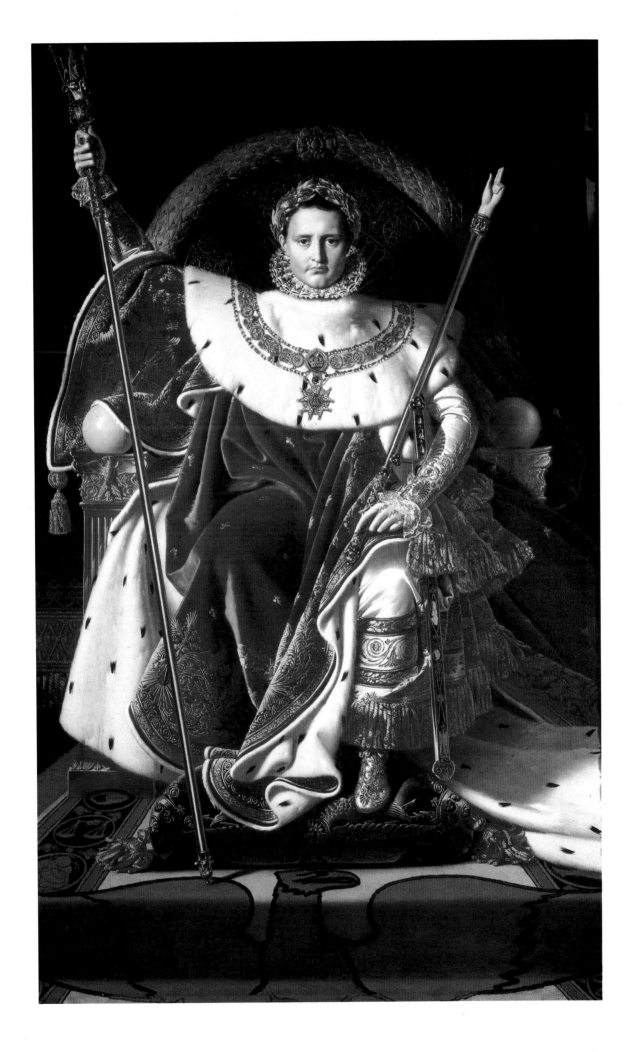

THOMAS STOTHARD, DESIGNER
ENGLISH, 1755–1834
BENJAMIN SMITH, SILVERSMITH
ENGLISH, 1764–1823
VICTORY (WELLINGTON SHIELD)
1821–22
GILDED SILVER
DIAMETER 40 INCHES
(101.6 CENTIMETERS)

APSLEY HOUSE, THE WELLINGTON
MUSEUM, LONDON

I N THE ILIAD, THE ANCIENT GREEK POET HOMER DESCRIBES THE HERO ACHILLES' SHIELD as life-sized and heavy and decorated with images of life in Heaven, Earth, and sea, and cities at war and at peace. In the Roman poet Ovid's *Metamorphoses*, Perseus uses the shield of Minerva to kill Medusa, whose head then turns a sea monster to stone, allowing Perseus to release Andromeda.

These images, rooted in the classical past, come to mind when looking at the impressive Wellington Shield, presented in 1822 to the First Duke of Wellington (1769–1852) by the merchants and bankers of the City of London. They wished to express their gratitude for Wellington's dazzling military victories, which eventually led to Napoleon's defeat on June 18, 1815, at the Battle of Waterloo.

Like Homer's description of Achilles' shield, the Wellington Shield is also life-sized and heavy and decorated with images, in this instance with a high-relief scene of the Duke of Wellington on horseback, being crowned with a laurel wreath by a symbolic figure of Victory. The duke is surrounded by his officers, whose horses trample three nude figures, identified variously as defeated adversaries or as personifications of anarchy, discord, and tyranny. This central medallion is set against a background of radiating reeding, suggesting the glorious rays of a bursting sun. The wide border is composed of ten richly chased reliefs depicting nine triumphal events in Wellington's Peninsular campaign, with the tenth portraying the conferring of his dukedom by the Prince Regent in 1814. Thus, like the release of Andromeda by Perseus from the jaws of the sea monster, Wellington was honored for releasing his country from the jaws of the French.

The bankers and merchants of London raised more than £7,000 for this tribute. A competition was held for the design and was won by a painter, Thomas Stothard. In 1821, the execution of Stothard's design was entrusted by the retailers Green, Ward and Green to Benjamin Smith, one of the most important silversmiths of the Regency period. It took such a highly accomplished silversmith to achieve the decoration indicated in Stothard's design, in which massiveness, reminiscent of imperial Rome, had become an accepted Regency standard of taste. This monumental and exceptionally well executed work of art, intended only for display, became the archetype for presentation shields of the prosperous and confident Victorian period, further establishing this form as a traditional way to honor the triumphs of the nation's heroes.

ROGER M. BERKOWITZ

ATTRIBUTED TO THE PAINTER
OF THE WEDDING PROCESSIONS
GREEK, 4TH CENTURY B.C.
SIGNED BY THE POTTER NIKODEMOS
PANATHENAIC PRIZE AMPHORA
363/62 B.C.
TERRA COTTA
HEIGHT 35 INCHES (89 CM)

THE J. PAUL GETTY MUSEUM,
MALIBU, CALIFORNIA

COMPETITIONS IN ATHLETICS, MUSIC, AND POETRY ACCOMPANIED IMPORTANT RELIGIOUS festivals in ancient Greece. The most prestigious of the so-called cash games were held at the Greater Panathenaia, celebrated every four years in Athens to honor the patron goddess, Athena. Winners received valuable olive oil, pressed from the trees sacred to Athena and presented in special vessels called Panathenaic amphorae, which themselves became prestigious mementos of victory.

Panathenaic amphorae can be recognized by their distinctive shape, decoration, and inscriptions, but, within these conventions, the Painter of the Wedding Processions has created a masterpiece. On one side, armed Athena strides forward, flanked by columns supporting winged Nikai (divine personifications of victory). Athena in this configuration is symbolic of the games, and the image may well represent a statue on the Athenian Acropolis that figured in the festival. The inscription in front of her reads TON ATHENETHEN ATHLON, "prize from the games of Athens." Behind Athena, the potter who made the vessel has signed his name, Nikodemos.

On the other side appears a quasi-mythical scene of athletic triumph. In the center, winged Nike alights on earth to crown the victorious athlete with a fillet. The naked athlete appears gracefully at ease, the embodiment of innate excellence that the Greeks called *arete*. He holds an olive sprig in his right hand; another fillet is wrapped around his left arm. An older clothed man, probably a judge, points in acknowledgment toward the victor while the defeated athlete leans on a post. The contest must have been in boxing, for both athletes hold the long leather thongs that served as boxing gloves.

Painters decorated Panathenaic amphorae in the black-figure technique (with figures rendered in black silhouette and linear detail incised onto the surface so that the color of the clay might show through) long after it went out of fashion for all other vessels; clearly it carried the powerful authority of tradition. The tall, slender vessel, however, follows contemporary form, and the scene of Nike crowning the victor reflects the elegant naturalism of Late Classical style. The Athena retains the formal quality of the earlier Archaic style, but her direction, elongated shape, and mannered pose and clothing all reflect trends from the mid-fourth century B.C.

BONNA DAIX WESCOAT

Thomas Eakins
American, 1844–1916
SALUTAT
1898
Oil on canvas
50⅛ x 40 inches (127.3 x 101.6 cm)

Addison Gallery of American
Art, Phillips Academy,
Andover, Massachusetts,
gift of an anonymous donor

Salutat is part of a larger prizefighting series that Thomas Eakins executed in the last years of the nineteenth century. Eakins had devoted himself almost exclusively to portraiture for many years before returning to sporting images, a theme he had pursued earlier in his career. The boxing series allowed him to study the male nude and seminude form in motion and repose, a theme he had explored in his photographic studies of the 1880s. Study of the nude figure was crucial to Eakins's art, so much so that he studied anatomy at Jefferson Medical College after attending the Pennsylvania Academy of the Fine Arts. Eakins went to Paris in 1866, where he studied in the studios of Jean-Léon Gérôme, Léon Bonnat, and the sculptor Pierre Dumont. After several years of study and travel in Europe, Eakins returned to Philadelphia to join the faculty of the Pennsylvania Academy. As an instructor, he eschewed all study from casts in favor of the live nude, and it was his insistence upon the use of nude models for both his men's and women's classes at the academy that had forced his resignation in 1886.

Salutat is a full-scale genre scene, yet the individualized figures are a series of portraits. Among them are several of Eakins's fellow fight-goers, including a sportswriter and several artists. The fighter is Billy Smith, a champion featherweight who fought under the name of "Turkey Point" Billy Smith. He posed for Eakins on several occasions, and the two developed a close acquaintance that lasted throughout their lives.

The celebration of athletic achievement was a fundamental element of classical art, and Eakins's Salutat explores that tradition in modern times. The artist's prizefighter is a modern gladiator, standing in triumph in a hazy Philadelphia arena. He proudly salutes the crowd as he exits the ring. The painting has been compared to Gérôme's classical, academic paintings of Roman gladiators in a grand stadium—a comparison underscored by the fact that the original frame for Salutat bore the carved Latin inscription DEXTRA VICTRICE CONCLAMENTES SALUTAT, "with the right hand of victory he salutes the spectators," the title under which the painting was exhibited at the 1904 St. Louis World Fair.

ALISON MACGINNITIE

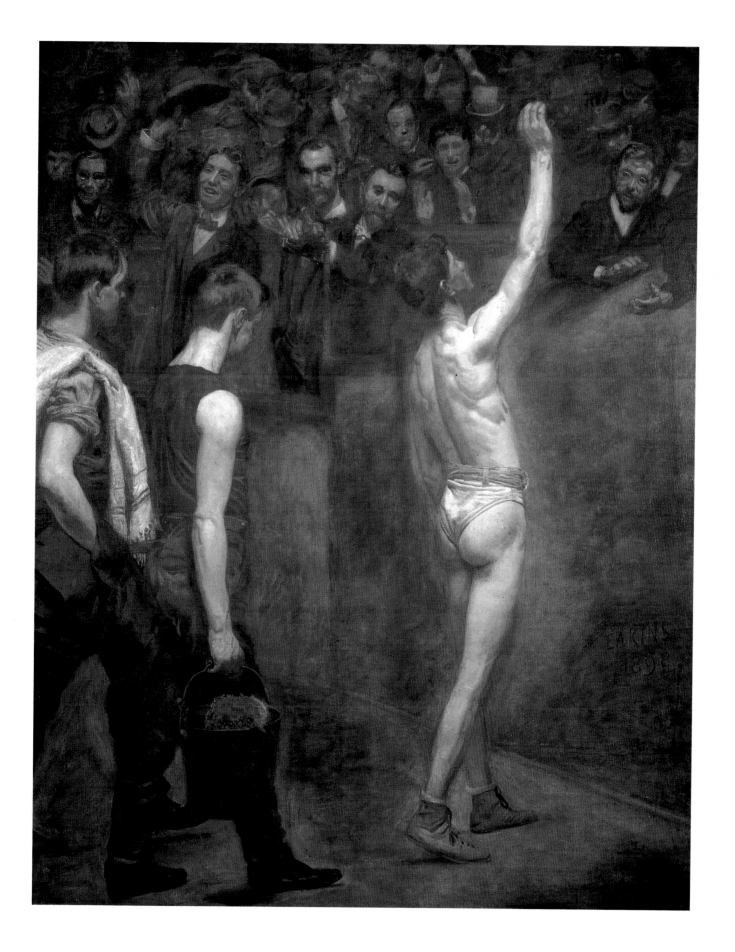

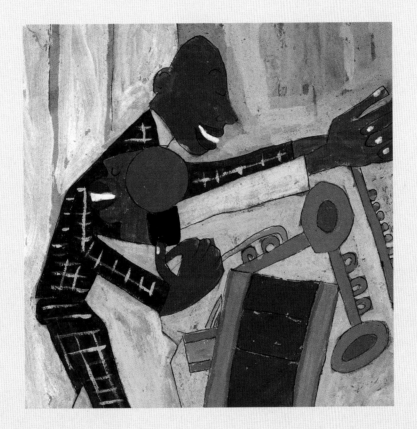

S MILING WITH HIS EYES, GERRIT VAN HONTHORST'S **THE MERRY FIDDLER** INVITES US TO
share his joy in music, in wine, and in the opulence of costly textiles. The smiling white porcelain from China
represents a popular reincarnation of the Buddha, Budai Heshang, who has been called the Asian Santa Claus.
The Hindu god Ganesha, well-fed in a continent where starvation was not unknown, is the playful god who
makes everything come out right. In China, the figure of Bo Juyi communicates to us directly the delight he
takes in each of his legendary Four Joys, and we enter the joy of Paradise in a Tibetan evocation. The joy of
the terra-cotta figure from Veracruz is beyond mere playfulness; it is the joy of religious ecstasy. The imme-
diate here-and-now joy induced by surf and sea and the insouciance of youth, enforced by the spontaneity of
gesture and virtuoso brushwork, encapsulates the joy of summer in the large canvas by the Spanish painter
Joaquín Sorolla y Bastida.

We then have the opportunity to savor joy in nature, in the life-renewing celebration of spring. Beginning
with a lyrical Japanese folding screen, we also can participate in the joyfulness of a famous Chinese painter's
mastery of the spontaneous wet brush, as it communicates the abundance of nature with a dithyrambic
abandon verging on twentieth-century abstraction.

Discovery of Japanese art in Europe after the Meiji Revolution in the 1860s had an enormous impact on
Western artists. No European painter was more impressed by Japanese art or brought more intensity to his
response to nature than Vincent van Gogh. His love of blossoms and joy in the renewing powers of nature he
himself felt particularly intensely in moments of remission from the effects of a recurring manic-depressive
debility that would periodically force him to stop painting. We see him celebrating early spring, and then the
swelling progression of nature as a wheatfield begins to ripen in the wind.

Joy in flowers is evoked in many ways. There is the meticulous opulence of Jan van Huysum, with its own
reference to spring and rebirth in the little bird's nest at the bottom. Easily one of the most joyful painters
throughout a long career was Claude Monet. His backlit *Woman with a Parasol*, caught amid wildflowers and

a fresh breeze, causes viewers, involuntarily, to catch their breath. Monet's love of flowers and his own garden at Giverny is expressed in the loosening brushwork as his art developed (to the point, seen at close range, of virtual abstraction). Visual joy, as it approaches the abstract, is then developed, beginning with the expressively powerful simplicity of Georgia O'Keeffe. Joy in spring is rendered in total abstraction by the dynamic brushwork of the influential German-American painter and teacher Hans Hofmann.

The group of ceramics that follows combines painting and sculpture in a medium where joy in abstracted nature carries out the theme of floral abundance and ends with the exuberance of the spiral. The large Matisse *Acanthus* explodes in a profusion of intense color in a ceramic mural that has been packed away in storage for almost the entire half-century since its creation, and is here reproduced for the first time. A series of ceramics from different cultures follows, evoking joy: in flowers, from the master Japanese potter Ninsei; in the brilliance of Iznik floral painting from the Turkish Ottoman kilns; in Chinese export ware for the Portuguese aristocratic market; in a fifteenth-century blue-and-white Chinese covered vase of a kind that defined ceramic quality for generations; in a lyrical large blue plate from seventeenth-century Iran; in a bowl from Arizona of the eighth-to-tenth centuries A.D. with its captivating spiral of birds; or in the dazzling spirals from the first half of the fifteenth-century B.C. in ancient Crete.

The swirl of these circular forms is echoed in the colorful disks in the abstraction by the Czech pioneer František Kupka prefiguring music (and in fact subtitled *Study for Fugue in Two Colors*), bringing to a symphonic level of abstraction a vocabulary whose circular shapes give further resonance to the concept of rings.

Music is evoked by Renoir's *Woman at the Piano*. We can imagine the sounds she is producing with fingers that seem to be in rapid motion over the keys, while that wriggling dark line in her dress connotes an almost Mozartian grace. A Cycladic harpist from as long ago as 2,500 B.C. strikes us with a simplification of form that seems wholly comfortable in the century of Brancusi. A fresco from the Italian Renaissance, an angel playing an instrument and dancing, provides a transition to the final section of Joy, swirling us into the dance.

The African-American artist William H. Johnson brings his sense of rhythm and color to *Jitterbugs (II)*; Elie Nadelman's *Dancer* from the Jewish Museum in New York kicks up her heels; the dancing Shiva, or Nataraja, from tenth-century India embodies the spirit of a god who danced the world into creation; Willem de Kooning seems to invite us to dance with the forms in his large painting of 1985; in Japan, music and the dance generate a sense of swirling abandon; while the spinning waltz and passion evoked by Camille Claudel, Rodin's pupil, assistant, and mistress, circles us back to the interlocking embrace with which the exhibition began.

Finally, Henri Matisse's *Dance (II)* of 1909–10 from the State Hermitage Museum in St. Petersburg catches us in its life-affirming rhythm and brilliant color. A ring of dancers, five in fact, linking hands, catches us up in an emotion that spins in our imaginations a kind of visual and rhythmic joy that, if we open ourselves to it, the arts can bring us, across boundaries of time and place, to penetrate recesses in our psyche that are, it is my firm belief, shared by all humankind.

J. C. B.

GERRIT VAN HONTHORST
DUTCH, 1590–1656
THE MERRY FIDDLER
1623
OIL ON CANVAS
42½ x 35 INCHES (108 x 89 CM)

RIJKSMUSEUM, AMSTERDAM

ONTHORST'S NATIVE CITY OF UTRECHT, THE PRIMARY CATHOLIC STRONGHOLD IN the predominantly Protestant Netherlands of the seventeenth century, had unusually close ties to Rome. Consequently, many painters from Utrecht traveled to Rome, and Honthorst was no exception. He made his artistic pilgrimage between 1610 and 1612 and remained in Rome for some time, enjoying a considerable reputation. By 1620, he was back in Utrecht, where he (and Dirck van Baburen, also newly returned from Rome) introduced into northern painting the single half-length genre figure. These life-size figures included musicians, shepherds and shepherdesses, and peasants, often depicted enjoying themselves while engaging the spectator. The idea, which met with great success, was apparently borrowed from Bartolomeo Manfredi, an Italian follower of Caravaggio, whom the artists might have known in Rome.

This painting is Honthorst's earliest known example of the half-length type. The artist has emphasized the volume of the violinist and heightened the illusionistic effect by placing the bulky figure behind a window ledge and extending his arm toward the viewer. Honthorst here employs Caravaggio's characteristic palette, the vitality and nearness of his figures, and the strong contrasts between light and dark, innovations that were quite new to northern art. What Honthorst contributed to Caravaggio's pictorial strategies is the directness with which his figure appeals to the viewer, almost proffering an invitation to join in the fun.

The violinist's outdated, theatrical costume and the suggestive symbols he holds might have carried specific associations to the seventeenth-century viewer that are now lost to us. Furthermore, *The Merry Fiddler* might have originally had a pendant. The *Flute Player* in Schwerin shares the dimensions, the height of the windowsill, the space in front of the painting, and the musical subject with the work in Amsterdam. Whether or not a further meaning was intended, *The Merry Fiddler,* alone or as part of a pair, was certainly intended to convey delight—in wine, music, and life.

RONNI BAER

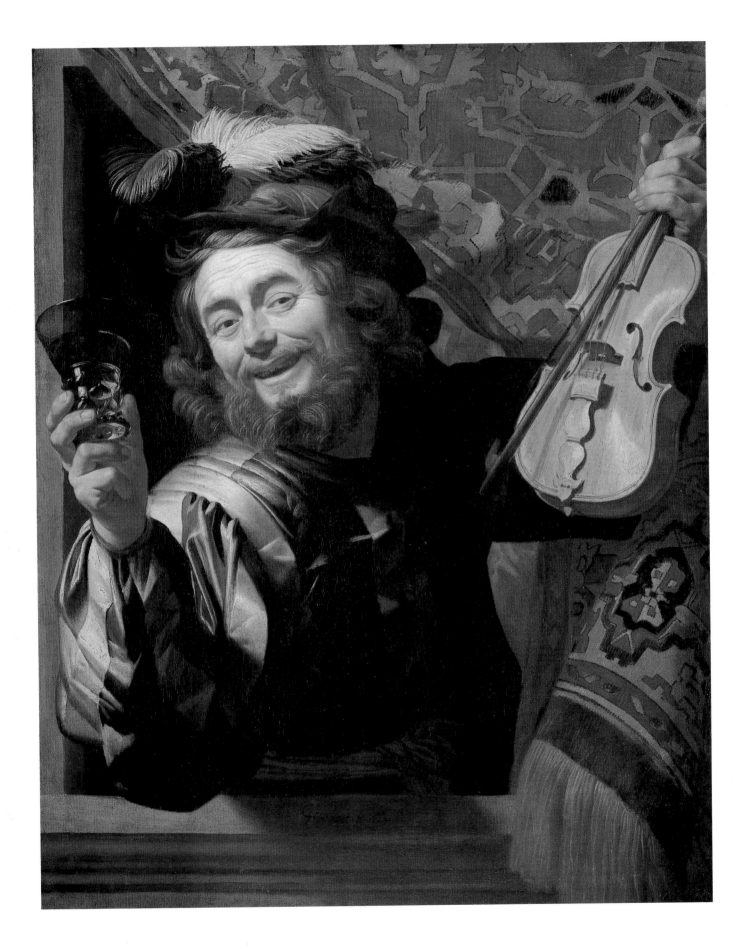

FIGURE OF BUDAI HESHANG
Late 17th century
Fujian Province, China
Dehua porcelain
Height 6⅞ inches (17.5 cm)

The Metropolitan Museum of
Art, New York, The Friedsam
Collection, bequest of
Michael Friedsam, 1931

ACCORDING TO LEGEND, QI CI WAS A MONK WHO LIVED IN CHINA'S ZHEJIANG Province during the Five Dynasties period, A.D. 907–960. His date of birth is unknown. Qi Ci was a rather colorful figure. He would often go into town carrying a cloth sack containing his belongings on a stick. There he would beg for food whenever he saw it, talk to anyone who might be around, and sleep wherever he found himself at night. From his appearance and actions, most people thought he was insane.

Qi Ci was constantly reciting a poem about the Maitreya Buddha, but nobody understood what he was talking about. Eventually, in jest, he was given the nickname of "The Maitreya Buddha." It was only after he died in A.D. 917 that people realized Qi Ci really was the Maitreya Buddha, who had come to earth in one of his many incarnations.

Sculptures of the Maitreya in his incarnation as Qi Ci, or as he is popularly known, Budai Heshang, "The Monk with the Cloth Sack," can be found in Buddhist temples in China and Japan (where he is known as Hotei). He is always depicted as a laughing figure with a big stomach, and he is often carrying a cloth sack or a string of beads.

Representations of Budai Heshang frequently appear in Chinese ceramics. This particular figure is a fine example of the beautiful *blanc de chine* porcelain figures that were produced in the Dehua kilns of Fujian Province in the late seventeenth century. A similar Budai Heshang at Burghley House, Stamford, England, is listed in the Burghley House Inventory of 1688 as "one ball'd fryor sitting [in] My Ladys Dressing Roome."

SUZANNE G. VALENSTEIN

GANESHA

8TH CENTURY

MADHYA PRADESH OR

UTTAR PRADESH, INDIA

SANDSTONE

49½ x 26½ INCHES

(125.7 x 67.3 CM)

THE ASIA SOCIETY, NEW YORK,

THE MR. AND MRS. JOHN D.

ROCKEFELLER 3RD COLLECTION

GANESHA, CHILD OF THE HINDU GODS SHIVA AND PARVATI, SWAYS IN THE EXAGGERATED contrapposto of dance. His ten hands, instead of indicating his various attributes of power or carrying weapons, display gestures of dance. The sculptor has presented his fleshy body humorously, without mockery, working the sandstone to its highest expressive potential. Inasmuch as Hindu representations of divine figures function as visual theologies and theophanies, this vision of Ganesha is awe-inspiring; his ten hands, his well-integrated elephant's head and human body all bless the viewer both in the journey through the temple and through life. He is the god of easy passage and good fortune.

The various surrounding figures, objects he holds in his hands, his dress, and indeed his body, all refer to various narratives associated with his life, many of which are humorous. The lion's-skin skirt, the rosary, and the snake all mark him as the son of the ascetic Shiva. The broken tusk in one hand tells of the moment when, humiliated, Ganesha threw a piece of tusk to spite the moon, who laughed at him. His corpulent body also speaks of his sweet tooth, which he indulges regularly at the behest of his worshipers. And finally, his elephant head indicates his origins. While there are many myths associated with his birth, one is particularly evocative. One day, before bathing, Parvati patted her exfoliated skin into a boy's form and gave life to him. She asked her son to stand guard at the door while she bathed. Meanwhile, Shiva arrived and, not knowing Ganesha to be his son, asked him to step aside and give access to his wife. Ganesha, not knowing him to be his father, refused. In anger, Shiva slashed off his head. On hearing of the tragic event, Parvati commanded him to restore Ganesha's life with the first head he saw—hence, the elephant head.

This seemingly simple story imparts deep ideas about marriage, the relationship between animals and humans, and the passions that cleave and construct bodies, human and divine. Since this particularly sensuous representation of dancing Ganesha was probably placed in a niche at the beginning of the ritualized circumambulation accompanying a devotee's journey into the Hindu temple, the viewer would have been allowed to contemplate all of these matters and more while being graced by the presence of this joyous being.

ANNAPURNA GARIMELLA

CHEN HONGSHOU
CHINESE, 1599–1652

THE FOUR JOYS OF BO JUYI
1649
HANDSCROLL; INK AND COLORS ON SILK
12³⁄₁₆ x 114³⁄₁₆ INCHES (31 x 290 CM)

MUSEUM RIETBERG ZURICH,
CHARLES A. DRENOWATZ COLLECTION

THE KNOWLEDGEABLE OLD CRONE
DRUNKEN CHANTING
TALKING ABOUT MUSIC
MEDITATION

IN 1644, THE CHINESE EMPIRE WAS OVERTHROWN BY THE MANCHU REGIME. THE painter of this handscroll, Chen Hongshou, was threatened and deeply shocked by the new political situation. He suffered under the alien regime and led an unhappy, restless life in— as it seemed to him—an era without relief. This painting, however, created five years after the Manchu conquest, is not a document of grief and sadness; it is one of the most impressive and charming representations of joy and private pleasure in Chinese art.

The scroll shows the famous Tang dynasty poet Bo Juyi (772–846) as a personality completely at ease with life and nature. It does not depict him as the influential governor or the disappointed, exiled magistrate; instead, in four sections separated by short poetic colophons, the artist offers an insight into the intimate and quiet pleasures of this noble gentleman. The first episode shows the pensive poet awaiting inspiration. To the knowledgeable old crone at his side, he will soon recite his newly composed poem, expecting her judgment. In the second section, he has put a chrysanthemum in his hair and almost floats happily over the empty ground. In the following scene, we see the poet, author of the beloved and popular "Lute Song," in the company of a young lady musician, who is about to unveil the stringed instrument. Finally, in the fourth section, he sits on a luxurious banana leaf seeking relief in Buddhist meditation.

At the end of the scroll, the artist states that although he depicted the Four Pleasures of the Tang poet, he actually gave him the countenance of his friend, the government official Nan Shenglu, and that he let him play these joyful roles. This painting, created in dreadful times, revives ideal images of a golden past.

ALBERT LUTZ

(details)

DIVINE ASSEMBLY

1796

TASHI LHUNPO MONASTERY,
TSANG REGION, TIBET

COLORS AND GOLD ON COTTON

30¾ x 19 INCHES (79 x 48 CM)

MUSEUM OF FINE ARTS,
BOSTON, GIFT OF MISS
ELIZABETH G. HOUGHTON

THE CENTRAL IMAGE ON THIS TIBETAN RELIGIOUS HANGING PAINTING (**THANGKA**) IS a colossal tree. It sprouts from the world ocean of undifferentiated existence and unfolds into a radiant cosmos. In addition to fruit, it bears the pantheon and the spiritual lineage of one of the four orders of Tibetan Buddhism.

Buddhism originated in the sixth and fifth centuries B.C., in the border region of Nepal and eastern India, with the historical Buddha Shakyamuni. Shakyamuni taught a philosophy of "right living" that would allow the practitioner release from the endless cycles of suffering and rebirth that are fundamental to the Indian understanding of the world. Throughout the following millennium, succeeding generations of Buddhist adherents came to consider Shakyamuni as a deity and built up a complex pantheon of multiple Buddhas (enlightened beings) and related gods.

The form of Buddhism brought to Tibet is called *Vajrayana,* "the Indestructible Way" (*vajra* meaning "thunderbolt" or "diamond," *yana* meaning "way"), often termed Tantric or Esoteric Buddhism. Practitioners of Vajrayana Buddhism make use of intricate rituals as the means to reach the ultimate goal of enlightenment. Paintings such as this are used during rituals to visualize the divine realm and contemplate the transmission of knowledge.

At the very center of the tree, Shakyamuni sits on a lotus throne and from him emanates a rainbow aura. A host of Buddhas, fierce manifestations, and other divinities surround this central image. Above, clouds support important teachers and monks of the Geluk Order of Tibetan Buddhism, identifiable by their peaked yellow hats. Below the branches of the tree appear, among other deities, the four heavenly guardian kings dressed in elaborate armor. To the lower left is placed a group of auspicious emblems. At the lower right, Sumeru, the central world mountain, rises from a ring of golden peaks.

Taken as a whole, this painting depicts the entire philosophical-religious lineage of the Geluk Order. In Tibetan Buddhism, enormous respect is shown to teachers—from the Buddha himself through the adepts who brought the tradition to Tibet to the founders of the four orders and their various successors—for it is they who perpetuate the sacred and often secret teachings that offer the possibility of enlightenment. This vast branching tree, aglow with the joyful and triumphant fruit of its teachings, is a kind of vision of paradise, the ideal symbol of the continuity of divine and human knowledge.

DARIELLE MASON

ARTICULATED FIGURE

c. 700–900

Veracruz, Mexico

Terra cotta with polychrome

17 x 14⅜ x 7¾ inches

(43.2 x 28.9 x 19.7 cm)

New Orleans Museum
of Art, Louisiana, gift
of Mr. and Mrs. P.
Roussel Norman

This fully articulated figure from Late Classic Veracruz is one of only a few effigies created in ancient Mesoamerica whose separate limbs and head were tied on with string. Such capacity for actual movement is rare, as is the attention to anatomical detail. The figure's joyful countenance features not only prominent teeth but also laugh lines on his cheeks and under his eyes. Yet it is quite likely that he is not merely a happy person.

In contrast to Western art tradition, Mesoamerican human figures were very seldom represented as emotional beings. In fact, the world of external appearances and internal feelings did not gain prominence in these art styles at all. This may be explained by the widespread Amerindian belief that humans were but one of many cosmic players, natural forces—the landscape, animals, and spirits—being equal, if not dominant, in the scheme of things. Therefore, an emotional response to a specific situation was insignificant as a subject for art.

This figure's gleeful visage signals a more profound state of being than first seems evident. His joy may more accurately be described as ecstasy, almost certainly the result of altered consciousness. Mesoamericans believed that there were many simultaneous realities, which could be traversed by trance, often drug-induced. Drugs in the ancient Americas were plentiful—more than a hundred hallucinogenic plants were known there, as compared with fewer than ten in the Old World. The plants were not used recreationally but were considered special doorways to other realms. The tendrils and dots on this figure's headdress have been interpreted as the vine and hallucinogenic seeds of the morning-glory plant. His transported state of consciousness, representing a sacred duty to travel the cosmos, connects his ecstasy with an intense religious fervor found in all times and places.

REBECCA STONE-MILLER

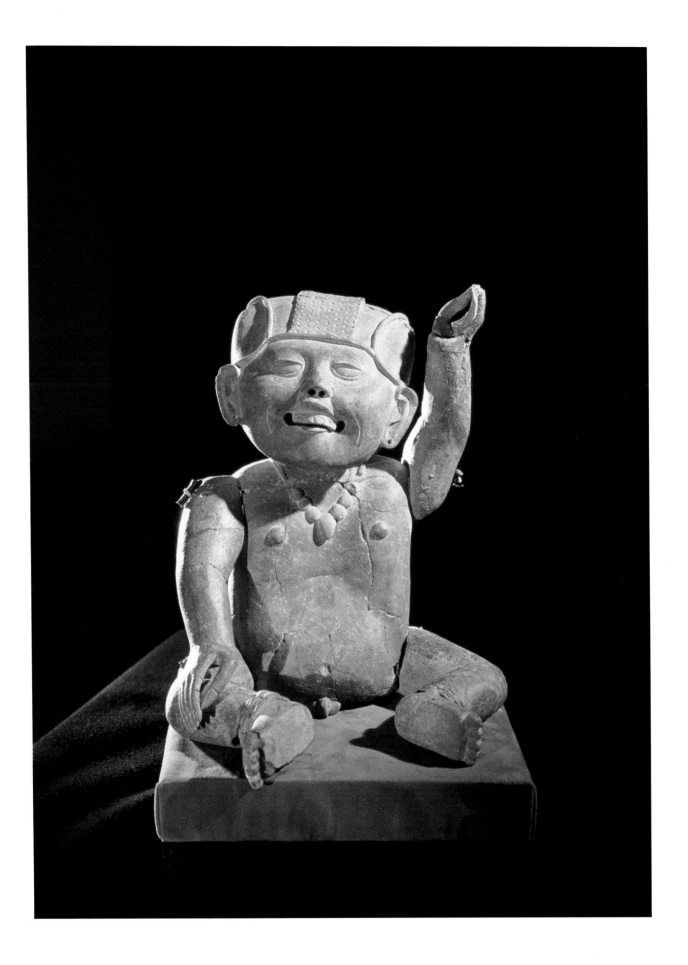

SOROLLA WAS THE GREAT MASTER OF THE PAINTERLY TRADITION IN SPAIN. TRACING HIS artistic lineage back to Diego Velázquez, he worked to extend the legacy of his native Spain into the competitive markets of contemporary Europe. In fact, he can be considered among the first truly international Spanish artists of the modern period, and, after many appearances at juried exhibitions in Paris, Munich, Vienna, and London, he was the subject of major mono-graphic exhibitions in Paris (1906), Berlin (1907), London (1908), New York (1909), and Chica-go (1911). His friends and artistic peers were the American John Singer Sargent, the Swede Anders Zorn, and the Italian Giuseppe Boldini, all of whom competed with Sorolla for the crown of the greatest society portrait painter. Sorolla's popularity was immense, and his New York exhibition, held at the Hispanic Society, broke all the attendance records for the society, luring nearly 160,000 people, who bought a whopping 20,000 catalogues, as well as 195 of his paintings, for a then-staggering amount, in excess of $180,000.

Sorolla and his wife made the first of several trips to the United States to attend the open-ing of the New York exhibition, returning to Spain in the summer to recuperate from the social whirl of the United States, where Sorolla's fame—and skill—led to a commission to paint the portrait of President Theodore Roosevelt in the White House. When he arrived in Spain, Sorolla immediately took a beach house on the Mediterranean port of Valencia, where he painted *The Two Sisters*.

Sorolla was already well known as a masterful painter of the beach and of the complex visual interaction of nude children, rustling drapery, sand, sun, and water. Like his compatri-ots among the Impressionists in France, Sorolla liked to work out-of-doors, and photographs from the summer of 1909 show him painting canvases even larger than this one directly from life on the beach. Although *The Two Sisters* represents two wonderfully alive figures, the sub-ject of the painting is surely "light." The older girl shields its brilliance from her eyes with one arm as she holds the hand of her baby sister with the other. The play of that light on her bril-liant white swimming costume is the "motif" of the painting.

This self-consciously brilliant painting made its first appearance in the 1911 Sorolla Exhi-bition held at the Art Institute of Chicago; at that time, it was acquired by the great Sorolla patron Thomas Fortune Ryan of New York. The work was later sold to the Norths, who insured its return to Chicago. Sorolla spent a good deal of the winter of 1911 in Chicago, where he paint-ed several superb society portraits and taught at the Art Institute of Chicago with his friend and rival Anders Zorn.

RICHARD R. BRETTELL

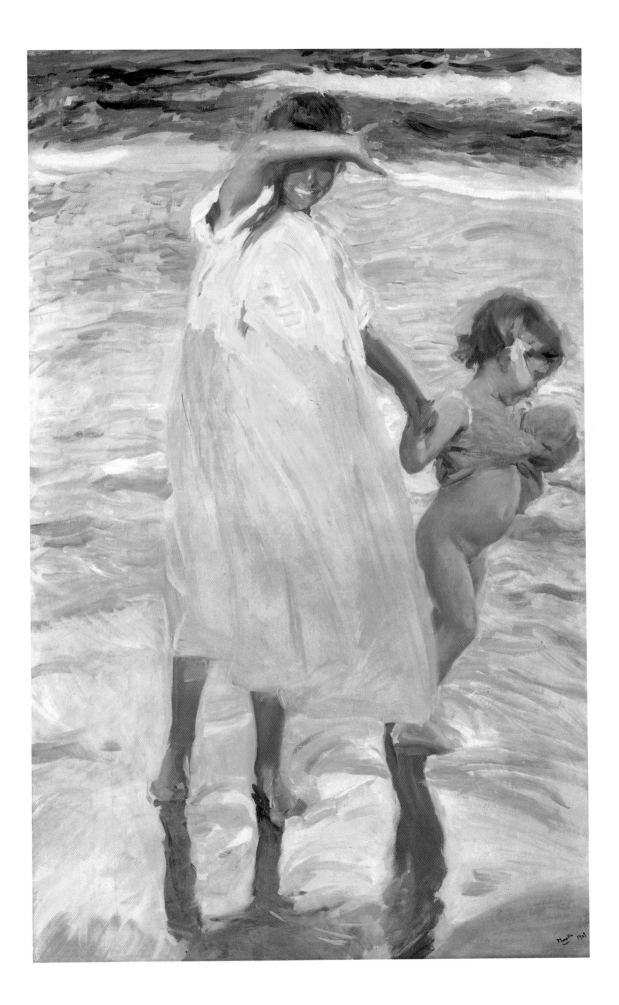

ANY HEART MUST BLUSH WITH JOY IN THIS SYMPHONY OF FORM AND COLOR, a lacework of blossoms on large arcs of flat green accented by scallops of golden mist and set against a solid ground of gold leaf. This dramatic design is only part of a grand composition for a pair of screens that have recently been reunited. In its time, this image immediately and unmistakably evoked the eagerly awaited vernal procession of pink and white cherry blossoms that ascends the separate ranges of the densely wooded Yoshino Mountains to the southeast of Japan's ancient capital at Nara. The fleeting glory of their flowering evinces the inexorable transitions of nature and human life. Here a filigree of falling petals adds a temporal element, subtly underscoring the poignance of this vision of ephemeral beauty.

Celebrated since ancient times for its myriad *yamazakura,* the wild cherry, the mountains of Yoshino are also deeply imbued with history and poetry. The site of an imperial palace built for the Empress Jitō (ruled 687–96), Yoshino's scenery has drawn admirers from ancient time to the present. At the end of the twelfth century, its forbidding recesses gave refuge to the tragic warrior Minamoto no Yoshitsune (1159–1189). A century later, the dissident Emperor Godaigo (1288–1339), who tried in vain to reestablish imperial power in the early fourteenth century, found haven for his court in Yoshino.

Cherry blossoms at Yoshino, scattered all too soon, still touch the heart as they have since the early tenth century, when they were cited in the commanding preface to the *Kokinshū,* the first imperial anthology of poetry. Here textured layers of blossoms, clouds, and hilltops elicit emotions of countless poems. This one, chosen as the opening verse of the nearly two-thousand-poem sequence of the *Shinkokinshū,* the early thirteenth-century compilation still considered to be the finest among all anthologies of court poetry, conveys the feeling embedded in this gorgeous painting:

> *miyoshino wa* Lovely Yoshino:
> *yama mo sasumite* haze drifts over the hills
> *shirayuki no* and in a hamlet
> *furunishi sato ni* where snow was falling,
> *haru wa kinikeru* spring has come.

> —Gokyogoku Yoshitsune
> *Shinkokinshū,* 1.

BARBARA FORD

Xu Wei
Chinese, 1521–1593
INK FLOWERS
Ming dynasty
Handscroll; ink on paper
14⁹⁄₁₆ x 411 inches (37 x 1044.5 cm)

Nanjing Museum, People's
Republic of China

One of the great virtuoso performances in Chinese art, this extraordinary handscroll by the sixteenth-century painter Xu Wei is an eloquent example of how the same passions that excited murderous rage could inspire artistic exuberance. The Chinese van Gogh, Xu Wei fits the description of the mad genius: unstable and violent. Xu punctured his ear with a nail and killed his third wife. Yet he was one of the foremost dramatists, as well as painters, of the Ming dynasty, revered by posterity as a folk hero.

In this painting of flowers and fruits, the ink forms that Xu flings and drips onto the paper are, in their avoidance of naturalistic detail, at times barely decipherable as plants. Yet it was only through this kind of abstract ink-play that he achieved what he defined as authenticity in art—the capturing of life rather than likeness. This is painting akin to natural creation: it aims to make visible the continuous process of growth and transformation that distinguishes living organisms from inanimate things. The ever-changing nature of the organism is conveyed not through a precise surface description of color, shape, and texture, which locks an image into a single manifestation, but rather through a suggestive pattern of brushstrokes rendered with such vitality that the act of painting becomes synonymous with the process of natural growth.

A poem inscribed on the painting reveals Xu's artistic method: "I never copy from . . . [painting] manuals but trust to my hand, whereupon the spirit [of the subject] flows from the brush." It is as if the artist's task is to reveal an essence that is already embodied in the ink. The brush is the instrument of revelation, and the hand becomes an extension of the brush. The artist paints as if possessed and comes to inhabit his subject through the ink. Yet the seemingly spontaneous explosion of ink in splashes, drops, puddles, and threads is in fact a perfectly counterbalanced interplay of dark and light tones and wet and dry effects, where any excesses of nature are held in check by the abstract ink pattern that is never out of control. This painting is a testimony to the sheer joy of living, expressed not in human terms but through the life of plants.

WAI-KAM HO AND DAWN HO DELBANCO

1

5

6

8

10

(details)

VINCENT VAN GOGH

DUTCH, 1853–1890

**FLOWERING PEACH TREE
(SOUVENIR DE MAUVE)**

1888

OIL ON CANVAS

28¾ x 23½ INCHES (73 x 59.5 CM)

KRÖLLER-MÜLLER MUSEUM,
OTTERLO, THE NETHERLANDS

IN FEBRUARY 1888, VAN GOGH—A DUTCHMAN LIVING IN FRANCE—LEFT PARIS TO explore Provence, "wishing," he wrote, "to see a different light, thinking that looking at nature under a bright sky might give us a better idea of the Japanese way of thinking and drawing."[1] During two years in Paris, he had bought dozens of Japanese woodblock prints and conceived a fantasy of moving to the idyllic Asian isle their imagery conjured: a land of lush landscapes and intriguingly exotic characters. Unable to realize so dramatic an escape, Van Gogh settled for relocation to the South of France. As he told his brother in a letter, "We like Japanese painting . . . all the impressionists have that in common; then why not go to Japan, that is to say the equivalent of Japan, the South?"[2]

He settled in Arles and soon began painting flowering fruit trees, a motif he had admired in Japanese prints and one suggestive of regeneration and invigoration—themes appropriate to the commencement of a new life in a new place. The buoyant mood inherent to his subject matter was enhanced by the animated brushwork Van Gogh developed in Paris and his new-found passion for bright hues. Using his brush almost like a drawing implement, he employed both Impressionistic impasto and delicate Pointillist stippling to achieve textural richness and—in pictures like *Flowering Peach Tree*—created bold coloristic effects unconstrained by strict naturalism (hence, sky-blue tree trunks contoured in red).

By the end of April, as the Arlesian orchards lost their blossoms, Van Gogh had made fourteen canvases of flowering trees. Around the same time, he received a clipping eulogizing his former mentor, Anton Mauve, a prominent Dutch artist and a relation by marriage. Mauve had tutored Van Gogh in the rudiments of drawing and painting before their falling out in 1882. Now, in a burst of sentiment, Van Gogh dedicated *Flowering Peach Tree* to Mauve's memory, signed his painting (which he rarely did), and sent it to Mauve's widow. Rejecting the conventionally elegiac, Van Gogh chose to counter death with an ebullient emblem of renewed and ongoing life.

JUDY SUND

1. *Complete Letters of Vincent van Gogh*, 3: 207–8.
2. *Complete Letters*, 2: 589.

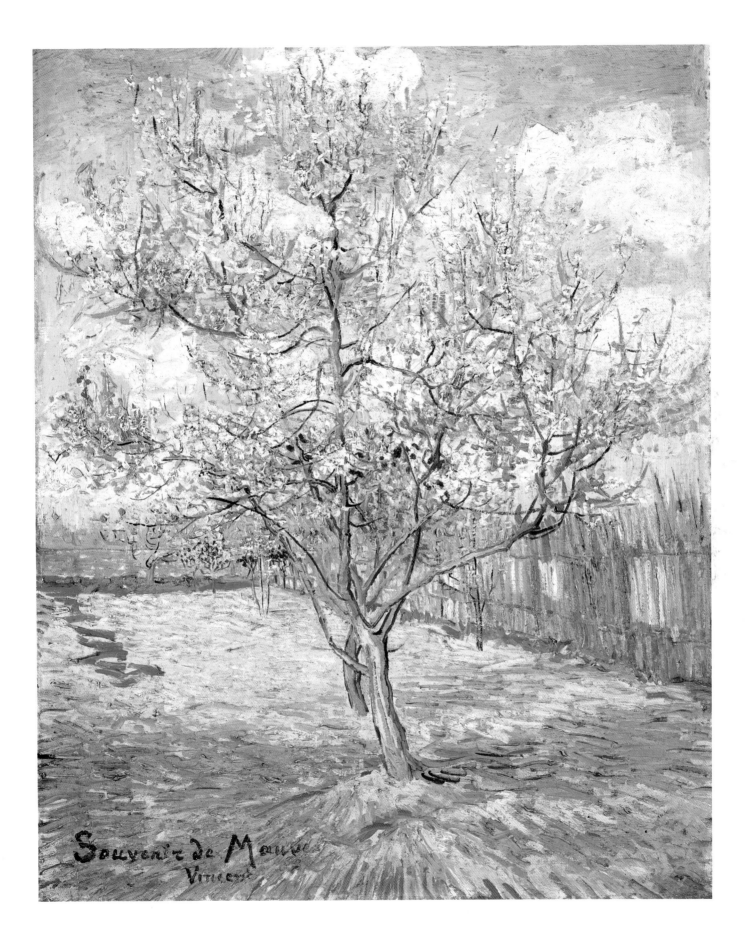

Jan van Huysum
Dutch, 1682–1749
FLOWERS IN A TERRA-COTTA VASE
c. 1730
Oil on panel
31½ x 24 inches (80 x 61 cm)

French & Company, Inc., New York

J an van Huysum was born in Amsterdam, and there is no record of his ever leaving that city. He seems to have worked in extreme seclusion, jealously guarding the secrets of his techniques and materials. Van Huysum's success was tremendous. He received commissions from several European monarchs and commanded high prices; his works maintained their value and continued to be held in high esteem for centuries after the artist's death.

Van Huysum's fame rests largely on his flower and fruit paintings, in which his colors were lighter and brighter than in earlier Dutch art. He painted a large number of pairs, usually a flower painting matched with an arrangement of fruit. This pairing is thought to show the joyous glory of creation by the beauty of the seasons: the flower painting signals the spring and early summer, the fruit picture refers to late summer and autumn. In this painting, the bird's nest is also a spring element.

This composition, surely one of van Huysum's finest achievements, contains the characteristic elements of this artist's work—a light, almost pastel background, with a garden landscape and a classical statue. While the optical center of the work is the white rose, the combination of the morning glory at the bottom and the poppy at the top may hark back to the day and night (good and bad) symbolism of the seventeenth century: the morning glory opens only in the day, and the narcotic opium is extracted from the poppy.

S. SEGAL

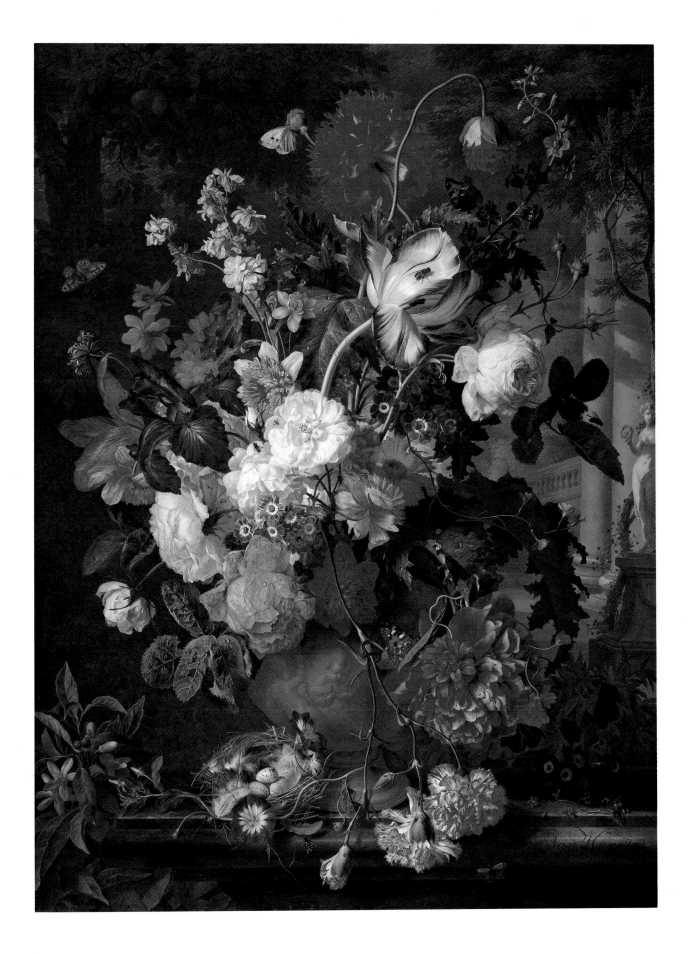

THE SUBJECTS OF THIS PAINTING BY CLAUDE MONET WERE HIS WIFE, CAMILLE, AND their seven-year-old son, Jean. Claude and Camille first met during the 1860s as artist and model. In 1866, Camille became pregnant by Claude, a development that stirred the wrath of Monet's staunchly middle-class father. Their son Jean was born in August of 1867, but the couple did not marry until July of 1870. Shortly thereafter, Monet fled France because of the outbreak of war with Germany, and, for the next two years, the artist and his family lived first in London and then in Zaandam, Holland. In 1872, they returned to France and settled near Argenteuil, where Monet found an almost idyllic setting both for his family life and his work. *Woman with a Parasol* was executed during these happy days at Argenteuil, and, while the relationship between Camille and Claude Monet was not always a loving one, this picture radiates intimacy and warmth. Camille died in 1878, after the birth of their second son, Michel.

During the 1870s, Monet devoted himself almost exclusively to landscape painting, but he was also capable of producing highly innovative figure paintings, as *Woman with a Parasol* demonstrates. The low vantage point from which the figures were painted was an unusual compositional maneuver that allowed for the dramatic framing of the back-lit figures of his wife and son against the cloudy sky. The degree to which this painting features Monet's painterly virtuosity is also striking. As one leading Monet scholar, John House, has noted, the freedom of brushwork seen here is not present in the more highly finished works he produced for his dealers during this time. *Woman with a Parasol*, which was probably executed out-of-doors, appears not to have been finished in the studio, as was Monet's usual practice, and one guesses that the private nature of the subject played a role in Monet's decision not to continue work on this extraordinarily fresh and exhilarating masterpiece of Impressionist painting.

DAVID A. BRENNEMAN

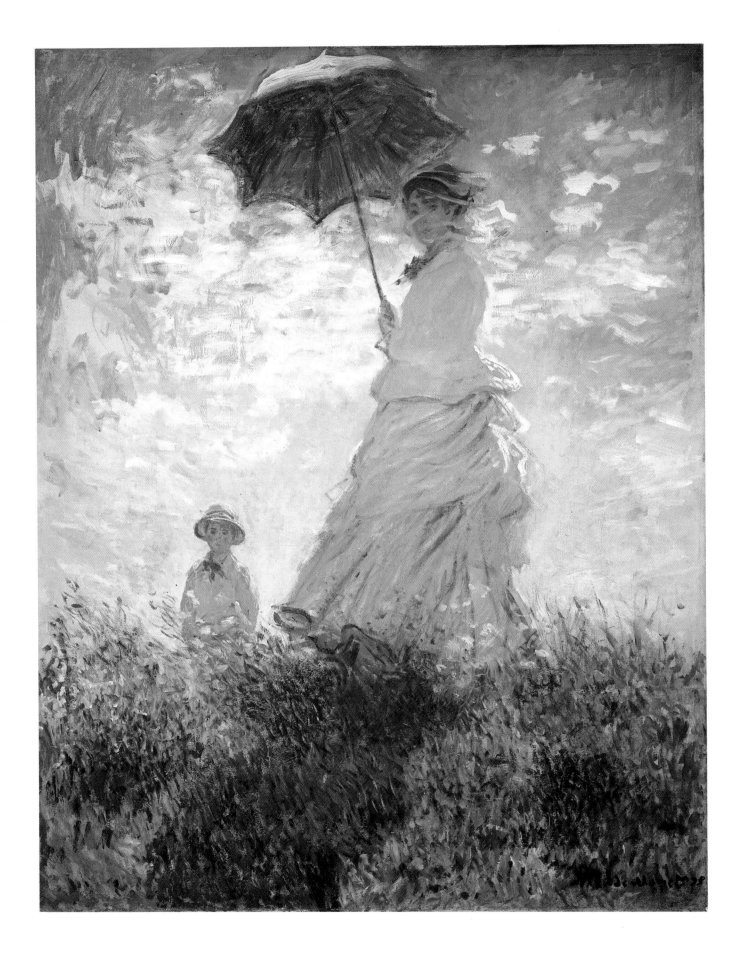

Vincent van Gogh
Dutch, 1853–1890
WHEATFIELD WITH CYPRESS
1889
Oil on canvas
29 x 36½ inches
(73.5 x 92.5 cm)

National Gallery, Prague,
The Czech Republic

Wheatfield with Cypress was made in the early months of Van Gogh's year-long stay at an asylum in St.-Rémy-de-Provence. He had suffered a series of nervous collapses at Arles—commencing with the famous incident of December 1888, in which the artist severed a portion of his own ear—and in May 1889 voluntarily committed himself to the care of Dr. Peyron in St.-Rémy. Van Gogh could not paint when he was ill, but his crises alternated with periods of great lucidity and productivity. After being confined to the walled precincts of the institution during his first weeks there, Van Gogh was delighted to venture into the surrounding hills and paint in the open fields.

In this era, Van Gogh preferred closely keyed color schemes to the juxtapositions of coloristic opposites he had favored at Arles, and though he did not entirely abandon the bright hues of the previous year, he was increasingly attracted to grayed and pastel tonalities. In keeping with these tendencies, this picture is dominated by cool blues and greens (many made chalky by an admixture of white paint), subtly offset by golden yellow touches that, according to the painter, "have the warm tones of a bread crust."[1] The painting's focal point, "a tall and somber cypress,"[2] provides a vertical accent in a predominantly horizontal composition and a note of sobriety in a vista of sun-washed amplitude.

The visual energy of Van Gogh's late works—as well as the artist's comments on them—indicates that they are not mere topographies, but meditations on the human condition mirrored in nature. Wheatfields and cypresses are recurrent motifs, not only because they bespeak Provence, but also because of their evocative potential. Ripening wheat suggests life's unfolding, for "in every man who is healthy and natural," Van Gogh wrote, "there is a *germinating force* as in a grain of wheat. . . . Natural life is germination."[3] The cypress, as corollary to harvestable grain, connotes mortality, the natural accompaniment to the cyclical completion mature crops imply. A fixture of Mediterranean cemeteries, the cypress was also—to Van Gogh's eye—"a splash of *black* in a sunny landscape,"[4] and from St.-Rémy he wrote that "cypresses are always occupying my thoughts." As pictorial motifs, they serve as foils to the vibrancy of blue sky, scudding cloud, and ripening wheat, to remind the viewer of the evanescence of such natural spectacles, and—on a more personal level—they emblematize the musings on death that vivified rather than overwhelmed the satisfactions of Van Gogh's own artistic maturity.

JUDY SUND

1. *Complete Letters of Vincent van Gogh*, 3: 453.
2. *Complete Letters*, 3: 453.
3. *Complete Letters*, 3: 425; his emphasis.
4. *Complete Letters*, 3: 184; his emphasis.

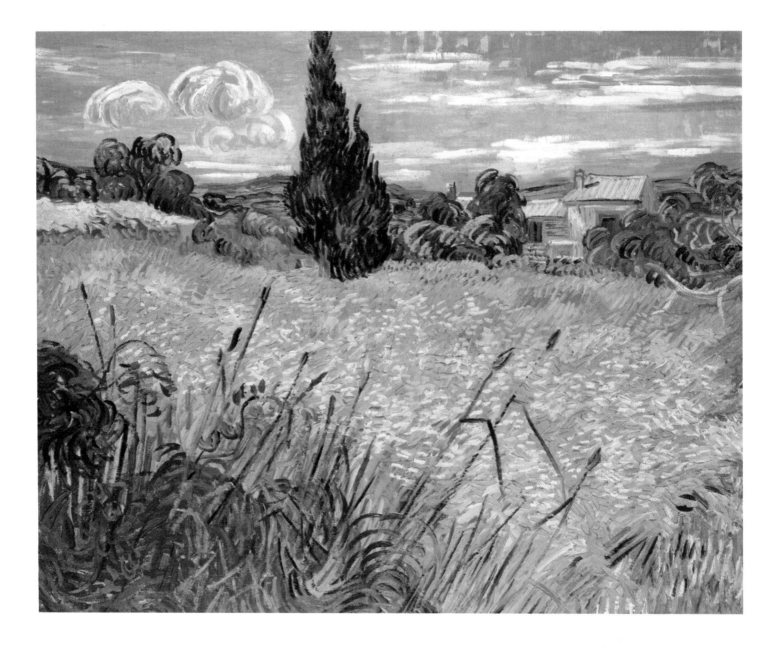

CLAUDE MONET
FRENCH, 1840–1926
THE ARTIST'S GARDEN AT GIVERNY
1900
OIL ON CANVAS
35¼ x 36¼ INCHES (89.5 x 92.1 CM)

YALE UNIVERSITY ART GALLERY,
NEW HAVEN, CONNECTICUT,
COLLECTION OF MR. AND
MRS. PAUL MELLON

In 1890, Monet bought a house in Giverny, a small town located along the Seine River about forty miles northwest of Paris. The artist's increasing prosperity allowed him to plant lavish gardens and to augment substantially an existing lily pond. The garden became something of an obsession for the artist, and he became intensely involved in the planting of an astonishing number and variety of flowers. The specific part of Monet's garden depicted in this painting was called *Le clos normand*, or the Norman enclosure. A contemporary visitor described this section of the garden: "There is an even and soft lawn; the gentle shade of the apple trees there shelters the broad beds of Irises from which violet blots follow the quick burst of light passing from the trees into the flowers."[1] The garden became an increasingly important subject for Monet's painting, and his visual pleasure in it is evident in the sheer number of works that take as their subject the flowers, trees, and pond that he had so carefully installed there.

This work, now titled *The Artist's Garden at Giverny*, was produced following the critical and commercial success of his series paintings during the late 1880s and 1890s. The self-confidence that resulted from the reception of the series works appears to have enabled Monet to push into increasingly abstract applications of color. As one can see in this work, the joyous riot of color produced by the numerous varieties of flowers in the artist's garden provided the perfect subject for such explorations.

DAVID A. BRENNEMAN

1. J.-C.-N. Forestier wrote in his *Jardin de M. Cl. Monet:* "C'est une pelouse plate et douce; l'ombre légère des pommiers y abrite de larges touffes d'iris dont les taches violettes succèdent à l'éclat vite passé des arbres en fleurs." Quoted in Daniel Wildenstein, *Claude Monet,* 5 vols. (Lausanne-Paris, 1985), 4:192.

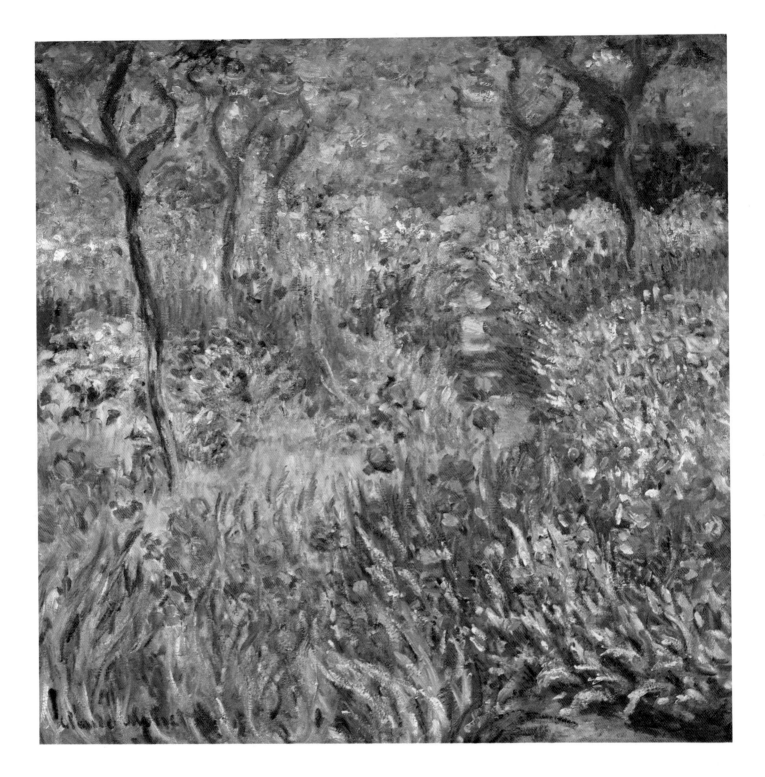

HANS HOFMANN
AMERICAN, BORN IN GERMANY,
1880–1966
AU PRINTEMPS (SPRINGTIME)
1955
OIL ON CANVAS
48 x 36 INCHES (121.9 x 91.4 CM)

FRANCES LEHMAN LOEB ART
CENTER, VASSAR COLLEGE,
POUGHKEEPSIE, NEW YORK,
GIFT FROM THE COLLECTION
OF THE LATE KATHERINE
SANFORD DEUTSCH, CLASS
OF 1940

LIKE MANY EUROPEAN ARTISTS WHO IMMIGRATED TO THE UNITED STATES ON THE EVE of World War II, Hans Hofmann was an established artist and respected teacher. Early in the century he had lived in Paris, where he associated with Pablo Picasso, Henri Matisse, and Robert Delaunay. Just before World War I, he returned to his native Germany and founded an art academy that attracted students from Europe and the United States. To the students who flocked to the school he opened upon arriving in New York in 1934, Hofmann represented a direct link to European modernism. Through the example of his own painting—an expressionist synthesis of Cubism and Fauvism—and his influence as a teacher, he became a guiding force in the emergence of Abstract Expressionism.

The work of Wassily Kandinsky provided a touchstone for Hofmann's art. When Kandinsky was forced to return to Russia at the outbreak of the war, Hofmann stored Kandinsky's canvases in his studio and so had ample opportunity to study them firsthand. Hofmann's admiration for Kandinsky is apparent in the few surviving works from Hofmann's years in Paris, and it reasserts itself from time to time over the years, such as in his Provincetown landscapes of the early 1930s and in this canvas, *Au Printemps*.

Nature served as an important point of departure in Hofmann's work. The artist believed that nature was "the source of all inspiration. Whether the *artist* works directly from nature, from memory, or from fantasy, nature is always the source of his creative impulses."[1] Here, earth and sky merge amid arrays of cosmically inspired details, reminiscent of Kandinsky's early *Improvisations*. Although the subject is landscape, Hofmann, like Kandinsky, eschews natural hues, preferring instead a bold palette of contrasting colors that reflects his faith in the ability of color to affect human emotions, to spark joy in the eye and heart of the viewer. With vivid oranges, yellows, purples, and reds, Hofmann captures the vibrant energy of new life as it bursts forth in the spring.

CARRIE PRZYBILLA

1. Hans Hofmann in *Search for the Real and Other Essays by Hans Hofmann*, eds. S. T. Weeks and B. H. Hayes, Jr., translated by Glenn Wessels (Andover, 1948), 65.

hanshofmann

GEORGIA O'KEEFFE
AMERICAN, 1887–1986
LEAVES OF A PLANT
C. 1942/43
OIL ON CANVAS
40 x 30 INCHES (101.6 x 76.2 CM)

PRIVATE COLLECTION,
SANTA FE, NEW MEXICO

WHEN GEORGIA O'KEEFFE PEERED INTO THE HEART OF A PLANT, SHE SAW SOMETHING of the joy and mystery of nature revealed there. "When you take a flower in your hand and really look at it," she said, "it's your world for the moment. I want to give that world to someone else."[1] To share that world, she painted her flowers and plants many times their actual size—large enough so they would not be missed.

O'Keeffe began to paint magnified flower details in 1919. By the 1940s she had looked at hundreds of them, studying their varied structures, capturing the intensity or delicacy of their colors, and inhaling the scents they released. In *Leaves of a Plant*, O'Keeffe's eye zeros in on the red-violet center of a brilliantly colored bromeliad. From its delicate, pulsing nerve center, plant energies explode into brilliant reds and greens that bleed into each other. The explosion stops at the cropped edges of the painting, where the energies plunge sharply back into the center, propelled by alternating white spears of space (a device O'Keeffe used in many other paintings) and sliding more gently down the concave green leaves.

The bromeliad is a relative of the pineapple plant, which the artist had first painted following a 1939 trip to Hawaii. There, and in earlier trips to Bermuda, O'Keeffe had encountered many tropical plants. She appreciated their exoticism and their brilliance, but her taste in plants was not dictated by rarity. With equal care she studied the recesses of a petunia and an orchid, a jimson weed and a rose. Flowers are, of course, the reproductive organs of the plant, and, from the beginning, critics seized upon O'Keeffe's flowers as private erotic statements, interpretations she vigorously denied. With or without that sexual content, we can see in *Leaves of a Plant* an unmistakable life force, a throb of joyous color that called upon all of O'Keeffe's skill to paint and all of our sensibilities to receive.

SHARYN R. UDALL

1. Mary Braggiotti, "Her Worlds Are Many," *New York Post* (16 May 1946), magazine section, 44.

HENRI MATISSE
FRENCH, 1869–1954
ACANTHUS
1953
CERAMIC
122½ x 138 INCHES
(311.2 x 350.5 CM)

COLLECTION OF CLAUDE
AND BARBARA DUTHUIT

THROUGHOUT HIS LONG AND PROLIFIC CAREER, HENRI MATISSE EXPLORED THE EXPRESsive potential of color. In the early years of this century, he joined forces with André Derain and Maurice de Vlaminck in seeking alternatives to the official art of the academies and the purely optical effects emphasized by the Impressionists. Taking their cue from the paintings of Paul Gauguin, Vincent van Gogh, and Paul Cézanne, these artists conceived of the picture plane as an alternative reality and sought to transcribe their feelings with color, in the most vivid and direct way possible, rather than simply reproduce what they saw. When they first exhibited these works at the Salon d'Automne in 1905, critic Louis Vauxcelles dubbed the group *Les Fauves*, or "wild beasts," because of their riotous use of color. By 1909, Matisse and the other Fauves had developed in independent directions and the movement had run its course. The original Fauve ideals, however, continued to shape Matisse's oeuvre.

Matisse experimented with a variety of mediums, including painting, sculpture, prints, book illustrations, set and costume designs, and ceramic tiles. His *gouaches découpées*, or cutouts, were a medium of his own invention. The cutouts' conflation of color and drawing appealed to the artist; he had sought this synthesis for years. "My *découpages* do not break away from my former pictures," he said. "It is only that I have achieved more completely and abstractly a form reduced to the essential."[1]

The ceramic *Acanthus* is the end result of a composition represented in a cutout of the same title (now in Basel, Switzerland). Its execution was personally supervised by Matisse, but it has never been reproduced in color until this exhibition. The acanthus is a common Mediterranean plant. Its leaves have inspired decorative designs, such as the capitals of Corinthian columns, since antiquity. The plant served as a natural source for Matisse as well: he frequently incorporated the shapes of foliage in his cutouts. Rendered in ceramic, *Acanthus* also reflects Matisse's well-known love of Islamic tiles, whose designs incorporate organic forms. The luster of its glazes adds brilliance to the work's vibrant combination of colors. This graceful composition seems to epitomize Matisse's lifelong ambition: "I have always tried to hide my own efforts and wished my works to have the lightness and joyousness of a springtime."[2]

CARRIE PRZYBILLA

1. Henri Matisse, "Testimonial," 1952, in *Theories of Modern Art,* ed. Herschel B. Chipp (Berkeley, 1968), 143. Originally published as "Témoignages," *XXᵉ Siecle* (Paris), January 1952, 66–80.
2. Henri Matisse, "Letter to Henry Clifford," in *Theories of Modern Art,* 140. Originally published in *Henri Matisse, Retrospective Exhibition of Paintings, Drawings and Sculpture Organized in Collaboration with the Artist* (Philadelphia, 1948), 15–16.

NONOMURA NINSEI
JAPANESE, C. 1574–C. 1660
**TEA LEAF CONTAINER WITH
CHERRY BLOSSOM DECORATION**
MID-17TH CENTURY
POTTERY WITH OVERGLAZE ENAMELS
11¼ x 10¹¹⁄₁₆ INCHES (28.6 x 27.1 CM)

SEIKADŌ BUNKO MUSEUM,
TOKYO, JAPAN

THE CERAMIC TRADITION OF KYOTO, KNOWN AS **KYŌYAKI**, STEMS FROM THE ELEGANT artistry of the seventeenth-century potter Nonomura Ninsei, whose genius as a decorator and technical skill at shaping and glazing brought early fame to the kiln he established in 1647 near the Ninna-ji temple in the Omuro district of northwestern Kyoto. This gracefully rounded and gorgeously decorated tea-leaf jar is among Ninsei's most striking works. In both motif and visual effect, it well represents the renaissance of art in Kyoto during the seventeenth century. Its black surface glistening with scatterings of gold leaf hints at the luxury of fine lacquer; clusters of falling cherry blossoms in brilliant hues of red and white and gold enamel suggest a vista of distant mountains shrouded in mist.

This could be no other image than the fabled hills of the Yoshino range. The poetic memory of cherry trees in bloom at Yoshino evokes centuries of courtly delight, extolled ever since the eighth-century paean to the legendary Empress Jitō's palace, built "where cherry blossoms fall\there she raised herself a mighty pillared palace" (*Manyo'shū* 78). An image that never fails to stir the Japanese heart with its multilayered emotional allusions, the Yoshino Mountains are splendidly rendered as ceramic decoration in echoing garlands of scalloped clouds that encircle the neck and the rounded forms of the blossom-covered hills.

BARBARA FORD

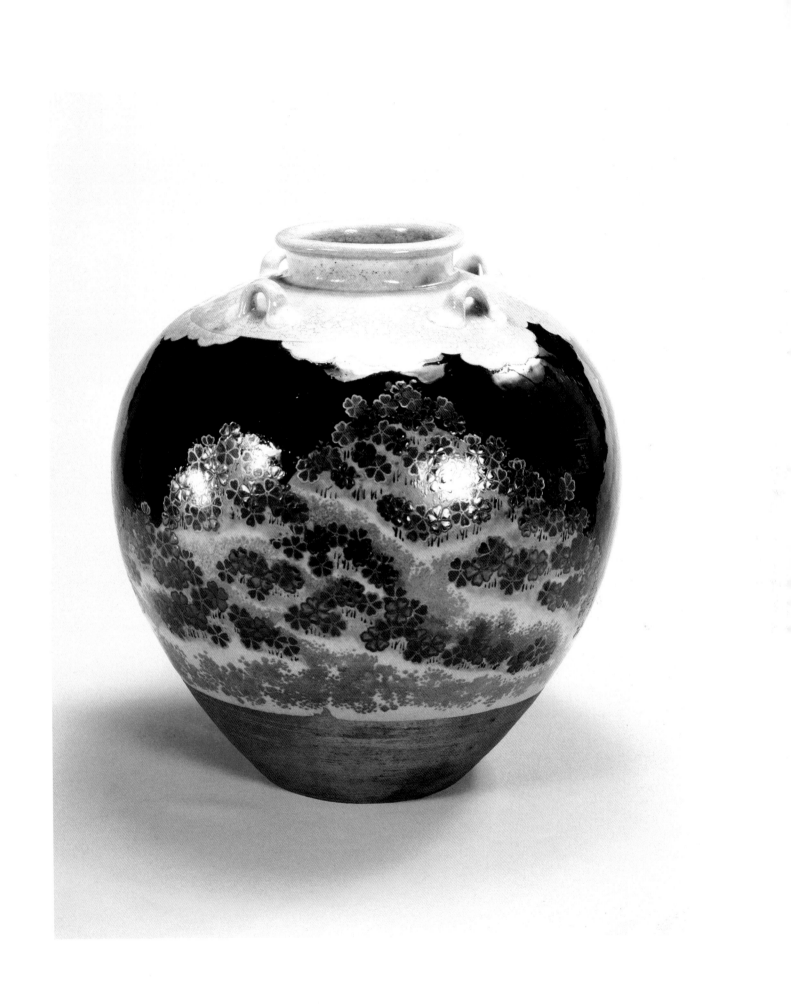

IZNIK CERAMICS, CHARACTERIZED BY EXUBERANT DESIGNS IN VIBRANT COLORS, RANK among the most renowned and highly prized arts of the Ottoman Turks (ruled 1281–1924). Named after its main production center in northwestern Anatolia, the ceramic tradition was in part inspired by Chinese porcelains flooding Near Eastern markets since the fourteenth century. Early Iznik vessels, dating to the late fifteenth and early sixteenth centuries, were decorated primarily with finely executed, stylized motifs in cobalt and turquoise blue, echoing Chinese blue-and-white porcelains.

During the second quarter of the sixteenth century, Iznik potters introduced a number of new colors, such as sage green and manganese purple, into their palette and began outlining their designs in black or gray. At the same time, the decoration became more naturalistic, combining different flowers, such as tulips, roses, and carnations. On the present dish, the gently swaying flower stems and the bulbous pomegranates springing from a cluster of carefully arranged, serrated leaves is typical of Iznik aesthetics. The harmonious composition of flowers and fruits in pale purple, deep cobalt, and muted green spreading across the entire surface of the plate creates the impression of a "wild and overgrown spring garden"[1]—an image inspiring visual pleasure and contemplative joy.

Produced in large quantities, Iznik ceramics served primarily as everyday tableware at the Ottoman court and for the elite. In preparation for his son's circumcision celebrations in 1582, the Ottoman ruler Murad III (ruled 1574–95) purchased 541 Iznik dishes and bowls from the bazaar to supplement the 397 pieces from the palace kitchen.[2] Although the most popular vessels were dishes with flaring rims or rimless ones, large footed basins, bowls, tankards, jars, ewers, water bottles, candlesticks, and mosque lamps were also widely used.

From the late sixteenth century on, Iznik ceramics were greatly appreciated abroad. Europeans not only imported, collected, and commissioned Iznik ware but also copied and imitated the rich, colorful designs, affirming the universal appeal of one of the most important Ottoman artistic traditions.

MASSUMEH FARHAD

1. Nurhan Atasoy and Julian Raby, *Iznik. The Pottery of Ottoman Turkey*, ed. Yanni Petsopoulos (London, 1994), 129.
2. As quoted in Atasoy and Raby, 14.

CARNATION SERVICE PLATE
c. 1775
CHINA, MADE FOR THE
PORTUGUESE MARKET
PORCELAIN
DIAMETER 9½ INCHES (24 CM)

PRIVATE COLLECTION, LISBON, PORTUGAL

A s EARLY as 1497, PORTUGUESE EXPLORERS INITIATED TRADE BETWEEN CHINA AND Western Europe, returning to Lisbon with exotic and highly desirable goods like spices, silks, and the most prevalent of still-surviving imports, Chinese porcelains. In the first century of the great European-Chinese trade, the 1500s, Lisbon emerged as a Western center of this highly profitable commerce. Between 1500 and 1850, the Portuguese made 2,100 voyages to China, carrying an estimated fifteen to eighteen million pieces of porcelain back to Portugal. Eighteenth-century Chinese porcelain factories were impressively adept at producing wares to suit contemporary European taste, as exemplified by this elaborate dinner service made to order for Portuguese nobleman Joaquim Inácio da Cruz Sobral (1727–1781).

During the first two centuries of the Chinese-European trade, the porcelains imported to Europe were mainly Chinese in form and decoration. These wares caught the fancy of Europe's royalty and nobility. Under their pressure and leadership, Western scientists, alchemists, and would-be wizards pursued the closely guarded Chinese secrets of making porcelain. In the eighteenth century, when that secret was unraveled and the methods of manufacture perfected at the Meissen factory in Germany, European designers began working in the medium. The Chinese factories responded quickly, copying forms from European porcelain produced for the European market. Actual Western examples in metalwork, earthenware, and porcelain must have been taken to China by the European traders to inspire the Eastern factories.

As early as the 1740s, the Meissen factory was producing bordered plates and platters mounted with molded flowers. These were copied by factories in England and France and then duplicated by the Chinese. In both form and decoration, the Chinese dinner service ordered by Sobral was a successful and convincing imitation of Meissen prototypes. Personalized porcelains, decorated with coats of arms like the Sobral service, were among the most expensive orders received from European nobility at the Chinese porcelain factories. Their execution often took more than three years to produce. The so-called carnation service, named for the enameled motif, was one of at least seven ordered by Sobral.

DONALD C. PEIRCE

COVERED VESSEL

EARLY 15TH CENTURY

JIANGXI PROVINCE, CHINA

PORCELAIN PAINTED IN
UNDERGLAZE BLUE

HEIGHT 14⅜ INCHES (36.5 CM)

PALACE MUSEUM, TAIPEI,
CHINESE TAIPEI

TRADITIONALLY, THIS LOVELY COVERED VESSEL HAS BEEN KNOWN AS A **MEIPING** (PRUNUS vase) because, without a cover, it would have been perfect for holding one elegant branch of flowering prunus. Practically speaking, however, inasmuch as it does have a cover, it most likely was intended for the storage of wine.

The floral design elements on this vessel include fungus scrolls and lotus blossoms, but it is the large peony scroll that dominates. The lotus and the peony are the two most popular flowers in Chinese art. While the peony is mentioned in classical literature as early as the Book of Odes, it really came into vogue during the Tang dynasty, when the Empress Wu (685–704) developed a passion for the flower. Since then, examples of both the tree peony and the herbaceous peony have been favorite subjects in both architecture and the applied arts. The peony symbolizes many things in China—wealth, honor, literary success, love, and happiness in general. It is one of the Flowers of the Four Seasons, where it is a sign of spring.

This vessel would have been produced in the imperial Ming dynasty kilns at Zhushan (Pearl Hill), in the ceramic capital of Jingdezhen, in Jiangxi Province. In 1973, these imperial kilns were discovered in the very heart of Jingdezhen; since then, they have been more fully investigated. Most of the excavated material came from waste heaps of deliberately broken porcelain. Only finished porcelains meeting the highest standards were kept for the emperor at these Zhushan kilns. The rest were smashed with a hammer, and the fragments were then buried on the grounds to keep them out of nonimperial hands. The Chinese have been meticulously assembling these fragments, and they now have thousands of reconstructed objects, among them a number of early fifteenth-century monochrome and blue-and-white vessels similar to this one.

SUZANNE VALENSTEIN

LARGE PLATE

17TH CENTURY

KIRMAN, IRAN

GLAZED CERAMIC

DIAMETER 16½ INCHES (42 CM)

MUSÉE DES ARTS DÉCORATIFS, PARIS

IN THE SIXTEENTH AND SEVENTEENTH CENTURIES, THE CITY OF KIRMAN IN SOUTHeastern Iran was a highly productive and innovative ceramic center. In addition to producing Chinese-inspired blue-and-white vessels that had enjoyed tremendous popularity from the fifteenth century on, Kirman potters specialized in brilliant, monochromatic glazed ceramics.

This large plate with its intense blue glaze is typical of one type of seventeenth-century Kirman ware. It was produced by applying a pure blue slip to the white body and cutting the design through the color into the milky white underneath. The vessel was then covered with a clear glaze.

Defined by wispy, undulating lines, the plate's floral motif gives the impression of apparent stasis and symmetry. On closer examination, however, the calligraphic lines appear to rotate slowly and sinuously around the empty center. The plate's overall visual effect is one of simple elegance and subtle movement, which must have been all the more striking in its original context.

During the seventeenth century, Kirman potters produced a large variety of ceramic vessels in different sizes, including ewers, vases, trays, bowls, cups, and plates. Glazed in brilliant colors—cobalt, turquoise, lavender blue, celadon, dark green, deep red, rich ocher, amber, and brown—they served primarily as functional objects. Vessels, like the large blue plate, were probably not seen individually but in clusters, such as during communal meals or more formal receptions. On these occasions, the vibrantly colored vessels were either arranged haphazardly or grouped neatly according to particular criteria. Creating a colorfully dazzling effect, they would have enlivened their setting and added to the pleasure and joy of mundane activities, such as daily meals, or enhanced the festive nature of more formal gatherings.

MASSUMEH FARHAD

T HE SONORAN DESERT OF SOUTHERN ARIZONA WAS THE HOMELAND OF THE HOHOKAM. Living in the desert valleys of the Gila and Salt rivers from about 300 B.C. to A.D. 1400, the Hohokam were master irrigation farmers who constructed a complex system of 150 miles of canals to water their maize, squash, beans, and cotton, which they wove into cloth. The Pima, who now live in the Hohokam region, are considered by archaeologists to be the descendants of this ancient tradition. In the Piman language, Hohokam means "all used up," sometimes translated as "those who have gone," or "the vanished ones."

The Hohokam are recognized for their painted pottery, which is decorated with an almost unlimited variety of red geometric designs and naturalistic human and animal figures on buff-colored clay. Like the spiraling flying bird motif on this bowl, Hohokam pottery vessels often are covered with creative patterns of dancing human figures, fish, lizards, turtles, snakes, or frogs. Some of the figures likely relate to the religious beliefs of these ancient people, while others are humorous depictions of the people and animals that made up the Hohokam world.

The animal motif appears in other mediums of Hohokam art, including carved-stone ornaments and paint pallets, etched shell ornaments, clay figurines, and shell, turquoise, and coral mosaic pieces. The red-painted pottery indicates influences of the Mexican native peoples to the south.

The archaeologist Emil Haury, who excavated the major Hohokam village site of Snaketown, characterized the society as a near-perfect adaptation to their desert homeland. By 1450, however, the culture had declined—perhaps due to a drought that occurred throughout the Southwest in the thirteenth century or perhaps because intensive irrigation had increased salinity of the desert soils. They left behind an irrigation system still followed by modern farmers and extraordinary examples of southwestern pottery and other art forms.

EMMA I. HANSEN

STRAINER

C. 1625 B.C.

STAVROMENOS, RETHYMNON,
CRETE, GREECE

CLAY

HEIGHT 16 INCHES; DIAMETER
10¼ INCHES (40.8 X 26 CM)

RETHYMNON ARCHAEOLOGICAL
MUSEUM, CRETE, GREECE

THIS CERAMIC VESSEL WAS MADE MORE THAN THIRTY-FIVE HUNDRED YEARS AGO ON the island of Crete in the Mediterranean. It is an unusual type of lidded strainer, and little is known about its exact function. While many strainer jars had a practical function related to the everyday tasks of food preparation, this elegantly decorated example must have been created for a specialized use, probably in a funerary ritual.

The painted decoration on this jar is unusually bold and varied. The rhythmic exuberance of the design bears testament to the artist's sensitivity to the strainer's ovoid form. Abstract and vegetal patterns festively complement the various parts of the vessel. The widest part of the vase is accented by a bold, running spiral, while plants spring up around the tapering lower body. Specific varieties, including the lily, the crocus, and the caper plant, can be identified. The delicate naturalism of the different plants stands in sharp contrast to the strong spirals linked by groups of wavy bands. The cylindrical base and conical lid are both decorated with horizontal zones of more stylized plant motifs.

The sophisticated Minoan culture of Bronze Age Crete takes its name from the legendary King Minos, a powerful ruler said to have controlled the seas around Crete and to have lived in a labyrinthine palace. Minoan Crete produced artists who took particular delight in rendering the beauties of the natural world. Even the spirals and wavy bands on this vase recall the rolling waves of the Mediterranean. They also echo the chased patterns used on vessels of bronze and silver, suggesting that the ceramic artist wanted to link his clay vase to the realm of more costly ones made of precious metals.

This strainer was found in a rock-cut tomb in western Crete, near the town of Rethymnon. Its archaeological context reinforces the impression that it was made expressly for a ritual use. Various suggestions have been made about the specific function of the vase, including as a receptacle for sponges for the cleansing of the body or as an incense burner.

PAMELA J. RUSSELL

Františeck Kupka
Czech, 1871–1957

**DISKS OF NEWTON, STUDY
FOR FUGUE IN TWO COLORS**
1911–12
Oil on canvas
39½ x 29 inches (77.5 x 73.6 cm)

Philadelphia Museum of
Art, The Louise and Walter
Arensberg Collection

K UPKA WAS ONE OF THE MOST ADVENTUROUS ARTISTS TO FOLLOW THE TRADITION, initiated by the Impressionists and boldly continued by Matisse, of liberating color from naturalist representation. This interest in freely interacting color—together with a fascination with movement as revealed in photographic investigations of animal and human motion—led Kupka to the creation of dynamic abstract pictures like this one. The title refers to Isaac Newton's discovery that natural light is made up of the colors of the spectrum, and painters from Impressionism on believed that presenting these pure colors on the canvas created a direct experience of light. Kupka uses the full range of hues—red, orange, yellow, green, blue, and violet, along with white—to give a sense of the sun's emanations in the expanse of the sky. The circular forms in the painting overlap and interpenetrate each other, producing an exciting feeling of movement and an image of cosmic space.

Larger meanings are suggested by the radiance of the picture, in accordance with Kupka's love of the effects of stained-glass windows in Gothic cathedrals, whose glowing light provides spiritual associations. The *fugue* referred to in the title further evokes spiritual experience, in particular the music of Johann Sebastian Bach. In fugues, Kupka wrote, "sounds evolve . . . intertwine, come, and go," and their sensuous, expressive, and intellectual richness helped him progress to a completely abstract form of painting. In fact, he declared, "I believe I can find something between sight and hearing and I can produce a fugue in colors as Bach has done in music." The ultimate goal of his art, he said, is "to give us joy, a sense of beauty."[1]

CLARK V. POLING

1. Quotations from Kupka's writings are from *Františeck Kupka, 1871–1957: A Retrospective* [exh. cat., The Solomon R. Guggenheim Museum] (New York, 1975), 31, 34, and 184.

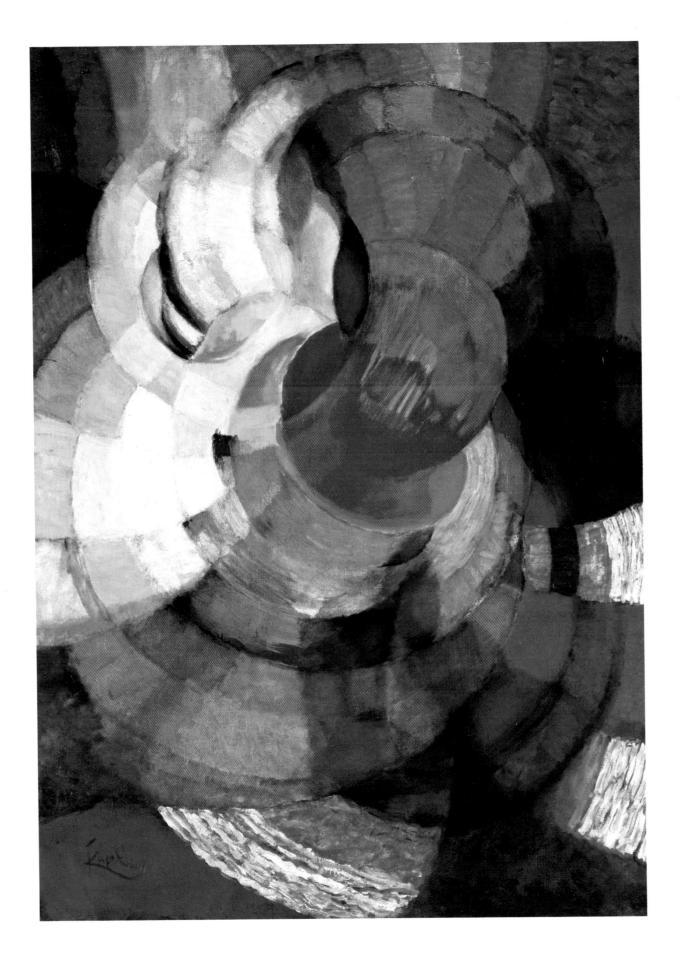

PIERRE AUGUSTE RENOIR
FRENCH, 1841–1919

WOMAN AT THE PIANO

1875–76
OIL ON CANVAS
36 11/16 x 29¼ INCHES
(93.2 x 74.2 CM)

THE ART INSTITUTE OF
CHICAGO, MR. AND MRS.
MARTIN RYERSON COLLECTION

T HE SECOND IMPRESSIONIST EXHIBITION, HELD IN PARIS IN 1876, WAS THE MOST IMPORtant in the history of the movement for its urban figure paintings. Major works by Renoir, as well as Edgar Degas, Gustave Caillebotte, Berthe Morisot, and even Claude Monet, defined a new role for the figure in a movement that had at first presented itself as almost exclusively interested in landscape. In recognition of that fact, critics as diverse as Edmond Duranty, Stéphane Mallarmé, and Henry James (the latter two writing in English) recognized the sheer contemporaneity and urbanity of the Impressionist aesthetic in 1876.

Woman at the Piano was the most wistful and moving painting of the exhibition. It represents a young woman—perhaps Renoir's wife, Aline—playing a new piano in a bourgeois interior with plants, works of art, and a patterned carpet. All is quiet, dark, and mysterious. The woman is seated on a contemporary revolving piano stool dressed in a superbly detailed white dress trimmed in black. The interior itself is suffused with deep blues, greens, and ochers, but there is a clear contrast between the whiteness of the woman's dress and the deep, recessive blackness of the piano. There are no windows in sight, but the fact that the candles on the piano are unlit and light seems to fill the room suggests that Renoir painted the scene to represent daytime practicing.

Renoir chose to represent a young woman whose skills are unquestioned, playing from a score selected from a pile of well-thumbed music on the top of the piano. Because she is completely absorbed in her music, we can gaze upon her with uninterrupted pleasure. She is, thus, both model and muse, and she surely serves in the latter capacity for us as we gaze at this supremely musical painting. The fluttering blue-black line that forms the trim on her white dress acts as a kind of visual summary of the music she plays, appearing and disappearing as does a melody in a passage of complex music. This line is as visually "musical" as her music is "artistic," and we are surely asked to relate—however subliminally—the respective performances of both pianist and painter.

This elegant—and seemingly effortless—painting is also a subtle investigation of the relationship between practicing (répétition in French) music and painting. The pianist plays a passage over and over until getting it "into one's fingers." The artist has the same task, working repeatedly from a motif until the representation seems to be as effortless and "natural" as does a really great performance of music. The difficulties and self-doubts that plague the performer or artist are of absolutely no consequence to the listener or beholder. Indeed, Renoir has given us a thoroughly modern muse, and we revel both in the paradoxically mute beauty of her music and in the artist's visual "translation" of it.

RICHARD R. BRETTELL

SEATED MALE FIGURE WITH HARP
2600–2500 B.C.
AMORGOS (?), CYCLADES, GREECE
MARBLE
HEIGHT 14⅛ INCHES (35.8 CM)

THE J. PAUL GETTY MUSEUM,
MALIBU, CALIFORNIA

THE CYCLADIC ISLANDS STRETCH LIKE ROCKY MARBLE STEPPING-STONES ACROSS THE Aegean Sea. Using gleaming white beach marble, Cycladic sculptors of the third millennium B.C. created representations of human beings in an abstract style strangely prescient of some of the great artists of the early twentieth century—Pablo Picasso, Amedeo Modigliani, and Constantin Brancusi. The seated harp player was the most complex image attempted by Cycladic artists, who used simple abrasive techniques to shape their figurines. The Getty harp player is both the largest and one of the best preserved, an aesthetic as well as a technical masterpiece. The harpist sits quietly but with his instrument held ready for play, his right arm poised gracefully on the sound box. He holds his head up in attention, and, while only the nose is carved, the areas of once-painted hair and eyes are still discernible.

Except for these marble musicians, which include woodwind players and appear all to be male, we know little of Early Bronze Age music—its sound, composition, or purposes. The harp players have been interpreted as a god prefiguring Apollo, to whom music was sacred, or, more possibly, a bard who sang poetry to the accompaniment of strings, as in the much later times of Homer. In a society that chose the spoken over the written word, the poet-musician would have played a central role in forging a cultural identity that comes by sharing stories from life and myth. We must imagine that his music would have been diverting and spiritually uplifting, and the fact that musician (as well as most other Cycladic) figurines were found in tombs suggests that this pleasure, among all other joys on earth, was worth taking to the beyond.

BONNA DAIX WESCOAT

Francesco Melozzo da Forlí
Italian, 1438–1494
ANGEL PLAYING A TIMBREL
c. 1477–80
Fresco
35⅞ x 44½ inches (91 x 113 cm)

Musei Vaticani, Città del Vaticano

Melozzo da Forlí is not well known today, but in the period in which he lived, he was considered an important artist who became the official painter to Pope Sixtus IV, one of the great patrons of art and architecture in the Italian Renaissance. Forli, the artist's birthplace, had no tradition of art, but Melozzo acquired a reputation as a painter at an early age in the cultural center of Urbino, where he would have known important artists such as Alberti and Piero della Francesca. Some scholars think that Melozzo's mastery of perspective suggests that Piero may have been his teacher.

Melozzo's most important work was done in Rome for Pope Sixtus IV. His most famous painting there was the fresco of *The Ascension of Christ* in the apse of the Early Christian Basilica of Santi Apostoli. The work was probably commissioned around 1480 by Sixtus or his nephew, the future Pope Julius II and the famous patron of Michelangelo and Raphael. The fresco was destroyed in the eighteenth century, and only a few fragments, such as this one in the collections of the Vatican, have survived. The loss of so much of Melozzo's work undoubtedly accounts for the lack of familiarity with his work today.

The original fresco in Santi Apostoli depicted the figure of Christ ascending to Heaven surrounded by angels playing musical instruments. The joy of the angels celebrating Christ's triumph over death illustrates Psalm 150, in which the psalmist exhorts the world to praise God "with the sound of trumpet: praise him with psaltery and harp. / Praise him with timbrel [as here in the Vatican angel fragment] and choir: praise him with strings and organs. / Praise him on high sounding cymbals: praise him on cymbals of joy. / Let every spirit praise the Lord."

JOHN HOWETT

WILLIAM H. JOHNSON
AMERICAN, 1901–1970
JITTERBUGS (II)
C. 1941
TEMPERA, PEN AND INK,
AND PENCIL ON PAPER
18 X 12³⁄₁₆ INCHES
(45.6 X 31 CM)

NATIONAL MUSEUM OF
AMERICAN ART, WASHINGTON,
D.C., GIFT OF THE
HARMON FOUNDATION

WILLIAM H. JOHNSON WAS BORN IN FLORENCE, SOUTH CAROLINA, THE SON OF AN African-American woman (with Sioux Indian ancestors) and a prominent white man. Johnson taught himself to draw by copying cartoons from the newspaper, and, when he was seventeen, he moved to New York and worked a series of menial jobs to pay for classes at the National Academy of Design. When he graduated in 1926, having earned many top honors, one of his teachers raised money to send Johnson to Europe, where he spent most of the next fifteen years.

Inspired by the works of Chaïm Soutine, which he saw in Paris, Johnson developed a rich, expressive style of landscape painting that was well received in Europe, though he remained largely unknown in his native land. In the fall of 1938, with war looming, he and his Danish wife moved to New York, where Johnson found work with the murals division of the Works Progress Administration and taught at the Harlem Community Art Center.

Inspired by Harlem's lively street life, Johnson began to depict the people and events of the neighborhood. He pared his palette down to fewer than ten bold colors, which he applied in broad, uninflected planes. He expanded his subjects to include scenes from old spirituals and Bible stories, depictions of the efforts of African-American soldiers in World War II, and events that shaped African-American history and culture. "In all my years of painting," Johnson said, "I have had one absorbing and inspired idea and have worked toward it with unyielding zeal—to give, in simple and stark form, the story of the Negro as he has existed."[1]

Jitterbugs refers to a loosely defined, post-Depression subculture of the same name, known for its "hep" slang, bold fashions, and frenetic swing music. In *Jitterbugs (II)*, a man and woman press close together as they execute a daring dip. Their broad smiles, stylish dress, and exaggerated dance movement exude joyous energy and confidence.

CARRIE PRZYBILLA

1. Nora Holt, "Primitives on Exhibit," *New York Amsterdam News,* March 9, 1946. Cited in Adelyn D. Breeskin, *William H. Johnson, 1901–1970* (Washington, D.C., 1972), 18.

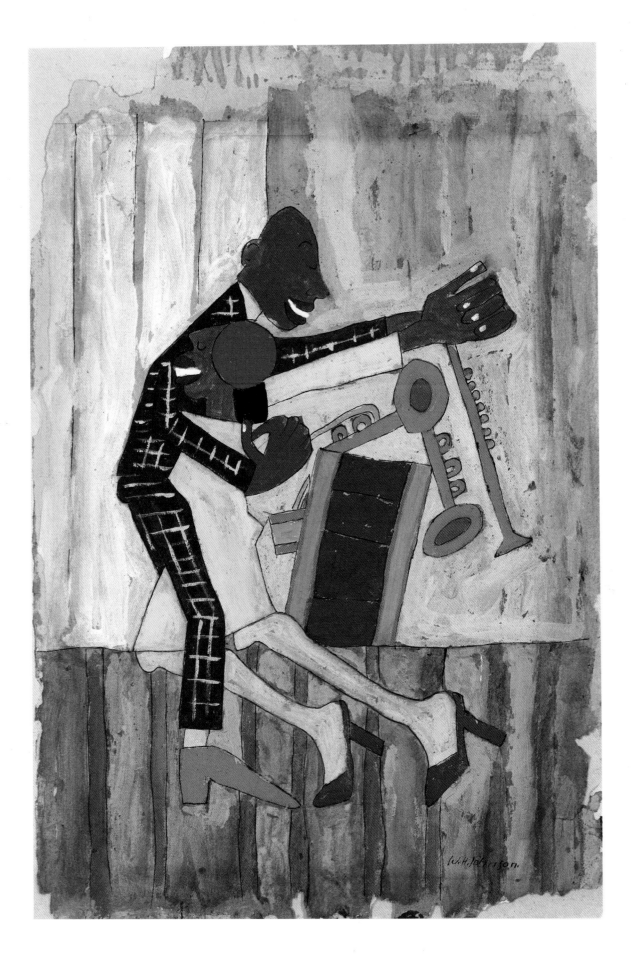

BORN IN WARSAW IN 1882, ELIE NADELMAN'S DEVELOPMENT AS AN ARTIST TOOK HIM briefly to Munich in 1904. There he encountered the fifth-century B.C. pediment sculptures from the Temple at Aegina at the Glyptothek and studied seventeenth- and eighteenth-century German dolls at the Bayerische Museum. After six months in Bavaria, Nadelman was drawn to Paris at a particularly ripe moment in that city's artistic history. Befriended by the Polish-born Natanson brothers (who published the influential periodical *La Revue Blanche*), Nadelman was welcomed into the modernist artistic circle of Gertrude Stein. It was in Paris that he produced his first classicizing yet animated heads and torsos.

When German advances during World War I threatened Paris, Nadelman, with the assistance of the American philanthropist Helena Rubinstein, traveled to the United States, where he prospered. After his marriage to a woman of considerable means, in 1919, Nadelman, with his wife, began to collect American folk art and hoped to create a museum that would display these works. The stock-market crash of 1929 wiped out the Nadelmans' fortune, required the disbursement of their folk-art holdings, and began a period of artistic and professional seclusion for the artist that lasted until his death in 1946.

The cherrywood sculptures of c. 1914–18 are among Nadelman's last major works. In subject, they relate to popular culture: a woman at the piano, a man with a bowler hat, a dancing couple. In medium, they are closely aligned to folk art. In content, they amalgamate influences as diverse as classical and Egyptian art. *Dancer* of c. 1918–19 is possibly the most exuberant sculpture ever made by Nadelman. Its uplifted leg and evocative stillness remind the viewer of Nadelman's joyous embrace of both ancient and modern sources for his art.

MICHAEL E. SHAPIRO

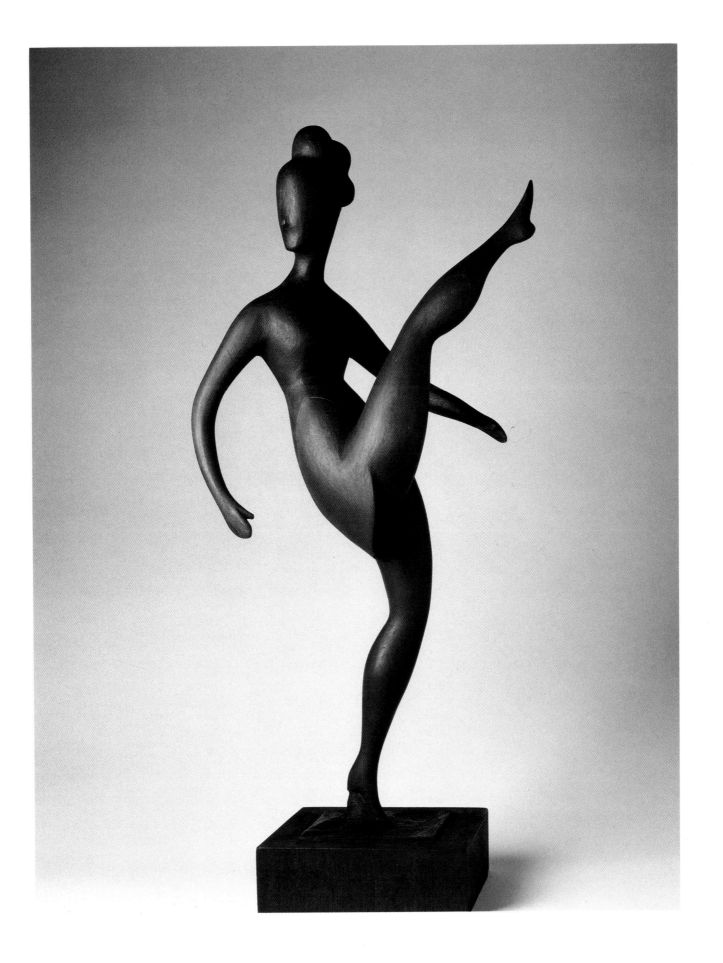

SHIVA AS LORD OF THE DANCE
(NATARAJA)
C. 950
TAMIL NADU, INDIA
COPPER ALLOY
30 x 22½ x 7 INCHES
(76.2 x 57.1 x 17.8 CM)

LOS ANGELES COUNTY
MUSEUM OF ART,
GIVEN ANONYMOUSLY

UNIVERSALLY REGARDED AS THE QUINTESSENTIAL IMAGE OF HINDU ART AND CULTURE, representations of the god Shiva dancing in joyous abandonment within a circle of flames graphically depict his five cosmic acts of creation, preservation, destruction, unveiling of illusion, and liberation of the soul. His creative aspect is symbolized by the hourglass-shaped drum, in his proper upper right hand, which reproduces the primordial sound of creation. Shiva's preservation of the universe is suggested by his lower right hand held in the gesture of reassurance and safety. The flame in his upper left hand and that encircling the aureole represent the fire by which he destroys the universe in order to recreate it. He lifts the veil of illusion through his engendering act of dancing. His liberation of the soul is shown by his upraised left leg, which tramples on a prostrate infant signifying forgetfulness and is thus a source of grace.

While Shiva is believed to dance in various forms and locales for differing purposes, in this pose as Lord of the Dance (*Nataraja*), he is praised by the renowned eighteenth-century South Indian poet Thayumanavar as performing the "Dance of Bliss in the Hall of Consciousness."[1] The dance of bliss is specifically associated with Chidambaram, the sacred center of Nataraja worship, where Shiva is said to have first performed it in order to convert a group of holy men who were engaged in heretical practices. Chidambaram is also the site of the great twelfth-century temple specifically dedicated to Shiva's aspect as Lord of the Dance. The temple has a silver image of the dancing god as its main icon, and the gateway around the complex is adorned with sculpted depictions of the 108 basic postures of classical Indian dance, Bharata Natyam, which has been performed since at least the second century B.C.

South Indian copper alloy images such as this were originally carried in processions during religious festivals; ropes were inserted through the square holes in the base to tie it to support poles. The distinctive elliptical shape of the aureole and slender figural style indicate that it is one of the earliest surviving images of this type.[2]

STEPHEN MARKEL

1. Calambur Sivaramamurti, *Nataraja in Art, Thought and Literature* (New Delhi, 1974), 24.
2. Pratapaditya Pal, *Indian Sculpture*, vol. 2: *700–800: A Catalogue of the Los Angeles County Museum of Art Collection* (Los Angeles, 1988), 262–64.

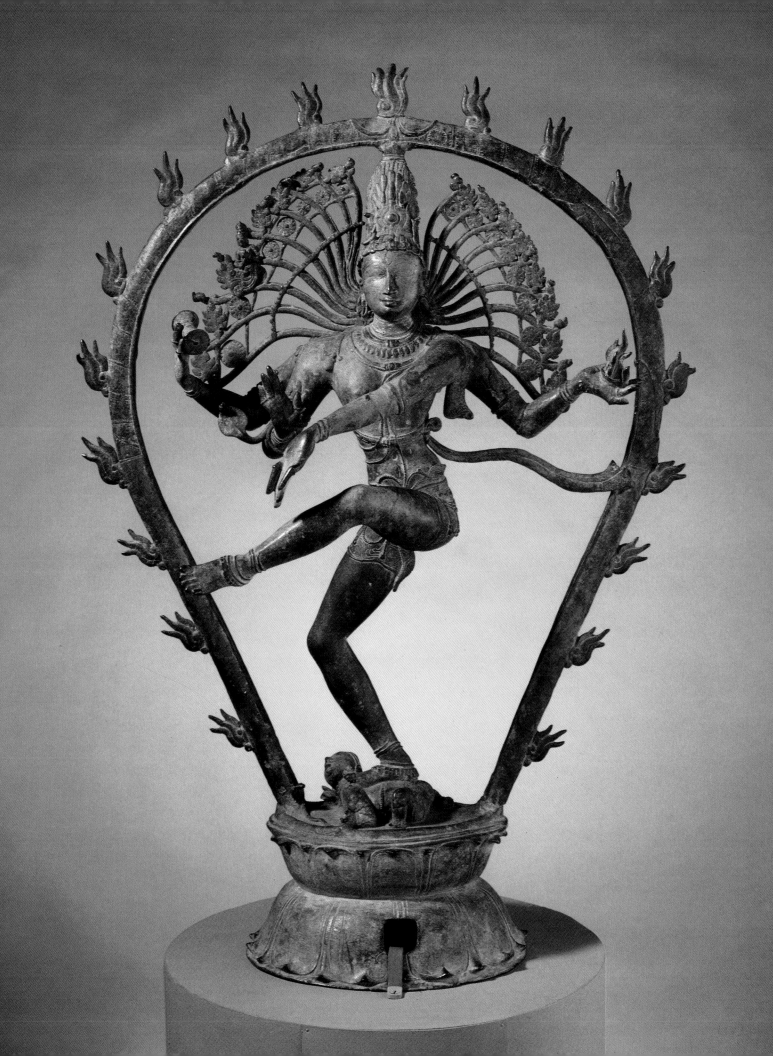

Willem de Kooning
American, born 1904
UNTITLED
1985
Oil on canvas
77 x 88 1/16 inches
(195.6 x 223.4 cm)

Hirshhorn Museum
and Sculpture Garden,
Smithsonian Institution,
Washington, D.C.,
Holenia Purchase Fund,
1991

I n 1963, after more than four decades in New York City, Willem de Kooning moved permanently to Springs, on the far end of Long Island. The expansive landscape—with its North Atlantic light, low-lying dunes, surrounding water, and deep-green foliage and fields—reminded the artist of his native Holland. From the time he settled in Springs at the age of fifty-nine, de Kooning embarked on a body of work often thought to rival that of Monet in its fresh momentum. The reference points of his art—landscape, figure, and gestural abstraction—meld seamlessly together.

Working exclusively during daylight hours in a large, open studio with floor-to-ceiling windows, de Kooning immersed himself in the subtleties of the steely gray-green landscape and luxuriated in the quality of the light and colors there. In contrast to his heroic and often turbulent earlier canvases, these late paintings reflect his joyous response to nature. Nature, for him, is at once edenic yet soulful; the transience of the pleasures he celebrates is always keenly present.

De Kooning returned again and again to the image of woman. The idyllic bacchanals of Renoir, Cézanne, Matisse, and Rubens were inspirations for him. In contrast to the aggressive *femme fatales* who peer at the viewer in his 1950s canvases, however, his late women are earthy (and at times ironically caricatured) sun-drenched nymphs cavorting amid the seaside landscape.

De Kooning's canvases of the 1980s are concise. The flow of his gesture is closely related to the economic line of his drawings rather than to the material mass of brushstrokes. In *Untitled,* 1985, the calligraphy simultaneously evokes windswept organic forms and two women (seen from front and back), arms interlocked and legs in dancelike attitude. The swaying movement recalls Matisse's bucolic masterpiece *The Dance,* whose unbridled view of female sensuality, observed from a distance as if at a performance, de Kooning shares. With the artist's advancing age, voluptuousness also takes on a redemptive edge; he said, "I think of woman as being light, soaring upward instead of heavily attached to the ground."

SUSAN KRANE

CAMILLE CLAUDEL
FRENCH, 1864–1943
THE WALTZ
1895
BRONZE
17 x 9½ x 13½ INCHES
(43.2 x 23 x 34.3 CM)

MUSÉE RODIN, PARIS

THE WALTZ REFLECTS CAMILLE CLAUDEL'S GENIUS FOR MANIPULATING CLAY INTO REAListic, expressive human forms. It is her third variation on the theme and one of some thirty editions created between 1892 and 1905. As Claudel's first endeavor after ending a long and tumultuous affair with her mentor, Auguste Rodin, *The Waltz* is both a spirited declaration of independence and a memorial to their untenable passion.

In her first version (*The Waltzers*, 1892, now lost), Claudel presented the dancers nude and was refused the commission she sought to translate the work into marble. The work was deemed improper, especially coming from a female sculptor. A determined Claudel responded with a second version in which she enveloped the figures in a windswept cloak that accentuated the rhythmic swirl of the dance. She retitled the work *The Waltz* to emphasize the shift in focus away from the sensuous embrace of waltzing lovers to the waltz itself. The revised work was accepted and exhibited at the Salon of 1893. It won Claudel her prized marble commission and her greatest critical acclaim.

This third rendering (and its subsequent variations) was created for the collectors' market to help offset the expense of the large marble undertaking. The female figure has been restored to partial nudity, covered now from only the waist down.

MELISSA THURMOND

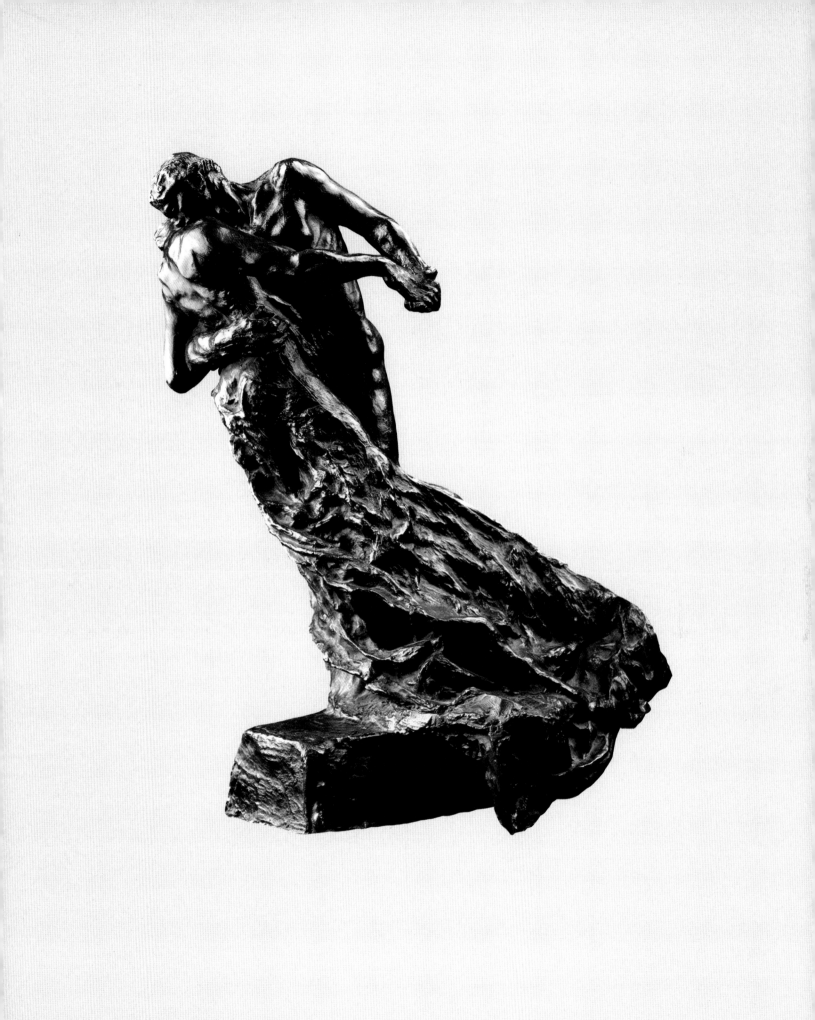

TAWARAYA SŌTATSU
JAPANESE, FL. 1602–C. 1643
BUGAKU: COURT DANCES
C. 1630
PAIR OF TWO-FOLD SCREENS;
COLOR AND GOLD LEAF ON PAPER
EACH 61 X 66½ INCHES
(155 X 169 CM)

DAIGO-JI, KYOTO, JAPAN

A STATELY CELEBRATION OF LIFE AND DEATH, YOUTHFUL VIGOR AND OLD AGE, AND the mysteries of nature and foreign realms in a brilliant palette of primary color in against a solid gold–leafed surface, this masterful composition of masked dancers is one of the masterpieces of the revival of the courtly tradition in the arts of early Edo-period Japan. Introduced from Korea and China between the mid-sixth and the eighth centuries, *Bugaku* became an essential part of religious and court ritual. By the Heian period, its performance was an expected accomplishment of the nobleman. Although costumes and poses are taken directly from a type of didactic picture scroll that, since the twelfth century, served to transmit the traditional costumes, masks, and choreography of these ritual dances, Sōtatsu inventively abbreviated the repertoire of some twenty-four pieces to five. Beginning at right with *Saisōrō*, the pace is magisterial in the slow steps of an old man in the white brocade garb of a Heian official. Although this dance celebrates longevity, it is rarely performed due to a tradition that it be danced only by one who will die within a year. The pace quickens in the paired dancers in green dragon masks and military garb for *Nasori*, a victory dance whose flowing motions mimic playful dragons. Their gracefully matched cadence is answered by the excitement of *Raryō-ō*, a dance signaled by the raised baton of the golden-masked Dragon King of Liang. This fast-tempo dance recalls the valor of the comely general Lan Ling, a prince who disguised his beauty behind a grotesque mask to frighten his enemies and bolster his troops' morale in battle. His victory dance, which augurs peace and prosperity, was also performed alone as a prayer for rain. Its joyous pace is echoed in the elated swirls and stomps of *Genjōraku*, the barbarian snake eater whose twisting form and downward gaze leads to *Korobase*, a quartet of dancers in beaked mask and feathered headdress whose swaying sleeves evoke the graceful motions of a flock of cranes, bringing the sequence to a stately denouement. Dramatically framing the dancers are diagonally disposed elements of music and setting.

Although Sōtatsu was not the first to paint *Bugaku* dances on a large format, his sure sense of composition, honed by a professional background as an artisan-director of a shop producing decorated fans, makes his the masterpiece of the genre. This screen was painted sometime after 1621, when Sōtatsu was honored with the title of *Hokkyō* with which he signed this work. At that time *Bugaku*, which, along with the imperial court, had been in decline since the thirteenth century, surviving only in isolated traditions, had been revived by the first Tokugawa shogun, Ieyasu (1542–1616). It continues to be the official music and dance of the imperial court, done today by descendants of the families first charged with its performance.

BARBARA FORD

NUNOZARASHI-MAI (CLOTH-BLEACHING DANCE), NAMED FOR THE UNDULATING SWIRL of white cloth that frames the dynamic movements of this young dancer, is a favorite piece in the kabuki repertoire. Mesmerized musicians accompany in a quickening tempo of hand-beaten drums, assonant chants, and the high-pitched plucking on the *samisen,* a three-stringed instrument imported at the end of the sixteenth century from the Ryūkyū kingdom that came to provide the distinctive music of urban pleasure quarters during the Edo period.

Although this image of pulsating sound and dancing abandon deftly captures the heady pleasure of the newly thriving city of Edo, it was painted in Miyakejima, a rural island where the artist spent twelve years in exile for a political indiscretion, beginning in 1698 when he was at the height of his remarkable power. When he was pardoned at age fifty-eight, after the death of ruthless and profligate shogun Tsunayoshi (1646–1709), he returned to Edo, adopted the name Itchō, and further pursued his open-hearted love for the sights and sounds of Edo's urban scene. His insightful and surely rendered images attracted a following of admirers and pupils but rarely surpassed the élan of this charming work.

The poor-quality pigments and paper of the exile notwithstanding, this is surely one of the finest and most telling artistic expressions of the heady Genroku period (1688–1704), when, in both the old capital Kyoto and the new center of the shogunate in Edo, a flourishing urban society gave birth to an irrepressibly exuberant and witty temperament. This spirit reverberates in his tongue-in-cheek signature that affects an aristocratic pedigree with the surname *Fuji,* perhaps a reference to his academic training under Kano Yasunobu (1613–1685), official painter to the shogunate, and gives as his personal name *Ushimarō,* an improbable combination with the paradoxical nuance of country bumpkin as urban dandy. This humorously self-mocking nom de plume of the would-be Edoite presents an engaging image of the artist, dejected but not embittered in his exile among cattle and their keepers, far from the intoxicating sights and sounds of the capital so ably captured here.

BARBARA FORD

HENRI MATISSE
FRENCH, 1869–1954
DANCE (II)
1909–10
OIL ON CANVAS
101⅝ x 153½ INCHES
(258.1 x 389.9 CM)

THE STATE HERMITAGE MUSEUM,
ST. PETERSBURG

M ATISSE DEDICATED HIS CAREER TO DEVELOPING A DECORATIVE, EXPRESSIVE FORM of abstraction. Among his best known works is the mural-sized canvas *Dance (II)*, commissioned in 1909 by Sergei Shchukin, a Russian merchant who had previously purchased several of Matisse's paintings. Intended for a grand, three-story staircase in Shchukin's home, Matisse conceived of *Dance (II)* as part of a suite of three paintings: *Dance (II)*, *Music* (also in the collection of The Hermitage), and a scene of repose. Because of the scandal *Dance (II)* and *Music* caused at the Salon d'Automne of 1910—Matisse's use of intense, vibrant colors in the former was even more shocking than the male nudes that populate *Music*—Shchukin briefly hesitated before accepting the two canvases. For unknown reasons, he refused the third canvas (now in the collection of the Art Institute of Chicago), which Matisse reworked several times between 1909 and 1916, when he titled it *Bathers by a River.*

The idea of dance clearly occupied Matisse's imagination for several years. A ring of dancers appears in the distant background of Matisse's *Le bonheur de vivre*, 1905–6 (now in the collection of the Barnes Foundation), a painting that celebrates life's hedonistic pleasures. *Dance (II)* literally and figuratively expands this theme: five nude women hold hands as they cavort atop a grassy knoll, entirely filling the canvas. The stylized lines of the dancers' bodies radiate energy and grace. The group's circular motion directs attention to the center of the canvas, indicating unity and balance. Matisse rendered the scene in vivid shades of red, blue, and green that emphasize the intense joy of the dance. Vibrant, lyrical, exultant—this ring of dancers eternally symbolizes life's ecstasy.

CARRIE PRZYBILLA

The loan of this painting was made possible, in part, due to the support of The State Hermitage Museum by The Coca-Cola Company.

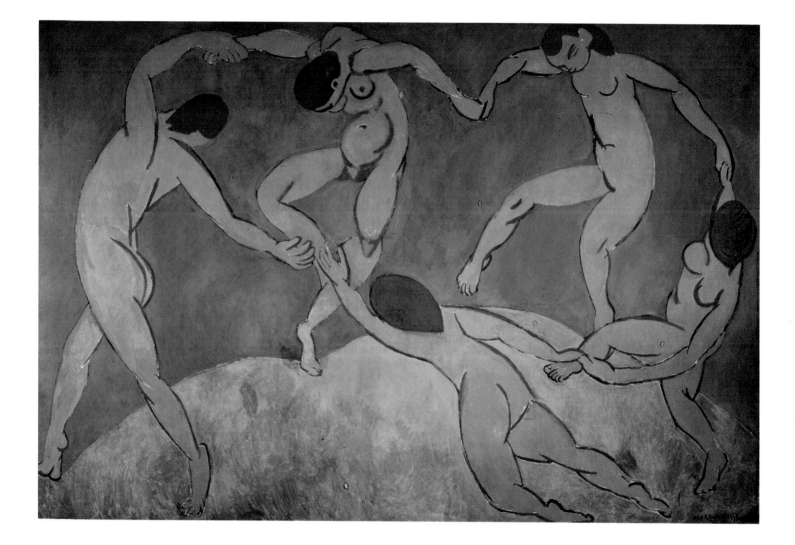

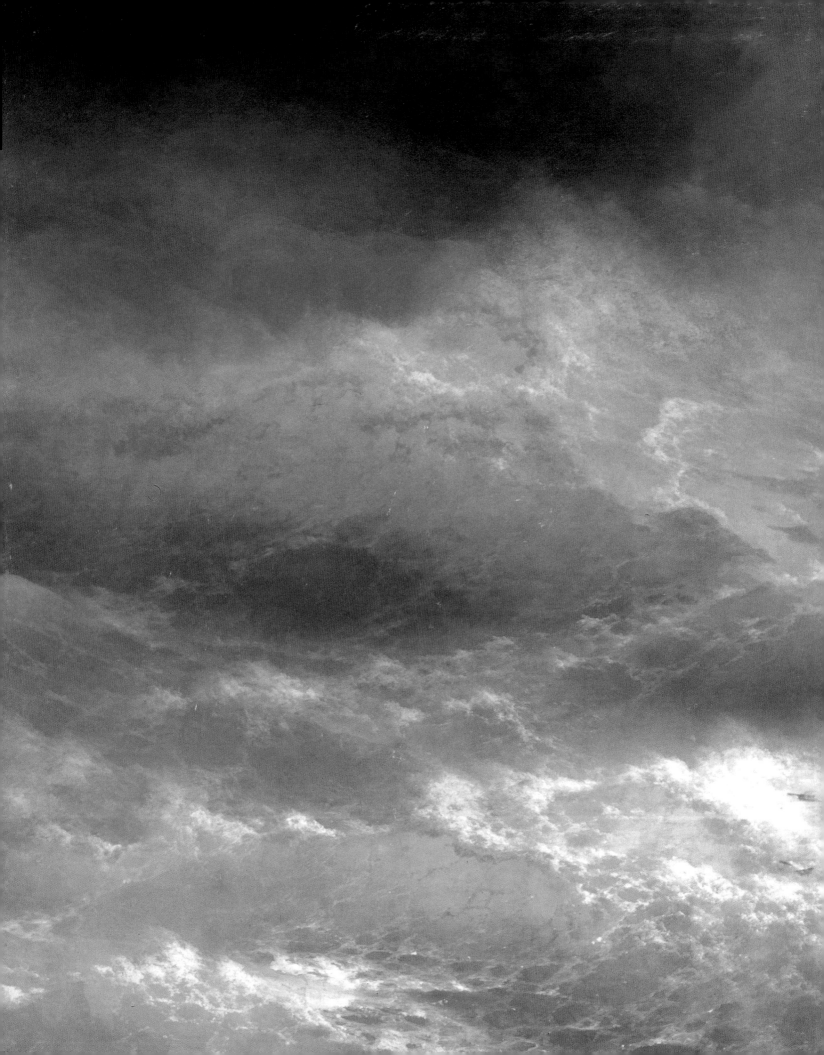